The NASA Northrop T-38
Photographic Art from an Astronaut Pilot

An immersive journey into the spirit of flight with photographer and astronaut, pilot and poet, Story Musgrave

The NASA Northrop T-38

Photographic Art from an Astronaut Pilot

Story Musgrave
Lance Lenehan
Anne Lenehan

First Edition 2009
Published by Lannistoria
Copyright © 2009 Lannistoria
Please direct all feedback and enquiries to info@lannistoria.com

Photography and Text by Story Musgrave
Production and Design by Lance and Anne Lenehan

Printed in the USA by Bookmasters Inc

ISBN: 978-0-9751873-2-6
Aeronautics and Space Flight

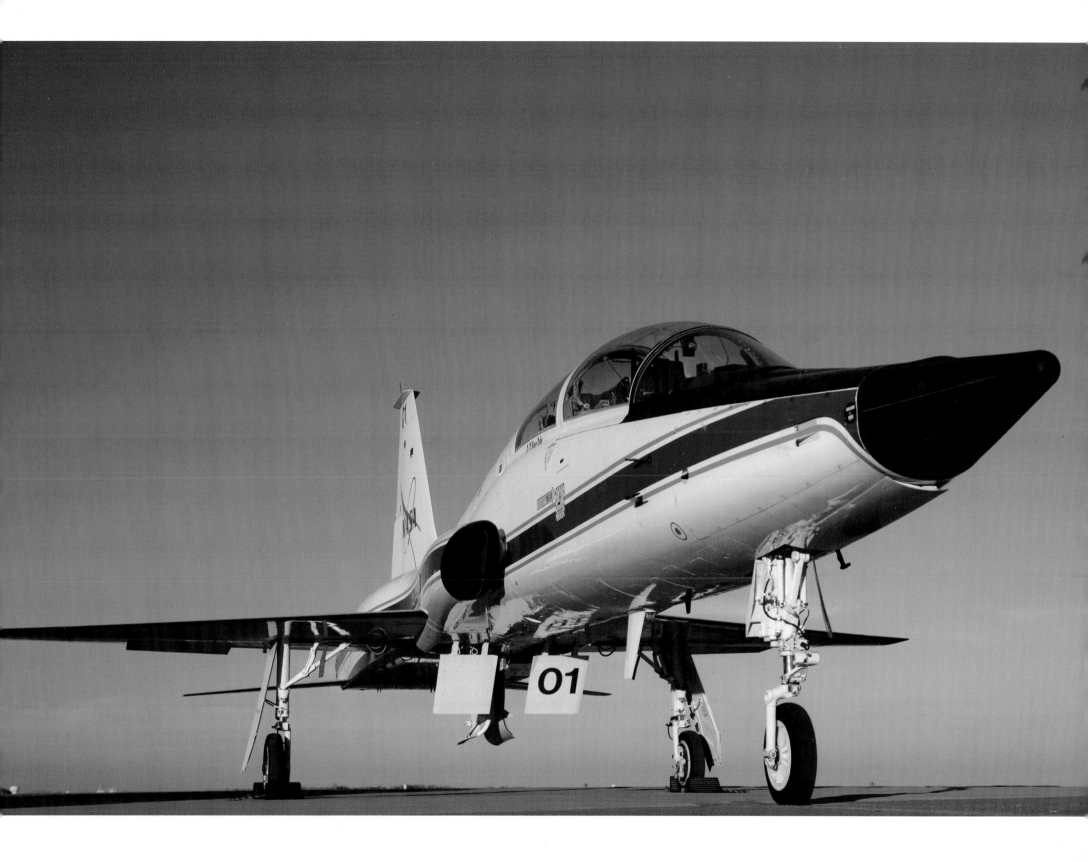

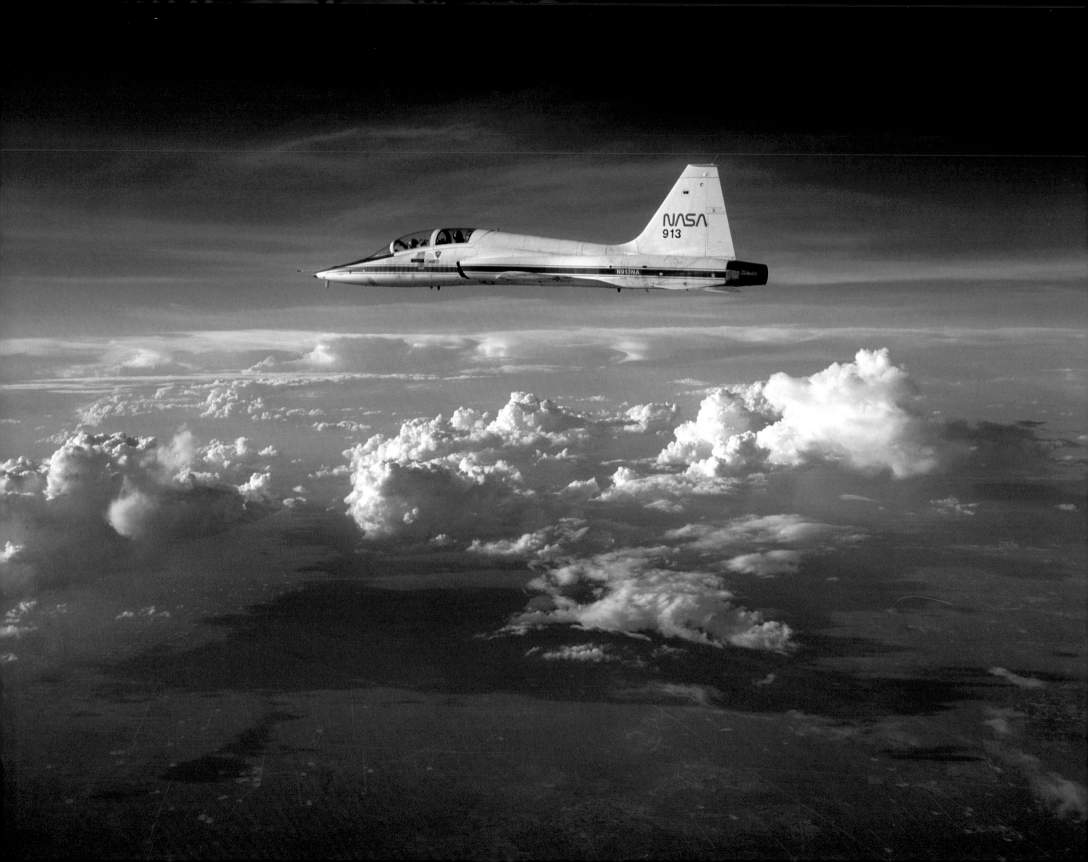

Foreword

On a brilliant afternoon in May 1978, I strapped into a Northrop T-38 Talon and rocketed into the blue sky over Oklahoma, easing effortlessly up through white cumulus towering over emerald wheat fields twenty thousand feet below.

The approach controller watched the twisting blip of my Talon on his scope and radioed, "Must be some nice 'puffies' up there today!" He heard the laughter in my reply: "Roger that!" A 19-year-old John Gillespie Magee, Jr. wrote of a similar flight in 1941: "Sunward I've climbed, and joined the tumbling mirth of sun-split clouds – and done a hundred things you have not dreamed of…" Surely my T-38 equaled his Spitfire in its capacity to delight a fledgling aviator.

Story Musgrave felt the same exuberance at the controls of his own T-38. In 1968, NASA had sent Story, a new scientist-astronaut, to pilot training in Lubbock, Texas. He broke every student performance record on the way to earning the Commander's Trophy as the outstanding graduate at Reese Air Force Base. He was just getting started. In nearly thirty years of flying, Story logged over 8,000 hours in the Talon, including 3,000 as an instructor. His love for the plane that so effortlessly broke the bonds of Earth is obvious in this beautiful book.

Story's astronaut colleague, Skylab 3 veteran Owen Garriott, was a frequent visitor to my training field, Vance AFB, located on the outskirts of Owen's hometown of Enid, Oklahoma. One frosty January weekend he dropped in for a quick family visit, parking his gleaming NASA "White Rocket" adjacent to our Air Force Talons. Spotting the blue-trimmed T-38 on the Vance ramp, I laid a reverent, gloved hand on the immaculate jet. A friend's snapshot captures my expression of admiration and hopeful envy.

Since 1961, the T-38 Talon has launched the dreams of nearly 80,000 USAF, allied, and NASA pilots. Northrop's swept-wing, two-place jet first flew in 1959; adopted by the Air Force as a high-performance jet trainer, 1,187 Talons were built by the time production ended in 1972. Its two General Electric J85-GE-5 turbojet engines (with afterburners) together pump out more than 6,000 pounds of thrust, enough to power the Talon from sea level to 30,000 feet in less than a minute. (In February 1962, the nimble, 12,000-pound aircraft set four international time-to-climb records.) In nearly a half-century of service, the -38 has proven itself as a workhorse student and attack trainer, a flight test chase plane, an astronaut proficiency trainer, and even a recurring performer in the movies. Updated and improved in the last decade, about 700 T-38s remain in service worldwide.

After pilot training, I went on to fly the Talon again in Strategic Air Command, and then again at NASA; it was exhilarating to rocket out of Ellington Field in the very jet Owen Garriott had piloted to Vance a dozen years earlier. Beginning with astronaut training in 1990, I was airborne once or twice a week, practicing everything from aerobatics, to instrument flying, to the principles of "cockpit resource management," often while dodging thunderstorms between Houston and Cape Canaveral at 39,000 feet and Mach 0.9.

Back on the ground, my astronaut candidate class, the "Hairballs," regularly heard from experienced shuttle veterans assigned to teach us a particular aspect of human spaceflight. Our EVA expert was Story Musgrave, spacewalker extraordinaire, who had helped design the shuttle space suit and in 1983 was the first astronaut to venture outside the shuttle's airlock. Already an astronaut for nearly 25 years, Story had more hours in the T-38 than any stick-and-rudder man on–or off—the planet. He loved to fly, and the object of that romance was the Northrop T-38.

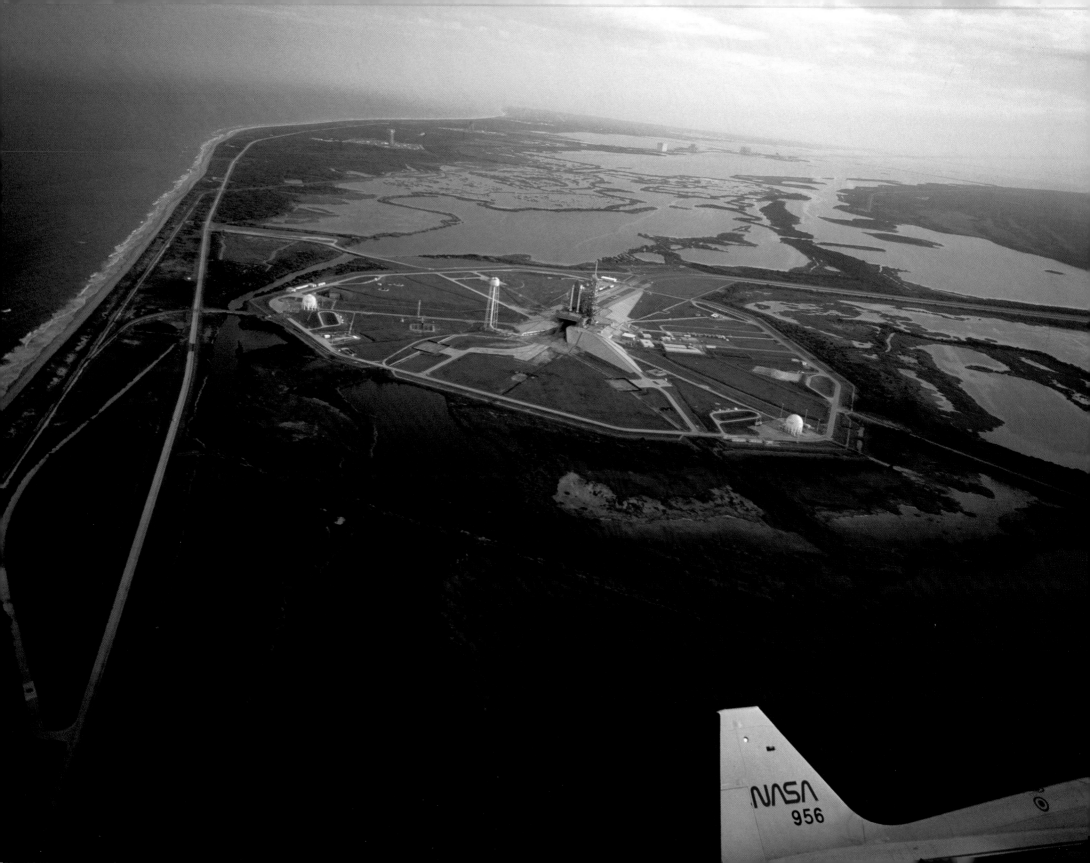

By 1990 NASA rules limited its mission specialists to only back-seat sorties, with instructors or shuttle pilots in the front cockpit, so I never got to crew a T-38 with Story. But in 1993 we teamed up as aircraft commander trainees in NASA's Cessna Citation II. Story and I sweated out two weeks of simulator and ground school sessions together, then joined a handful of other astronauts in the Citation's left-seat, helping other mission specialist astronauts acquire the cockpit and teamwork skills they would need aboard the space shuttle. I saw Story at work in the air: cool, methodical, yet lyrical about the joys of being aloft. He thrilled to have the machine respond to his deft touch, an exhilaration he experienced wherever he flew--in the T-38, in the space suit, or in the cockpit of a shuttle orbiter (his six launches aboard the shuttle set a record only lately surpassed).

In early November 1996, Story and I joined our STS-80 crew for a heady formation flight to the Cape. Entering the final days of pre-launch quarantine, our crew winged across the Gulf of Mexico to Kennedy Space Center, our four jets gliding in from high above Orlando until we whistled at 300 knots across the Banana River toward Launch Complex 39. Rolling left, Story, the crew and I looked down a thousand feet past our wingtips to Pad 39-B and our rocket – the shuttle Columbia! The hair stood up on the back of my neck. Our T-38s had delivered us to the threshold of space.

Story brought his T-38-honed serenity aboard Columbia on our 18-day mission, the longest in shuttle history. Those unequaled hours alone in the Talon's cockpit also gave him an expert eye for observing Earth. At nine-tenths the speed of sound, the Talon trims beautifully, easily controlled with a thumb and fingertip occasionally nudging the stick. On the ninety-minute run from El Paso to Houston's Ellington Field, the T-38 offered a superb perch for the prospective orbital observer. The ancient, up-thrust reefs of the Guadalupe Mountains, the eroded sandstones of the Permian Basin, the dissected central peak of the Sierra Madera impact crater – all unfolded beneath the Talon's wings. At sunset, stars winked on one-by-one in the deep blue-black dome above, wrapping the crew in a night sky nearly as thick with stars as space itself.

The Talon will train the crews of America's next-generation spaceship, the Orion crew exploration vehicle. A T-38 sortie serves up a rapidly changing diet of challenges, forcing future crewmembers to recognize and deal with problems of deteriorating weather, imperfect communications, task saturation, and marginal fuel reserves. The demanding operational environment in a T-38 cockpit produces teammates with mutual respect and trust, traits essential to success when strapping on a real rocket.

To fulfill that mission through 2020 and beyond, NASA has heavily modified its two dozen or so T-38s, improving the takeoff efficiency of engine inlets and tail pipes, protecting crewmembers with more capable ejection seats, and easing piloting and navigation workload with a modern, all-glass cockpit. The Air Force has followed with propulsion and cockpit improvements to its own fleet of T-38Cs.

For future deep space explorers, the road to the Moon, near-Earth asteroids, and Mars will still pass through the cockpit of Northrop's sleek, timeless Talon. As Story Musgrave puts it: "A thousand years from now its beauty will not have changed; it's not in any time or place - it's eternal."

Dear Story: Anytime you need a co-pilot ...

Tom Jones
STS-59, -68, -80, -98
Houston, Texas
December 2008

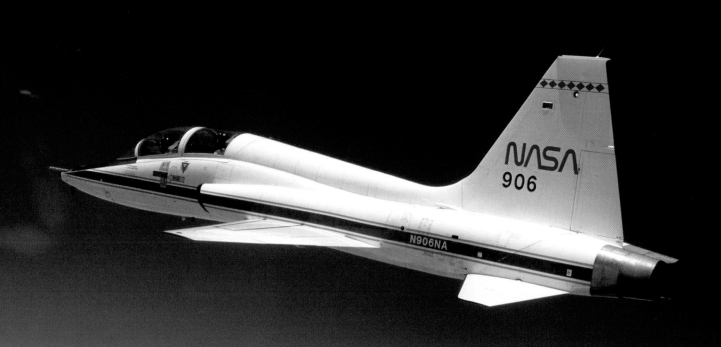

Introduction

Blue helmets, blue stripes, blue sky; a little white rocket, white clouds; and unknown reflections from within my cockpit. NASA 906, the first Northrop T-38 that I flew - 42 years ago in 1967.

42 years it has been and this spectacular beauty is still doing what she does with purpose, precision, elegance and grace. And yes, 42 years it has been since I joined the NASA Northrop T-38 community and embarked on taking up for myself all that community embodies: humility, common sense, accountability, responsibility, authenticity, honesty, respect, trust, teamwork, teaching, standards, leadership, motivation, energy. The community is a microcosm of contagious excellence and spirit that spreads to all elements of NASA and beyond. It is an environment to live and work in, to be challenged and to give the best you've got; a playing field on which to follow the rules of the game and achieve all that you can. It is a place to raise the bar as high as you can and there is no limit to that.

The game is the airplane, it challenges one to climb the heights, it sets the rules, provides the challenges. It is an aerospace game so its lessons apply across the entire aerospace realm and into many other technical realms. This airplane is so simplistic and so beautiful that it is a major triumph and lesson in design that could be emulated in endless other worlds. It is a major triumph in performance, safety, reliability, maintainability and cost.

The purpose of the T-38 and its community is to create and maintain a core of professionals who are superlative at what they do and who they are. The flying skills, and all that goes with that term, of the astronauts is maintained but the big picture and the benefits are much larger, there is a whole community of excellence in every aerospace field and technology driven by operating that little white rocket at the highest levels of perfection.

It has been an education, inspiration and privilege to be part of that community and to try to catch its spirit in photographs. This book is dedicated to the T-38 aircraft mechanics and is a tribute to everyone in the T-38 community.

I have immense admiration, respect and love for all of you.

Story Musgrave
Kissimmee FL
December 2008

Dedication

As a maintenance test pilot I was out one day over the Gulf of Mexico performing a functional check flight (FCF) on NASA 917. An FCF is required when an aircraft has undergone significant maintenance, i.e. pieces all over the hangar floor, to determine that everything meets specifications prior to the aircraft's release to the squadron for routine flying.

I was performing the full aft stick stall check which is to fully stall the aircraft in stable level flight and hold it fully stalled until the aircraft is descending at 6000 feet per minute. The specs state that any roll beyond 60 deg is a failed test. NASA 917 went beyond 90 deg over on to her back. To be fully stalled and inverted with the wheels pointing skyward in a swept wing high performance aircraft is more than uncomfortable, it is frightening. Through extensive personal experience with the T-38 and having read its flight test history I had huge faith in its predictability, but this was deviant behavior and the possibility of a departure flashed through my mind. In this industry, a departure is when an aircraft departs from the normal realm of flight into a realm that may be incomprehensible, may be uncontrollable, and may be unrecoverable. But, NASA 917 was true to form; I slowly released the back pressure on the stick, then did nothing, absolutely nothing but sit and wait till this beauty could sort things out which she pulled off with a supremely graceful agility. With no help from me she flopped around for a while then pointed her nose straight down to earth and fell like an arrow till she gained enough speed to get flying again and from that point I got back into the game, gave my thanks to her, caressed her instrument panel and guided her back to the barn. I had done hundreds of these full aft stick stall checks and this was the first failure that I had encountered or heard of. I called in the failed FCF to NASA Operations and returned to Ellington.

This book is dedicated with the depth of my being to those people who met NASA 917 and me on the ramp that day and to all those people who met me on all the ramps and the hangar floors for over 30 years - the NASA aircraft mechanics. Long before I got to the chocks I could see the seasoned intensity of those faces, the penetrating expression in their eyes. I had brought their baby home to them; they were concerned and the care was all through them. As always they listened with wholly absorbed attention and inquired with the clarity and understanding gained from decades of experience with this aircraft. The FCF is so important to them, they have given their best to the care of their aircraft and some of their work may have been really major, like an engine change, a wing change, structural work, hydraulic overhaul and so forth. When you meet them on the way out for an FCF you can see and feel the pride and the care, this is their work and this is the moment of truth. In an ideal world the crew chief would fly with the pilot on the FCF; that really would be doing it up right, just communicate the risk and accept it.

They aligned and rigged everything on NASA 917; I took her out again and this time ran several tests; she did better but she still could not meet the specifications. She got really good at flopping around and heading straight down. They then got into all kinds of structural stuff, bore sighting and the like but could not get her to meet the specs so they granted her a waiver that prohibited stalls and named her the Texas Rollercoaster. Years later I took her out for an FCF expecting the usual ride but she passed with flying colors, she had fixed herself, life happens.

The FCF and what I call maintenance flying and what goes before and after have been the most enjoyable and rewarding T-38 experience for me and the situation in which I feel the strongest bonds to my mechanics. I read the operating manuals but the hangar is hardware learning. I worked alongside the mechanics now and then but mostly would be reading about a system and then would go to them to show me the motors, rods, linkages, microswitches, solenoids, mechanisms and so forth. Sometimes I would just stop by someone at work and ask what they had to show me. After a while when I went flying I could see in my mind all that stuff working in response to some action that I called for.

So, my friends and fellow travelers, it is for your knowledge, experience, technical mastery and mostly for your tender lovin care that I present these 42 years of pictures to you. My best wishes for you on the journey.

Story

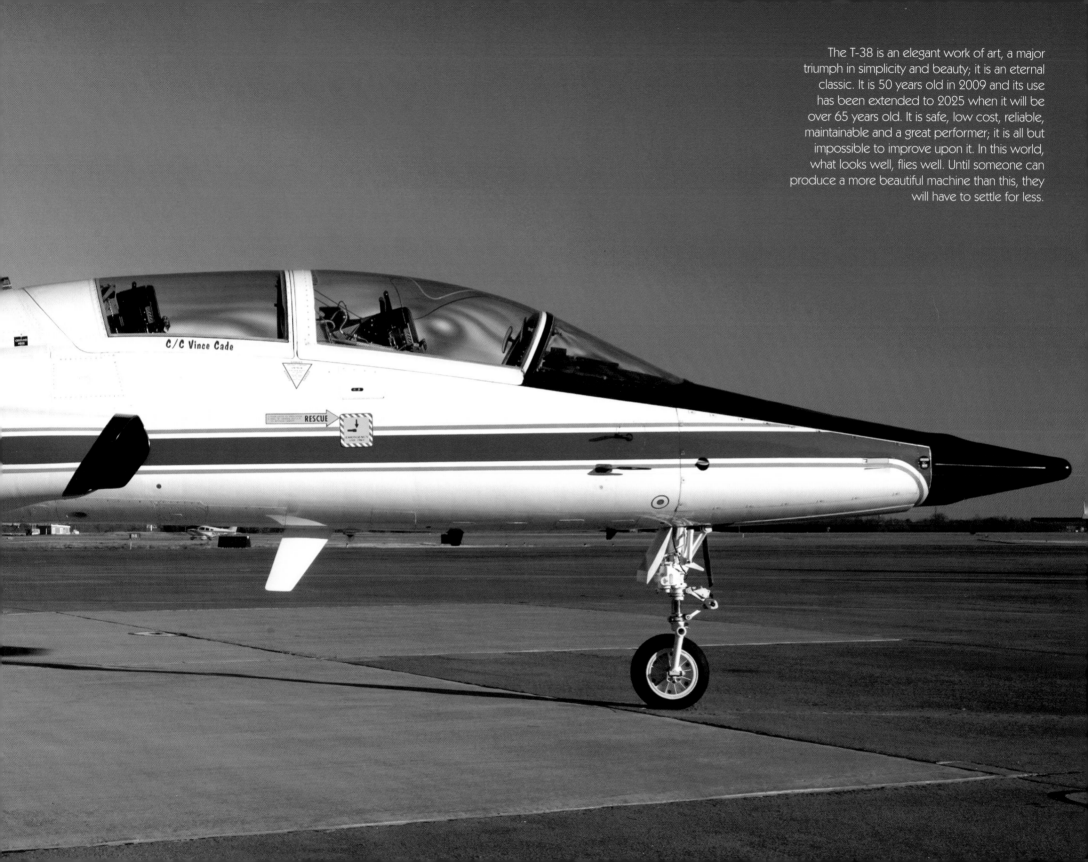

The T-38 is an elegant work of art, a major triumph in simplicity and beauty; it is an eternal classic. It is 50 years old in 2009 and its use has been extended to 2025 when it will be over 65 years old. It is safe, low cost, reliable, maintainable and a great performer; it is all but impossible to improve upon it. In this world, what looks well, flies well. Until someone can produce a more beautiful machine than this, they will have to settle for less.

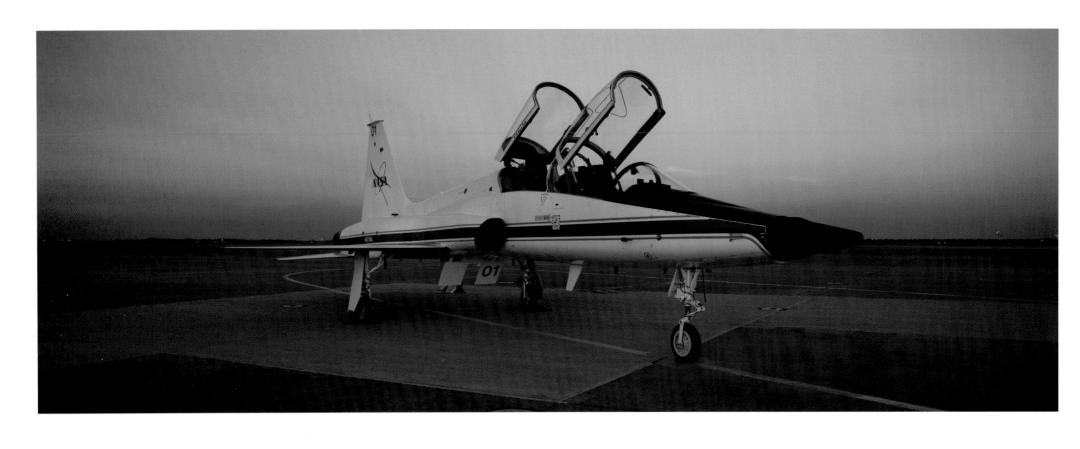

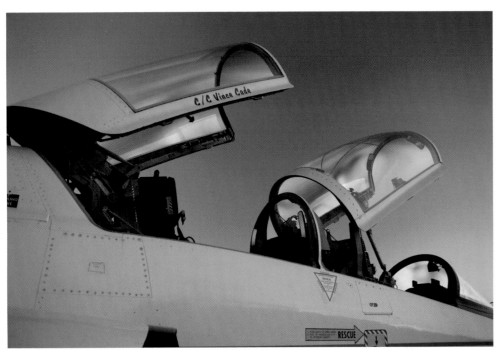

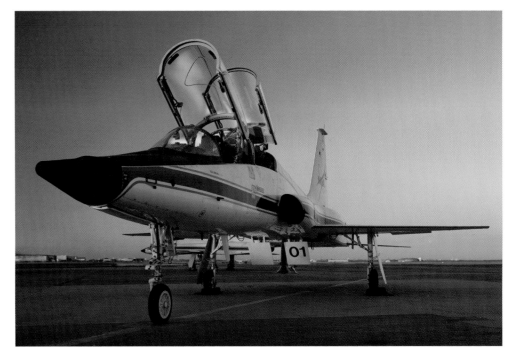

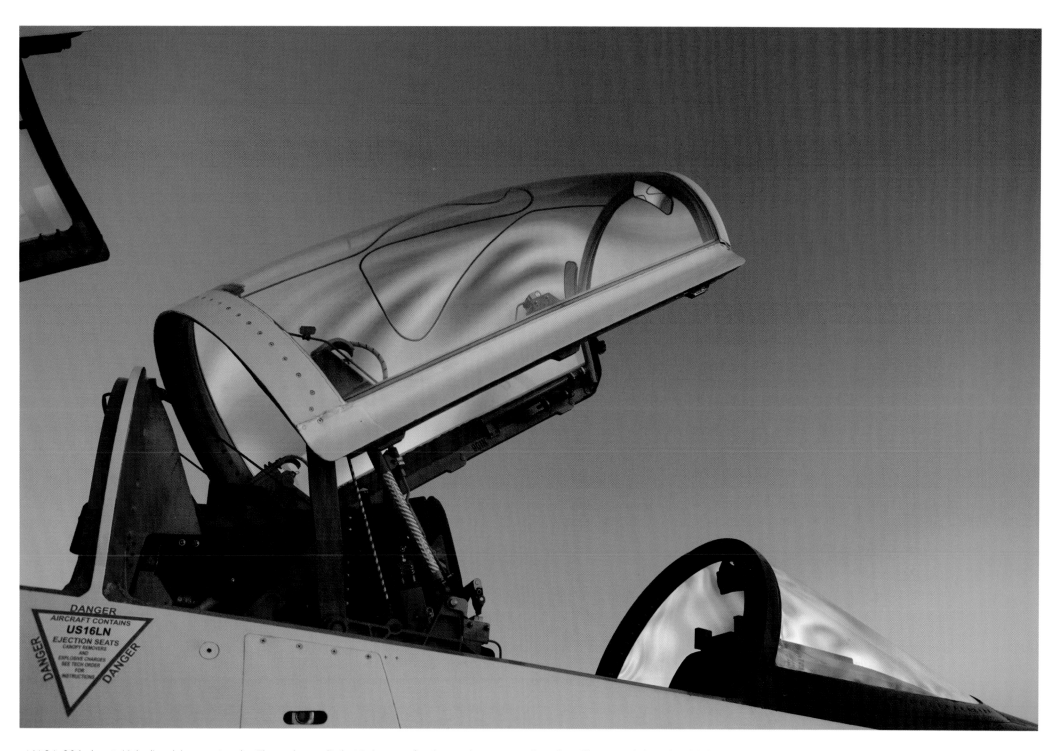

NASA 901 shoot. Unbelievably spectacular. The only credit that I deserve for these pictures was that after 42 years of shooting this beauty I was still at it, still in love with this machine and still with the faith that it ain't over till it's over. This was given to me, the gray canvas, the colors in the metal, the 3D effects and the auroral luminosity of the glass - just handed to me, all I did was shoot it. Electrons are cheap so I shot it till I got it. The canopy effects are probably a combination of the sunset, the attributes of the canopy and the circular polarization filter on the camera.

Nothing left of the sun; it got too dark
to shoot without a flash, so I went and
got my car out of the parking lot, put the
headlights on the machine and even this
worked. NASA 901 did it again today;
I just could not miss.

Like any great sculpture she is gorgeous from any view; this creature is like an Italian neoclassic. I sweep my eyes and hands over her and feel myself move to her. In this business, what looks well flies well; she was born of a simple and classical beauty and that is why she is who she is and does what she does and why she cannot be improved upon. She will be a champion for 65 years or longer.

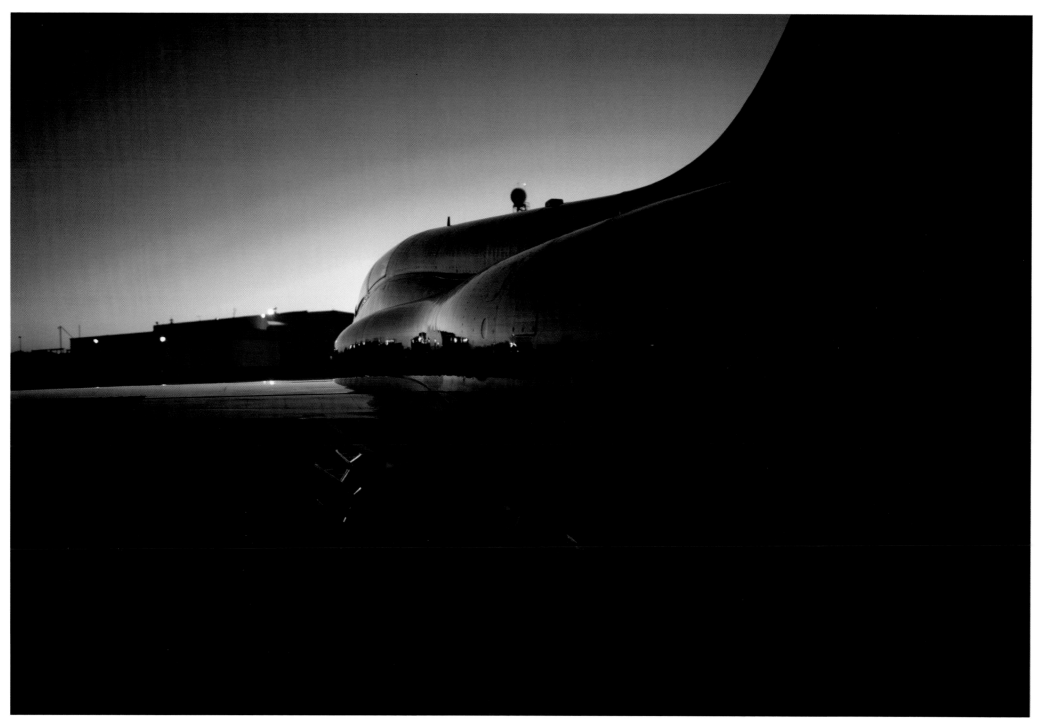

She really bulks up when the view has some angle into the engine; the engine, the intake, even the fuselage leading toward the cockpit are smooth but oh so muscular. The closed canopies help create the muscular curves. She's sort of got the shape of a killer whale. I can just bet if 901 was listening in on this conversation she would probably retort, "If you don't want muscle don't aim the camera at my engines, what would you expect"?

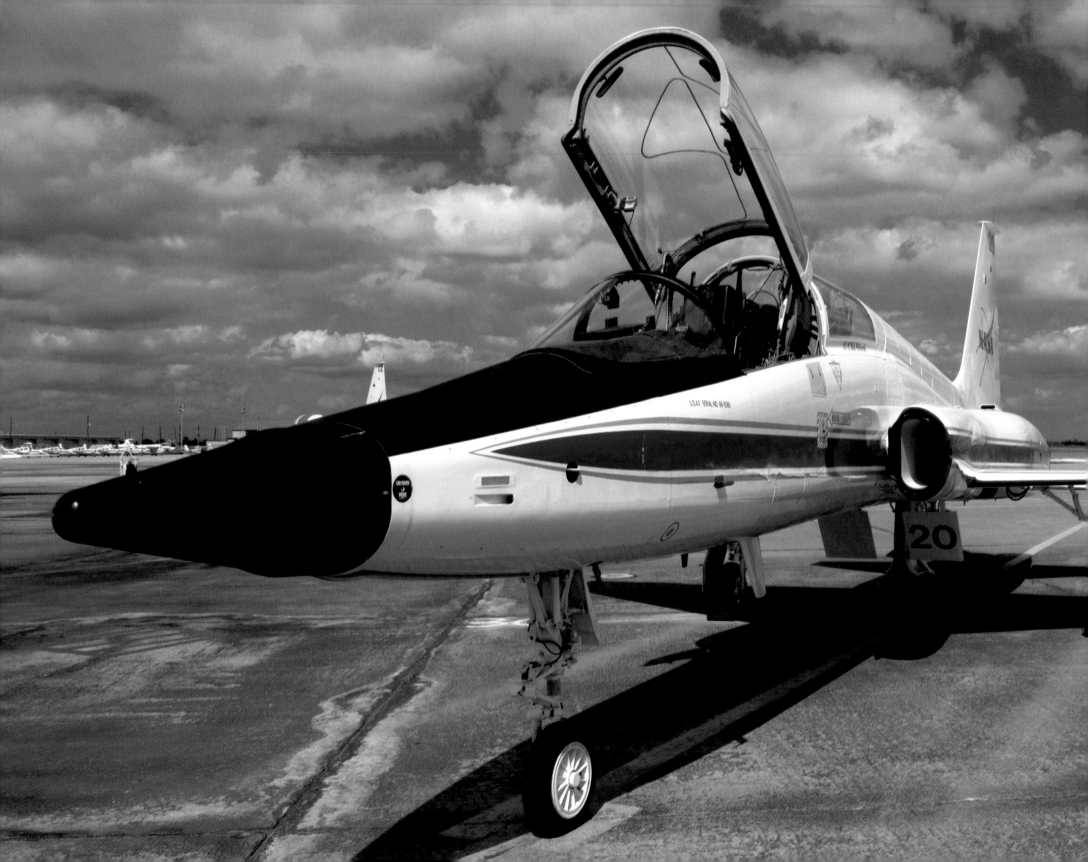

My NASA 920 Shoot

So often with these beauties I would not or could not know exactly what I was after. I would be there and when it happened, I saw it, thrilled to it and went after it.

Today I knew what I wanted from her. I had tried in the past but the conditions were not right. I knew what I thought could be there but did not know what it would take to get it.

Today I found out what it would take because it happened: direct overhead sun, the kind photographers don't like, fair-weather type puffy cumulus, brilliant blue sky, an uncluttered horizon toward the tail, aircraft parked toward the nose, a glossy surface and a clean aircraft.

NASA 920

For years I had tried to catch the spirit of her wings, after all it is with them that she flies. I worked them from every angle, every distance and every type of light, especially shooting straight onto the tip. In desperation I pretended that I had it and would triumphantly show my wings to some folks with great eyes and their only answer was "no". I did the same thing for decades, same result.

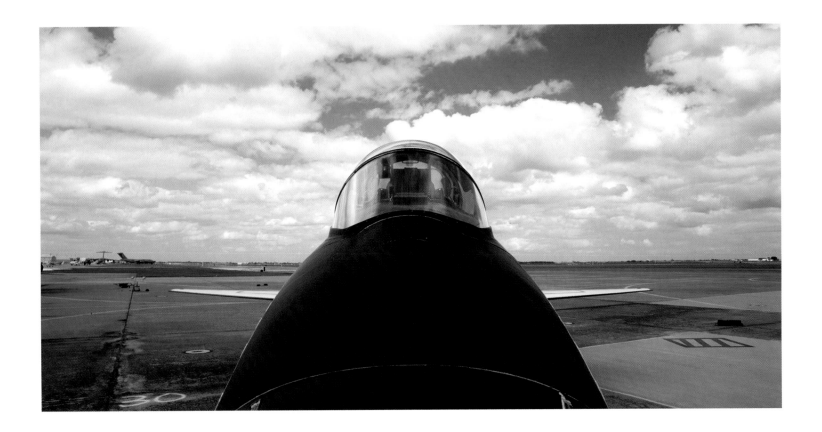

Today I learned of their photogenic shyness, elusiveness; one must shoot somewhere else and out they come, those little fins of stainless steely exactitude, those knife edges that cut through space and carry you to the heights.

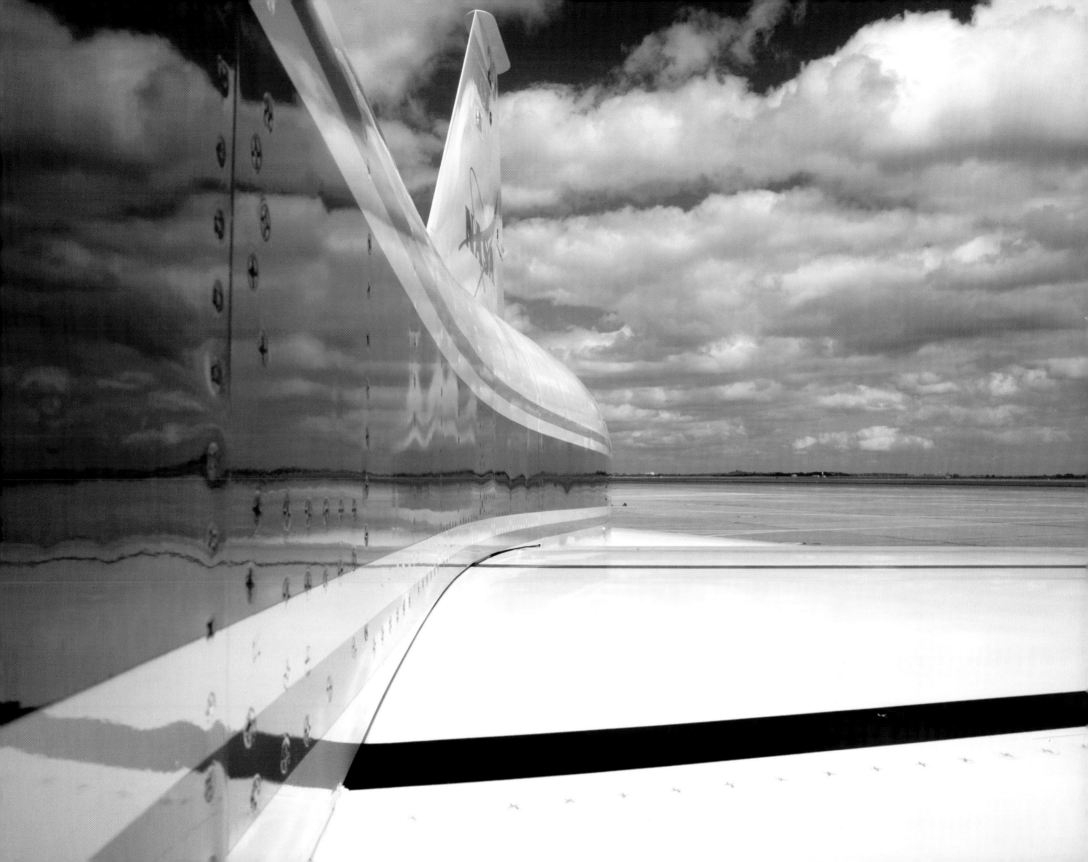

NASA 920

Over decades, I had more moments with her
than anyone else in the fleet; she just seemed
to turn up on the schedule and I warmed every
time it happened - so very happy that she
turned up here today, and in her glossy outfit.

I don't know if this one is the "best" that I got
but I care for it more than any of the other
thousands. For me it is the most organic, most
biological photograph in the collection. It creates
a fish-like portrait, a whale tail or something like
that.

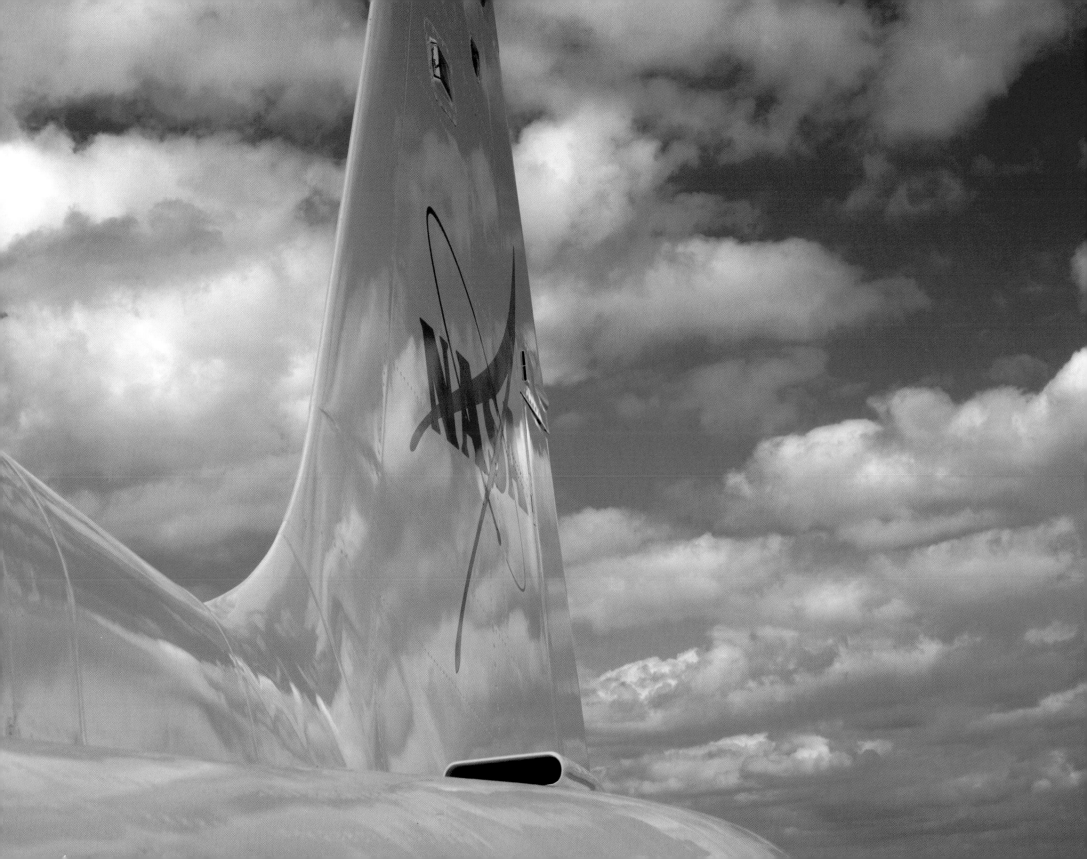

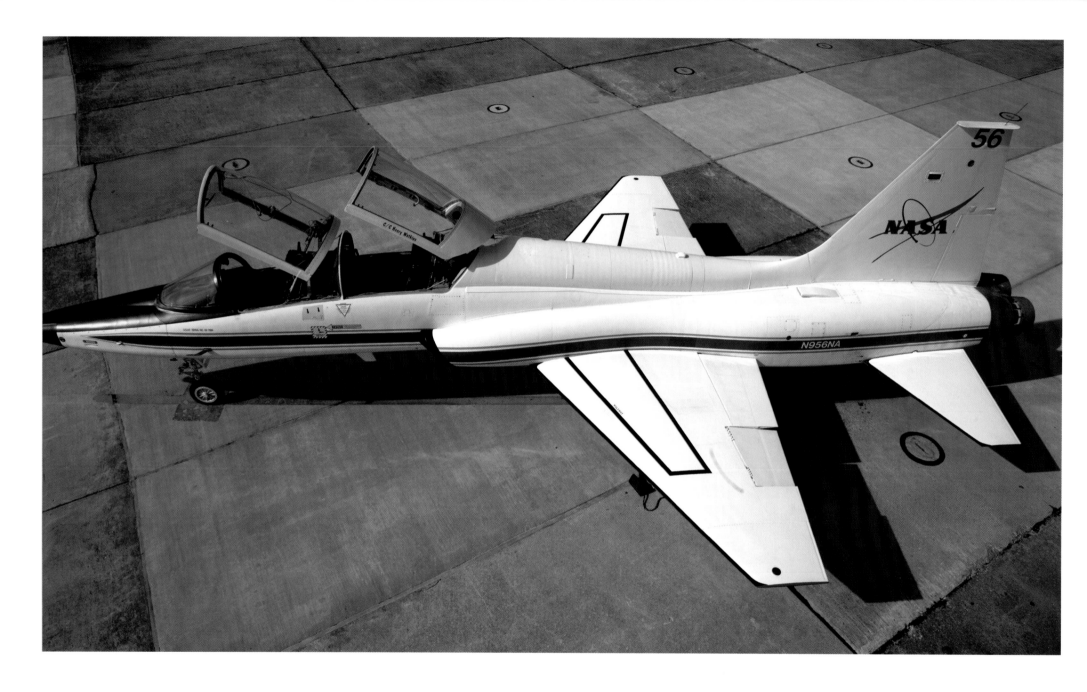

I weave my way through the flight line riding high on a JLG manlift looking for shapes, lines, curves, reflections and shadows. And find them I did.

Every point of view, 360 deg horizontal and 360 deg vertical has got something to offer.

26

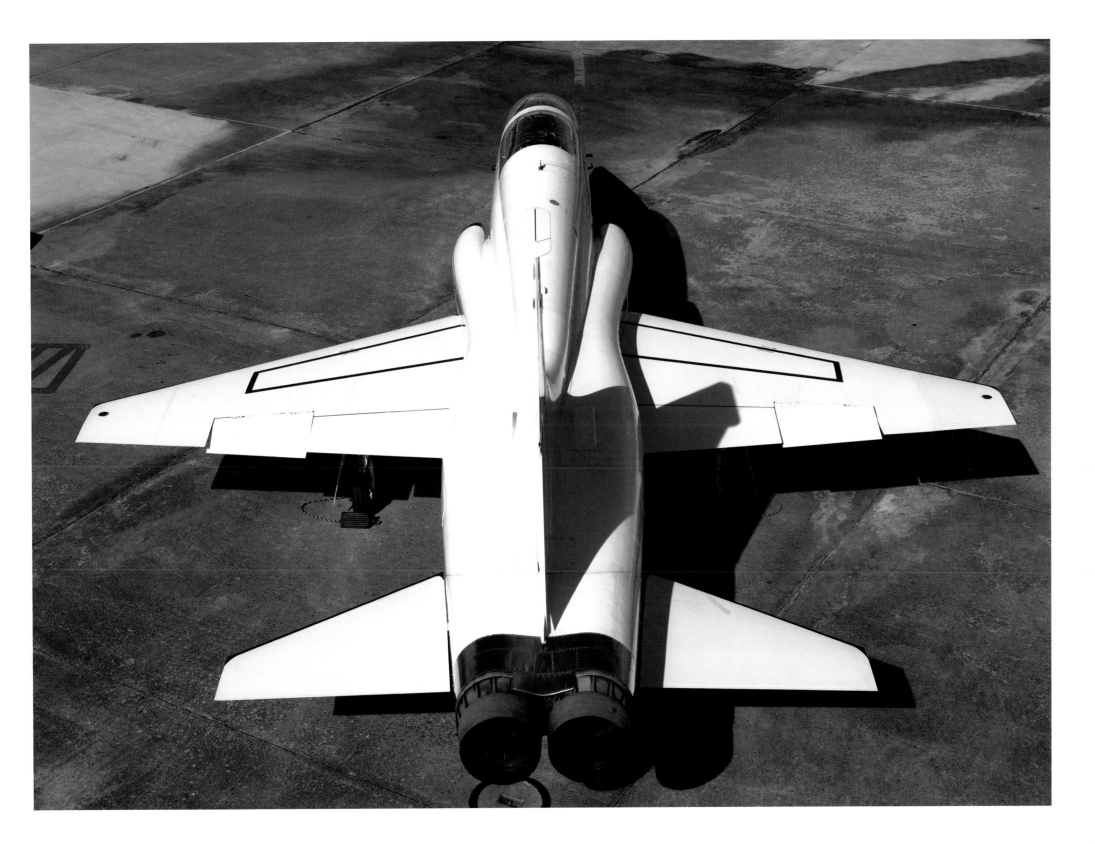

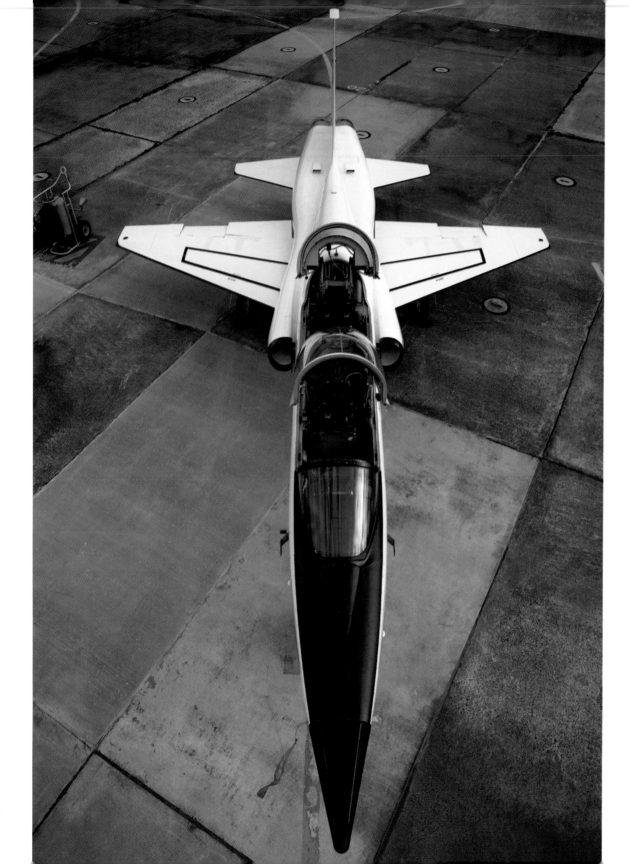

Now that you have been introduced to this little white rocket we are going to take a short but spectacular flight over the Gulf of Mexico.

Open canopies are always an invitation to come onboard, sit yourself down on the ejection seat, strap in, light the fires and go fly.

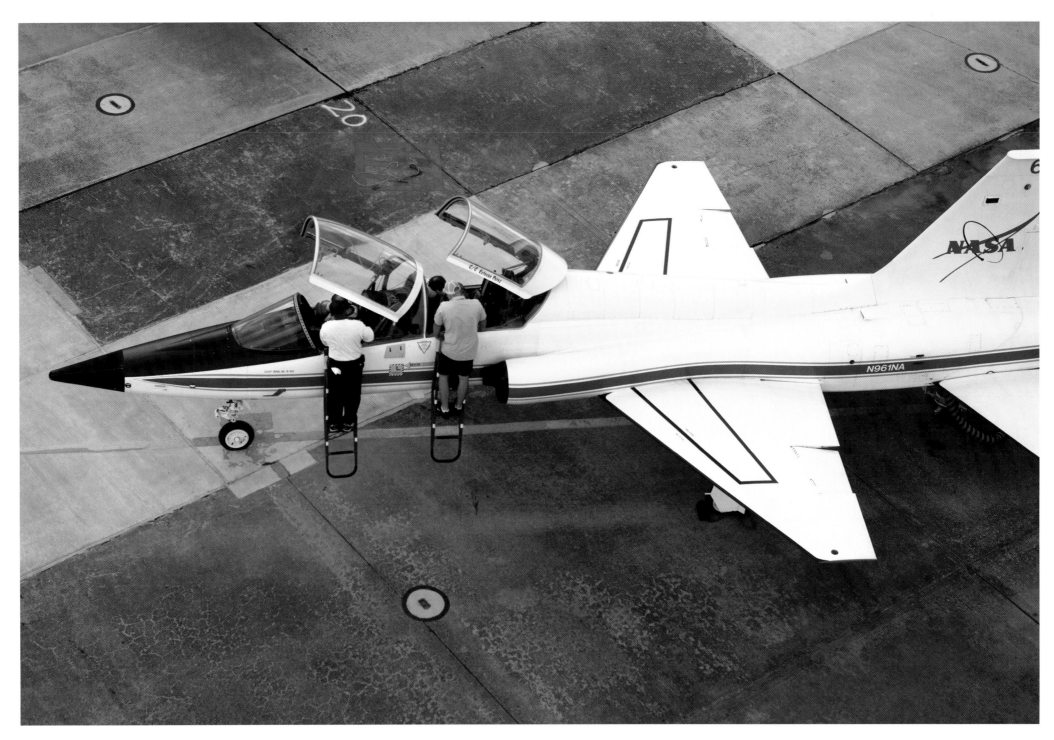

Our ever present and attentive crew look after all that we need a little help with:
ejection seat, survival gear, parachute, seat belts, helmet, oxygen mask, gloves, checklist, maps, safety pins, cockpit configuration and spirit.

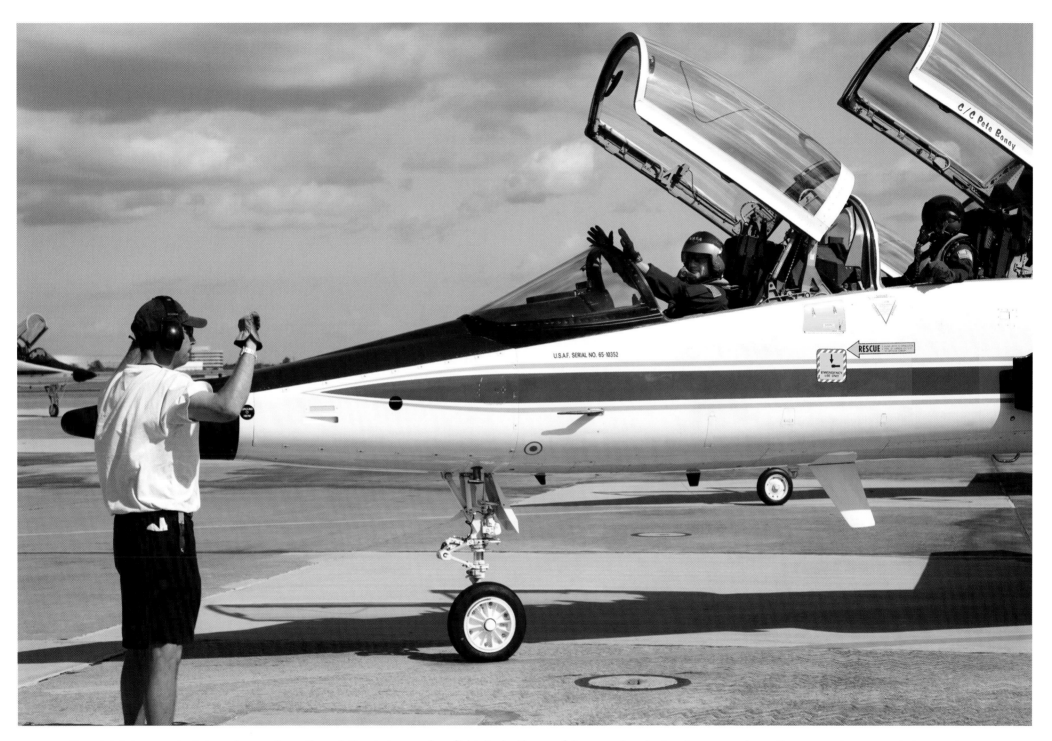

Completely in accord, pilots and crew dance through the start-up and preflight ritual with a confidence and understanding accrued over the years, using non-verbal cues where sync up is essential. Like figure-skating pairs we have the plan, we know it and who we do it with, and then perform it like we were at the Olympics every day of our lives.

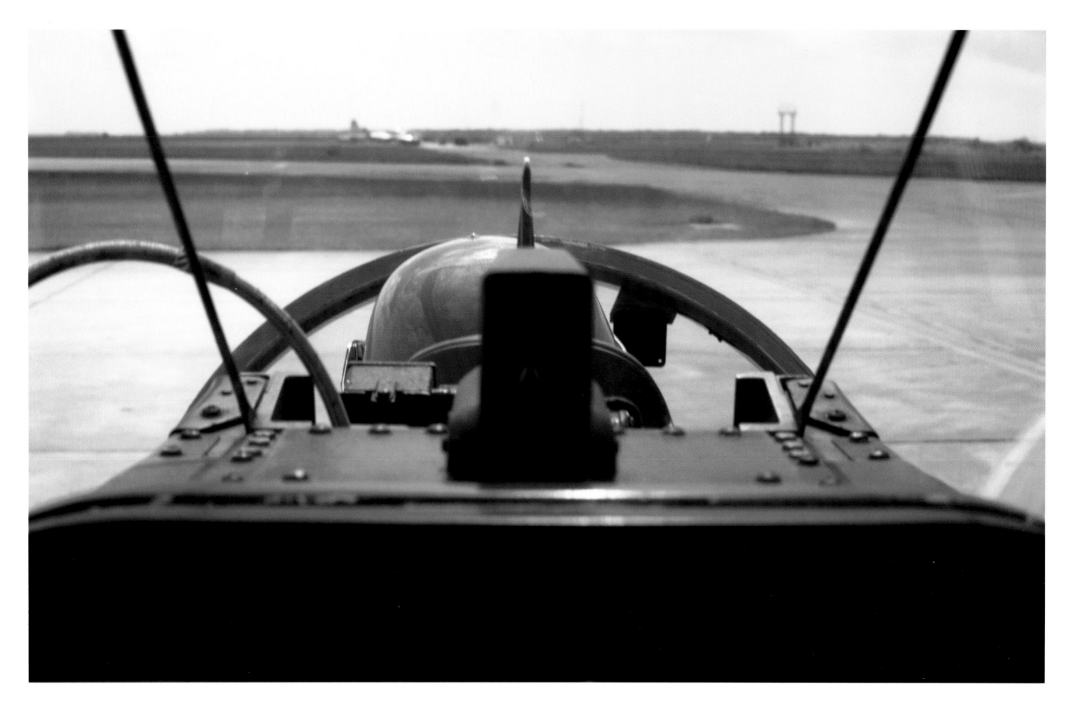

We walk the checklist, and by the tilt of his head I know what he is doing, I always know what he is doing and why. The airplane, myself, and Roger Zweig, my soul mate in this business for over 30 years, created and evolved this singular organism. We grew to push the aircraft and ourselves to the edge but never beyond. Like restless folks we kept raising the bar, decade after decade, for ourselves and for others. We never relaxed on that, we always found another peak to climb. Here, the path is before us, we go together on the journey with an absolute faith in ourselves and the machine.

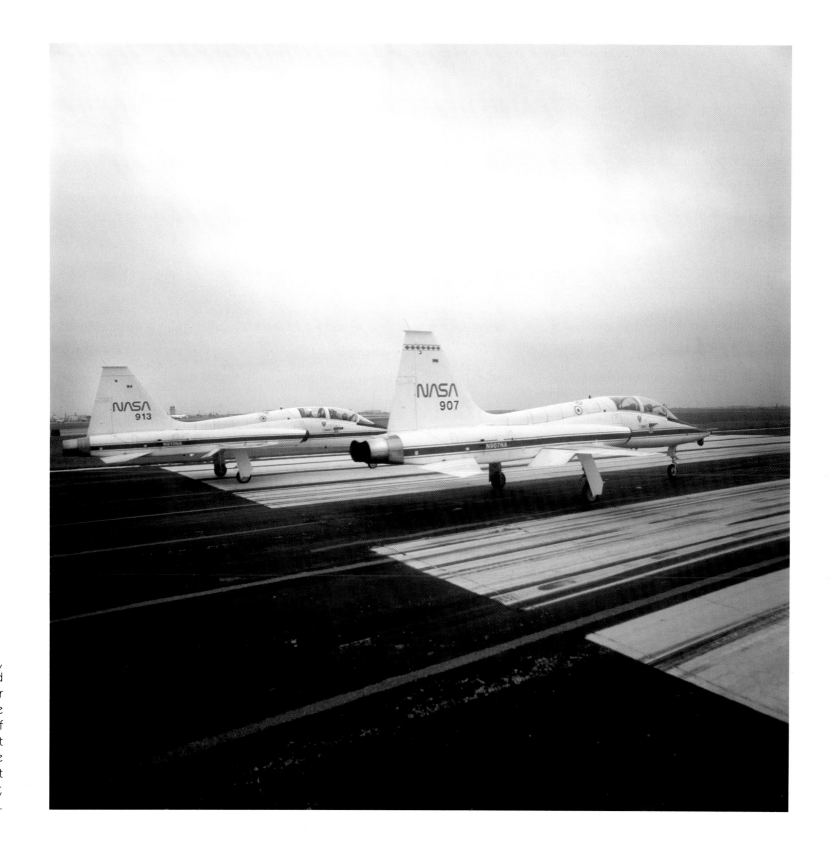

Two birds depart ahead of us. This, an intense image of anticipation and expectation; another flight, another chapter in life's journey to unfold. You are on the playing field once again. Your life, the life of your colleagues and the life of the aircraft are all in your hands and the health of the machine. You fly as you have since that first solo 57 years ago. Again and forever, "fate is the hunter".

My first flight in a T-38 was in NASA 906 on this runway 42 years ago.

Yes, she is a machine, but for me an animated machine. I have my particular experiences and relationships with each of them.

When I hug and kiss on one of them in the hanger, most of my friends get it. The animation and personification of what is otherwise an inanimate object.

On the roll again; she beckons and we follow.

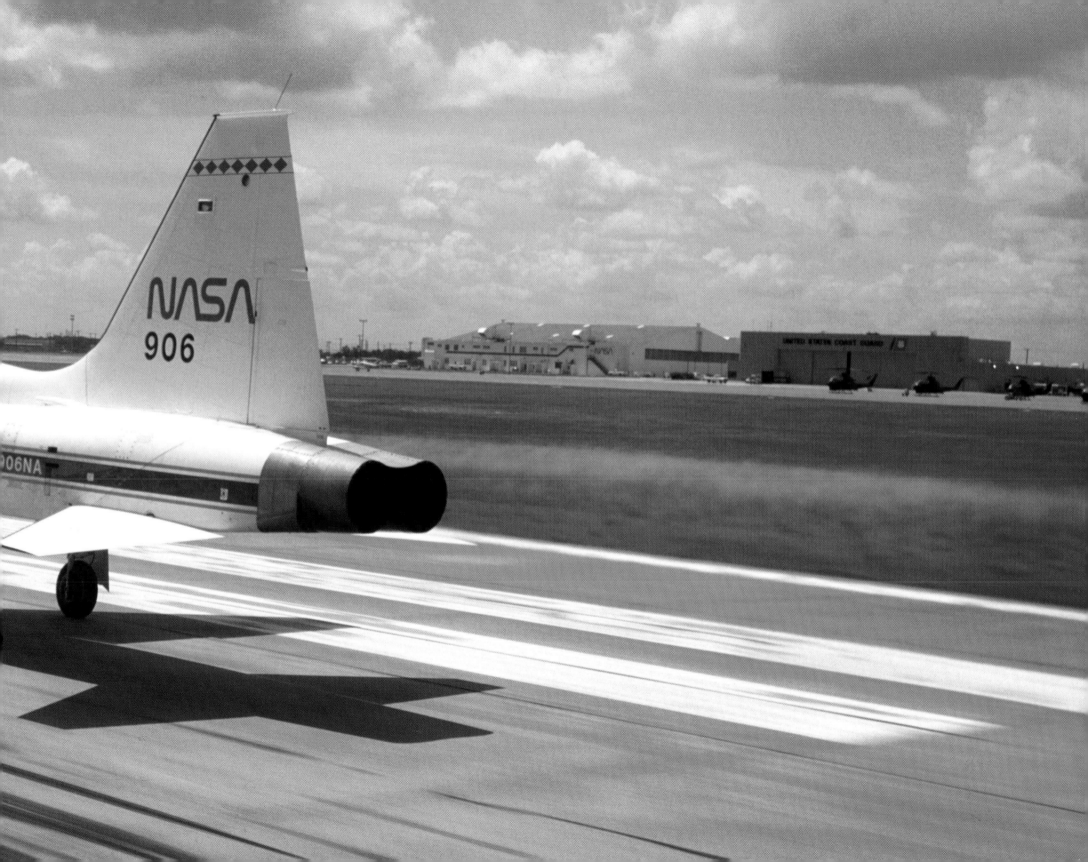

We pick up her nose and get ready to lift off into flight. In the background, over the wing, is Ellington control tower. 30 years of tender lovin' care for one Story Musgrave and a thousand other pilots. People being the best they can every second of the day because in this world one second is the spread between now and the eternal.

They are professionals in every sense of that word, they know the technology and the rules. But they also care, and it is this care that provides the energy necessary for the continual intense attention and awareness of a myriad situations and circumstances. They have looked after my aircraft, my trajectory, my being and spirit for 57 years. To all of you, I love and respect you immensely.

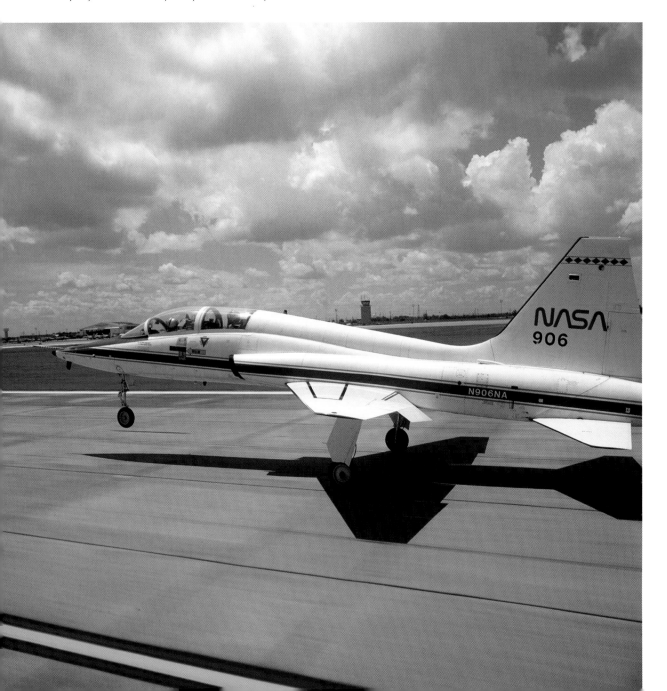

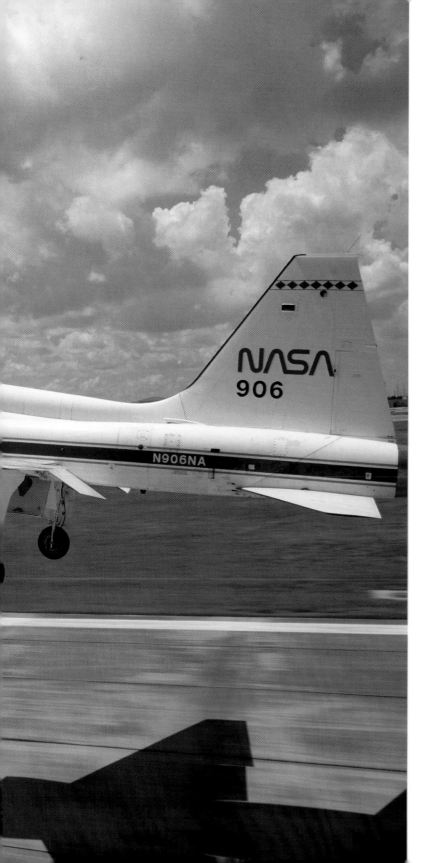

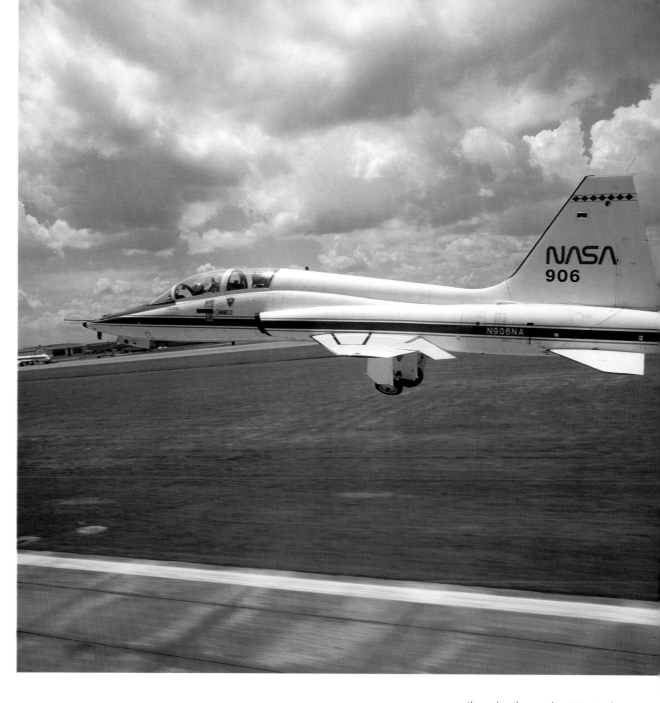

... the wheels are about to tuck themselves away 'til it is time to put them down for our landing.

We fly; the landing gear doors have opened so the landing gear is on the way up ...

37

We coax her nose up and climb out
toward the Gulf.

Now over the Gulf's green waters
I let her go and we fly
like an arrow
through cloud and blue air.

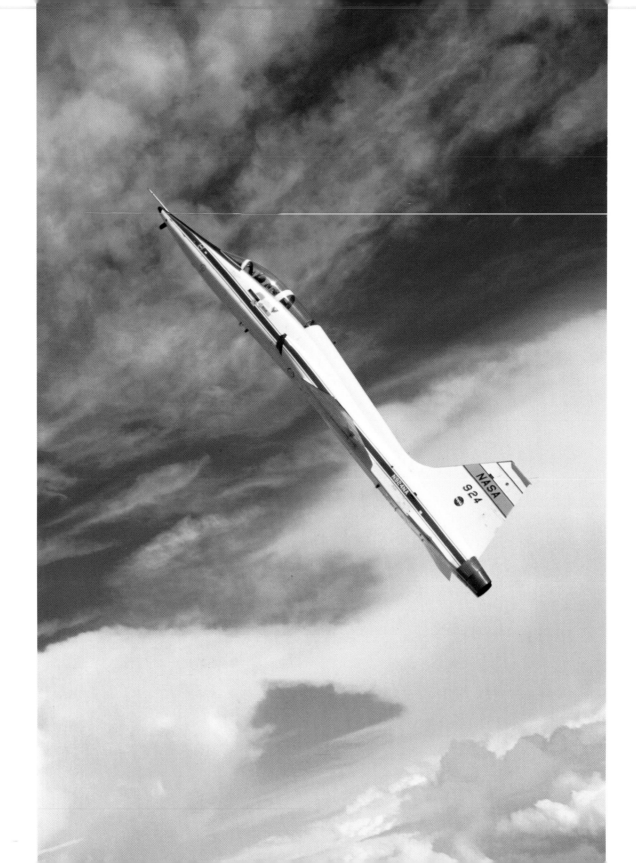

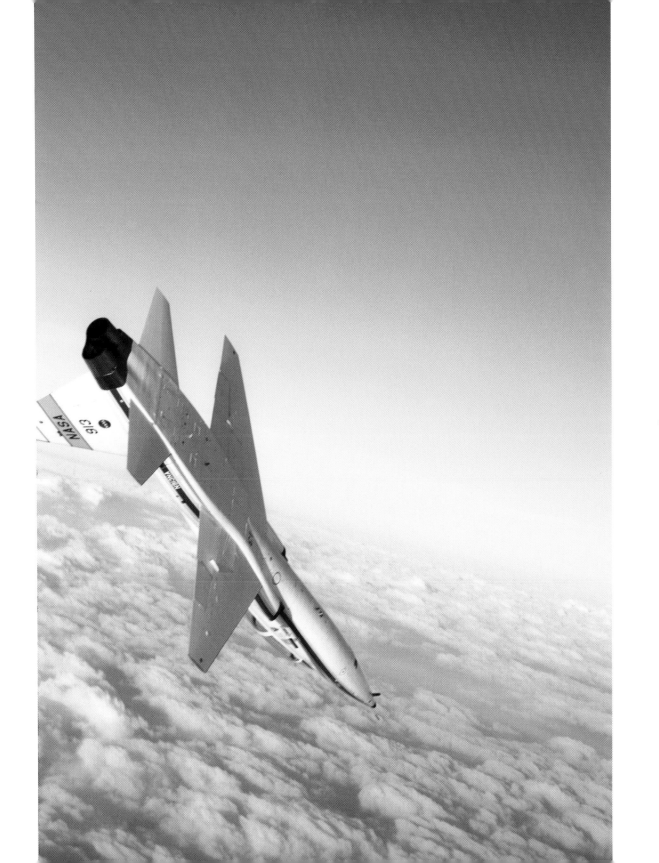

With ever decreasing airspeed
we reach the apogee of our path
and with two gentle fingers
I roll her on to her back ...

... and we take the plunge
like an arrow
back down toward the green waters

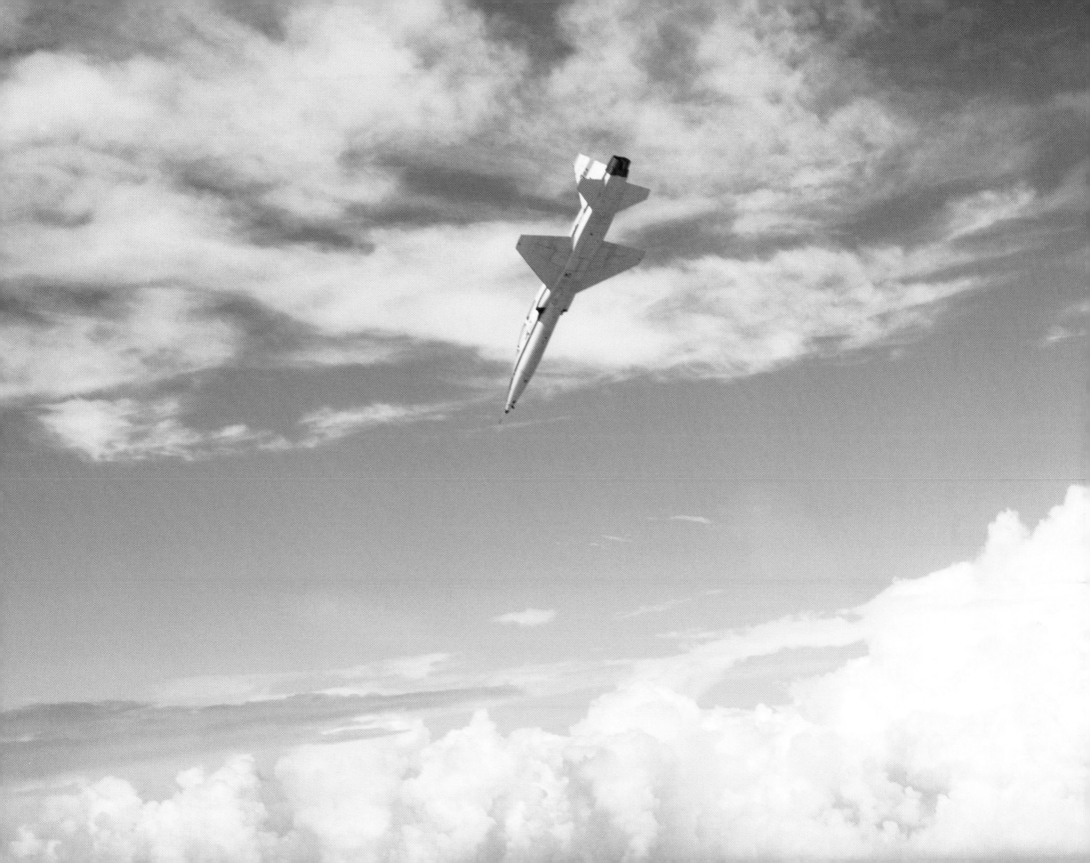

Approaching the vertical we are looking out the front window and gaining speed rapidly.

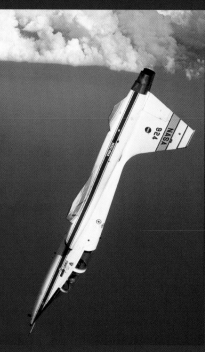

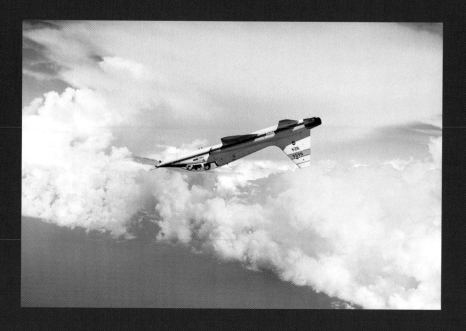

Vertical, looking straight down at earth and with speed accelerating. This is the most exhilarating part of this ride, for this maneuver, and for most of them that put you into this condition.

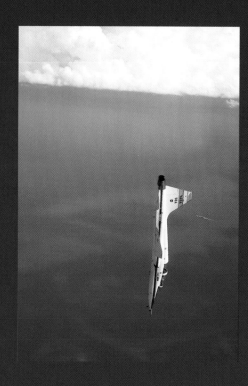

We pull hard again to bring us up to the straight and level.

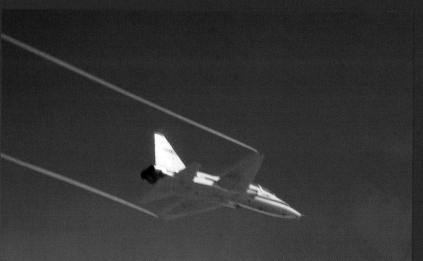

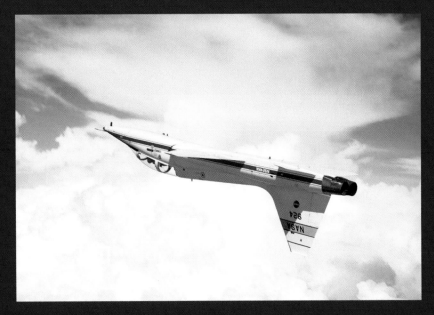

Almost inverted at the top of the loop we now pick up earth's horizon through the overhead canopy and have slowed to about 250 M.P.H. and pulling 1/2 a G.

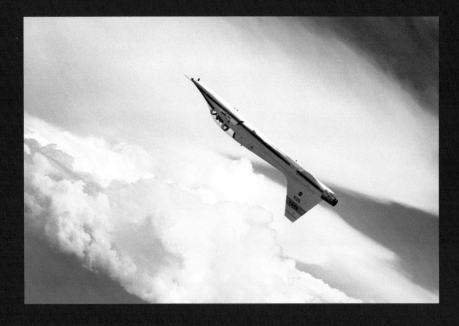

We started level at about 600 M.P.H. and are now pulling up hard into a loop leaving wing tip cloud trails in our wake.

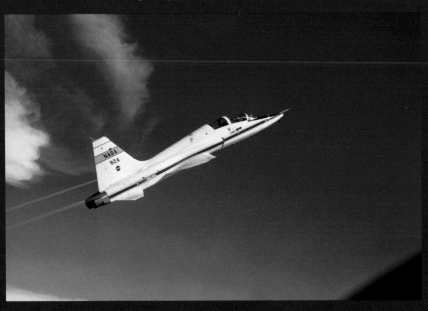

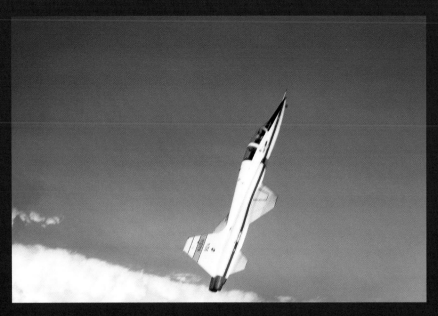

We are approaching the vertical, that means straight up, so we have now lost the horizon out the front window. We scan our wing tips to keep the plain of our loop square to earth.

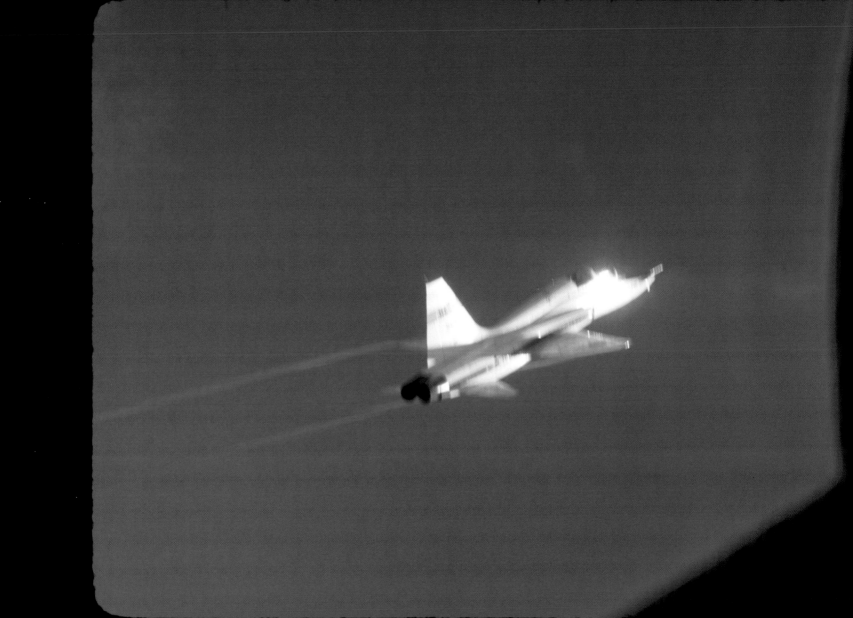

Dear Reader; So sorry for the blur but as fast as we are going, maybe going by like a blur is better art? Every time I try to point the camera at NASA 924 the lens bumps into the canopy. I am manual focus but I can't get to the viewer because of the position of the camera and if that did not stop me, the mask and helmet would. But I guess most of that is irrelevant since we are pulling 6G and I am grayed out most of the time and can't hold the camera steady anyway. In these kind of situations I approximate the distance to the other aircraft and mechanically set that on the focus ring.

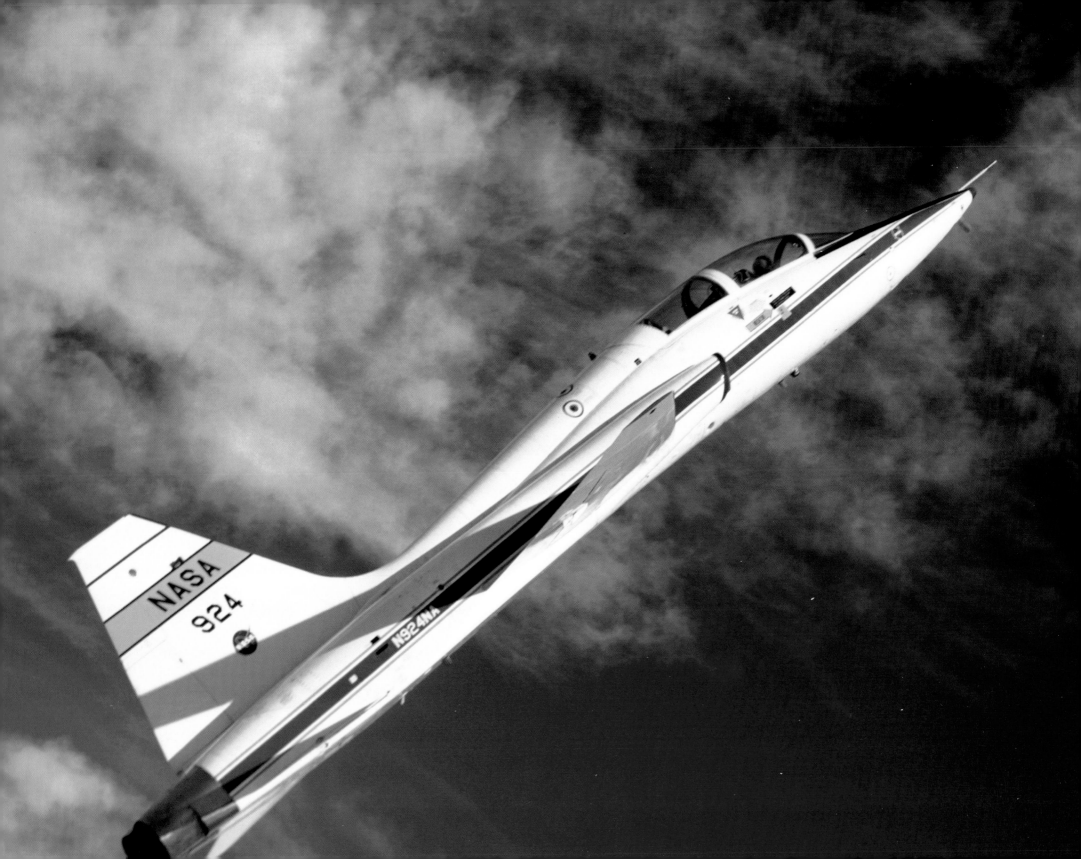

Some of the verticals may be more spectacular but for me this is the most beautiful climb in the collection - the blue helmet, blue stripes, blue skies; the white aircraft and pure white clouds; the steepness of the climb and the swept back shadows of the wing that reinforce the sweep of the aircraft and give a sense of speed.

I have had special times with most of the aircraft in the squadron and my relations with many of them are based on our history of shared experiences. Very often when I walk across the flight line one of the crew chiefs will point to NASA 924 saying "there is your aircraft". Many of the aircraft serve as particular bonds between myself and the crew chiefs. 924 belonged to Bob Mullen and we never forgot that.

In 1975 I took off to the west in NASA 924 at El Toro Marine Corps Air Station. The weld that attached the afterburner fuel line to the engine shattered and that fuel then flowed to the inside of the aircraft instead of into the engine. It ignited, melted the nozzle off the left engine causing it to compressor stall just as the aircraft lifted off then burned through the firewall between the two engines and set the right engine on fire. In the cockpit the left engine was rolling back, firelights were on for both engines and the tower called that I was on fire and that pieces were falling off the aircraft. I did what I could with the power that remained to gently turn around to the right and land to the north. The fire trucks were on me before I had stopped rolling. The pieces falling from the aircraft started 20 to 30 fires in the community adjacent to El Toro.

The bold face checklist, that is the part of the checklist that must be memorized by the pilot, requires: "fire confirmed and unable to extinguish---EJECT". The accident investigation board asked in reference to the checklist, "You had two confirmed fires and the aircraft was coming apart, what were you waiting for?" I was waiting till she could no longer fly, she was still flying, doing all she could to get us home. She is still flying 34 years later, so am I.

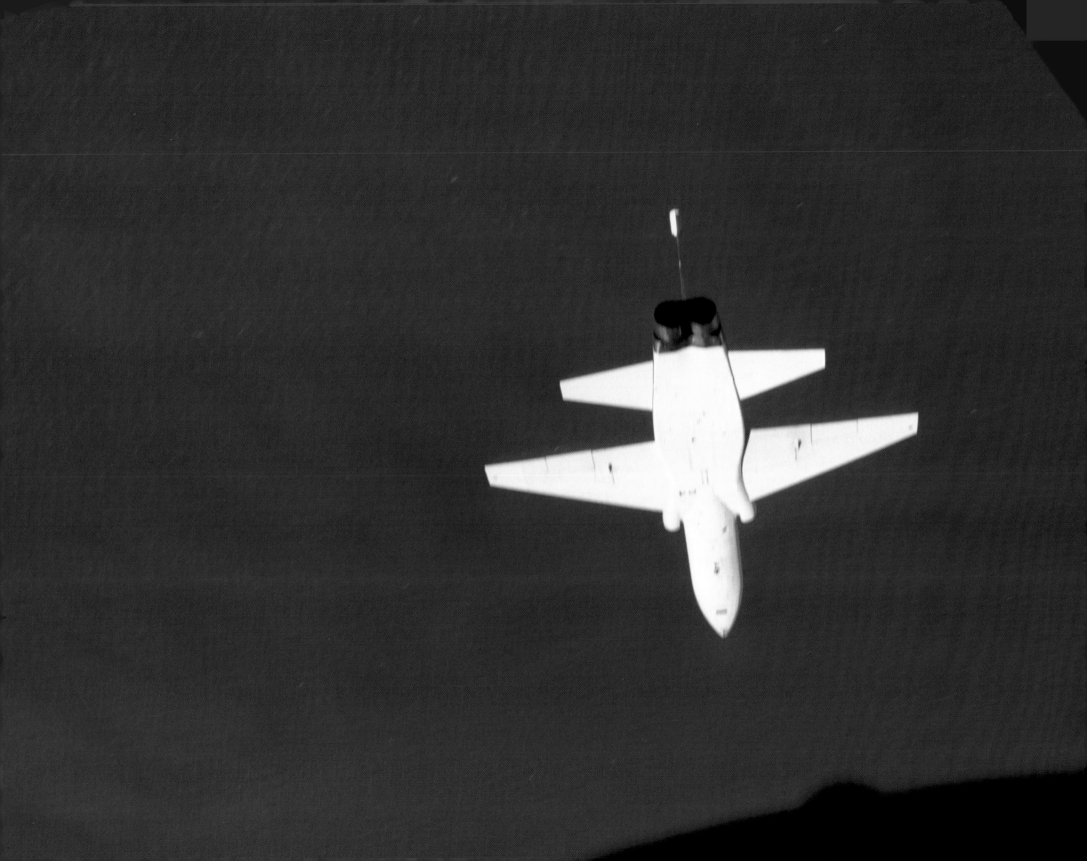

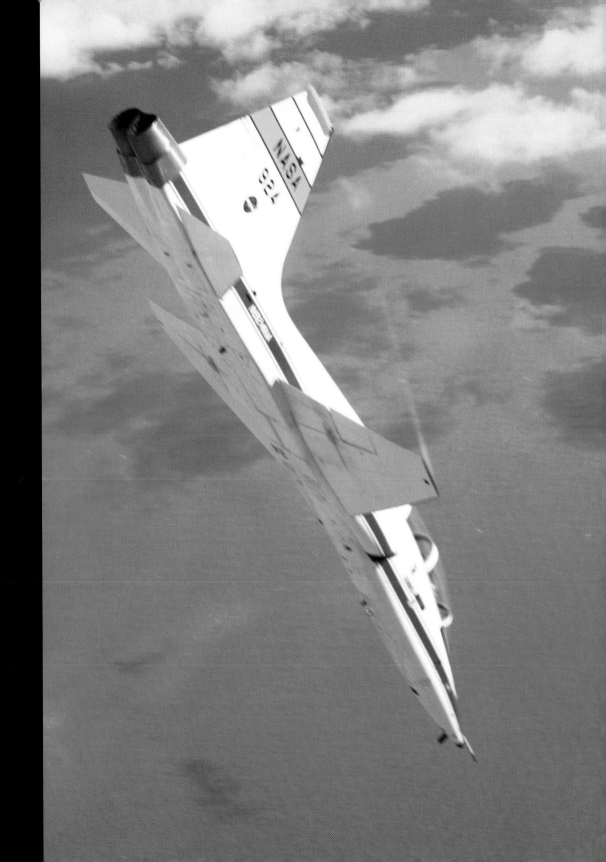

I chase after 924, now in the overhead canopy, full throttle straight down toward the green waters of the Gulf of Mexico.

We slip alongside my beloved 924; the waves and the texture of the water are becoming visible so it is time to pull out of this earthly plunge. We are pulling to the redline of the aircraft, which is about 8G. The camera is 8 times its usual weight so I can barely hold it up in position.

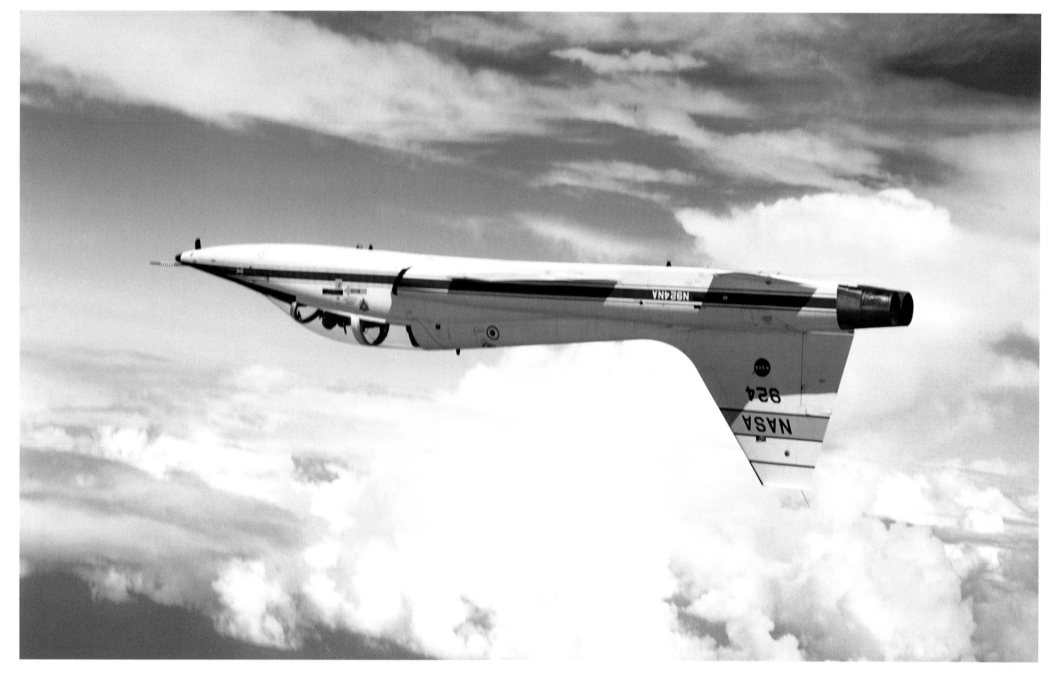

We roll over together and begin an inverted glide into Ellington Field.

She puts her speedbrakes out to slow down;
at this point I am still inverted,
filming out the overhead canopy.

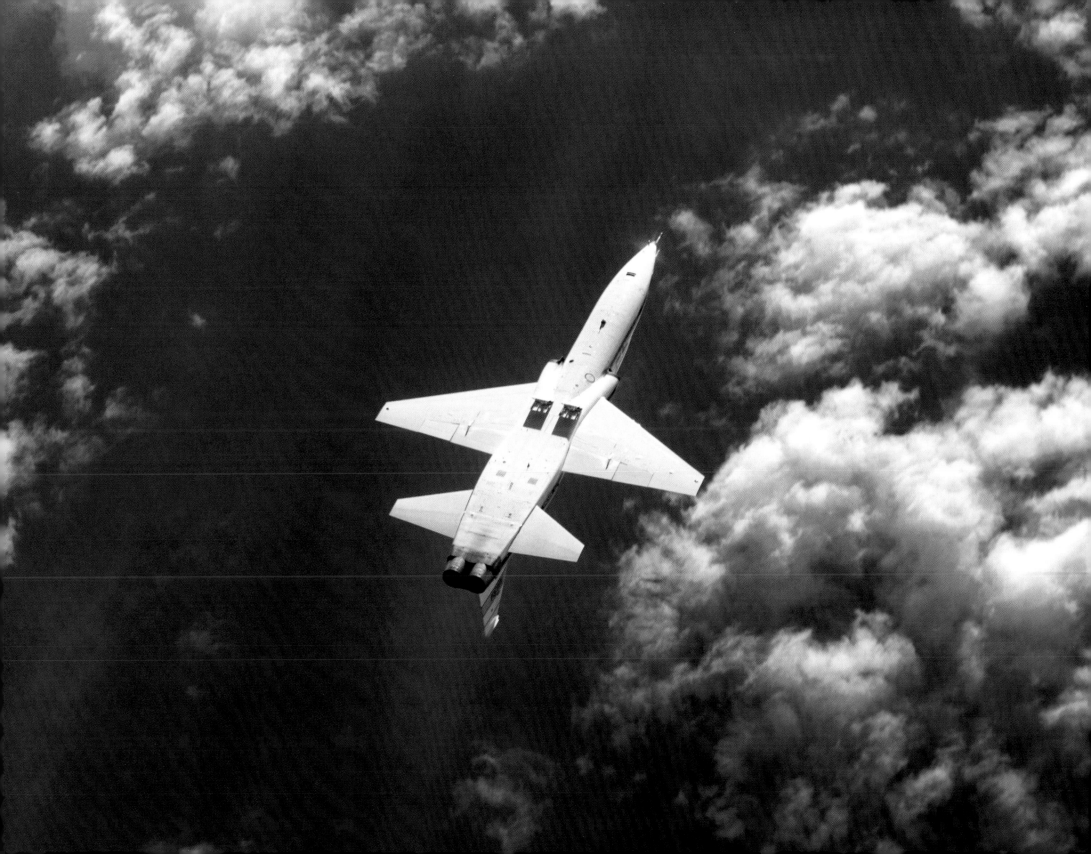

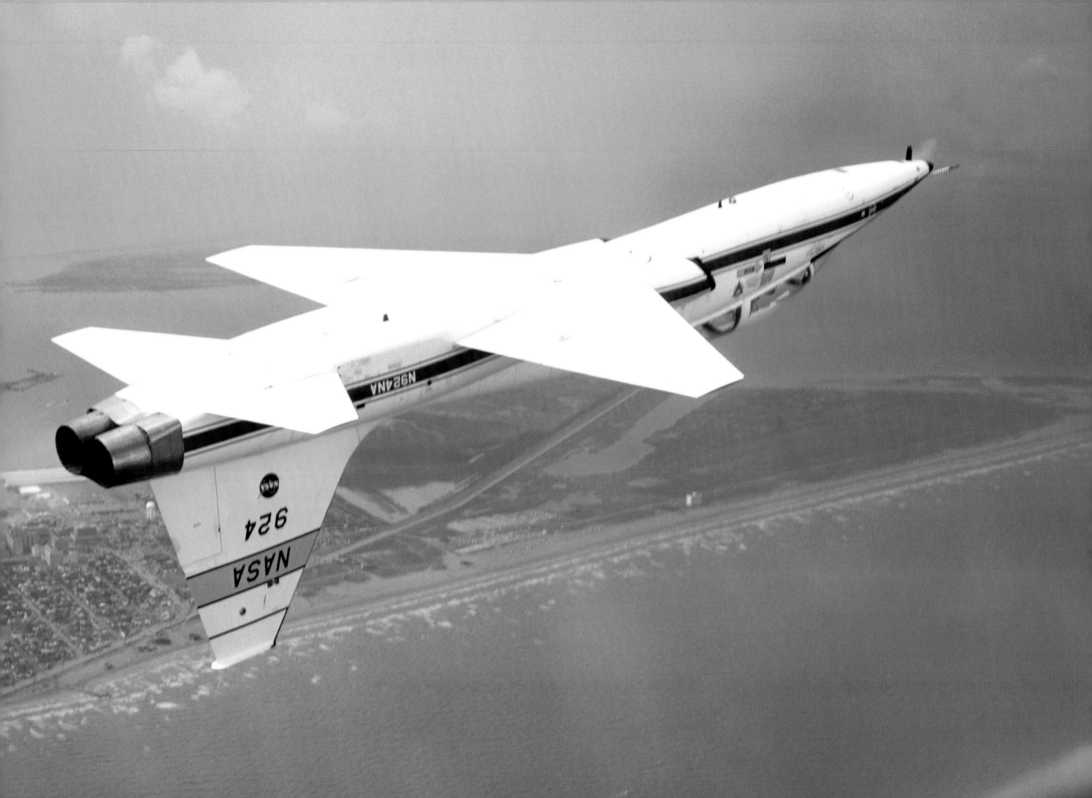

We fly along
Galveston Beach,
I am now right-
side up.

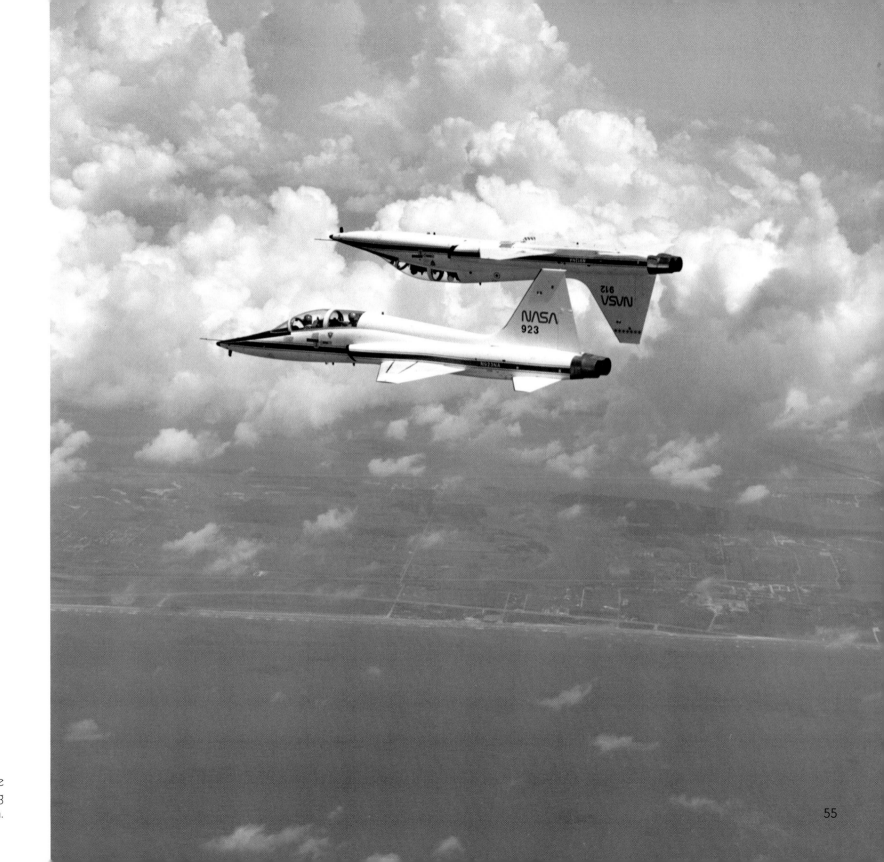

This is what we
look like going
down the beach.

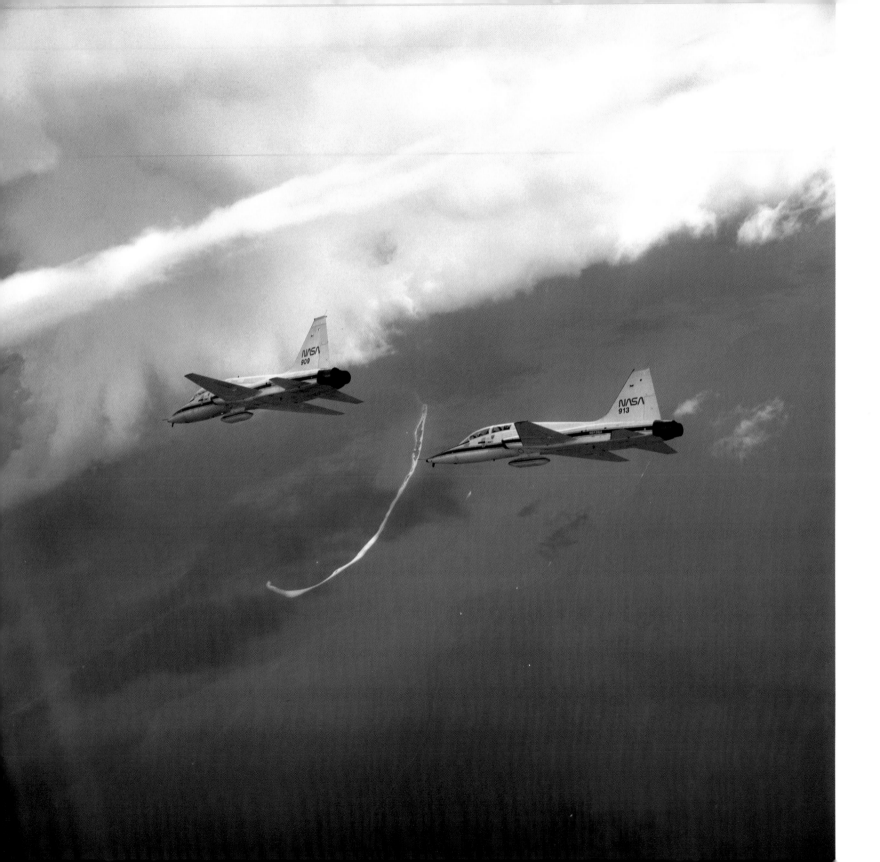

We let down over Galveston Bay on the way into Ellington. Redfish Island is below us.

We used to surf that tiny little beach on the waves created by super tankers passing by on the way to the Port of Houston.

The island is not there anymore, washed away by too many waves I guess.

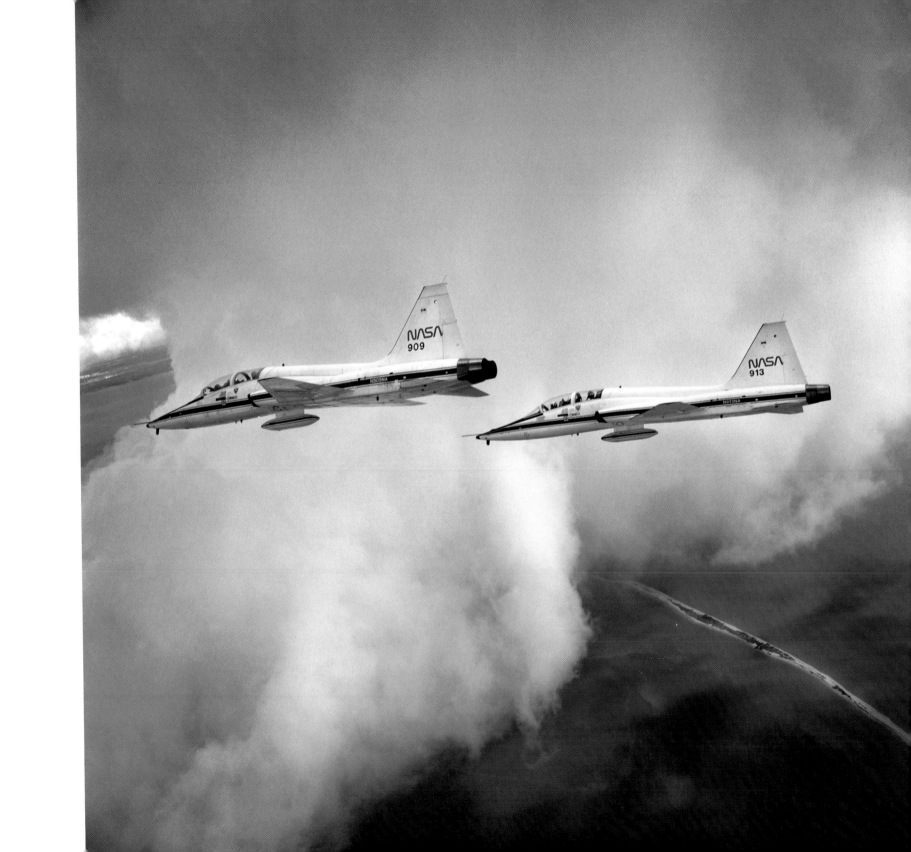

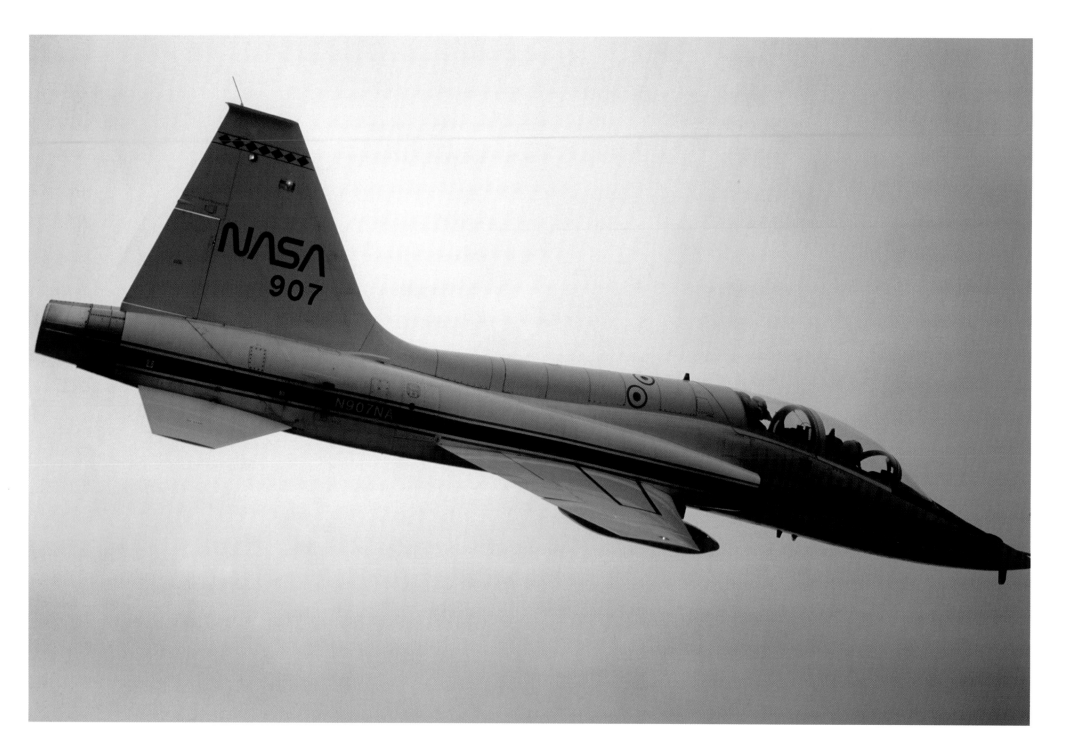

We momentarily pass into a cloud; the lights dim and a steadily escalating sense of foreboding comes upon us till we pass through to the other side of this weather and break into the clear.

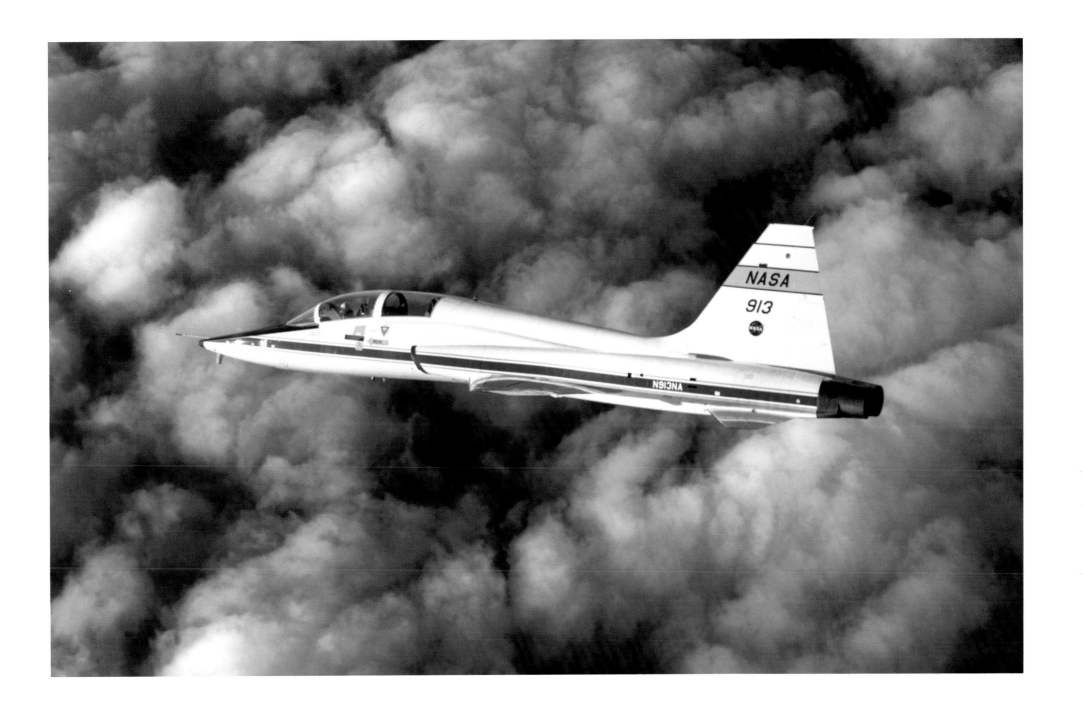

We maneuver to the approach corridor at Ellington.

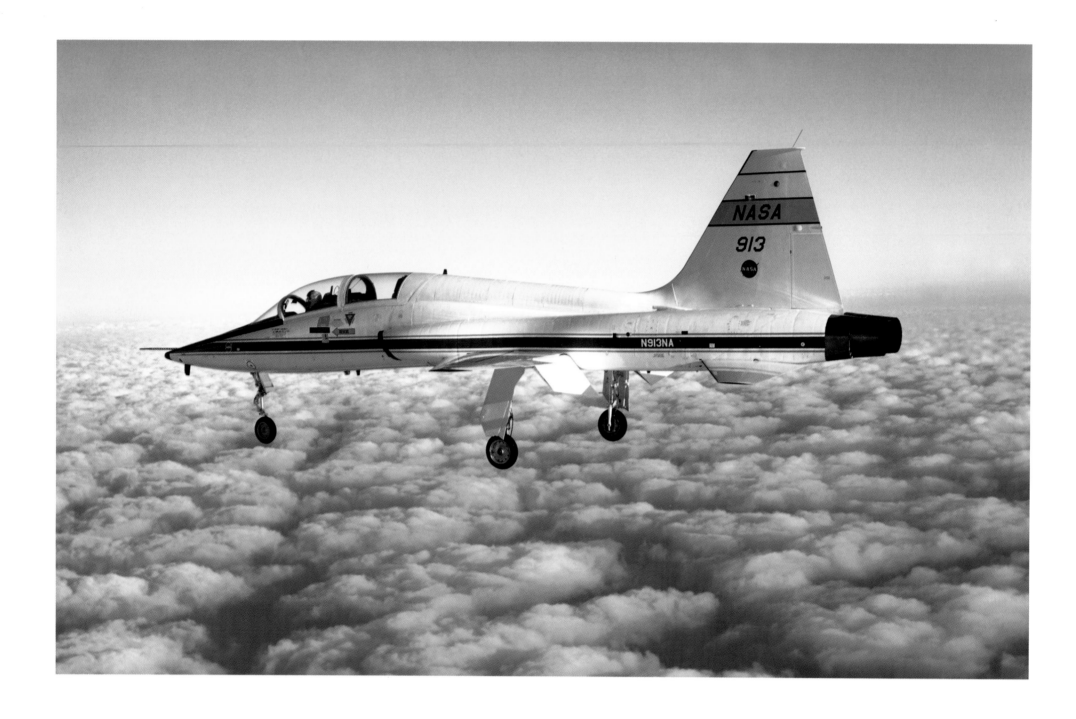

Put down the wheels and flaps, get the clearance from the tower and take it on in to the runway.

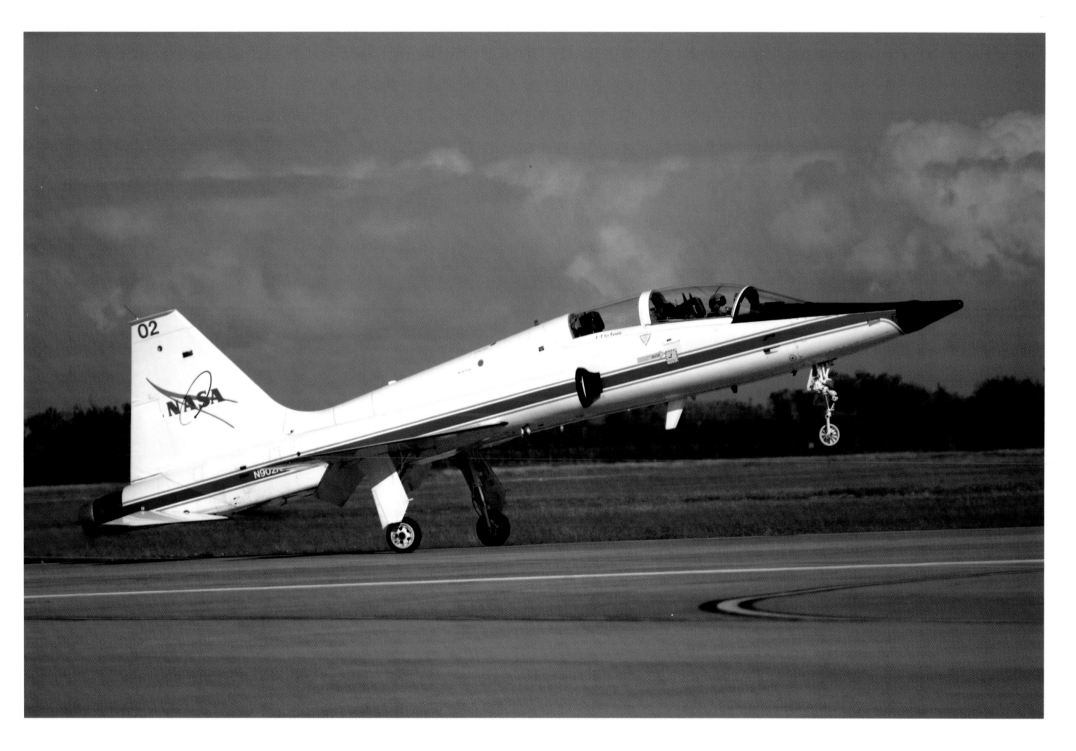

In a much later era I caught this landing to complete our story. I don't know who this was but I will find out who accomplished this perfection, just beautiful all the way around, a classic.

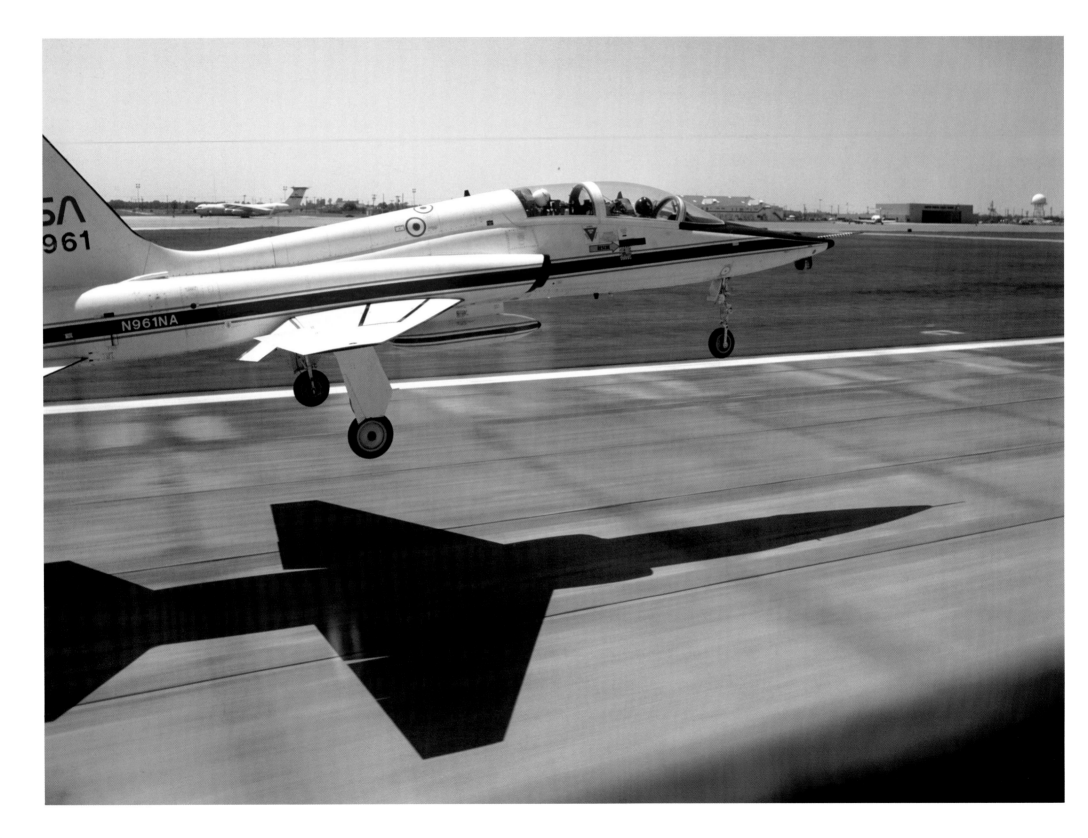

This was a take-off sequence but the overhead sun produced a shadow that very nicely drew the beautiful planform of the aircraft.

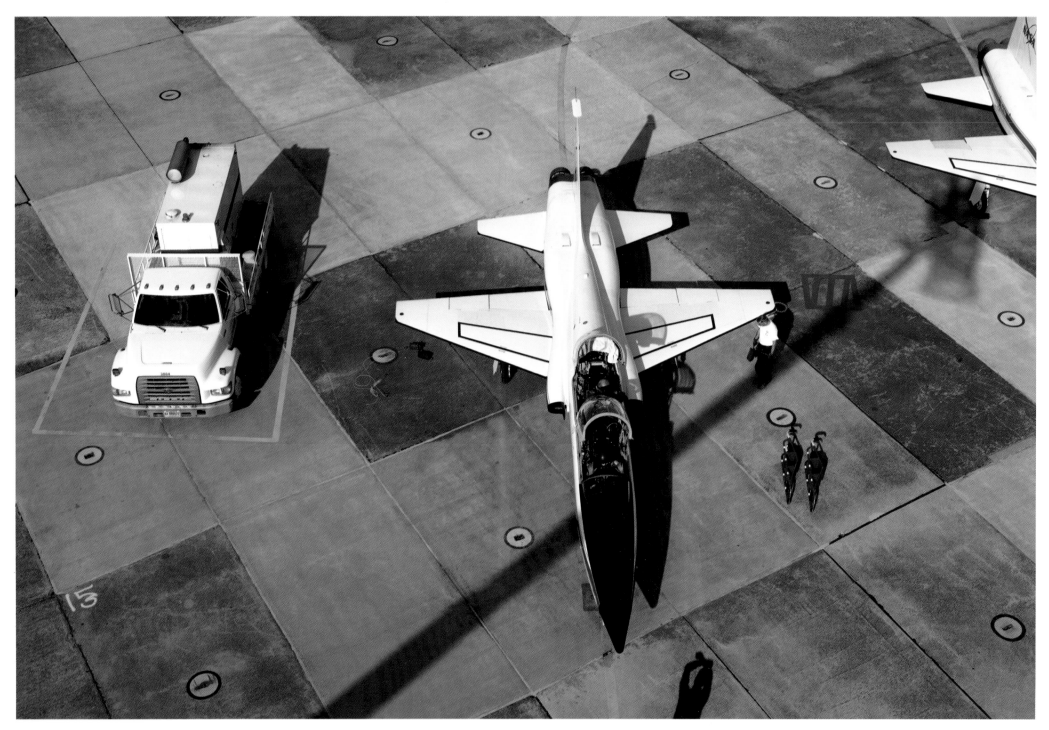

We pull into the ramp. The crossed arms at the bottom of the picture are our signal to stop on that spot.
The crew will chock the airplane, place our ladders on the canopy rail and help us to exit our craft.
Across the aircraft is another shadow, the JLG manlift that I am riding to get the shot.

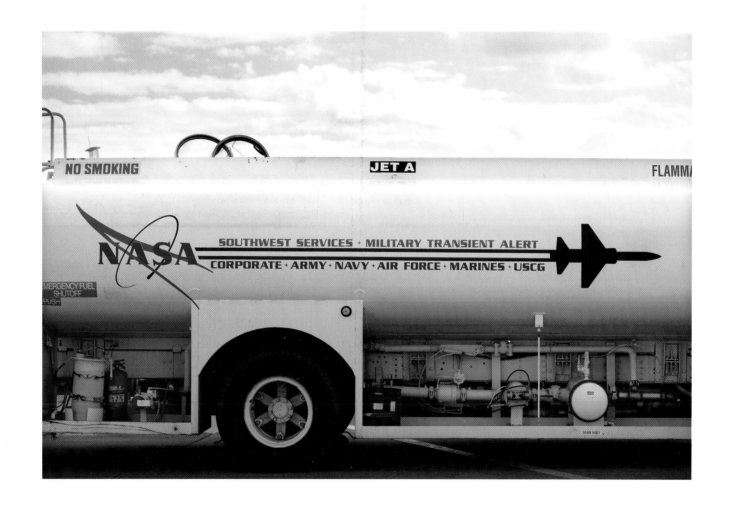

The fuel truck comes by to refuel our aircraft; they too got the spirit of flight; it is that spirit which is more than anything else responsible for how things are done, it is essential to doing things safe and right every moment of the day.

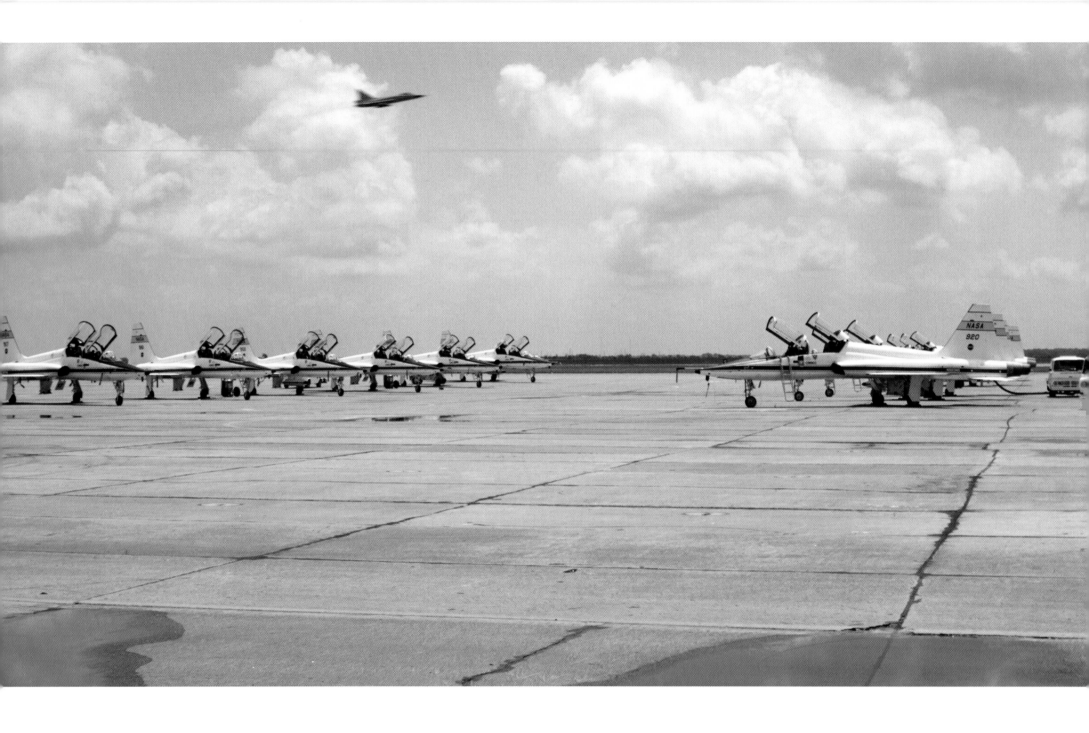

Our flight line at Ellington Air Force Base, Houston, TX about 35 years ago.

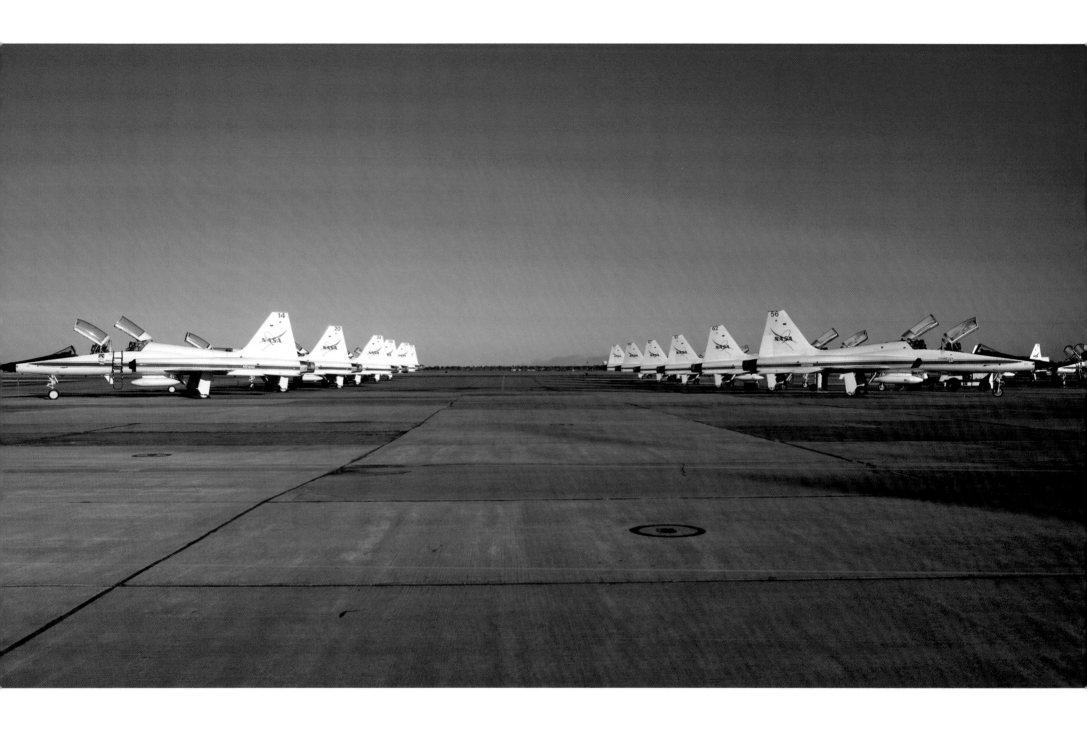

And the same flight line about 2 years ago.

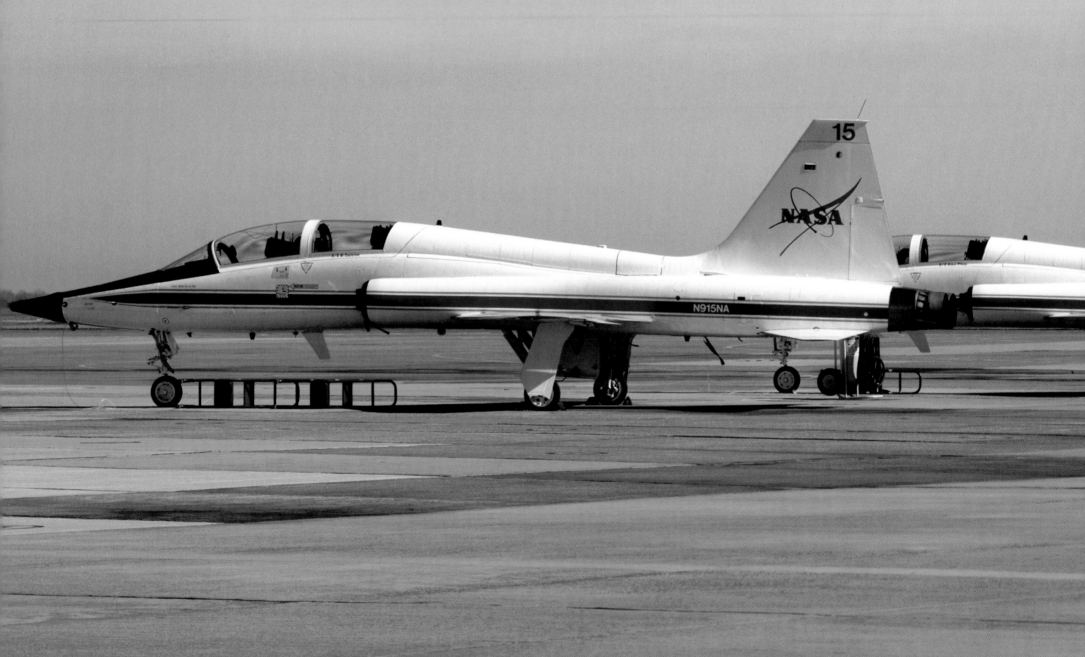

From this point of view you might say that these beauties are in an echelon formation. Whatever you call it, I just love this view of the flightline. So precise and orderly yet it looks like the spacing between aircraft changes in an orderly way. They look so ready to do something: peel off into a tight turn, or each in turn roll over and fall to earth.

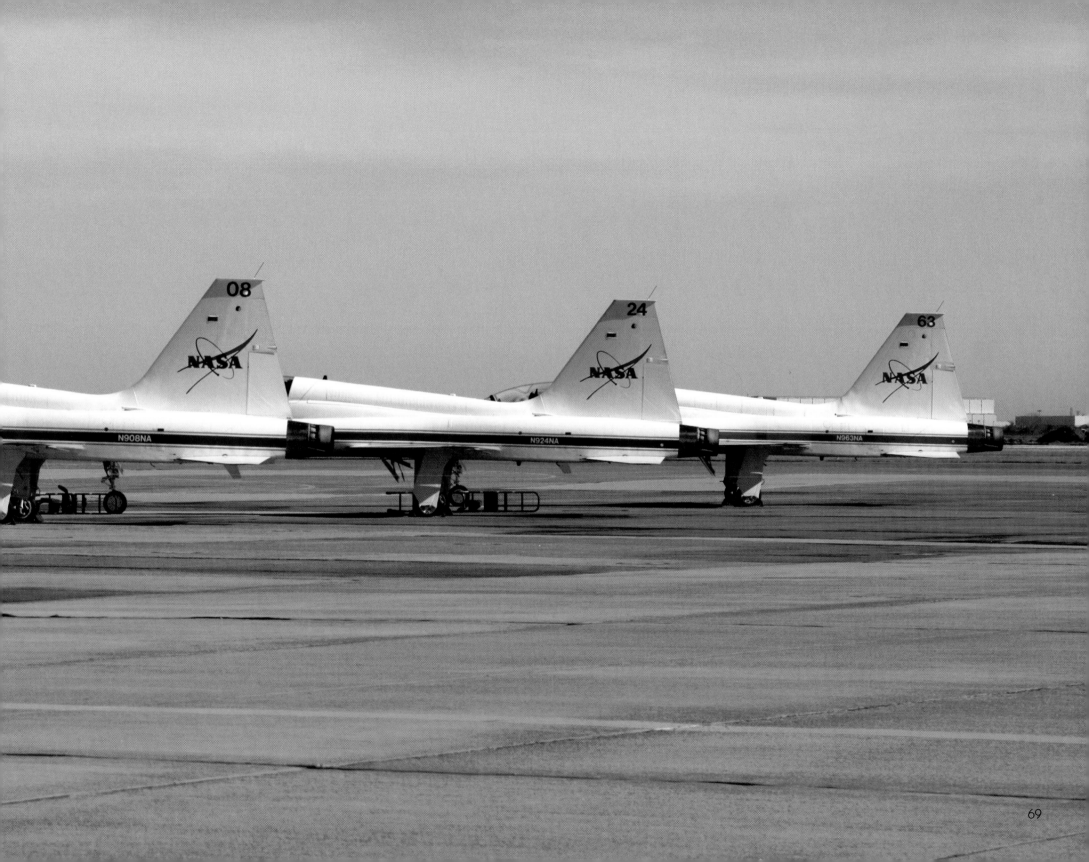

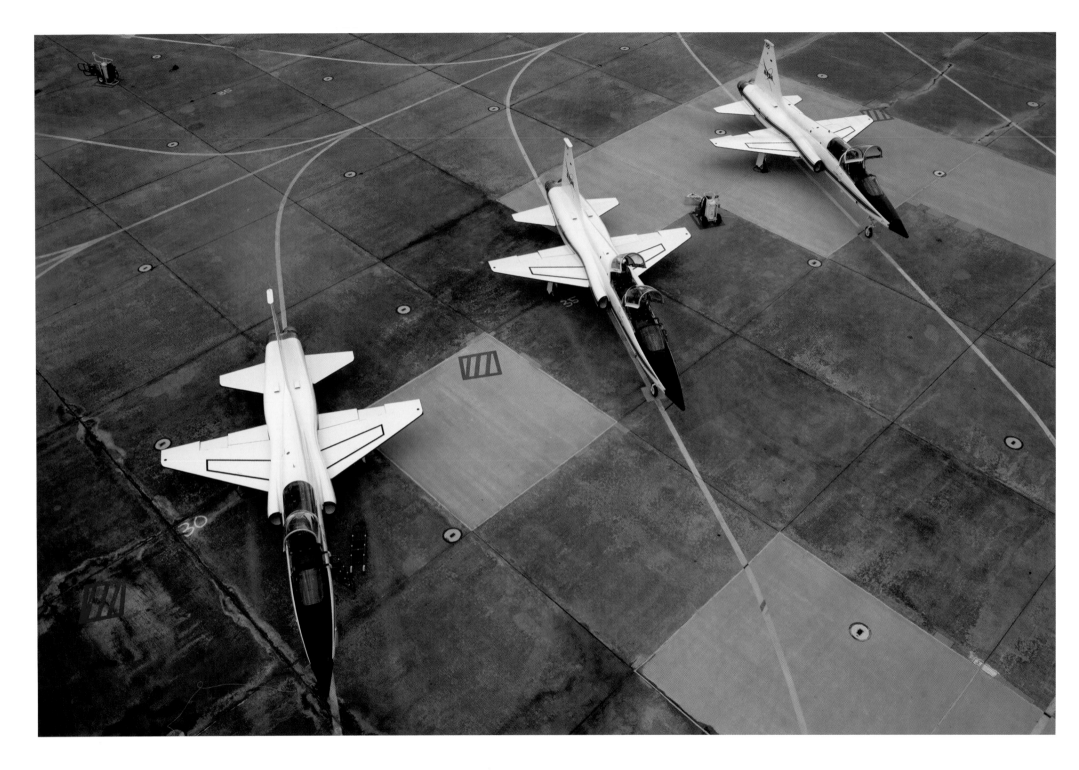

I am driving a JLG manlift around the flight line, up to 50 feet above the ramp, between and amongst the machines looking for evocative pictures. I really liked the line up of this open canopy threesome. It would have been a cleaner shot had the concrete not been all patched up but I cannot complain, I got 50 feet of lift and I got T-38s.

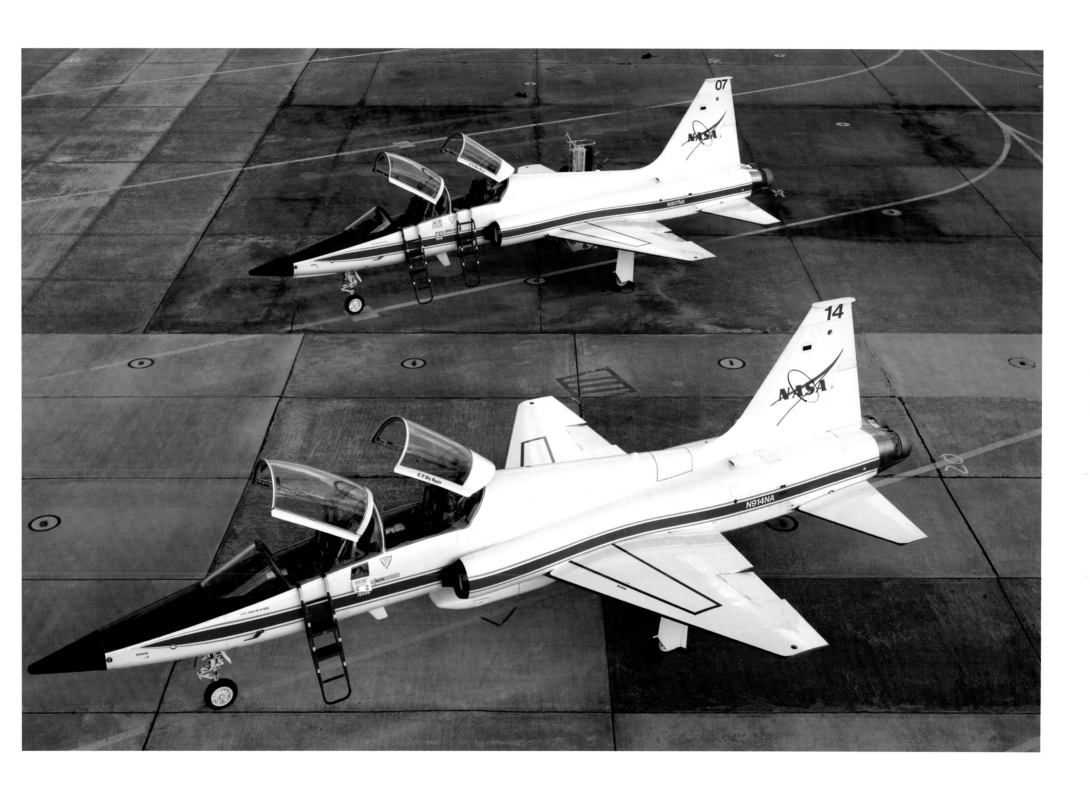

This little twosome from the side, with the invitation of the ladders, worked for me also.

I spotted this, the "bag", on the line and thought you'd be interested in how we'd practice "instrument flight" or "flight in the weather" on beautiful days like this.
A safety pilot in the front seat manages the flight and looks after the situation, while one of us gets in the back seat and pulls the bag over the canopy.
We fly around blind, as if we were in the clouds, dense fog or the like and then we fly approaches to several airports.

It was one of those days, the wind blowing hard, as you can see looking at the windsock and the "remove before flight" red flags. It was also raining, a driving rain. Other than shooting another round in the protection of the hanger I was not optimistic about the day. Nobody wanted to fly or work in this mess so there were only two aircraft on the line. I got in my car and drove out on the line, opened the window and got this shot that, for as yet unknown reasons, moves me more than any flight line shot in my collection. The aircraft seem to be saying that they fly in this stuff too, they are stoic about the day and patiently waiting for some pilots to take them into the weather. Maybe one of you know why this is a moving image?

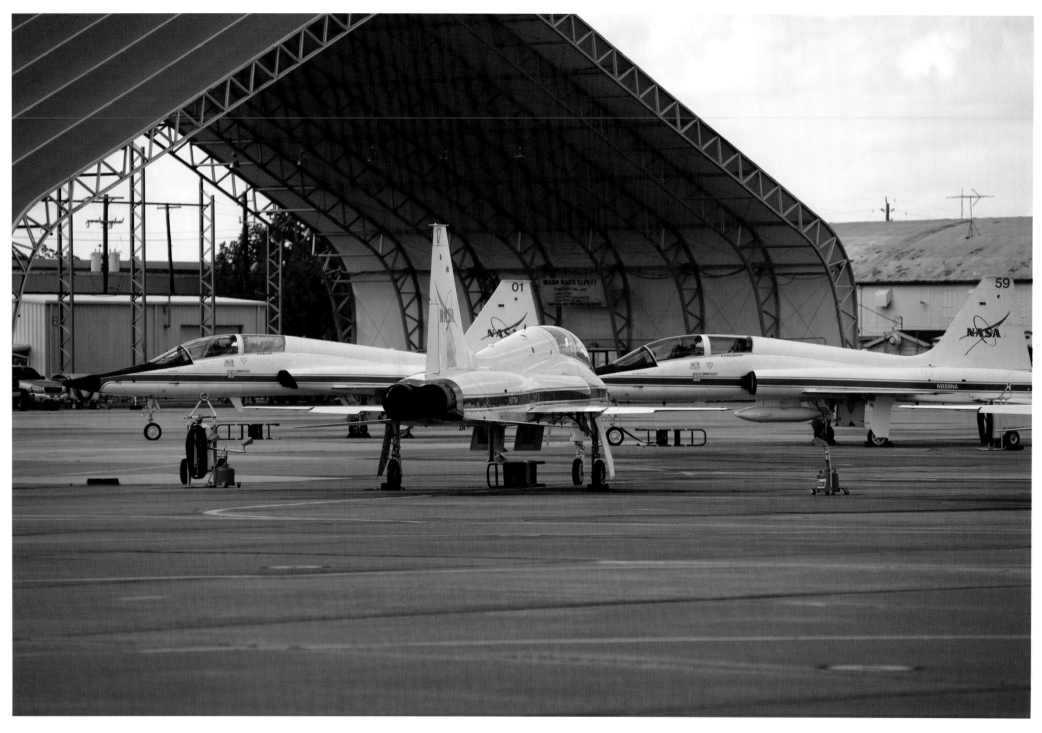

This part of the flight line caught my eye in the viewer. It is of two standard lines, but with some aircraft missing, and shooting through the rear of one line into the front of the other line. It produces a triangular three-pointed-star effect, that played well with the triangular roof of the temporary hangar.

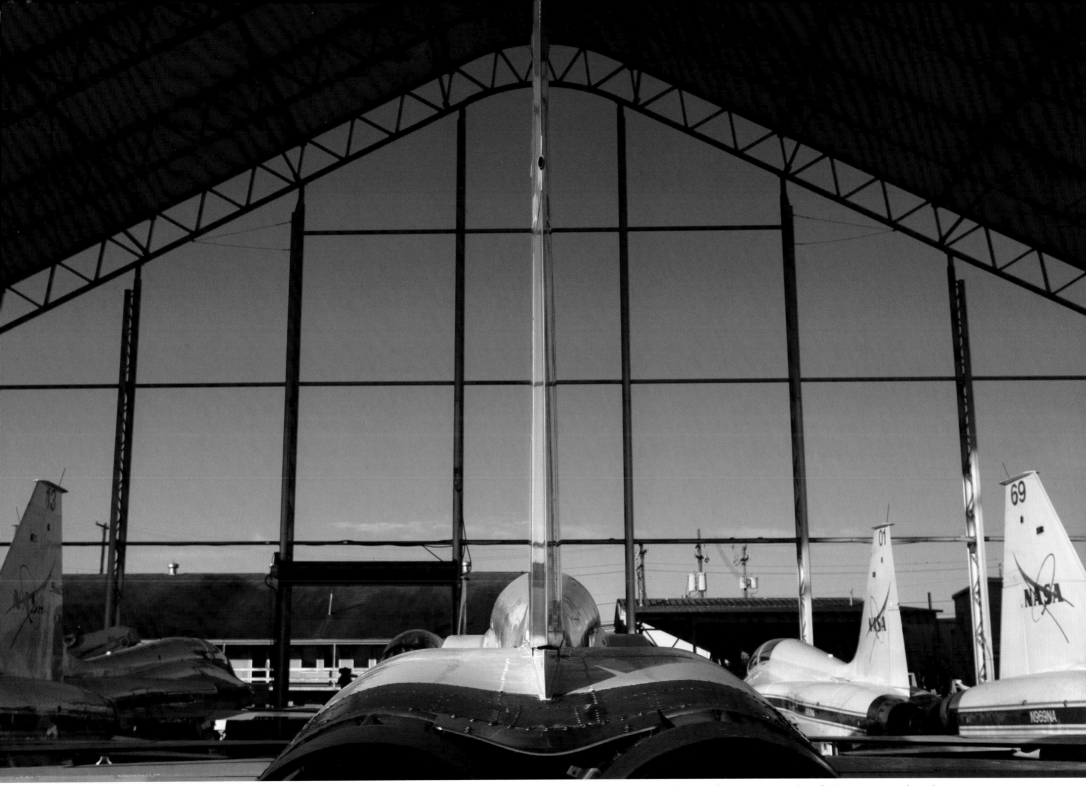

This view of the aircraft, starting just above the engines and sweeping forward over the top of the machine, really got my attention. So I went to work on it. This is my "cathedral stained-glass window" picture with clear sky in the windows.

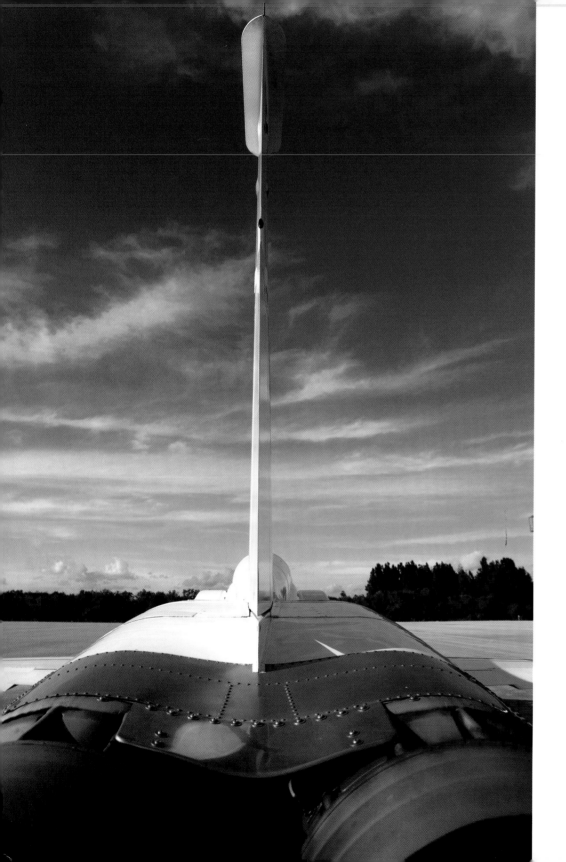

Same basic point of view as on the previous and facing pages, but this is the Shuttle Landing Facility at KSC - with a calm sky that does not overpower the trees in the background.

Back in my "cathedral" at Ellington.

Now zoomed out a little and with some photogenic clouds in the windows. Turns out that this is the first one that I shot and I could not improve upon this one, but I had to keep working it; I was addicted to this shot.

Hurricane Ike destroyed my cathedral, it is gone.

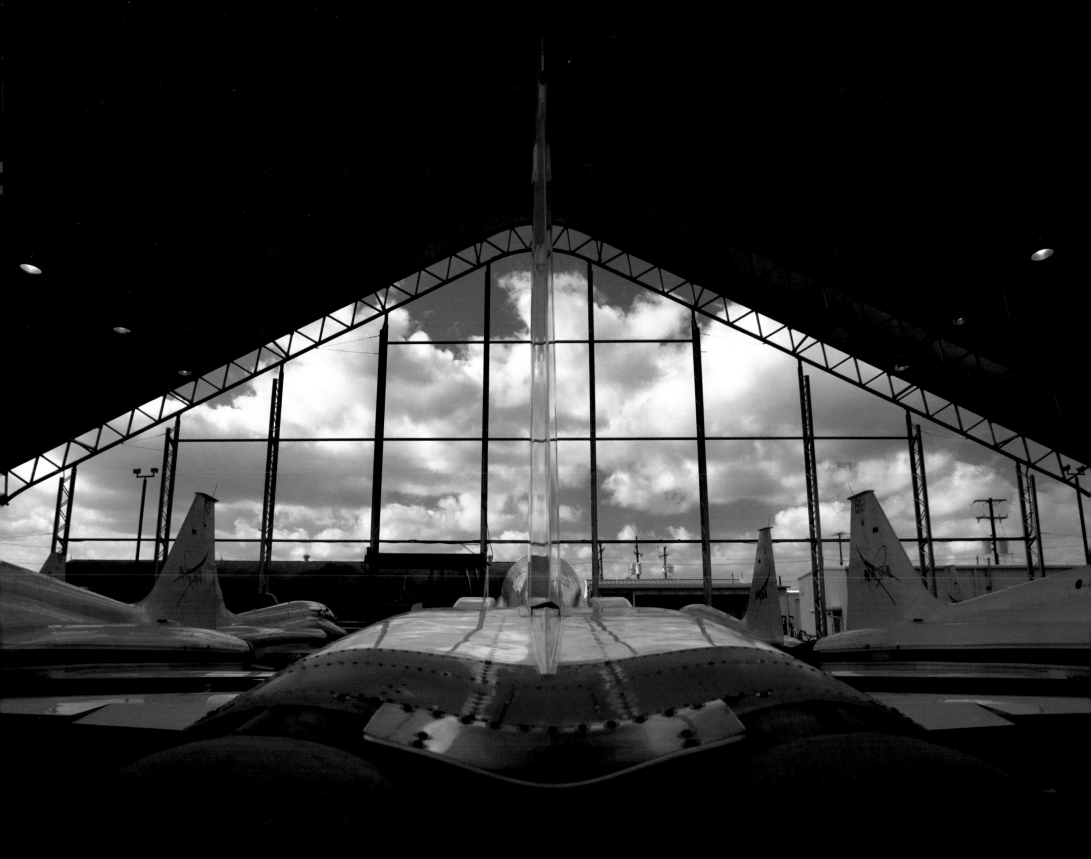

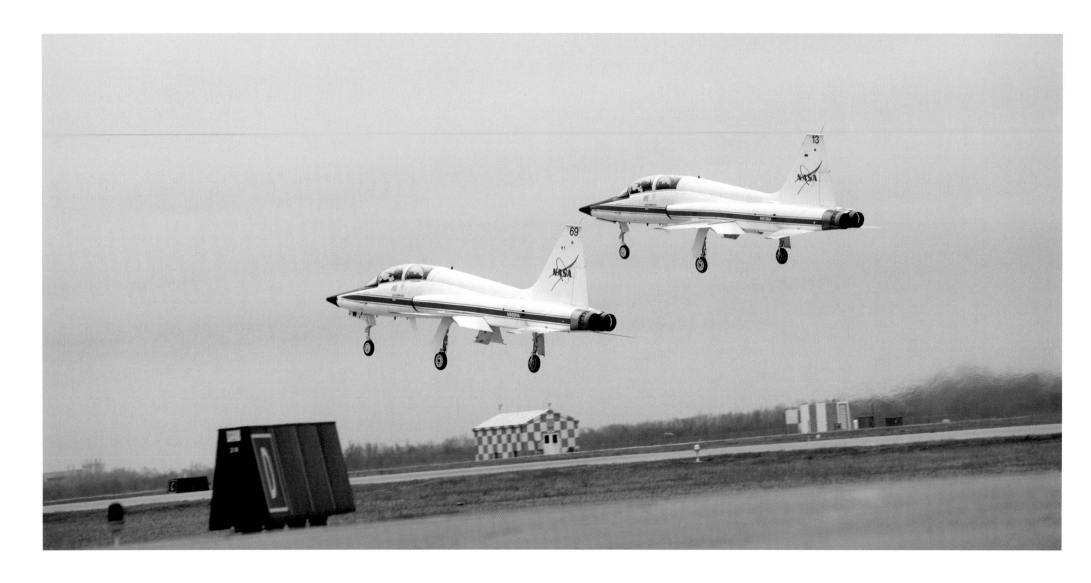

We are going to journey from Ellington Field to
Edwards Air Force Base via El Paso, TX to fly Space
Shuttle approaches into Runway 04 at Edwards.It is
in the 70's so it is our early exposure to acquiring the
skills necessary to bring the shuttle home. Here we
take off out of Ellington and raise the landing gear
handle. The doors deploy to allow the wheels into
the well and away we go.

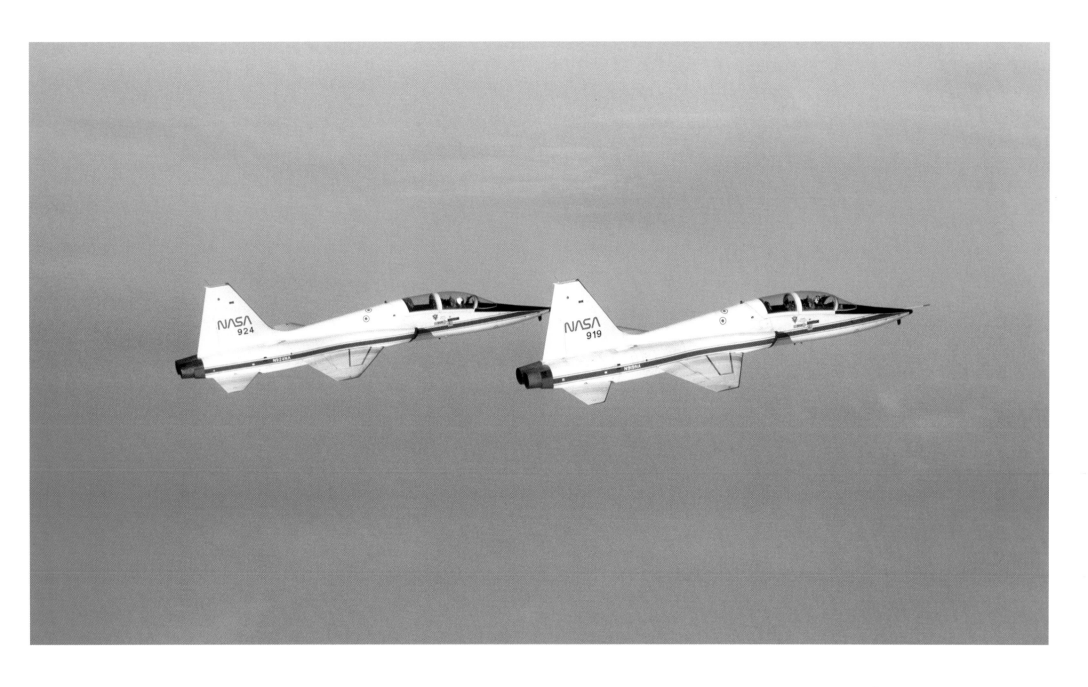

We fly, we concentrate, we focus, we attend, we lead, and we follow. We feel the sense of camaraderie, the spirit of the corps and the knowledge that together, someday, we will share this in space.

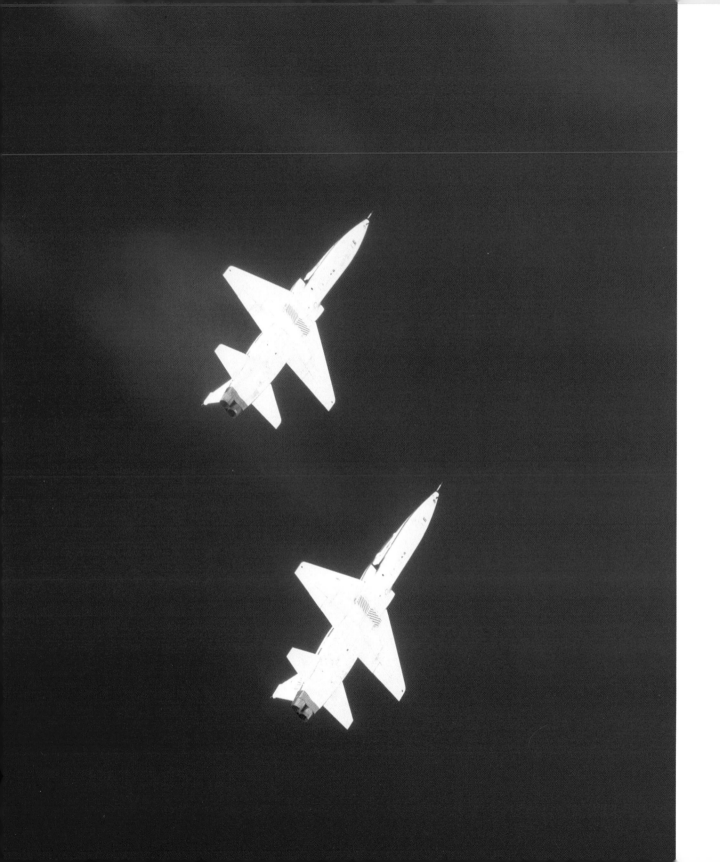

Climbing out of Houston you can see the larger modified red speed brakes on our bellies.

When deployed they add more drag than the standard speedbrake, and so speed our descent to earth to the same rate as the Space Shuttle.

I fly my aircraft into a position that places the moon neatly between my fellow travelers.

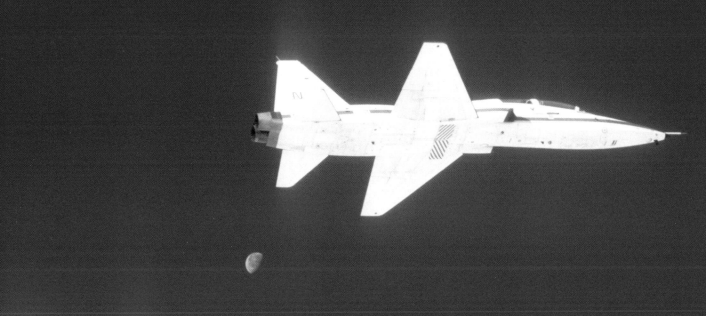
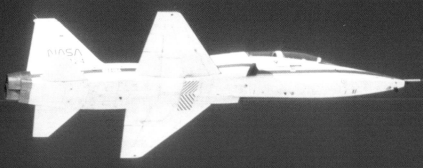

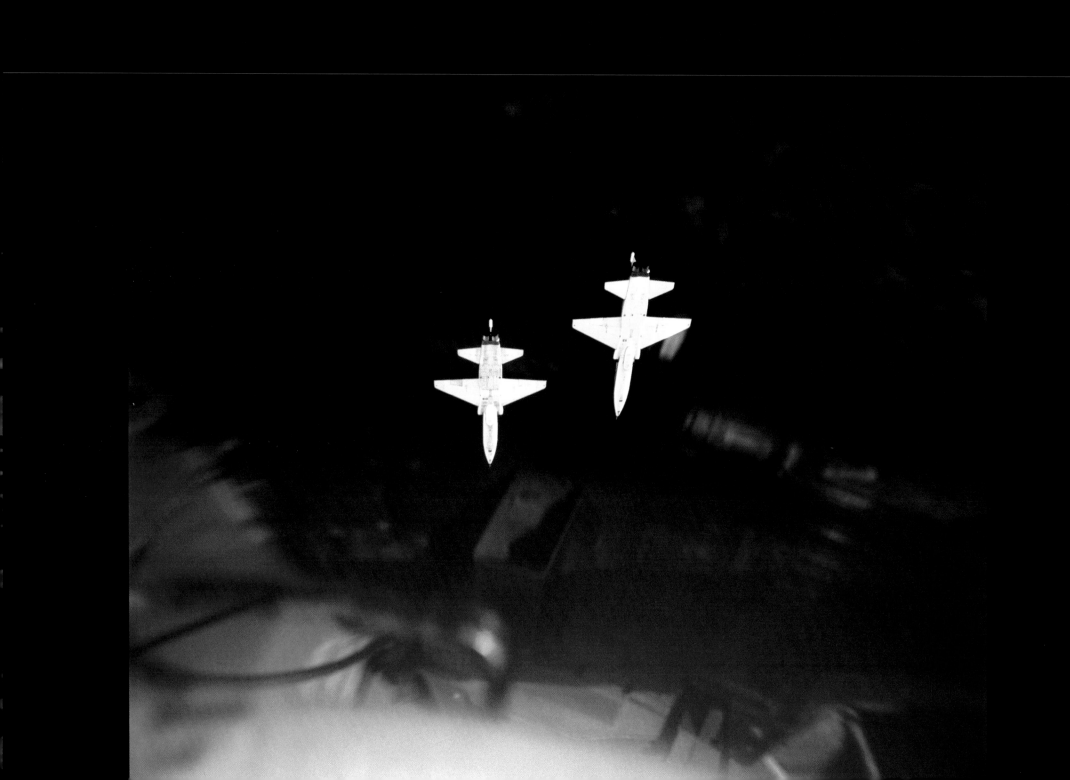

I wish that once in a while I had worked at getting more canopy reflections instead of trying to eliminate them. At times they show the ambiance inside my cockpit; adding a little narrative and drama to the external pictures of the aircraft.

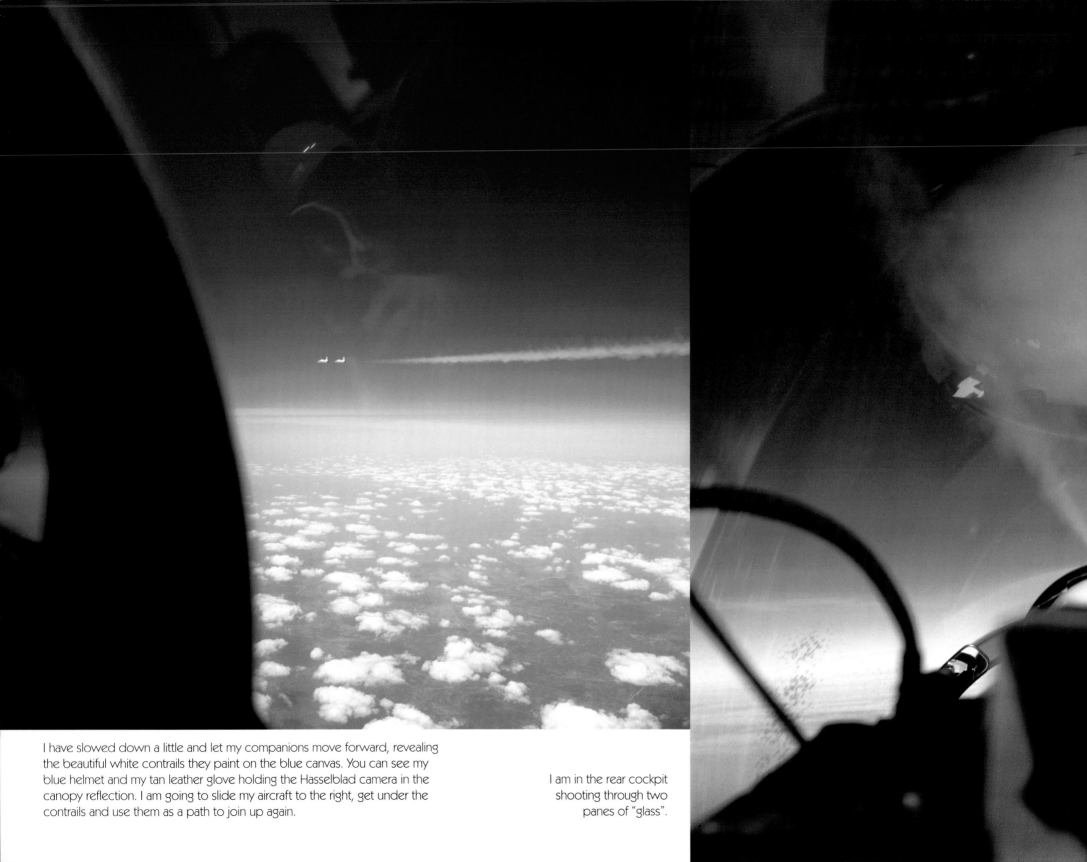

I have slowed down a little and let my companions move forward, revealing the beautiful white contrails they paint on the blue canvas. You can see my blue helmet and my tan leather glove holding the Hasselblad camera in the canopy reflection. I am going to slide my aircraft to the right, get under the contrails and use them as a path to join up again.

I am in the rear cockpit shooting through two panes of "glass".

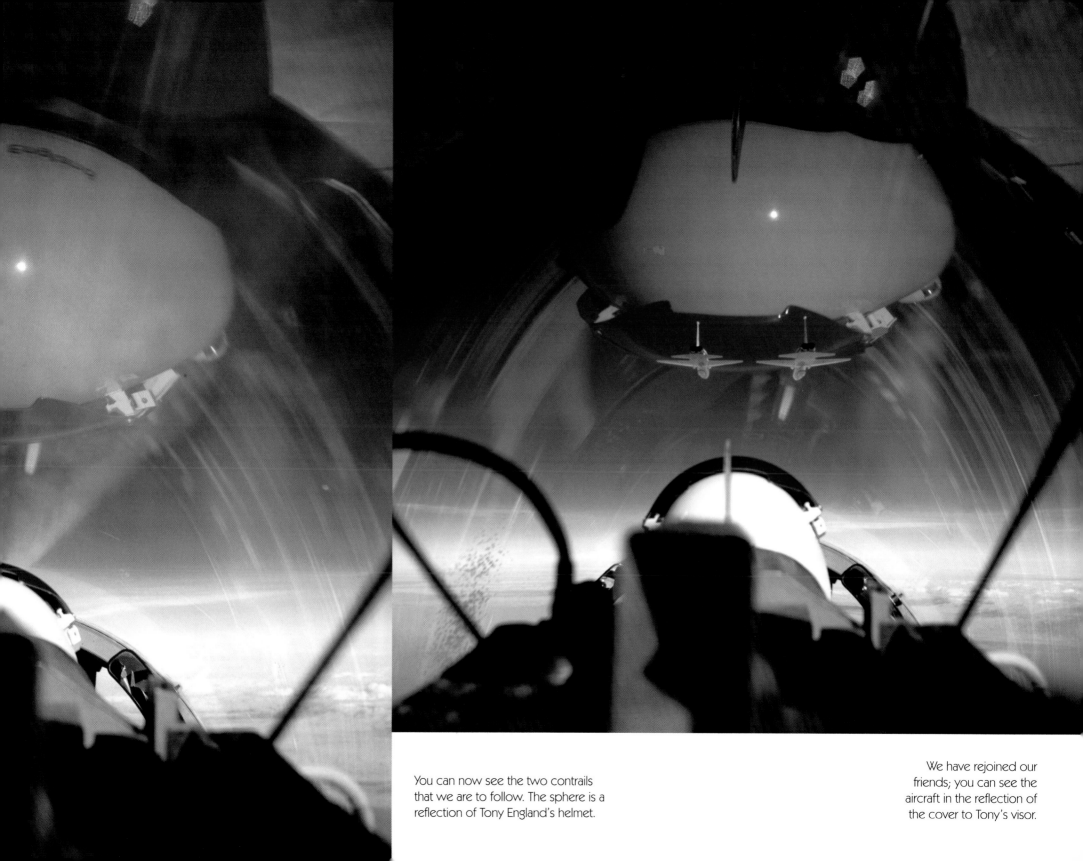

You can now see the two contrails that we are to follow. The sphere is a reflection of Tony England's helmet.

We have rejoined our friends; you can see the aircraft in the reflection of the cover to Tony's visor.

On the ramp at El Paso, TX we look up into a sky filled with contrails;
we just came from there.

We get some fuel now and shortly we will return,
to make some more contrails,
on our way to Edwards.

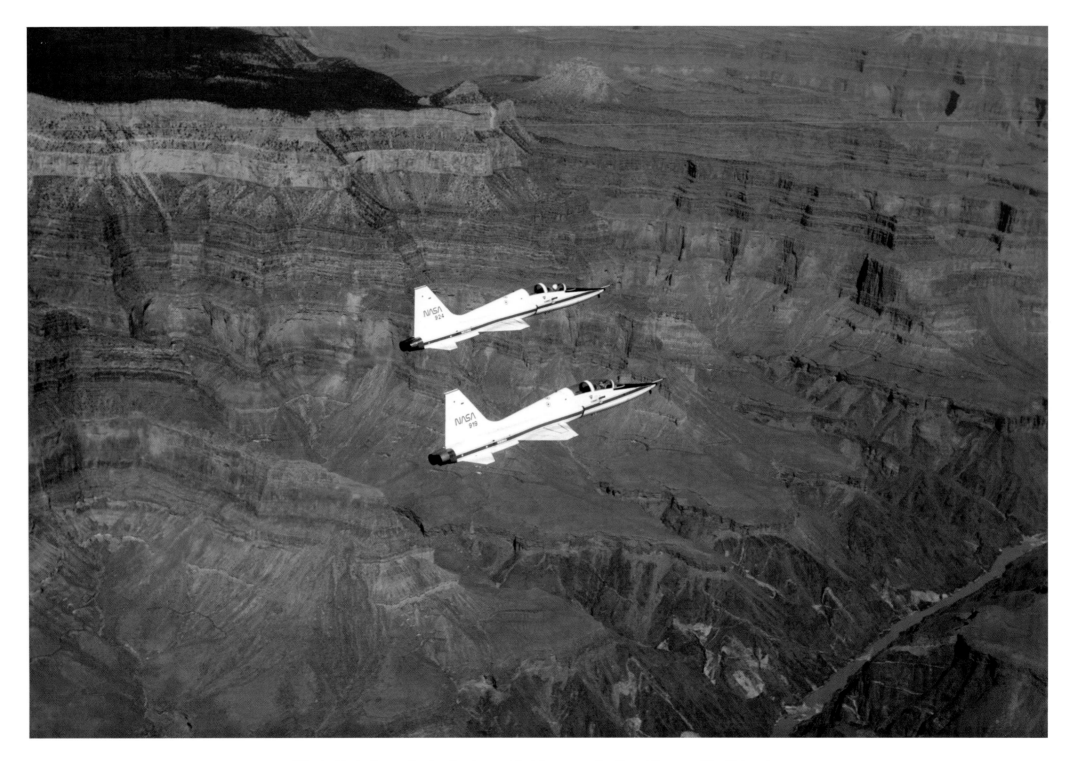

We deviate to the north of a direct course to take us over the Grand Canyon of the Colorado.

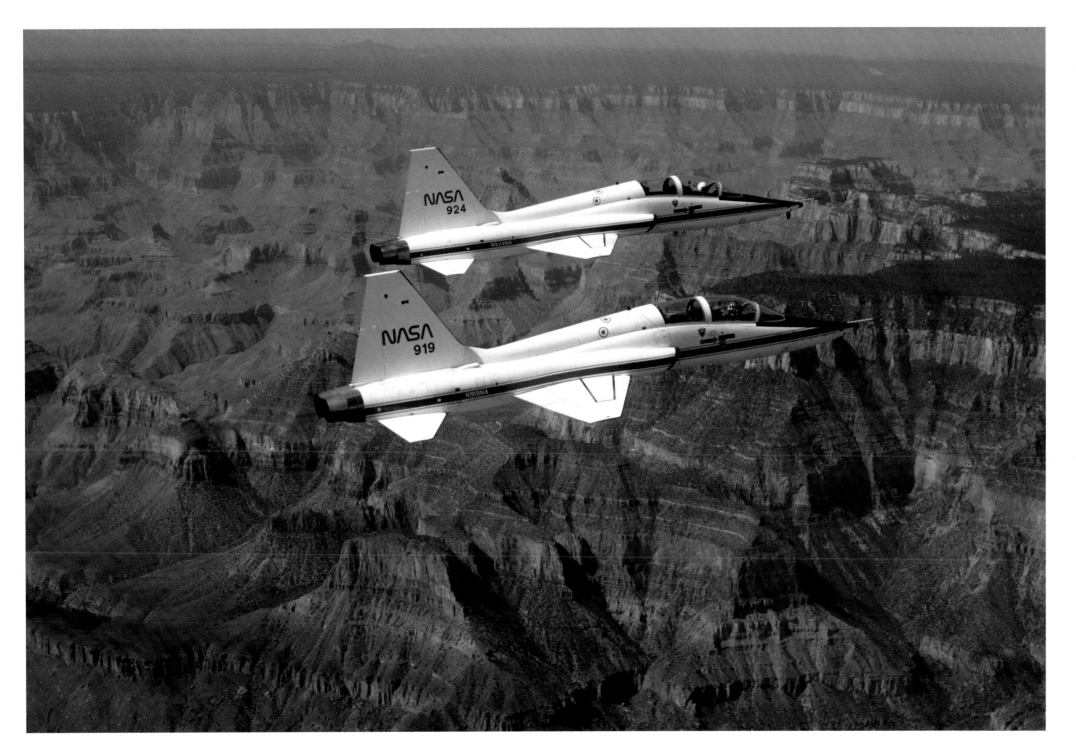

Oh, the art of technology and the beauty of nature!

On the ramp at Edwards we take in
a desert sunset with our T-38s and a
Gulfstream II shuttle training aircraft. We
soak up the dry evening air and dream
about the next day's flying.

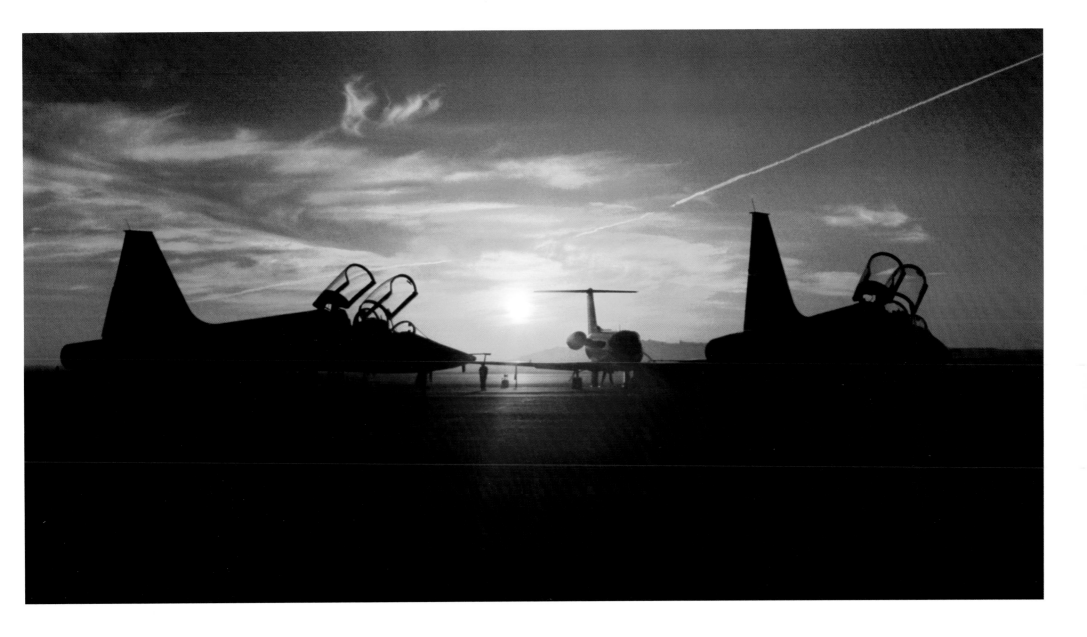

We are in the final turn for our shuttle simulation approach for Runway 04 at Edwards at about 16,000 feet altitude.

We complete the turn to final, gear is down, flaps and speedbrakes to go.

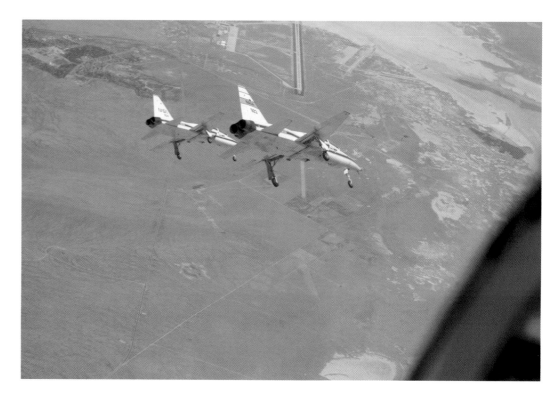

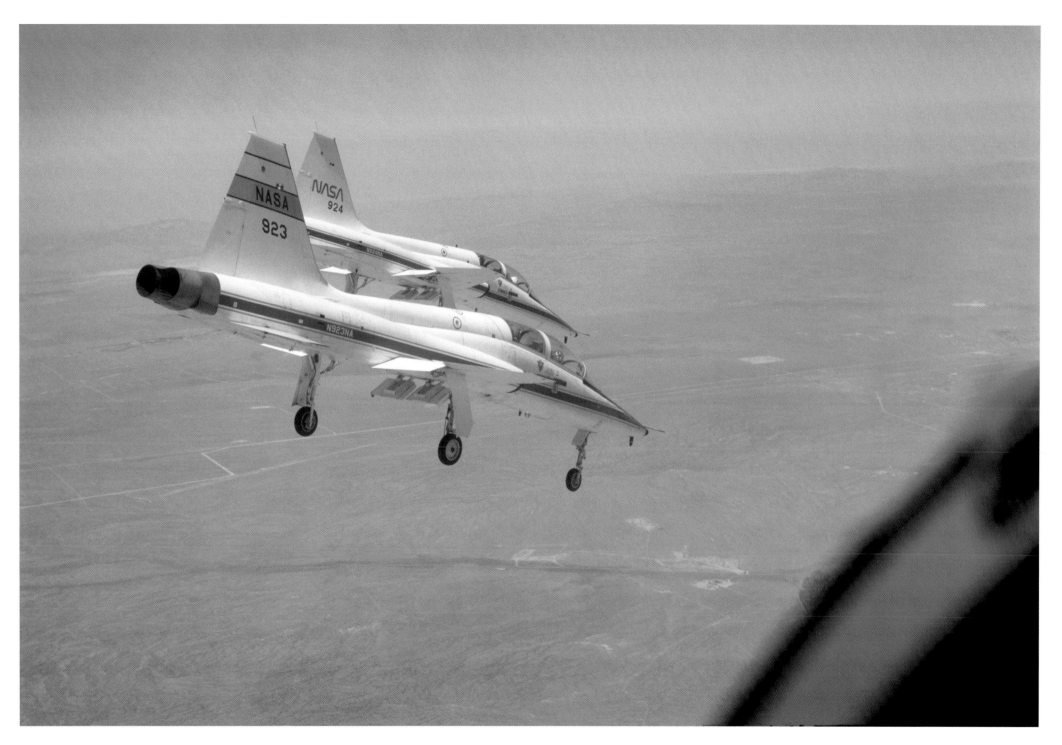

Of hundreds, even thousands of pictures of formation flying that I have taken over 42 years, this is my favorite. It is this one, more than all the rest, that puts me back in the cockpit; as if I was just now flying this beauty in a legendary land, with brothers of the bond.

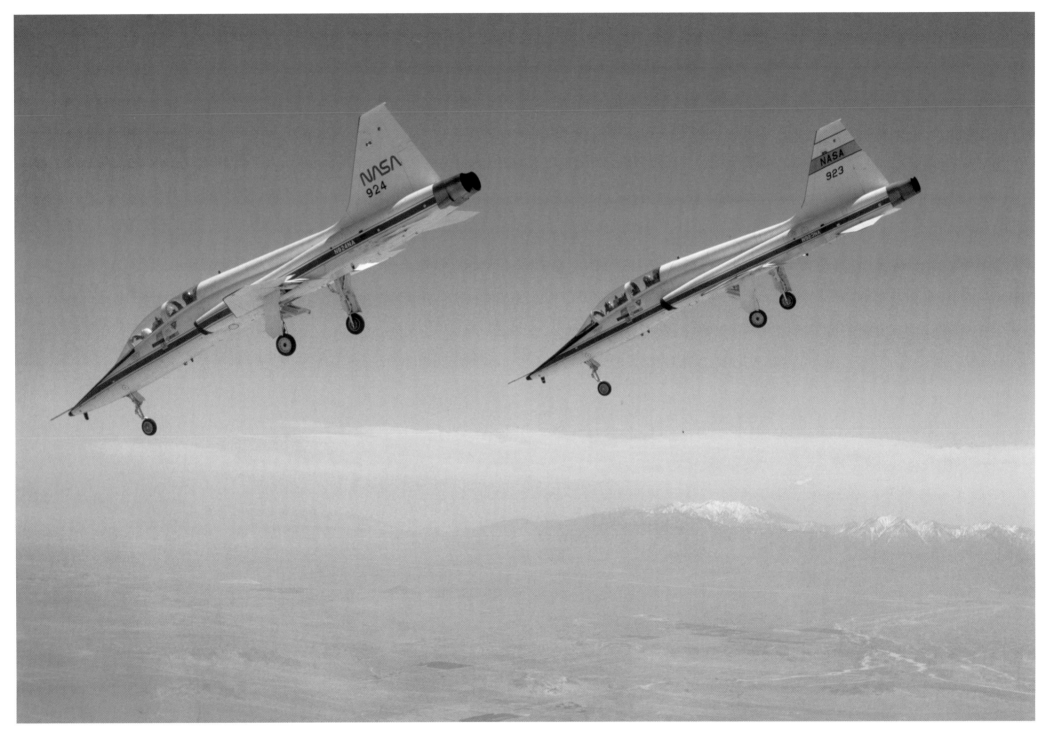

Looking out to the southeast horizon and the San Gabriel and San Bernadino Mountains one is able to see the steepness of a Space Shuttle simulation approach which is about 20 degrees.

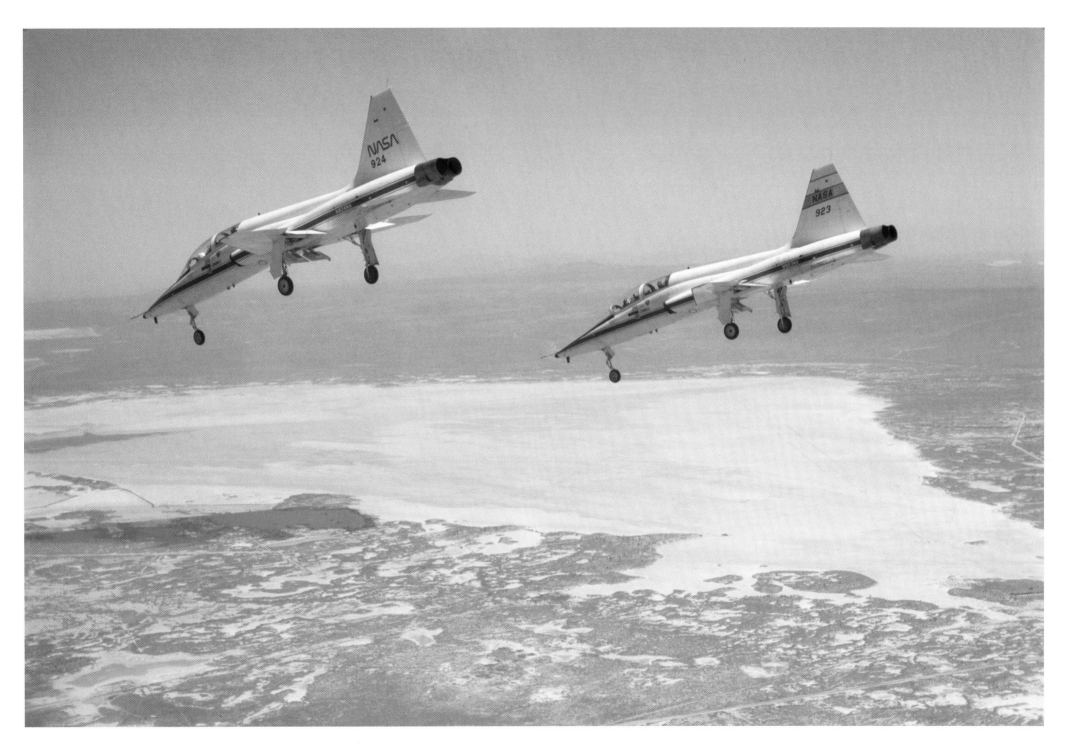

In the background is Rogers Dry Lake where the Space Shuttle made its early landings. I have landed here in the shuttle four times and in Florida twice.

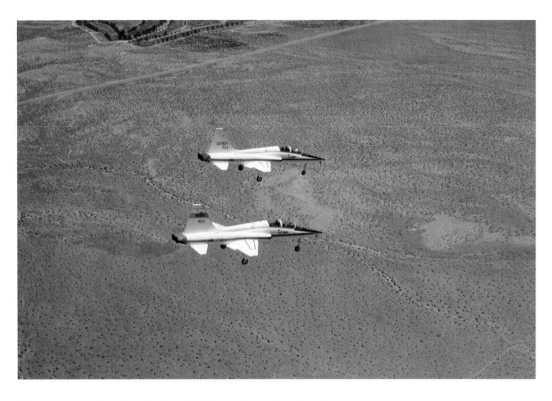

We have started our level off at 2000 feet above the desert ...

... and let our speed carry us to the runway

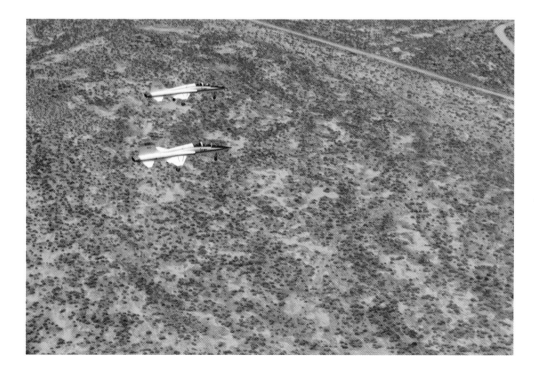

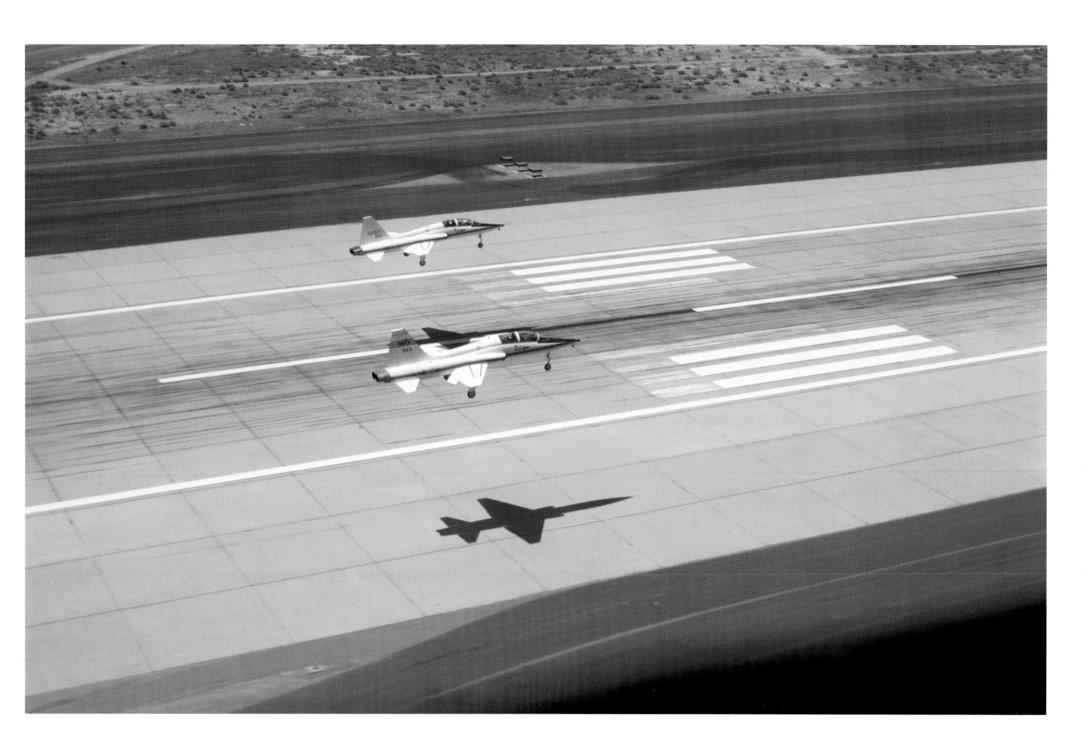

And here we are; we do not touch down when we come out of a shuttle simulation approach.

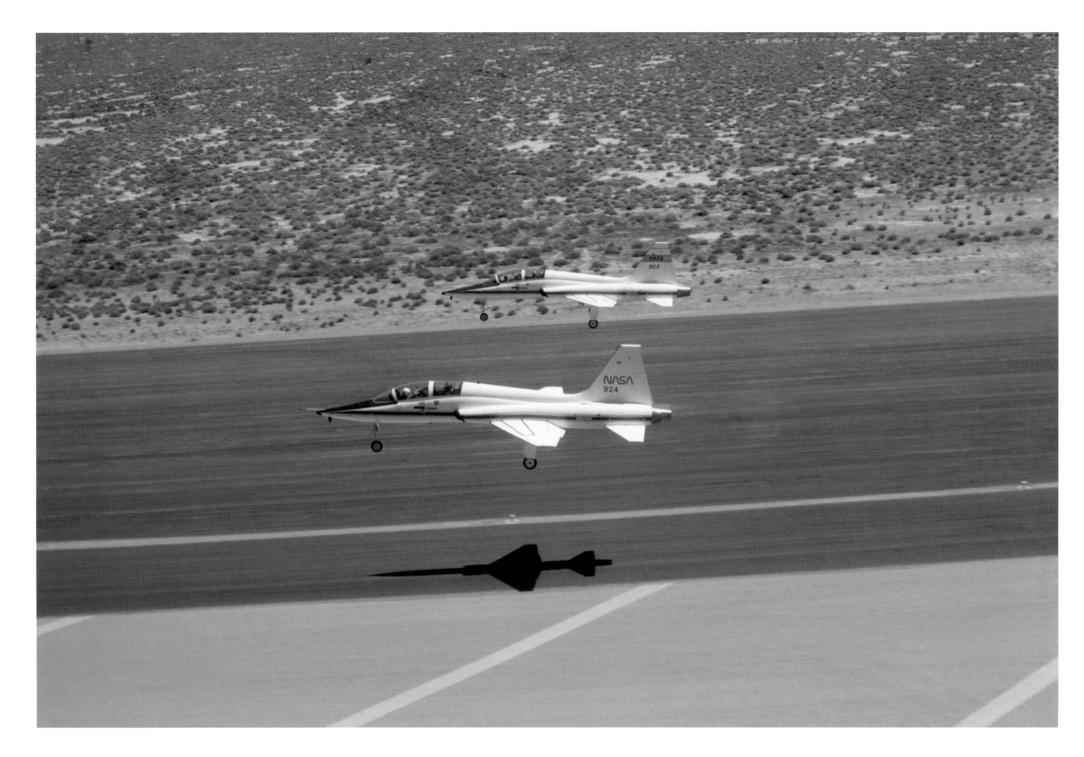

On the go for another one; look at our beautiful shadow.

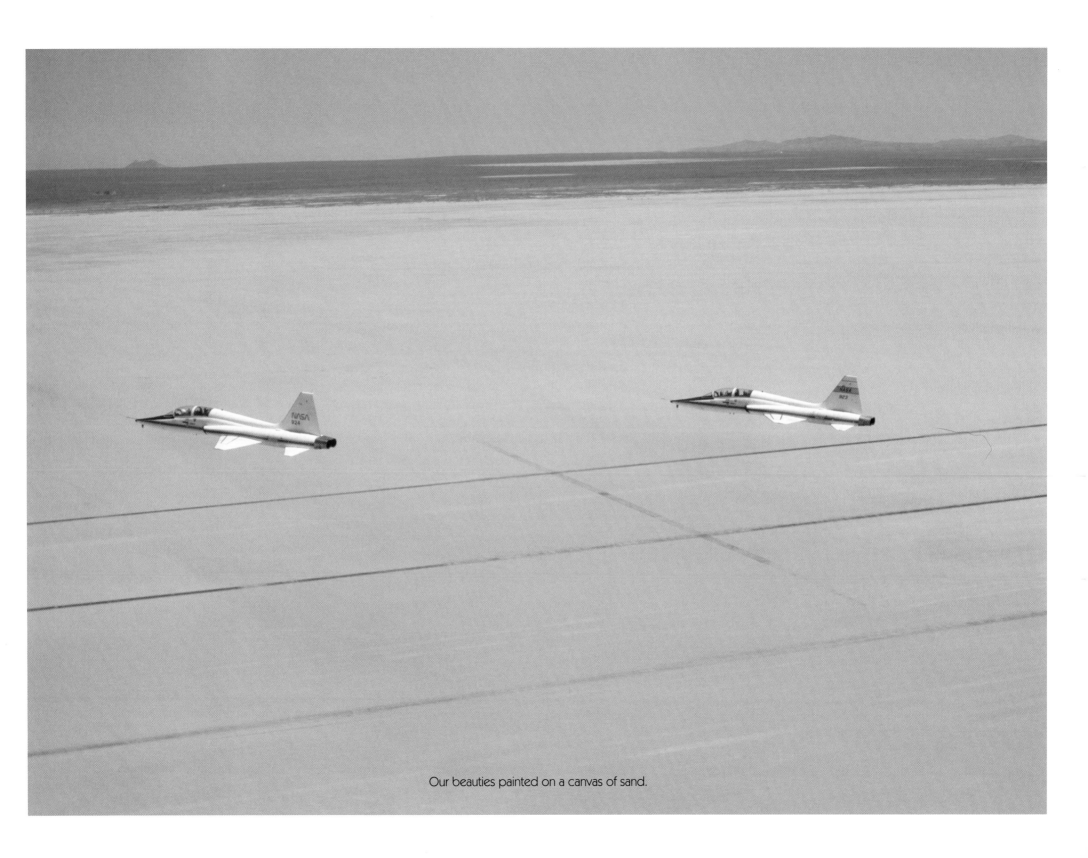

Our beauties painted on a canvas of sand.

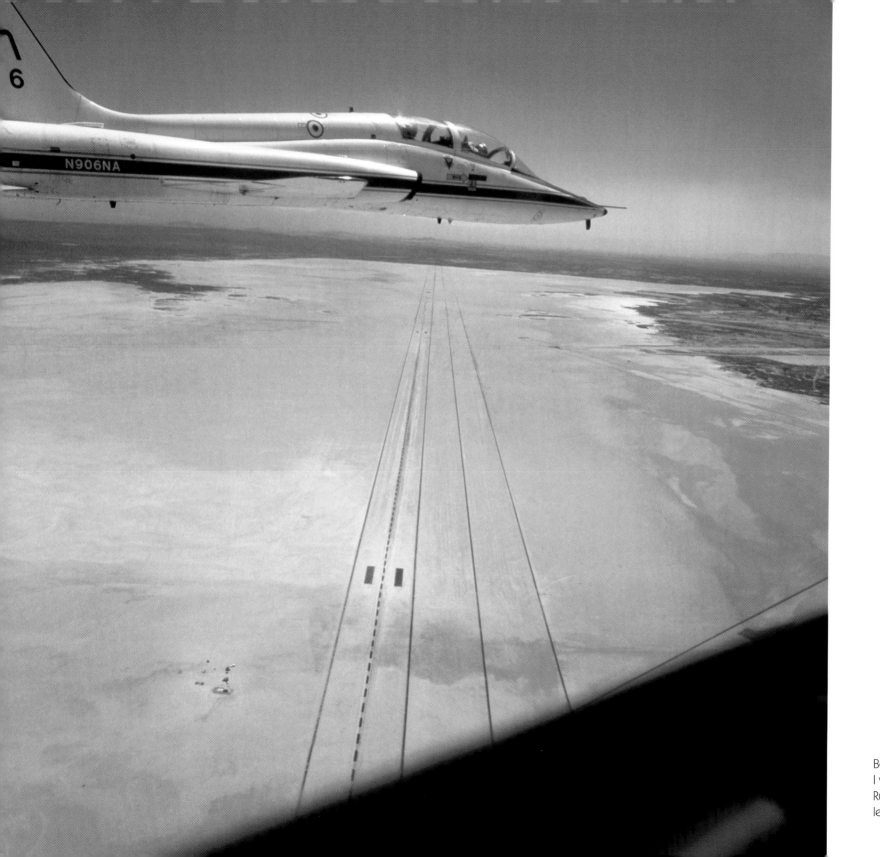

Before we depart for home
I wanted you to see lakebed
Runway 17/35 which is 7.5 miles in
length.

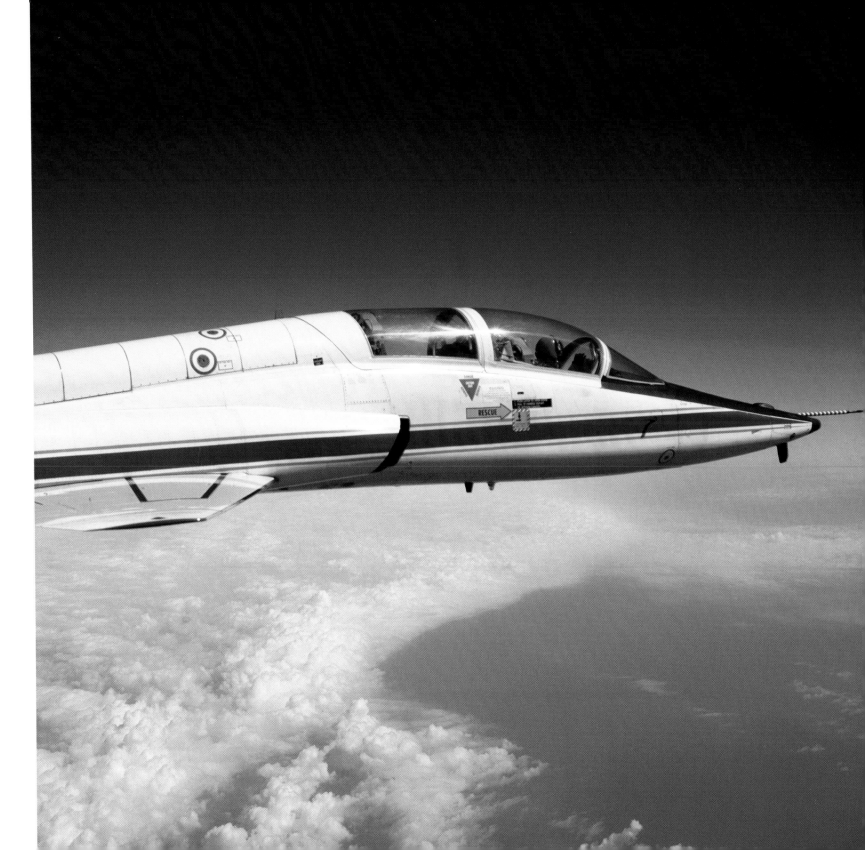

Six feet apart at 600 mph.

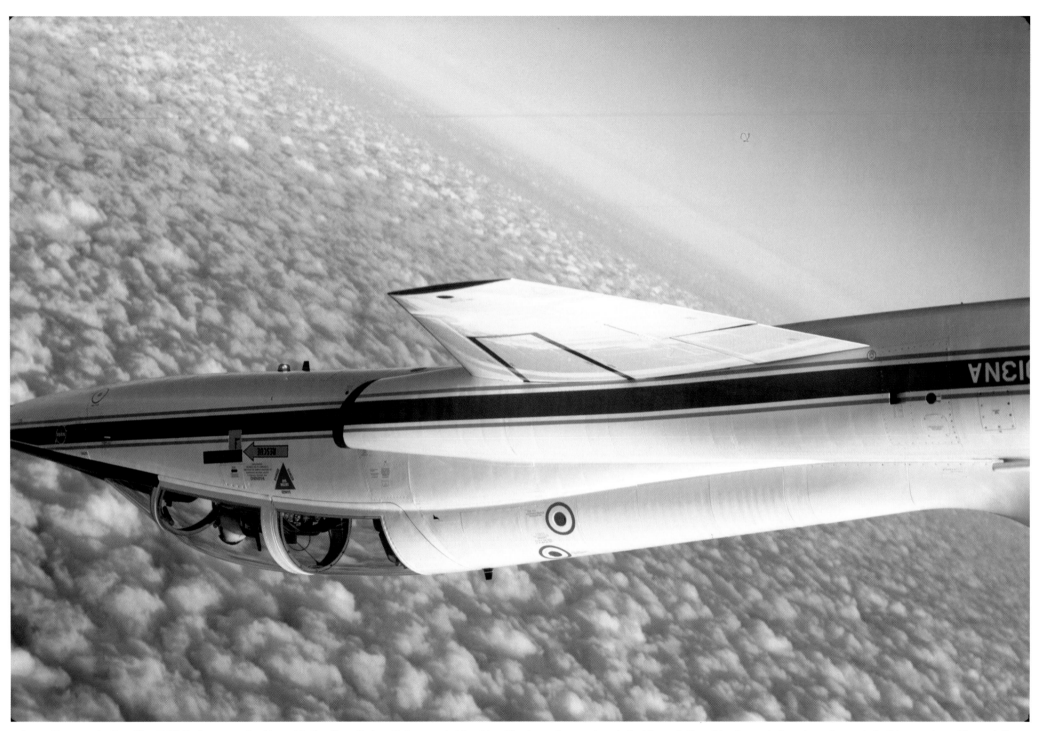

Formation aerobatics. The T-38 that you are looking at is the "lead" aircraft; I am matching his attitude and speed such that I can follow him through the air and remain in this exact position relative to him. I am on his wing so I am referred to as the "wingman". My distance from that aircraft is as you see it; I am using a 55mm lens and am not using any zoom in the processing. But this is not the way I see the other aircraft; I have rotated the image to put earth down, where it often is.

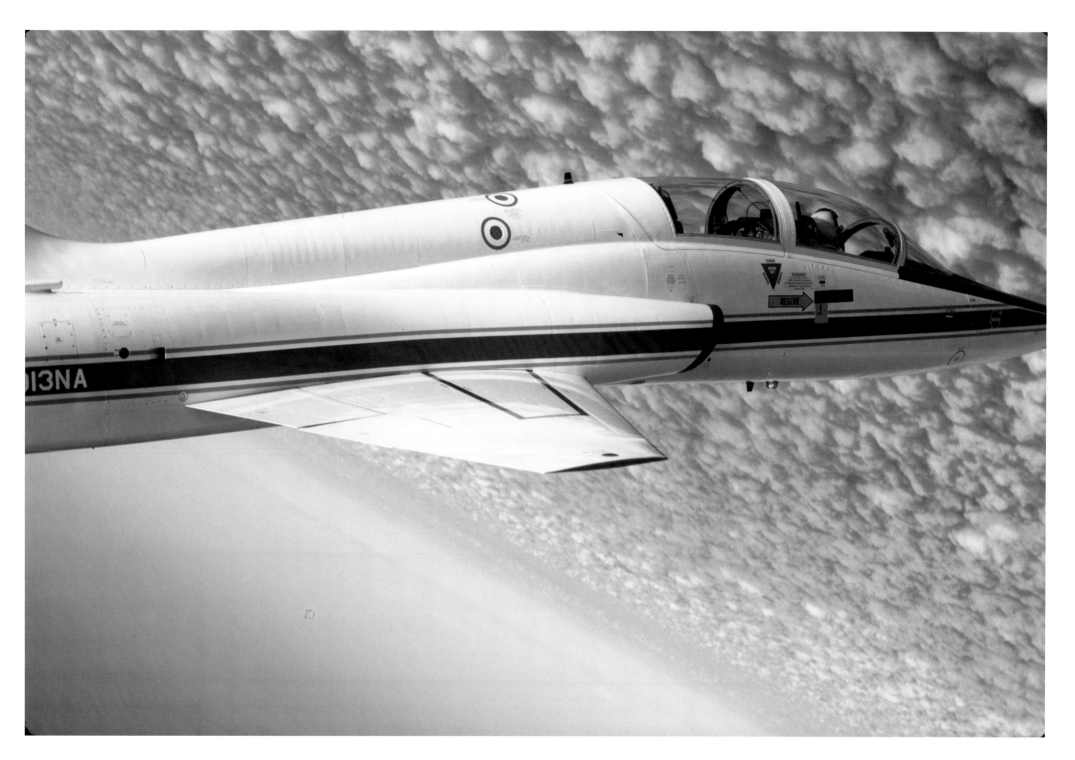

This is my view; the wingman's view. My attitude is identical to that aircraft as it must be to remain on his wing.

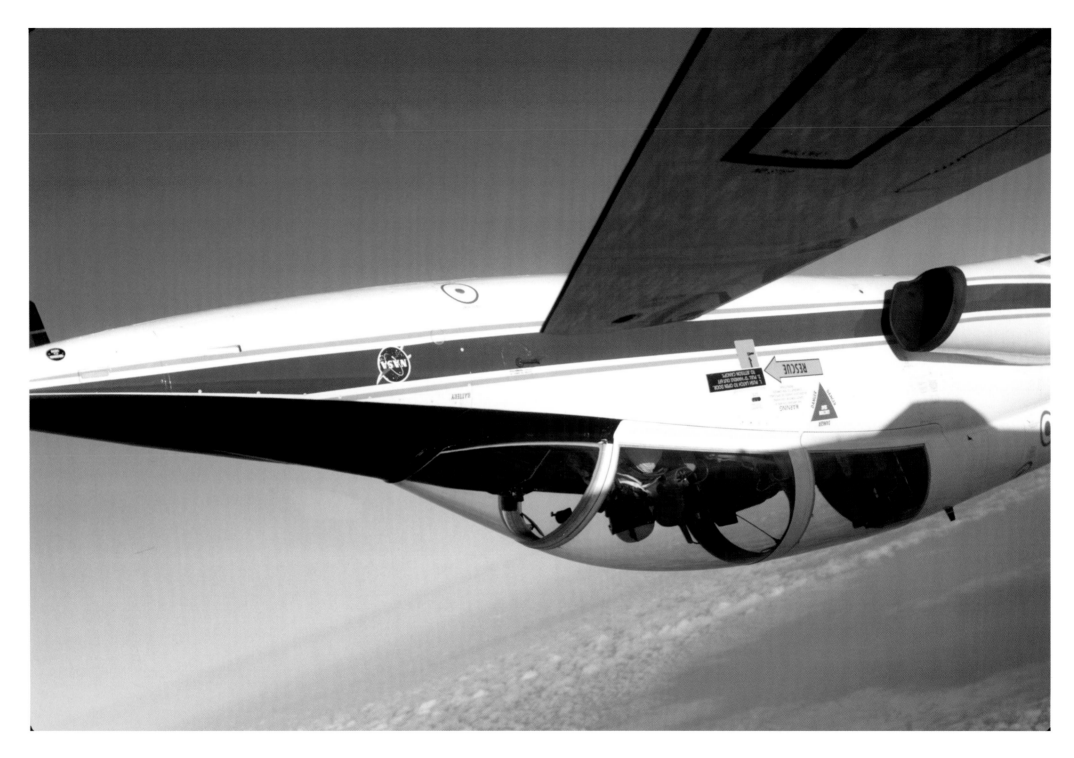

I am now the "lead" aircraft. You can feel the wingman's concentration and focus on my wing, which is about four feet from him. Again, this image is rotated to put earth down.

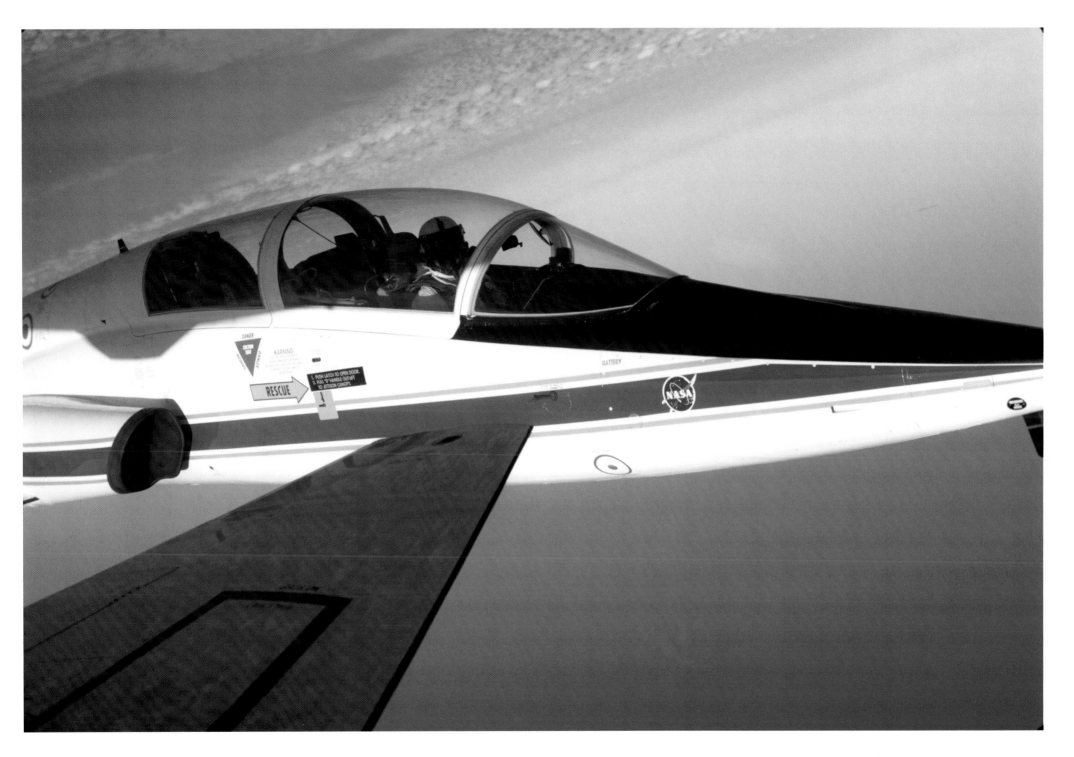

This is my view and the camera's view; the wingman is matching my attitude and speed.

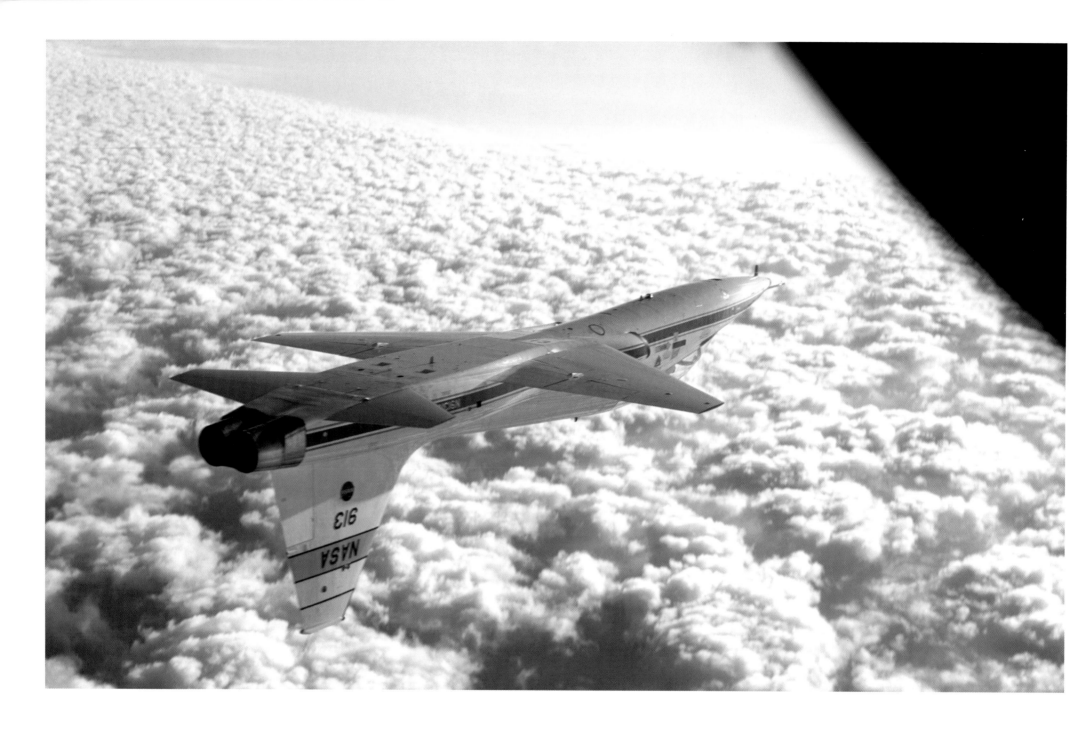

We are in level inverted flight and once again I am the the wingman, following NASA 913. This is not my view but one relative to mother earth being down.

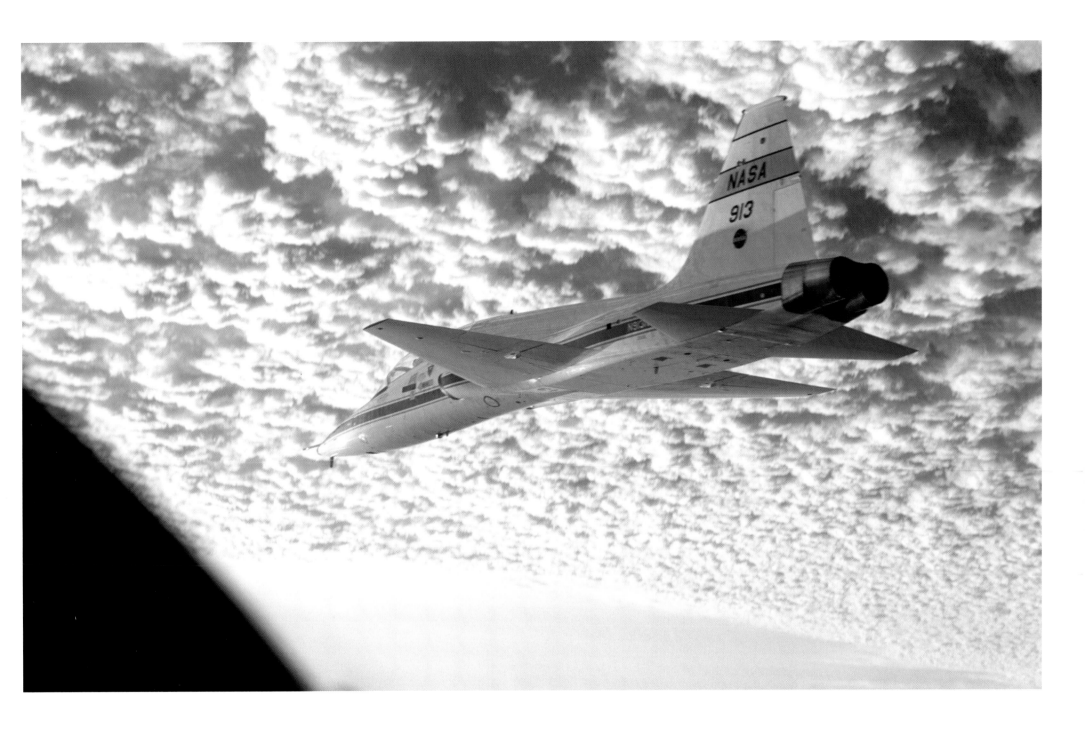

This is the actual view that I see, as the pilot.

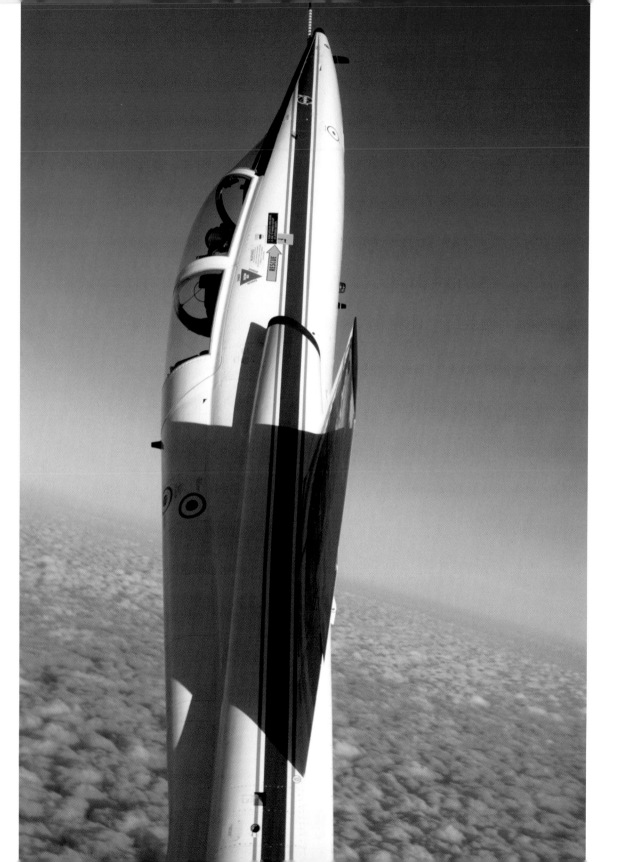

I love to fly and look at the
sequence of what goes up...

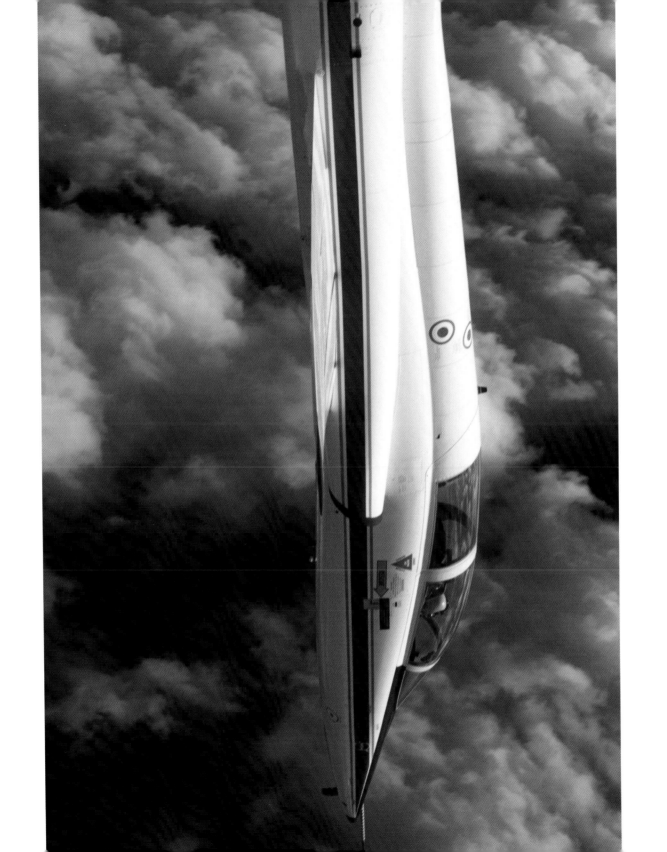

... got to go down.

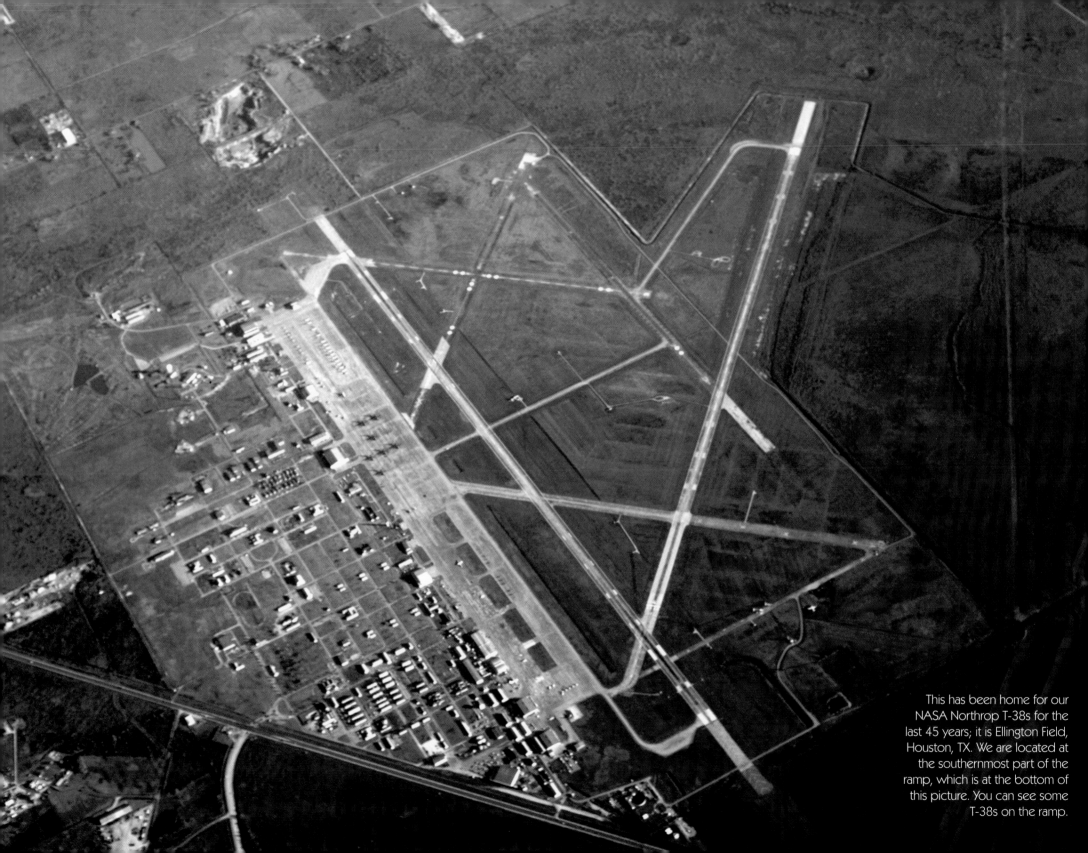

This has been home for our NASA Northrop T-38s for the last 45 years; it is Ellington Field, Houston, TX. We are located at the southernmost part of the ramp, which is at the bottom of this picture. You can see some T-38s on the ramp.

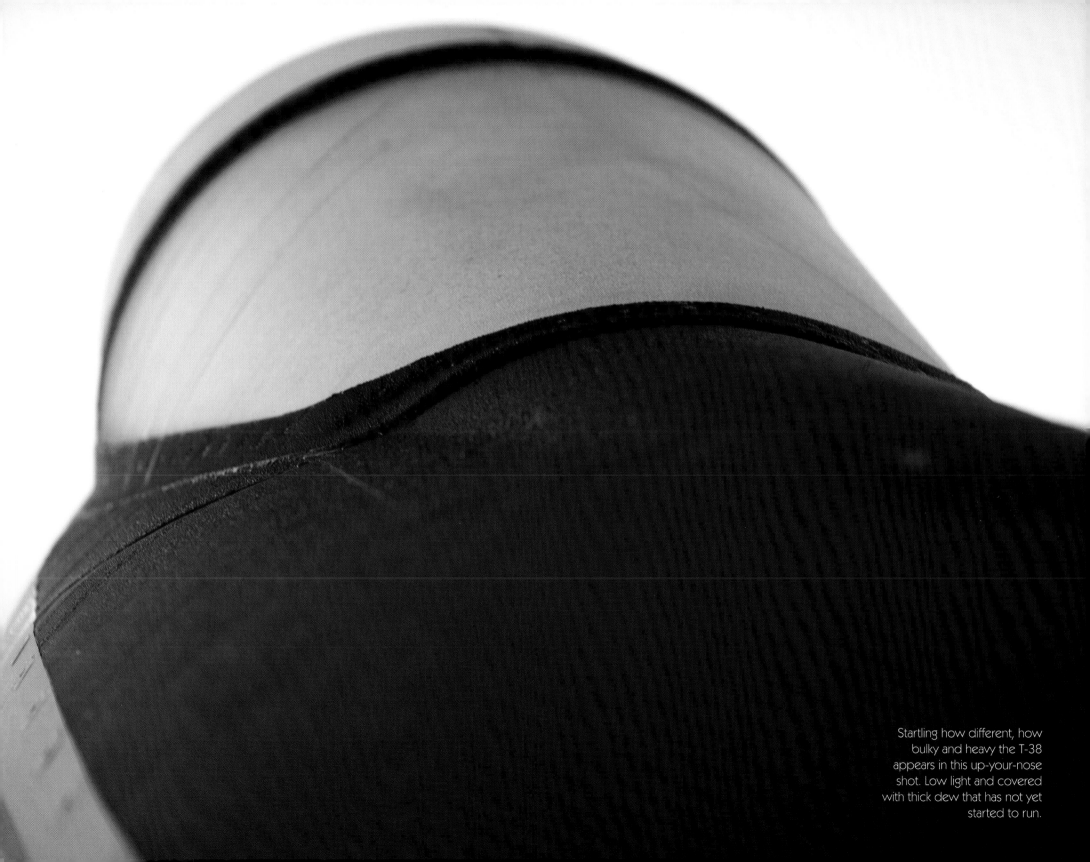

Startling how different, how bulky and heavy the T-38 appears in this up-your-nose shot. Low light and covered with thick dew that has not yet started to run.

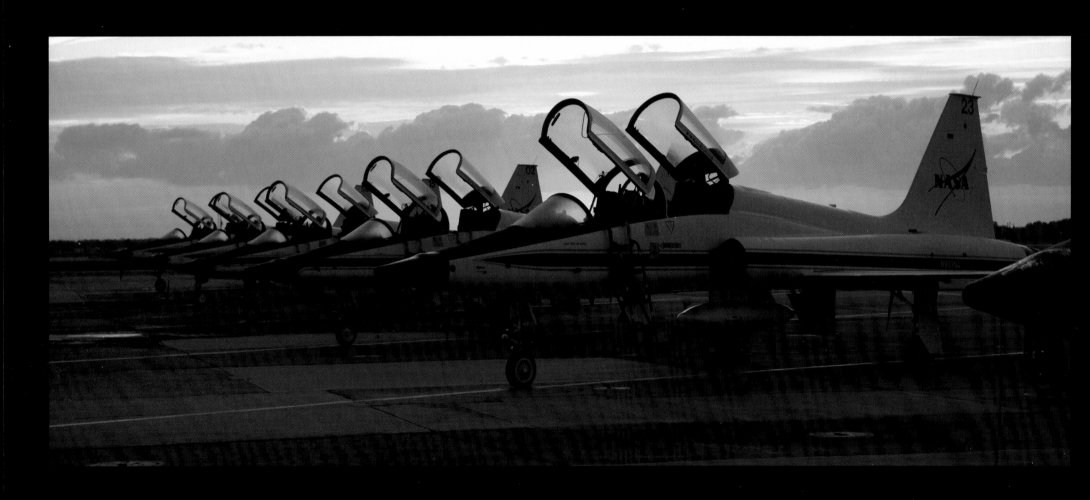

Sunrise arrives on the flight line at Ellington Field.

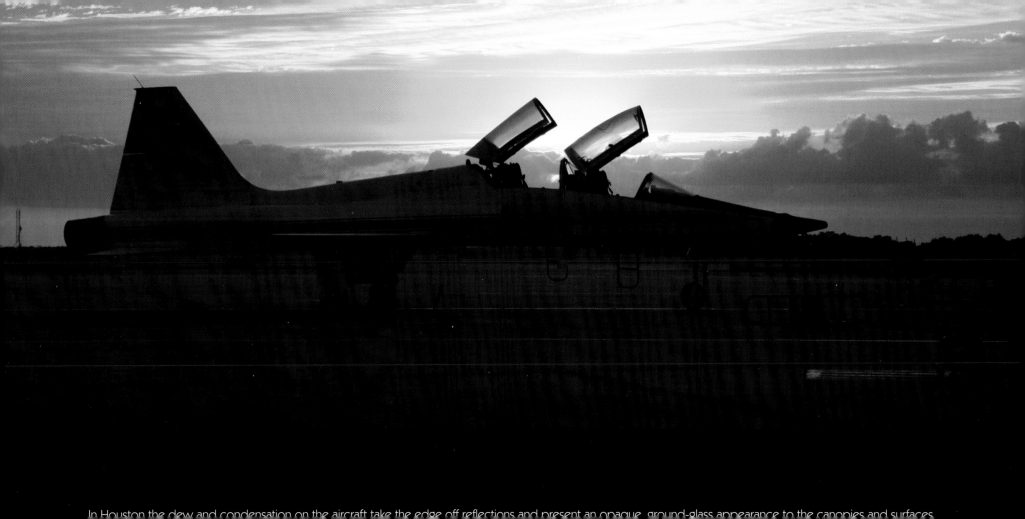

In Houston the dew and condensation on the aircraft take the edge off reflections and present an opaque, ground-glass appearance to the canopies and surfaces.

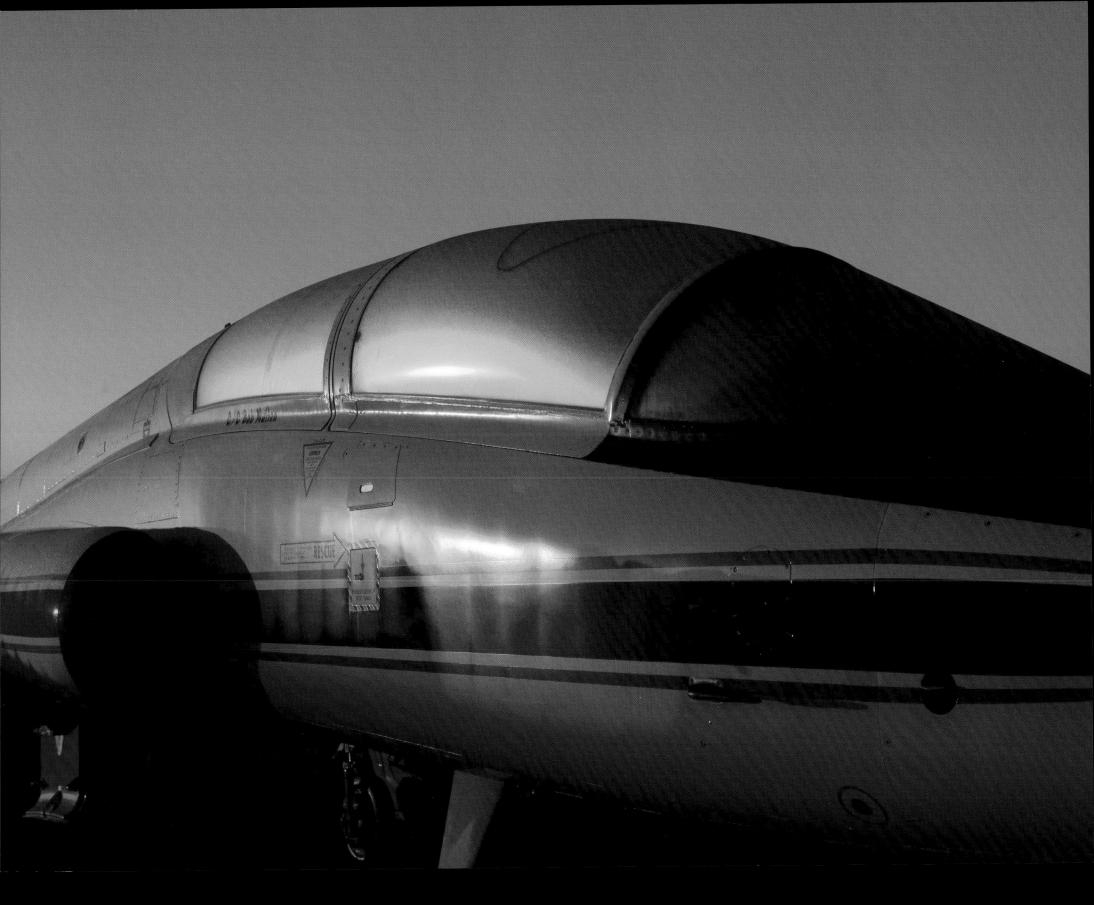

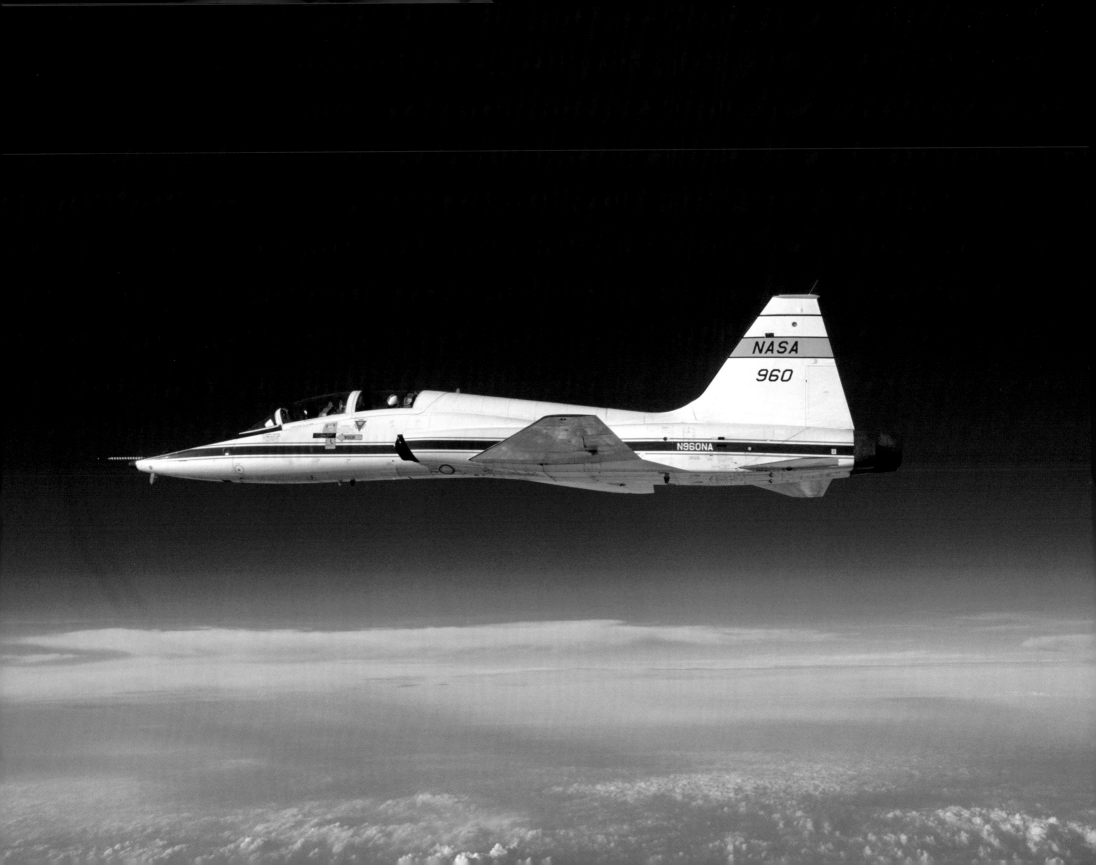

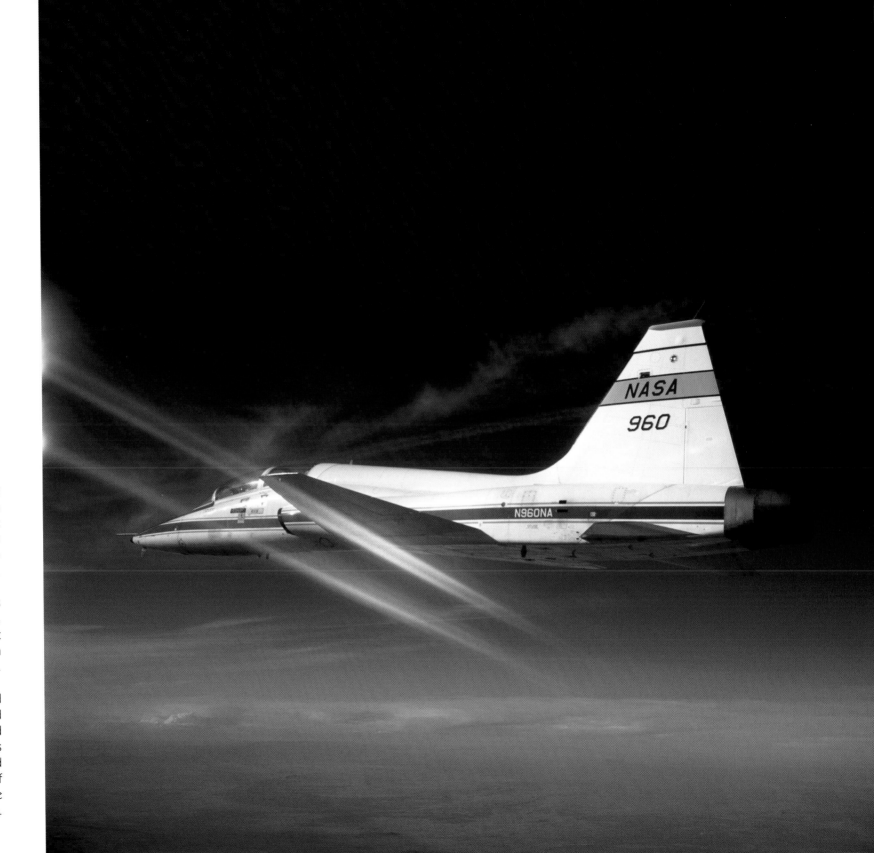

A series of shots that I call the NASA 960 shoot.; working with different sky, clouds, backgrounds and perspectives.

Here I have lowered my aircraft so that the background, the canvas for the shot, is a pure blue and, as usual, darker further out and lighter at the horizon.

I am always shooting through the canopy, so the sun's reflections change depending on the angle and closeness of my lens to the canopy.

Sometimes the reflections are a distraction or worse, just plain noise; but sometimes they are art in themselves.

This is film. If I'd had digital back then, I could have shot and shot and looked at what I was getting. I could have used the reflections, instead of always trying to eliminate them.

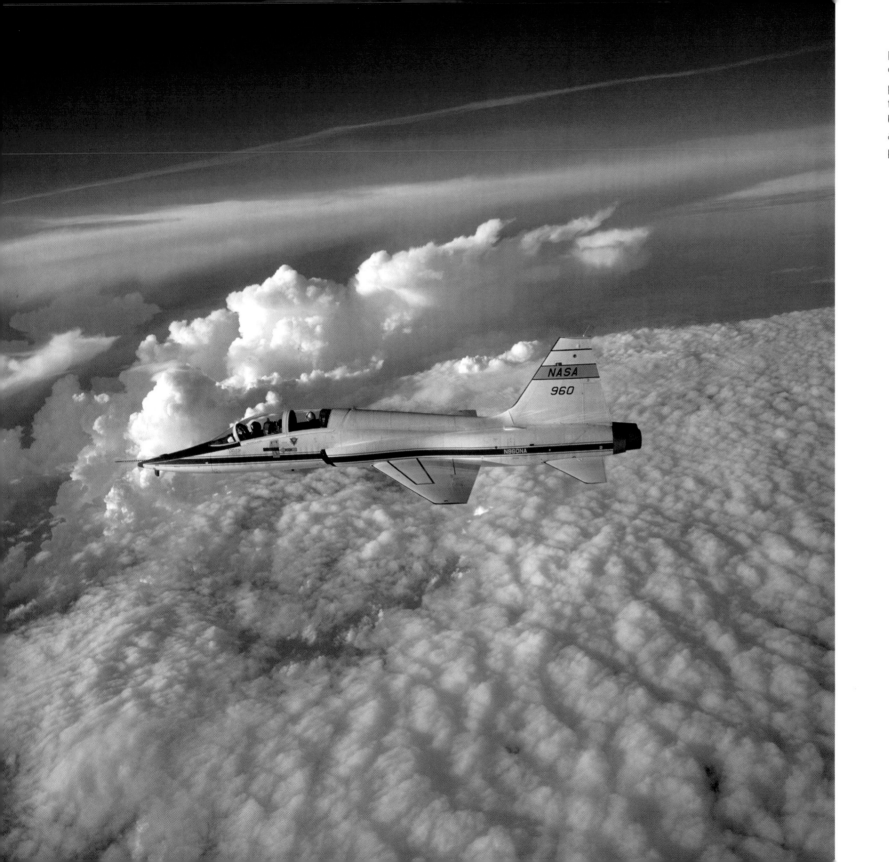

I have moved my T-38 above 960 to get a different top-down perspective on the aircraft and to place it with clouds in the background - a very nice result and very different to the earlier pictures.

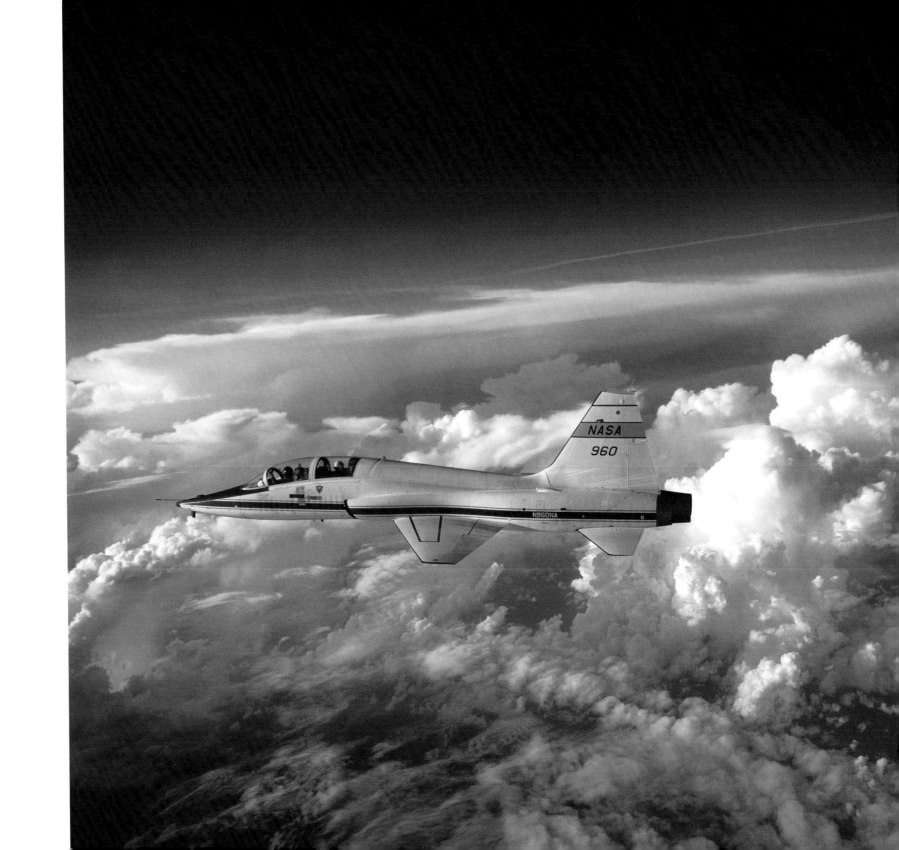

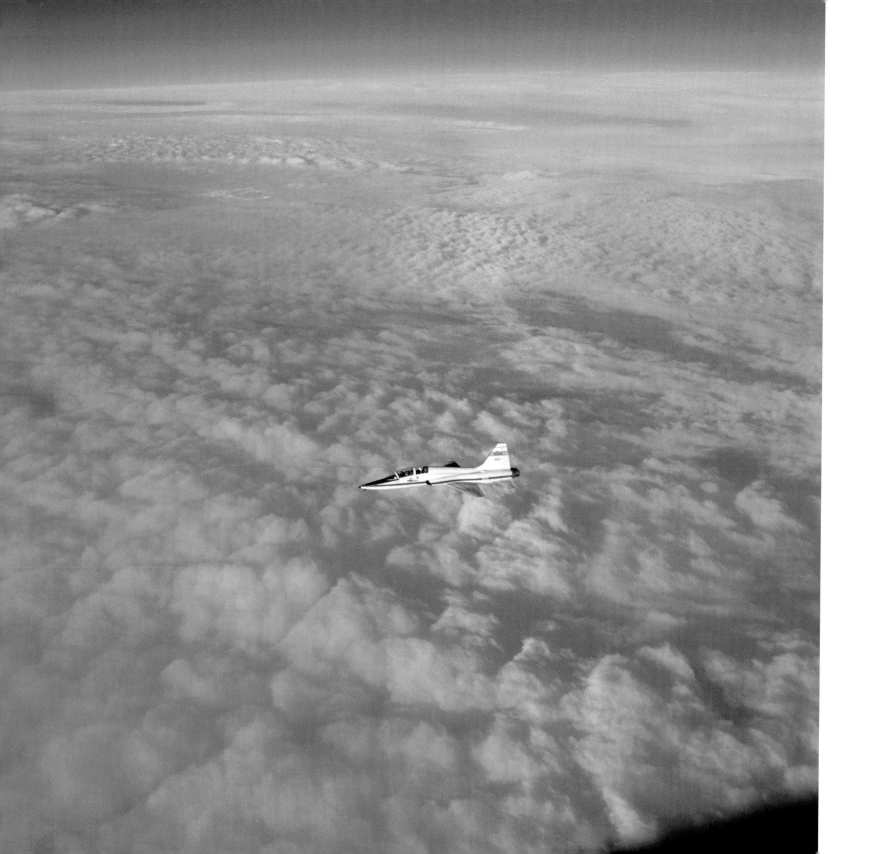

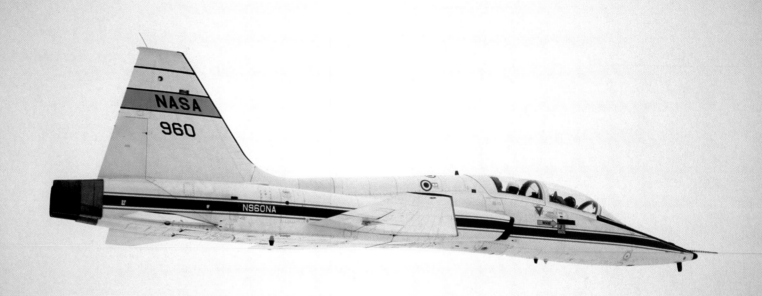

Here we are in a light cloud; if it were a heavy cloud we would not even see 960 from this distance and would have to break away. This cloud is light enough to retain the sharp edges on the photograph yet thick enough to provide a sort of three-dimensional white foreground and background.

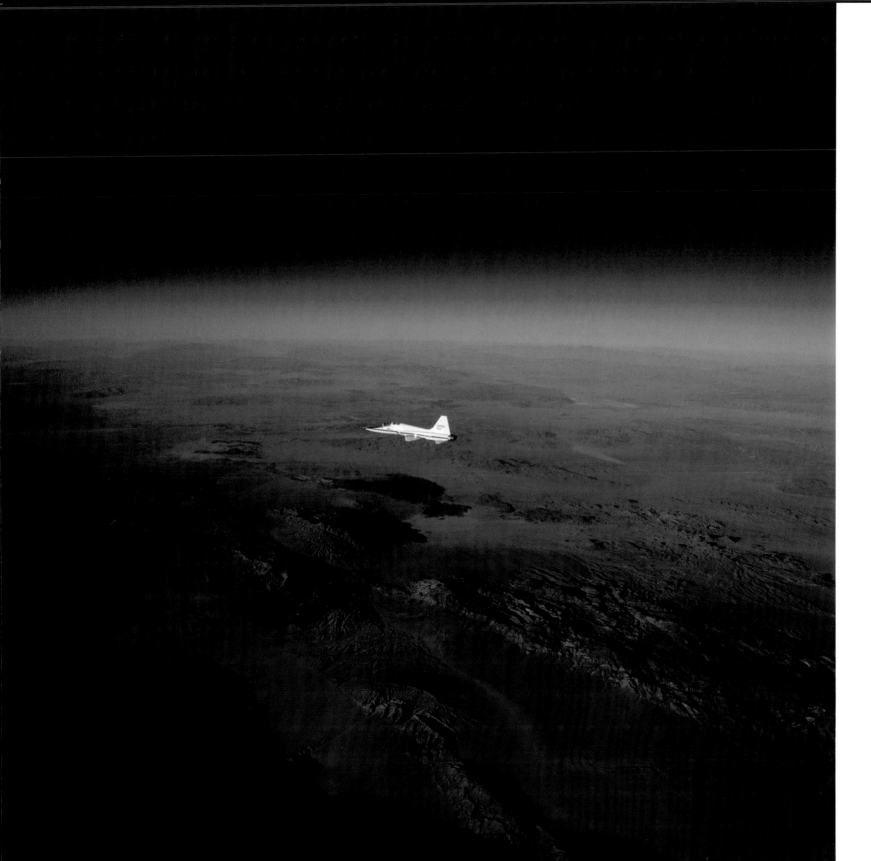

We fly across some wondrous geography on our way into El Paso, TX.

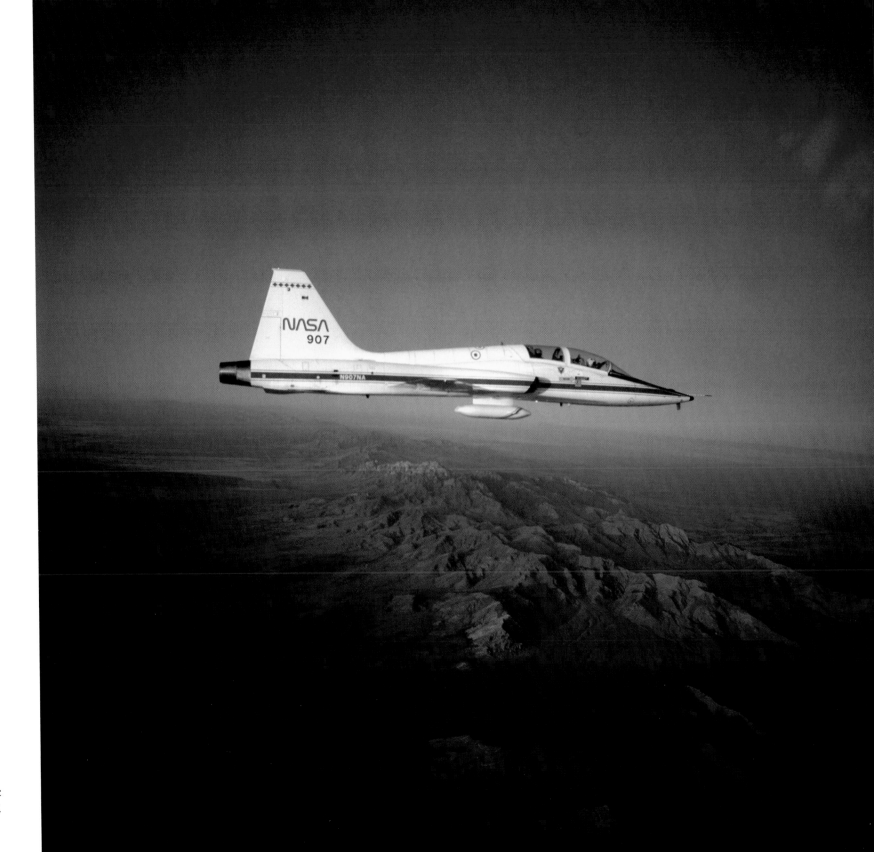

After crossing the mountains we
start our let down to the airport.

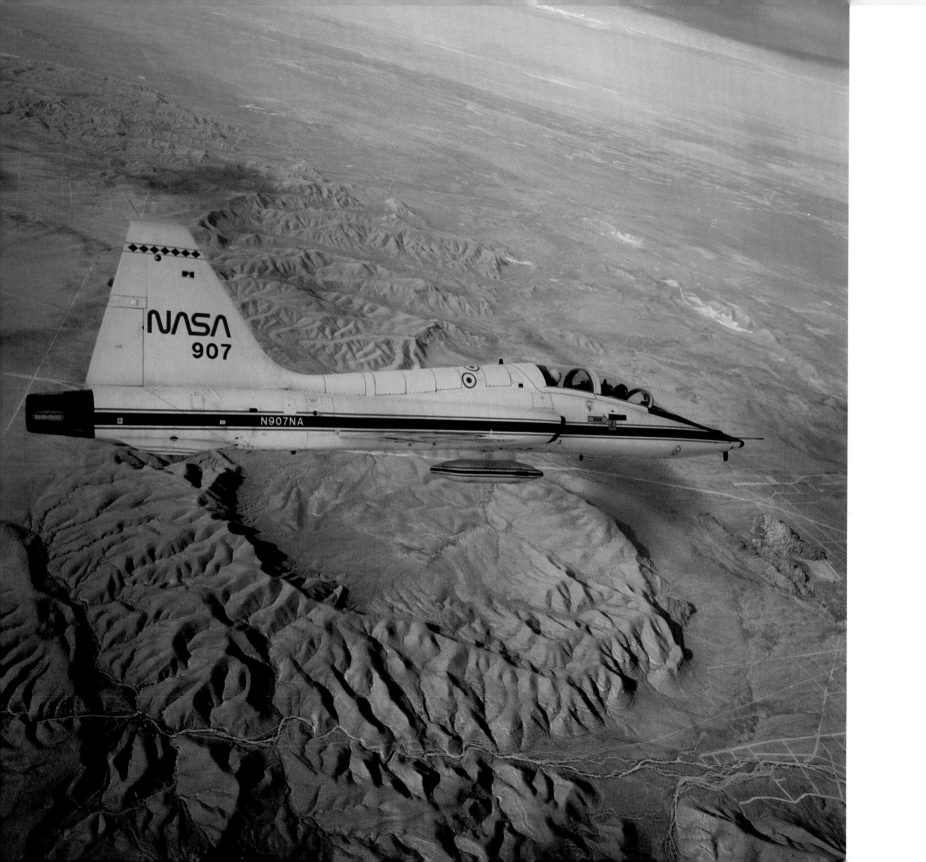

NASA 960 turns into the approach course. You can see our shadows on her belly; I had intentionally worked on that but ran out of time to get it just right.

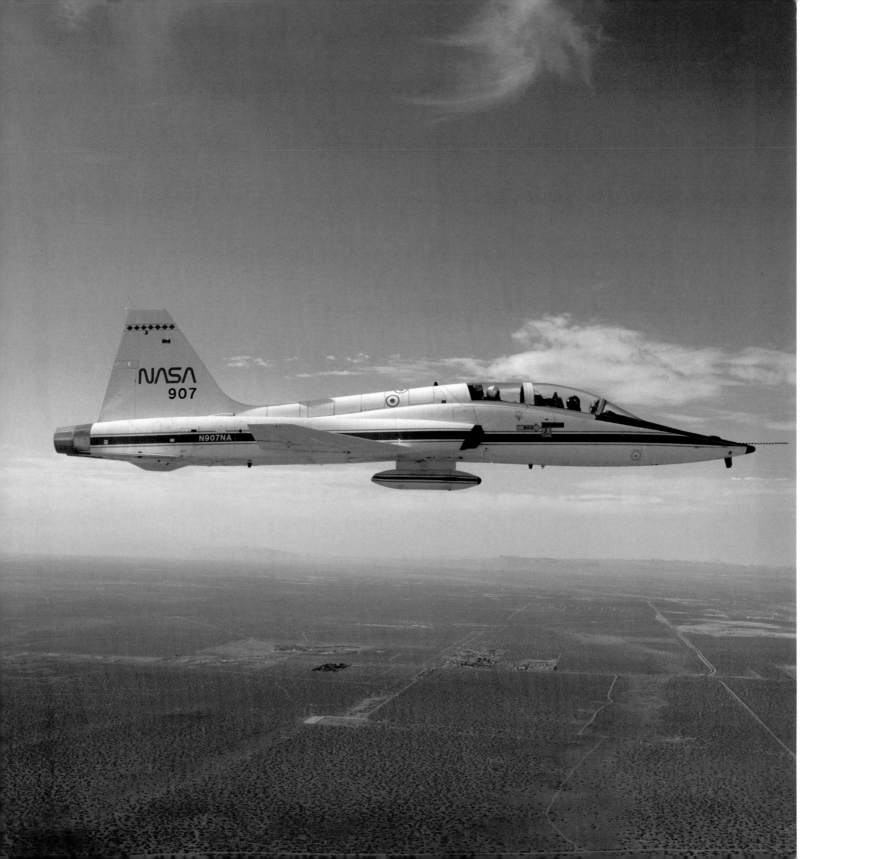

On the way into El Paso
International Airport.

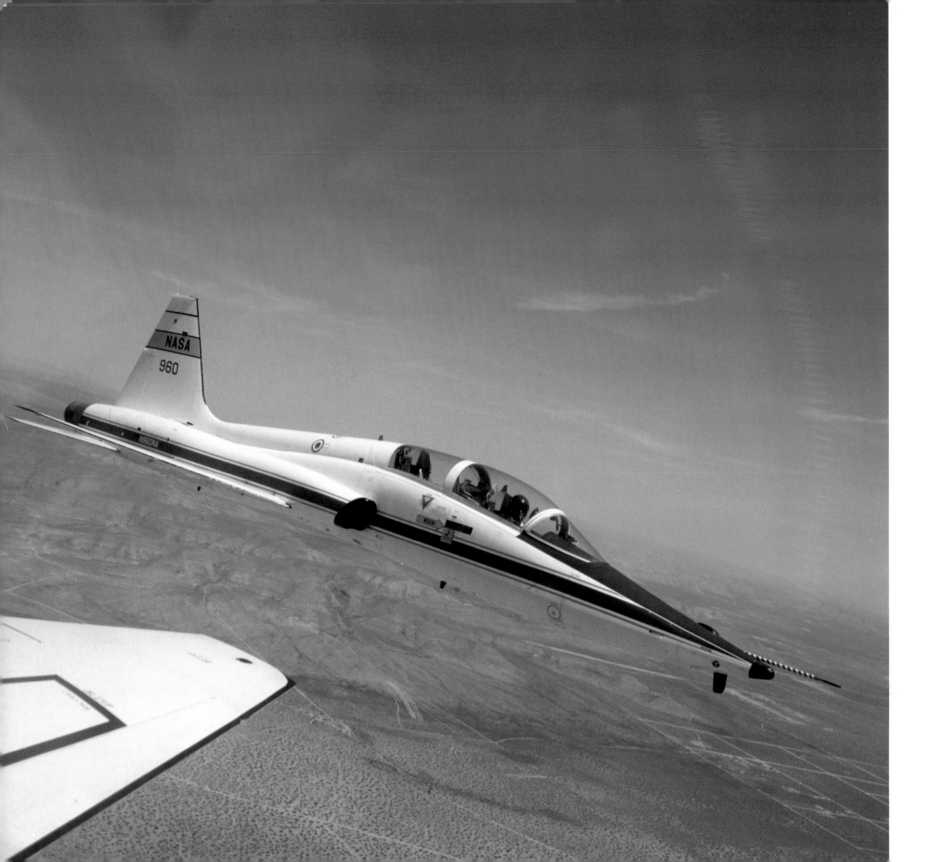

One feels the spirit of New Mexico, even in the air.

The blues and browns strike a chord in your being and again the sleekness of the quartering front view of this beauty.

At this moment I am leading this 3-ship into ELP; I trim out my airplane and walk my fingertips along the stick to coax her to where we got to go, most of the time I am not even touching the controls.

If I don't touch them, and my wingman gets it, he will not have to work at it either. It is like moving a horse by leaning in the direction or placing the hand on its neck.

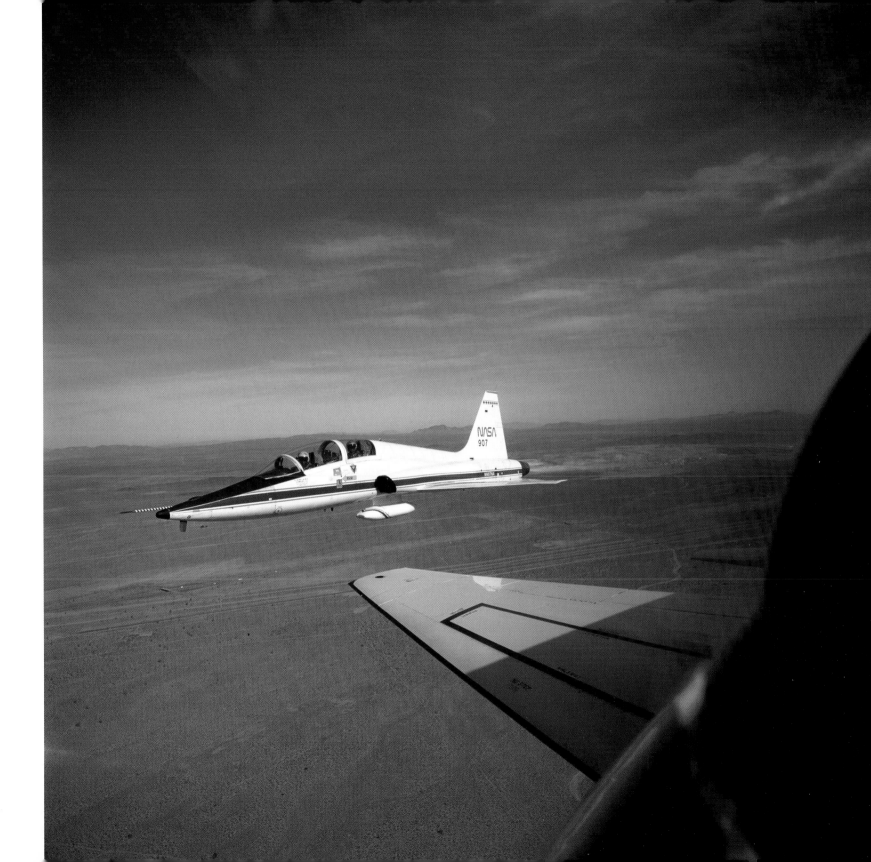

On my right side is 907.

Gorgeous wing on 907 here
and wonderful parallels with the
roads, the lines of the aircraft and
the horizon.

I like having my own wing and tail
in formation pictures, they show
me that 907 is my reflection, that
is who I am and that is what I am
doing.

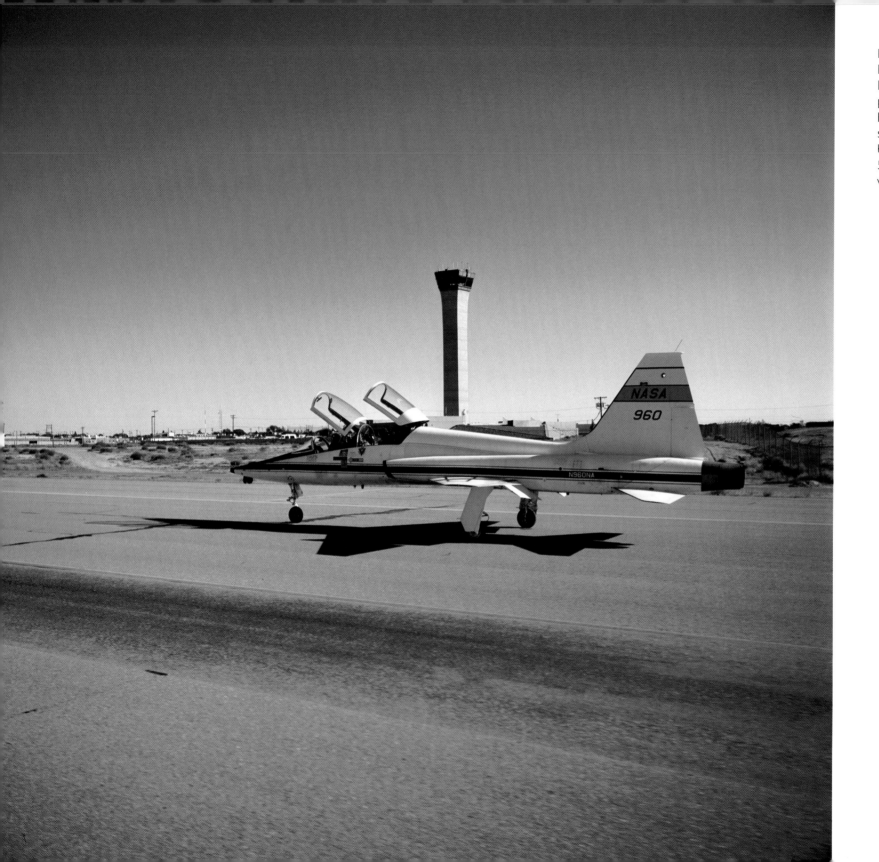

El Paso Control Tower. Every time I pass any control tower I send a little prayer of thanks to them; just plain great, professionals of the highest caliber; people who have supported me and cared for me beyond any sense of duty for the 57 years that I have lived in their world.

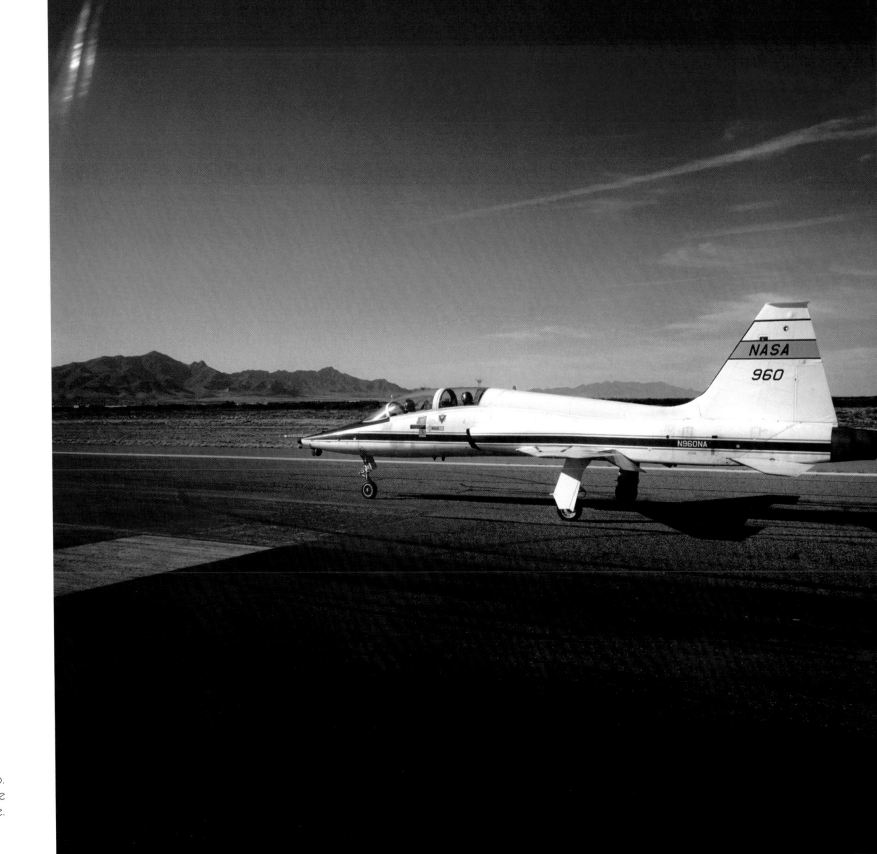

Ready to go: Runway 22 at El Paso.
The sunlight is very different in the
thin desert air here.

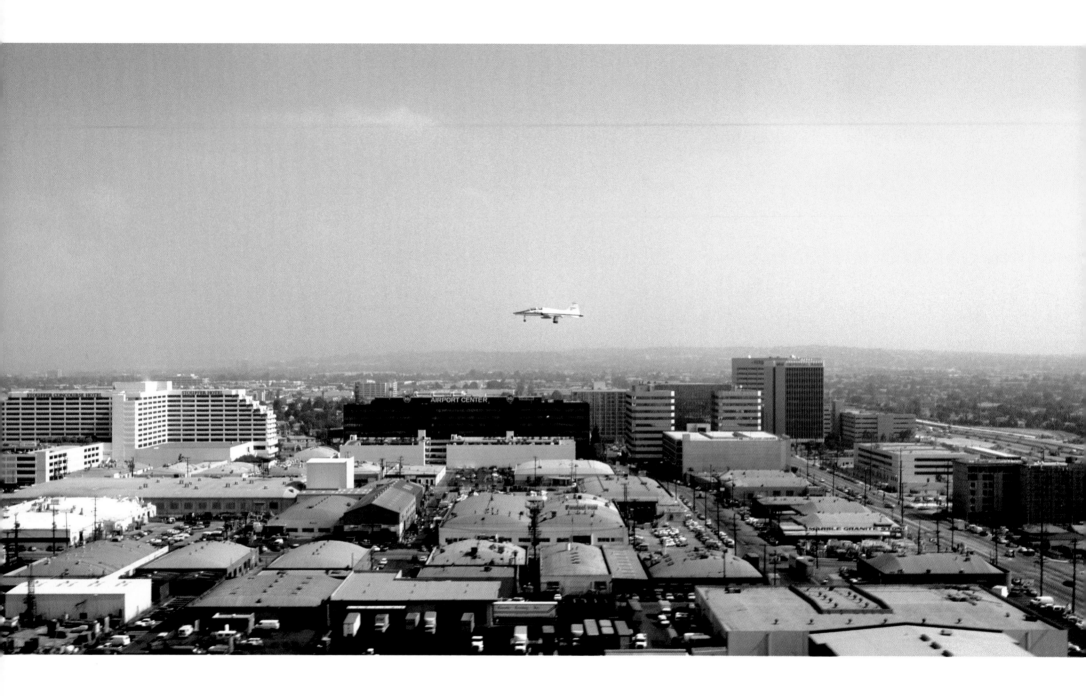

LAX, Los Angeles International Airport. Speaking of great controllers - center, approach and tower were always the best of the best. They understood that many times you were solo and in a very high performance aircraft without a flight director or autopilot; they tailored their handling of you accordingly; they took care of you; they made one of the busiest airports in the world the easiest and the friendliest. We did not land on the wing at LAX, so we would ask them to split up our formation. A simple way to do that was to speed up the lead aircraft, slow down the wing aircraft till we had the desired separation. In this case they wanted to have some fun and see two of us land at the same time on parallel runways so they sent us to different runways. I had the camera so got the other aircraft all the way down.

132

John Blaha takin' care of the paper. His perch and posture say it all.

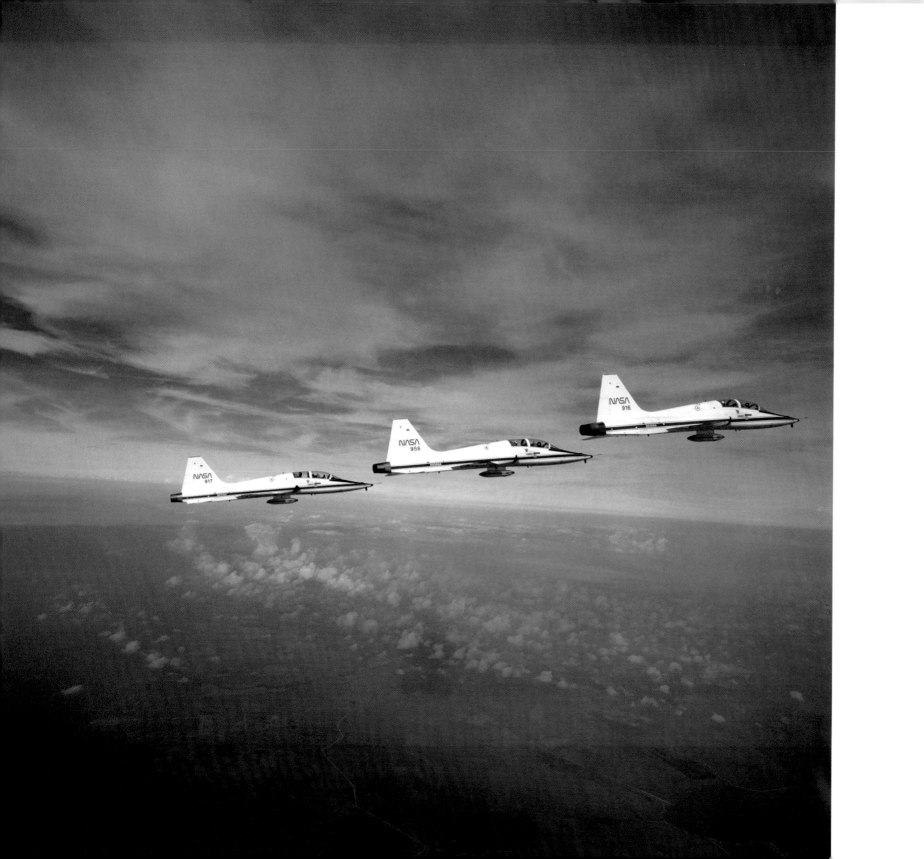

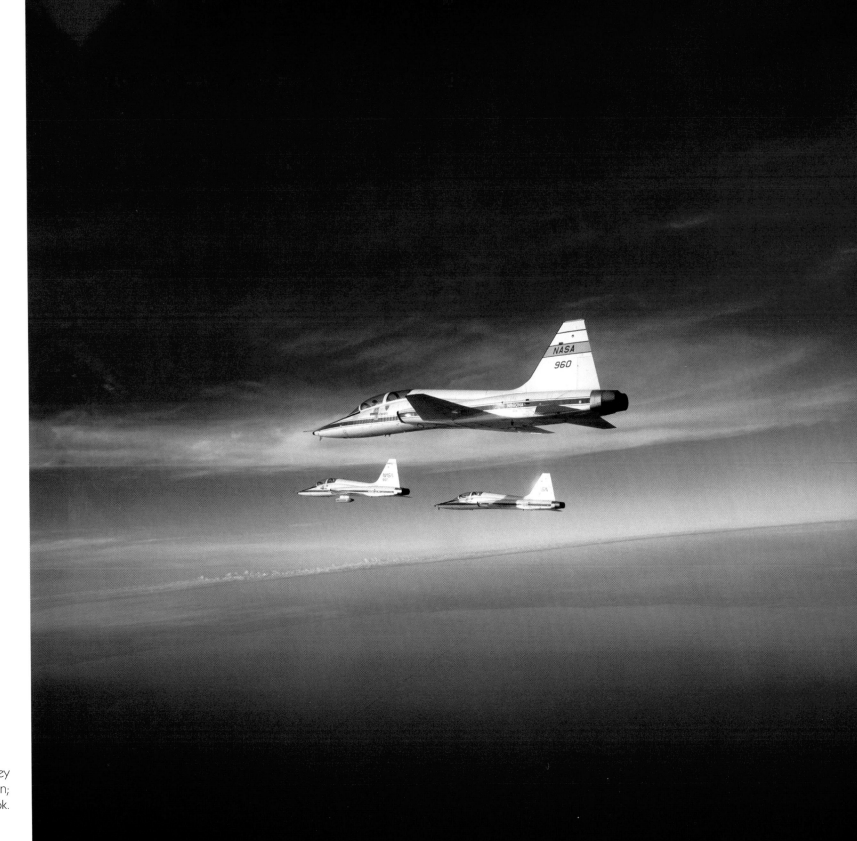

They are not in random positions; they are changing places in the formation; but I like the random look.

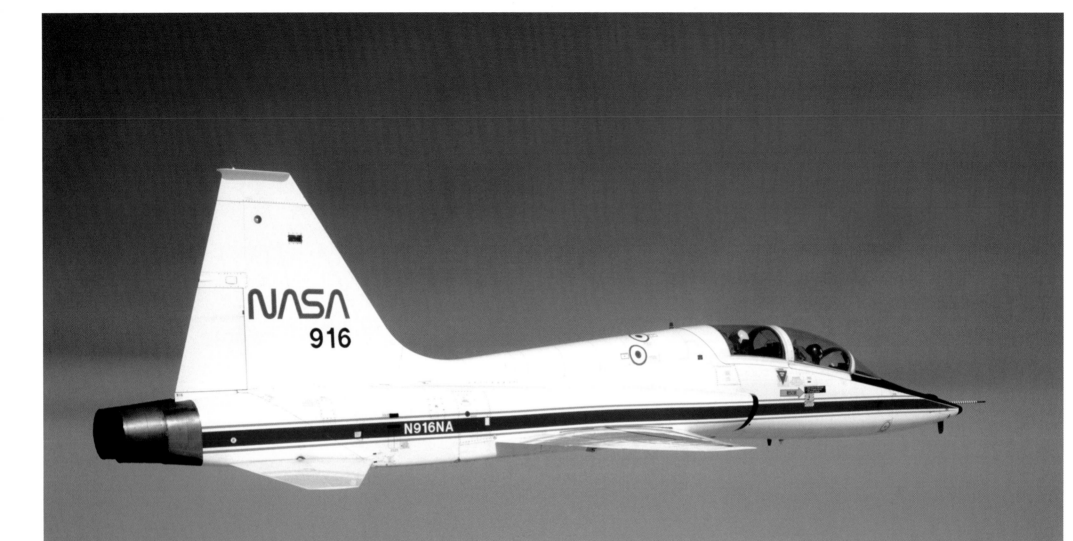

Like a dolphin in the waves I love to fly in mist; it is 600 M.P.H. in and out of mist, clouds, shadows and light.

I love to chase the other aircraft through mist and the tops of very light clouds where there is no difficulty staying in visual contact.

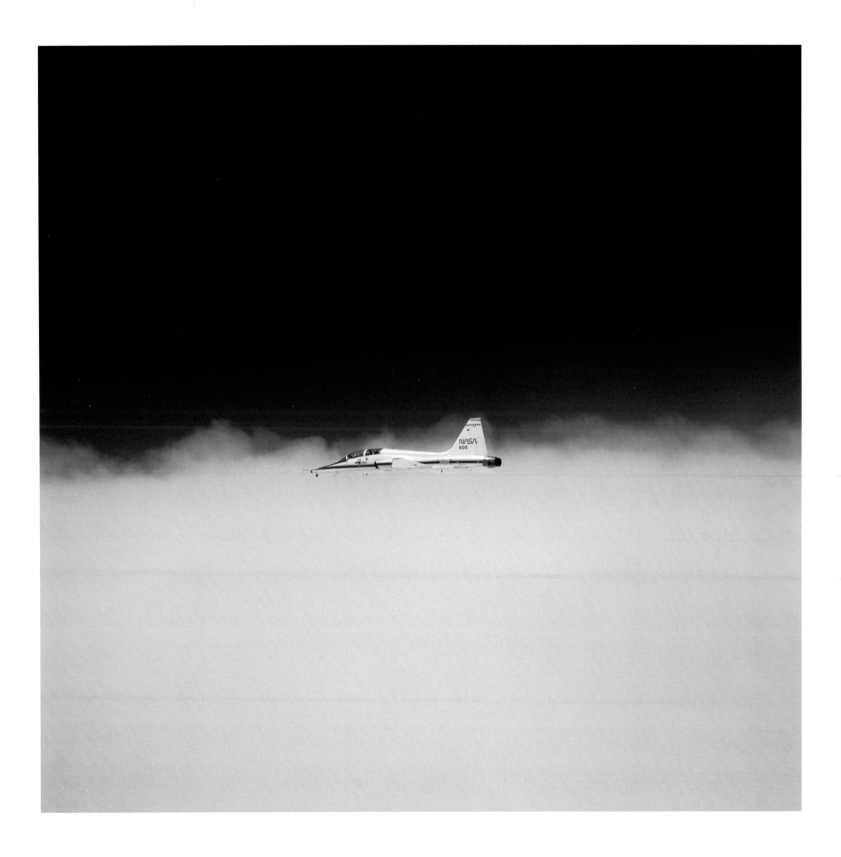

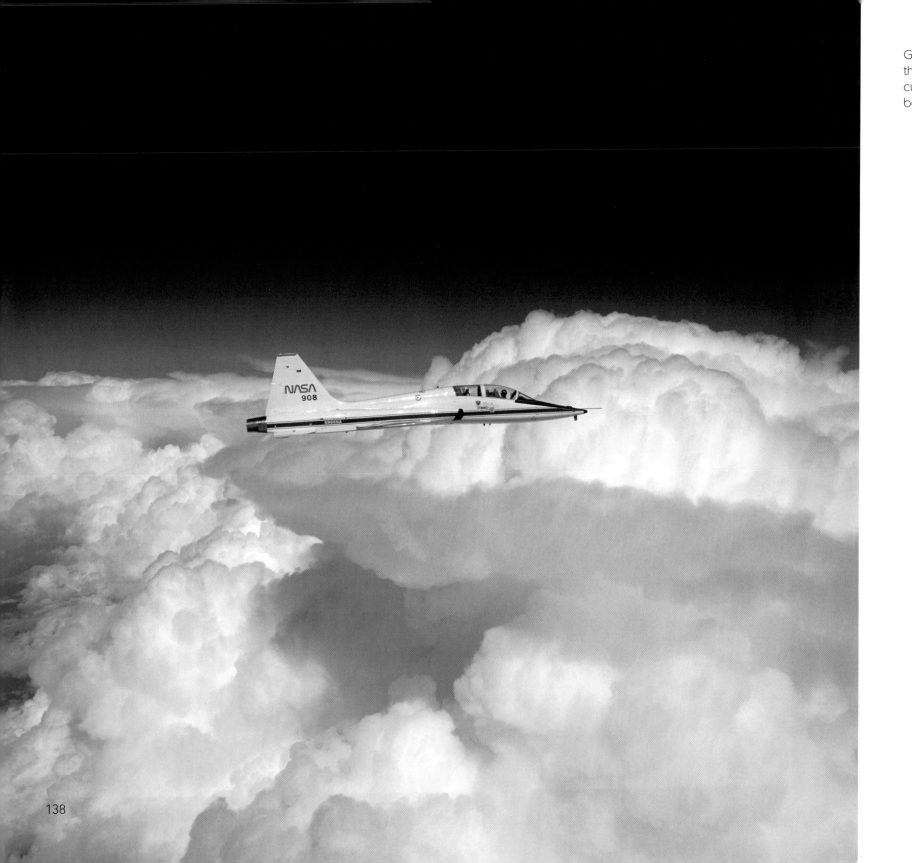

Gorgeous towering thunderstorms called cumulonimbus pushing up beyond 43,000 feet.

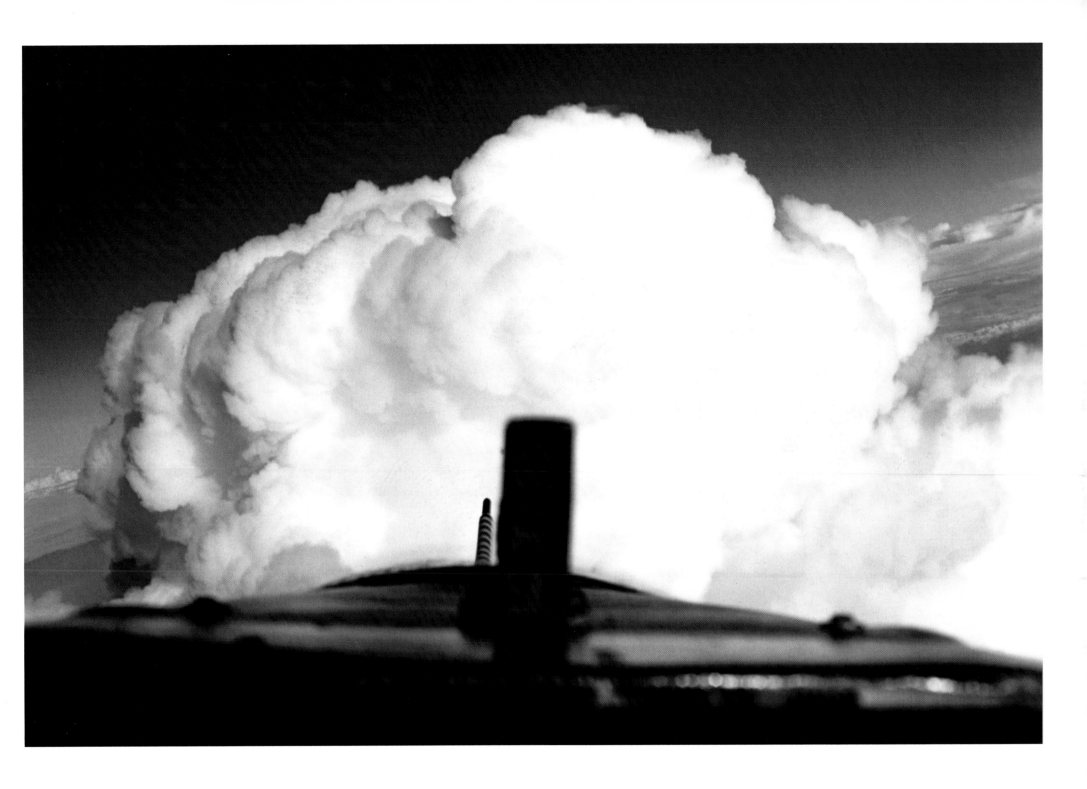

It is time to turn now, the path ahead is severe turbulence, hail and lightning strikes.

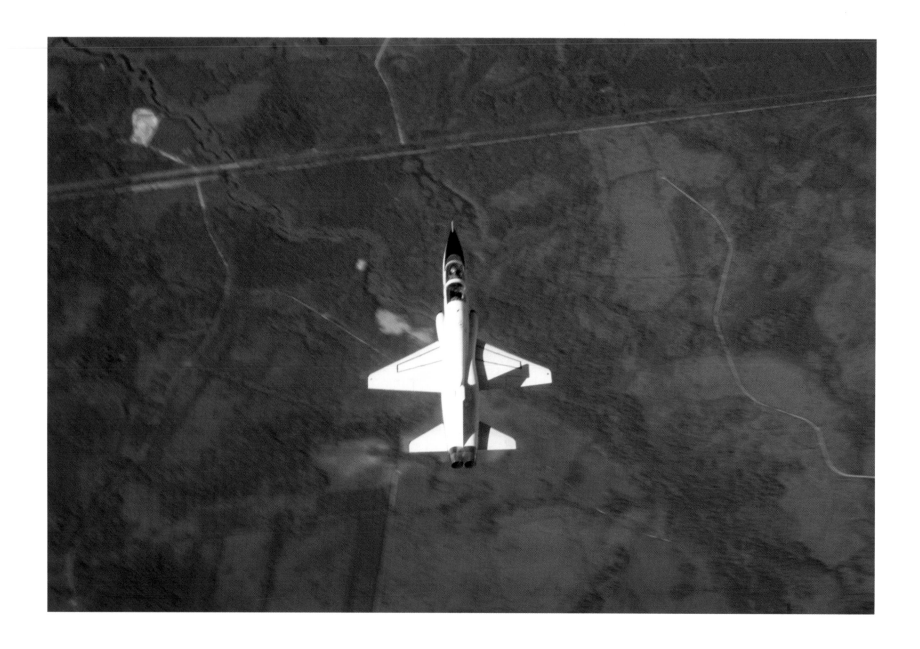

I roll over on my back and shoot this perspective, out the overhead canopy.
Not many folks wanted to fly with me when they saw the camera,
and I carried it most of the time.

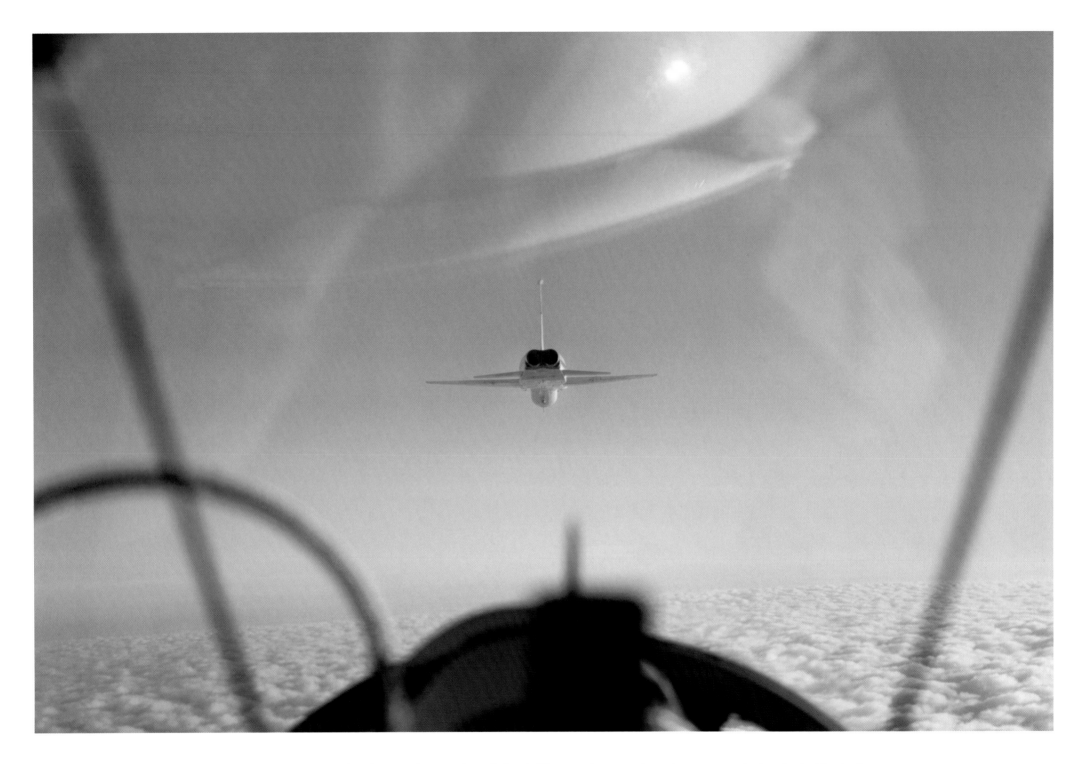

From this view you get a feel for how she cuts through the air. We are going to push up the power and take a look at her belly.

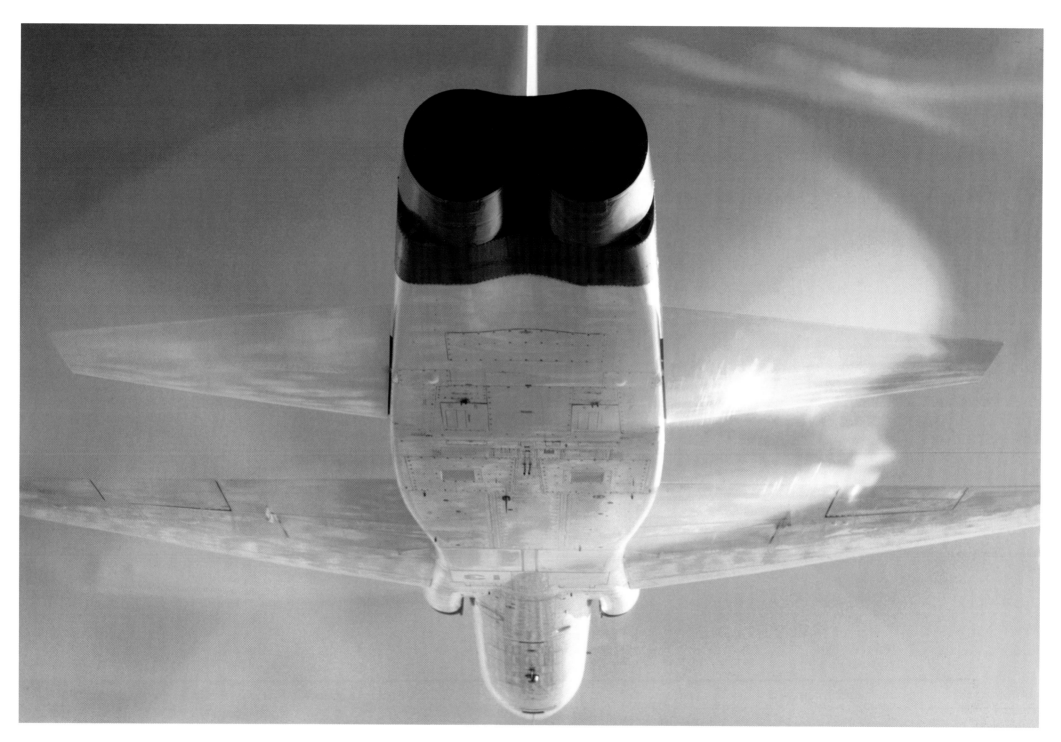

Shooting out the overhead canopy, lots of amorphous reflections. Wish my belly was that flat. One can see how with a little angle to the oncoming wind a lot of lift would be generated by the body as well as the wings.

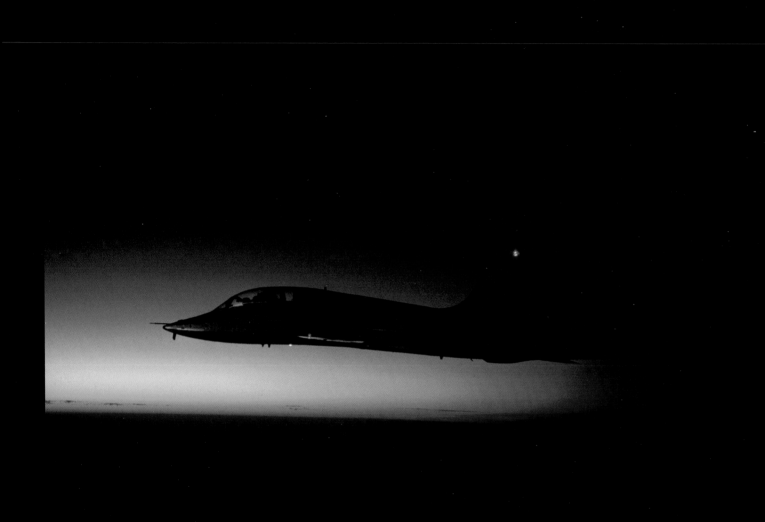

We fly westward slowing the sun's descent into the horizon. We get to spend twice the usual time in this evening light. The viewing is very different and magnificent because we are above 75% of the atmosphere.

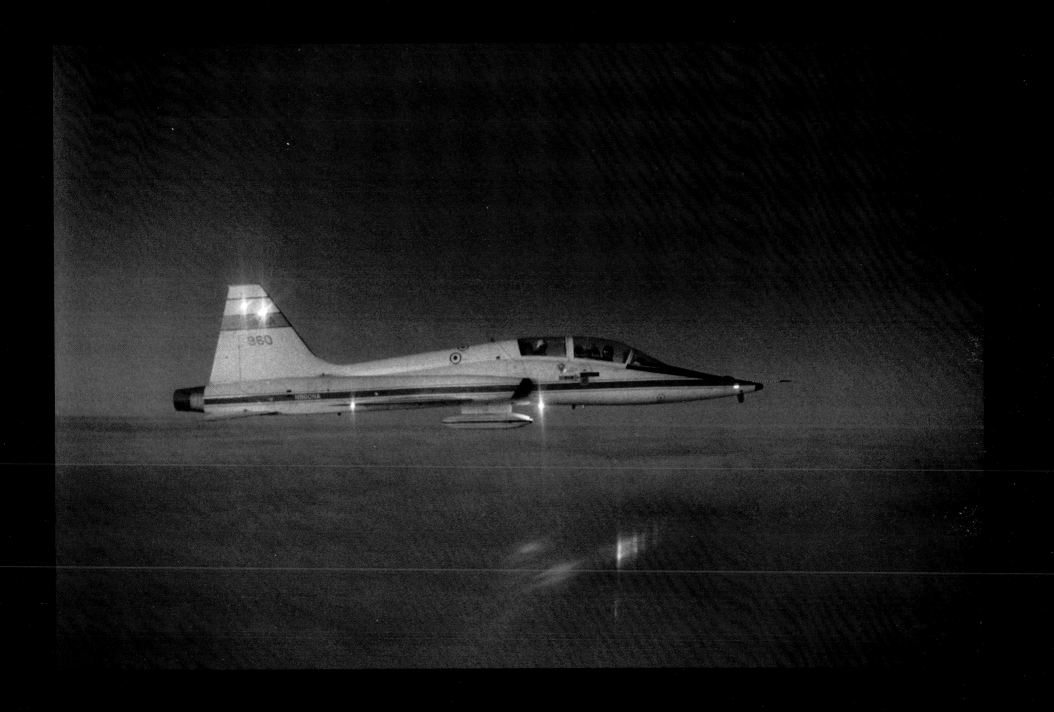

I had some very fast ASA 6000 black-and-white film left over from a prior flight, when I was after a comet in the pure air at high altitude.
So I shot NASA 960 in nothing but starlight. It certainly has a different feel than a daylight or sunset picture.

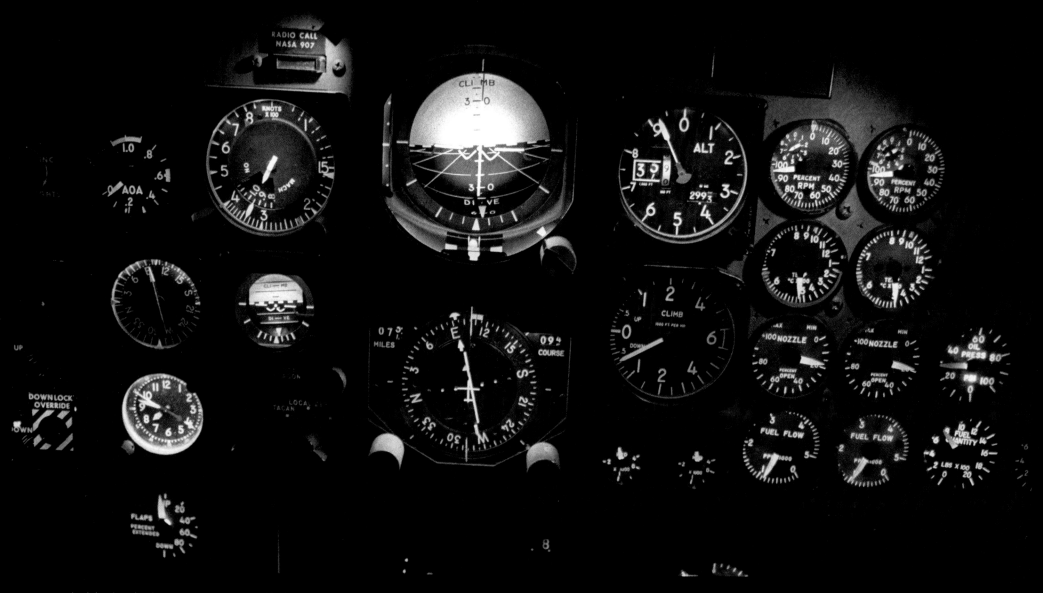

A night-time look at our instruments with their integral lights on. Even without lights the instruments are readable with only moonlight. Don't know when or where this was taken other than one can read our call-sign, NASA 907, in the upper left of the panel. I also know that I am not doing the flying as we are doing Mach .96 at 33,000 feet which is very fast, meaning less time to smell the roses or take pictures.

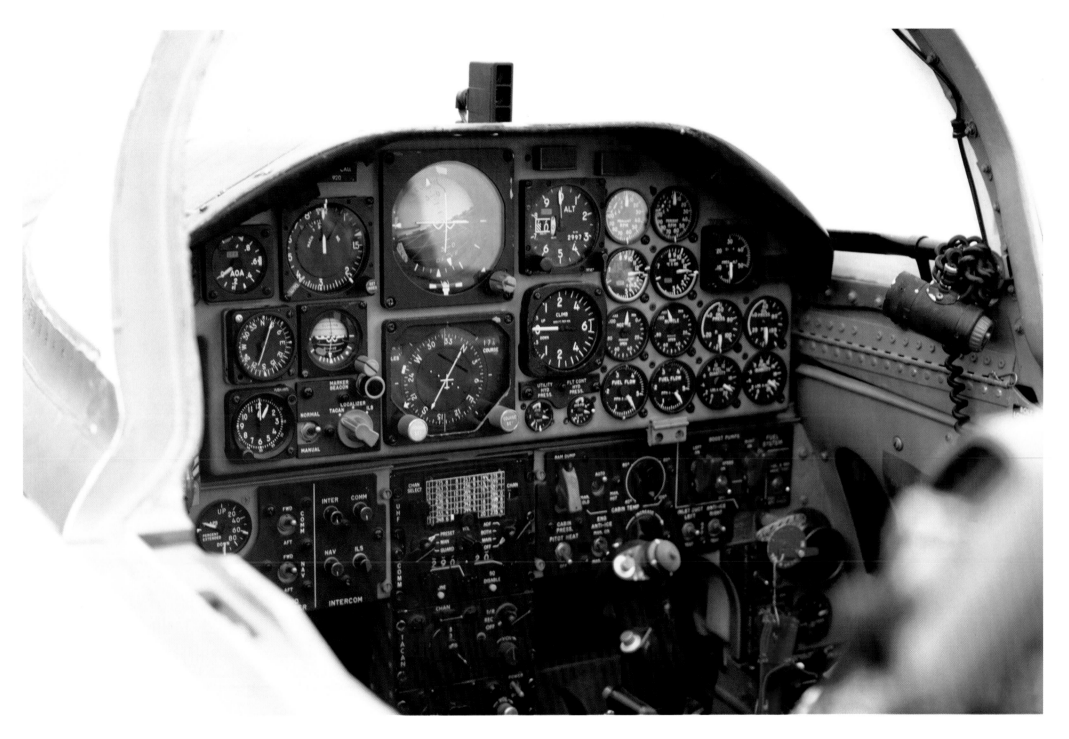

A daylight view of the old style cockpit.
Today, those 50-year-old machines have been upgraded - with the installation of a modern "glass cockpit".

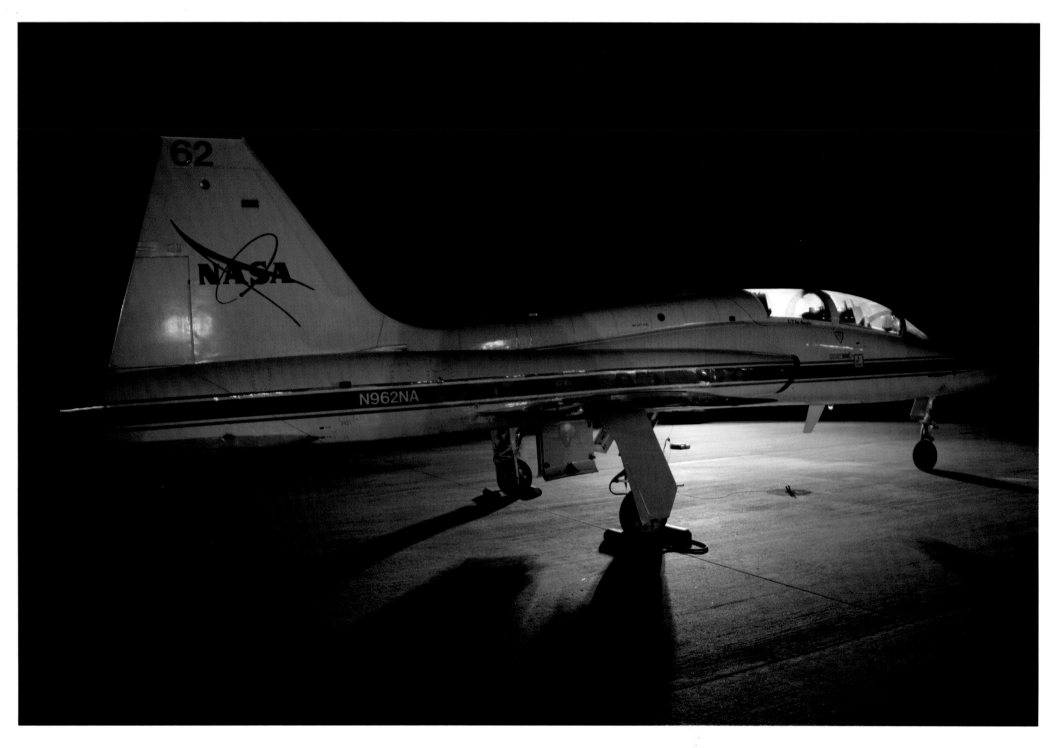

Still in the night but on the ramp at the Shuttle Landing Facility and decades later than the last few shots, I am playing around with artificial backlighting.

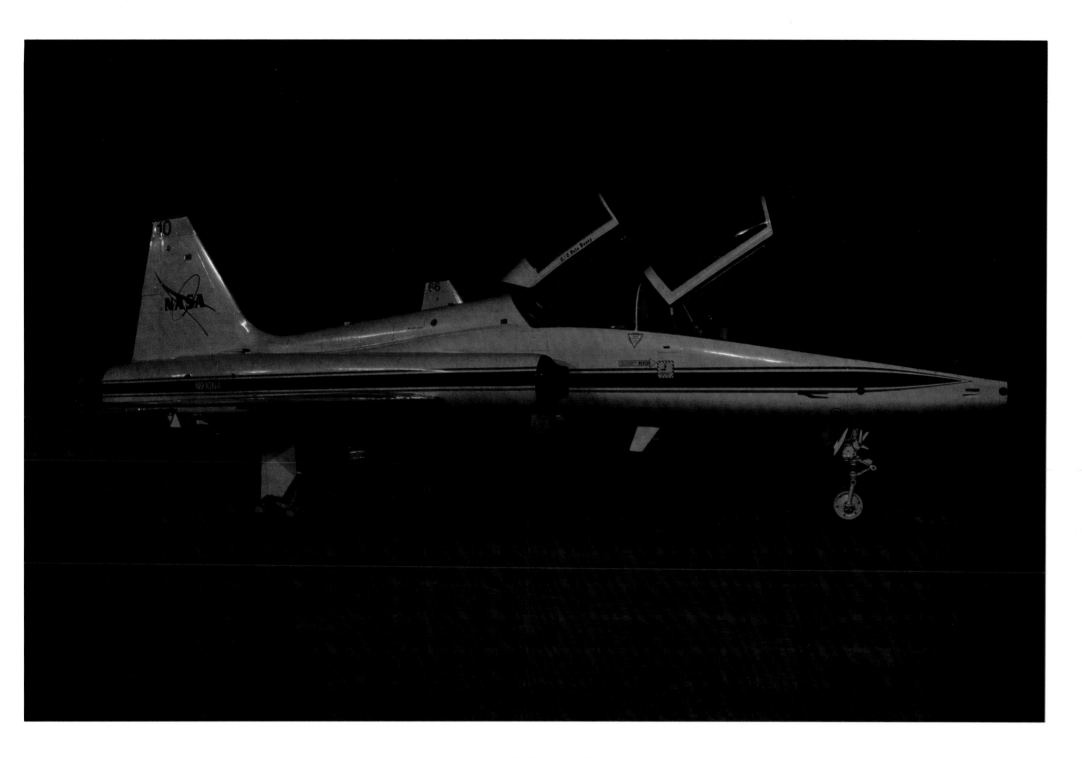

In this situation there are some street lights in the distance and I did a manual exposure to produce about what the eye was seeing.

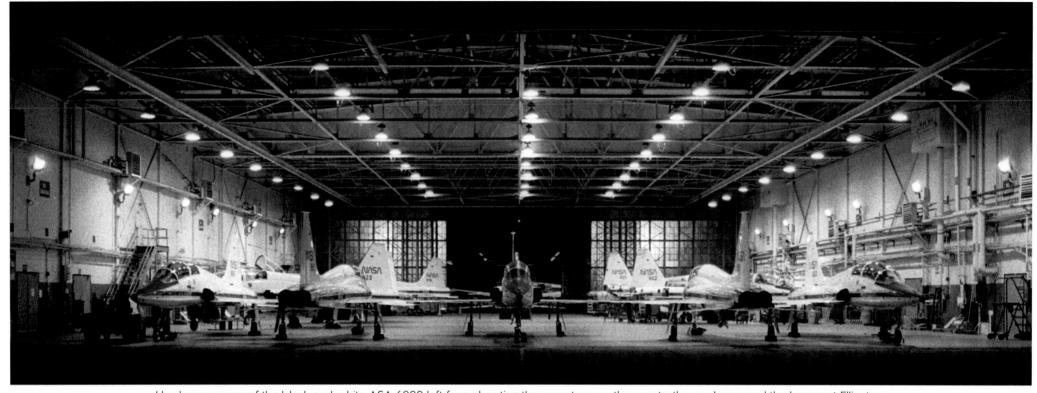

I had some more of the black-and-white ASA 6000 left from shooting the comet so, on the way to the car, I snapped the hangar at Ellington.

Here is a barn full of these beauties for you, some in maintenance and some just in for the night. This is one spectacular shop. Yes, I know the operating manuals, but this is where I really learned the hardware. I worked on the aircraft alongside the mechanics; they showed this machine to me so that, when flying it, I could visualize the parts and pieces at work.

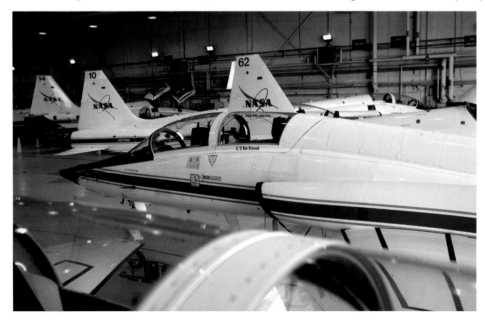

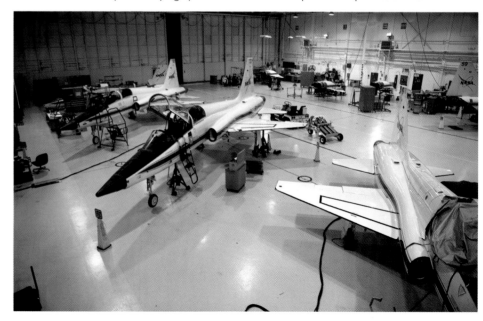

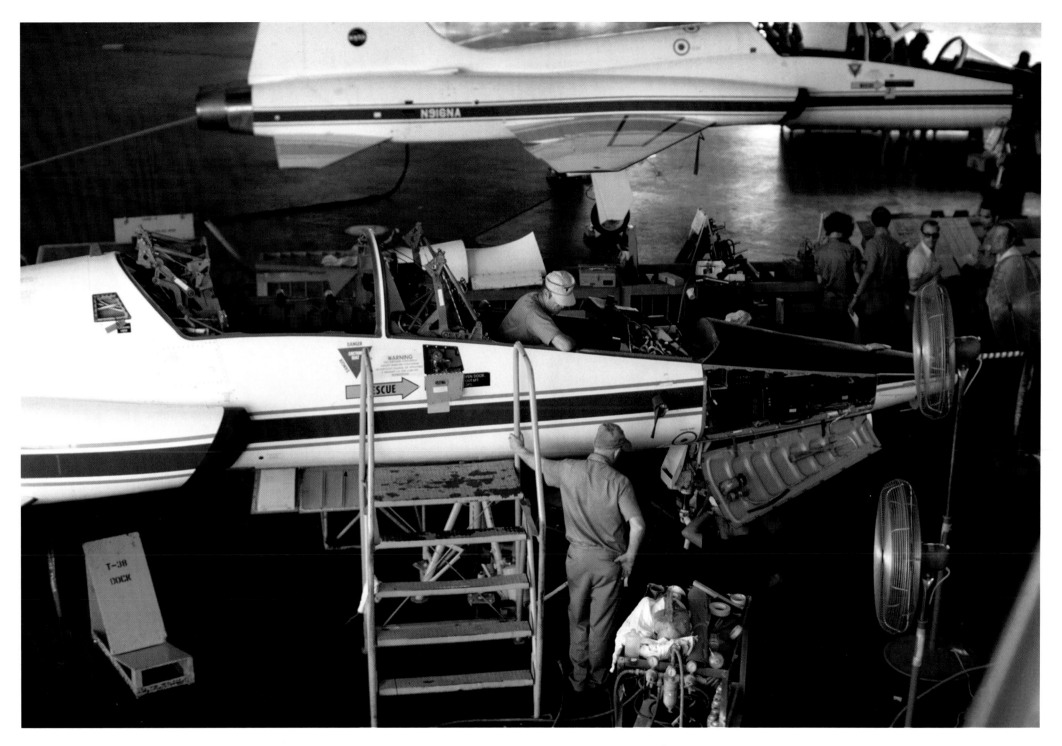

There really is no other way to know the hardware than to play with it, take it apart and put it back together. When an aircraft was in heavy maintenance and I knew that I would be the one to test it by performing what is called a functional test flight, I would follow its progress along such that I could understand all that happened to it in the shop.
Beautiful to fly, beautiful to work on—simple and elegant through and through.

151

Tools of the trade. I've been doing them all my life:
as a kid on the farm, as an aircraft mechanic in the
Marines, as a trauma surgeon; I guess that is why they
hurled me into space to fix that telescope.

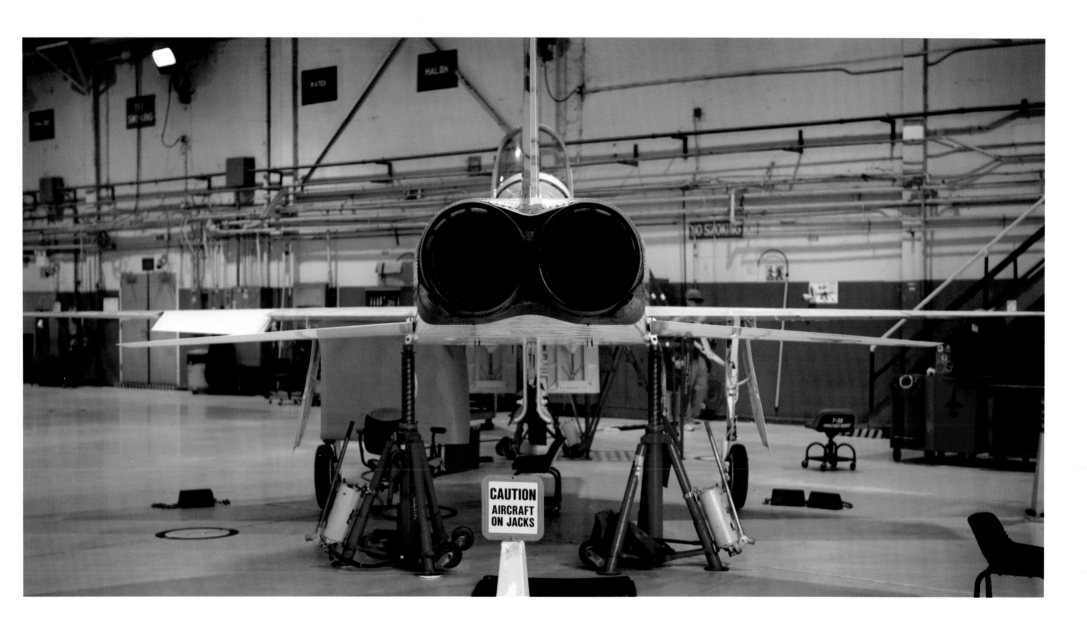

So very graceful in the air, flying
or on jacks

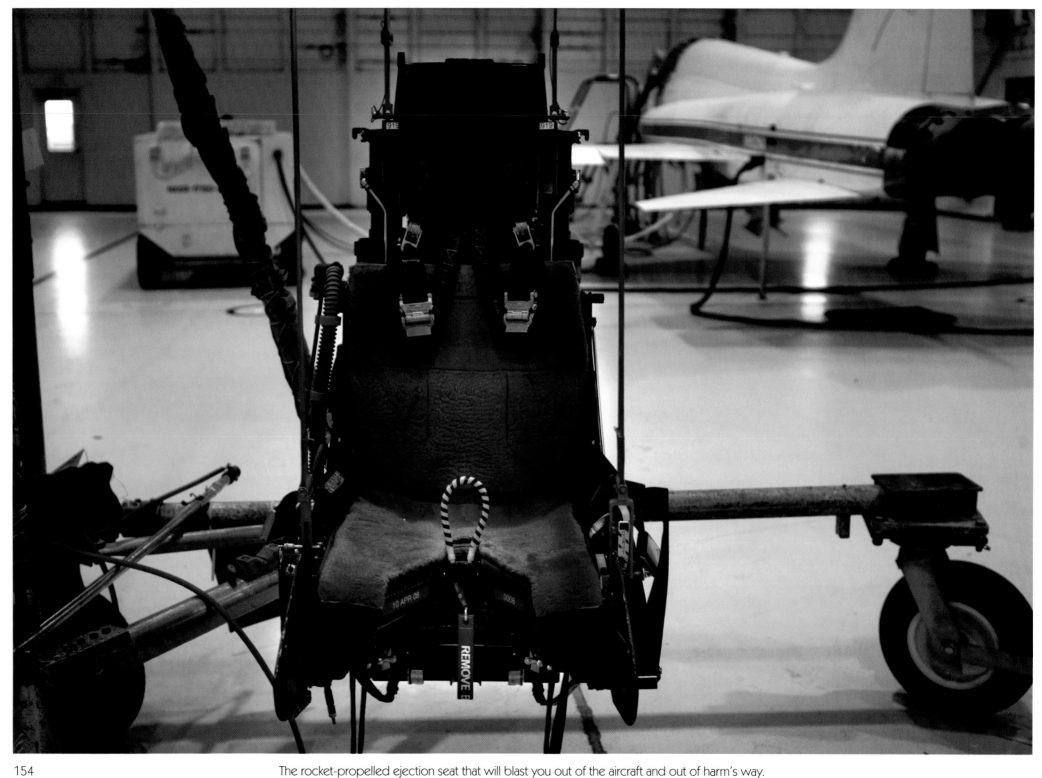

The rocket-propelled ejection seat that will blast you out of the aircraft and out of harm's way.

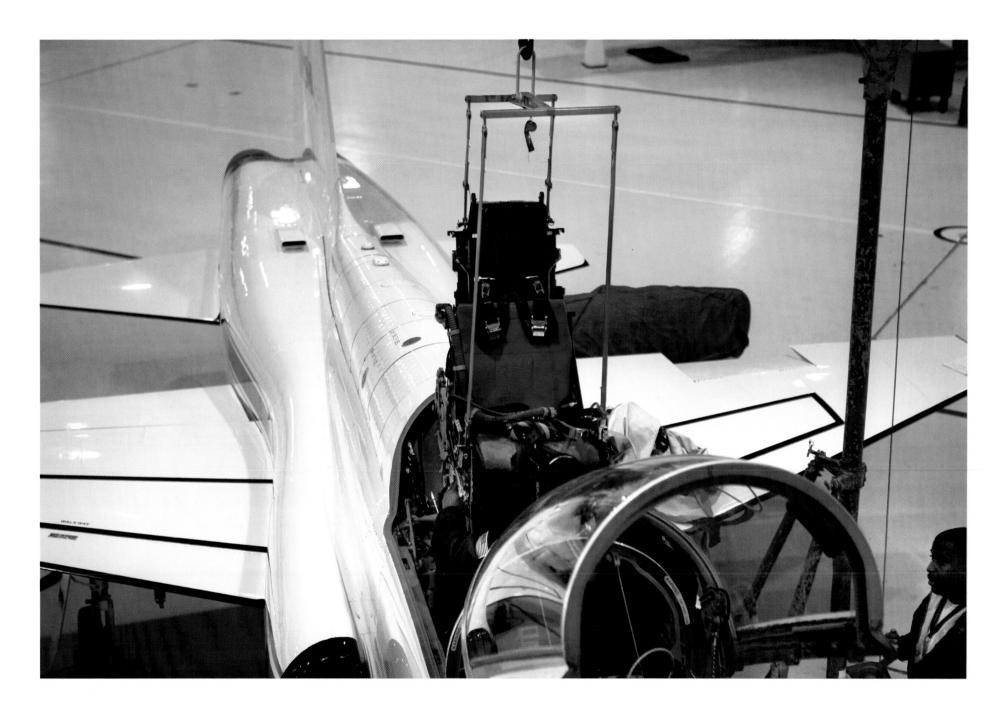

Being guided down the rails by those ever present hands,
your ejection seat is in those hands, now, and always,
your life is in those hands, now and always.

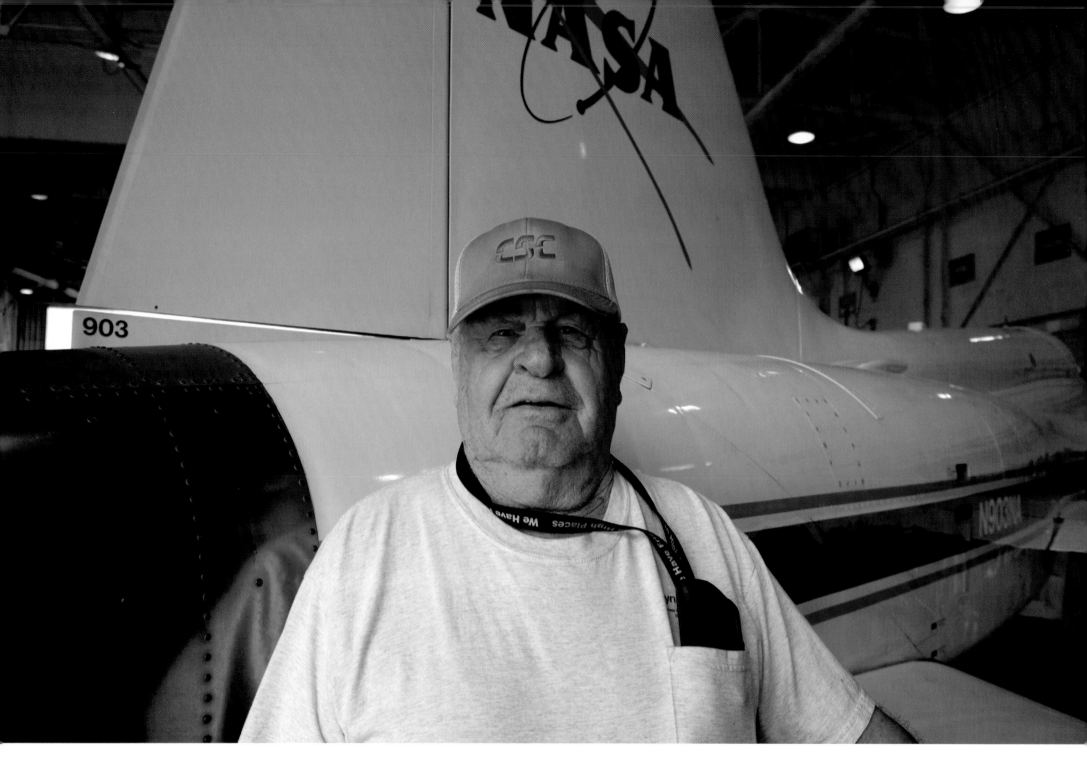

Pappy Cash, my mentor, leader and hero; my life has been in his hands hundreds of times; he has been caring for the NASA T-38s for 46 years. He is 85 and he is still caring for them.

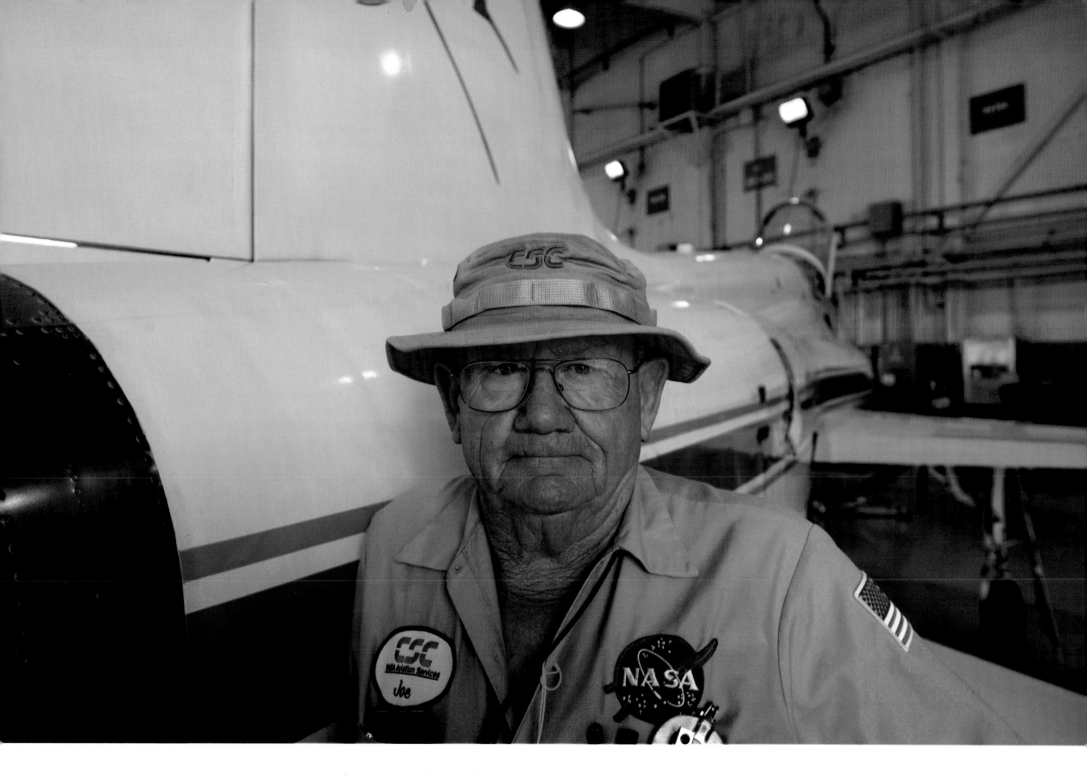

Joe Conway, over 40 years with this machine, the best and funniest in the business.

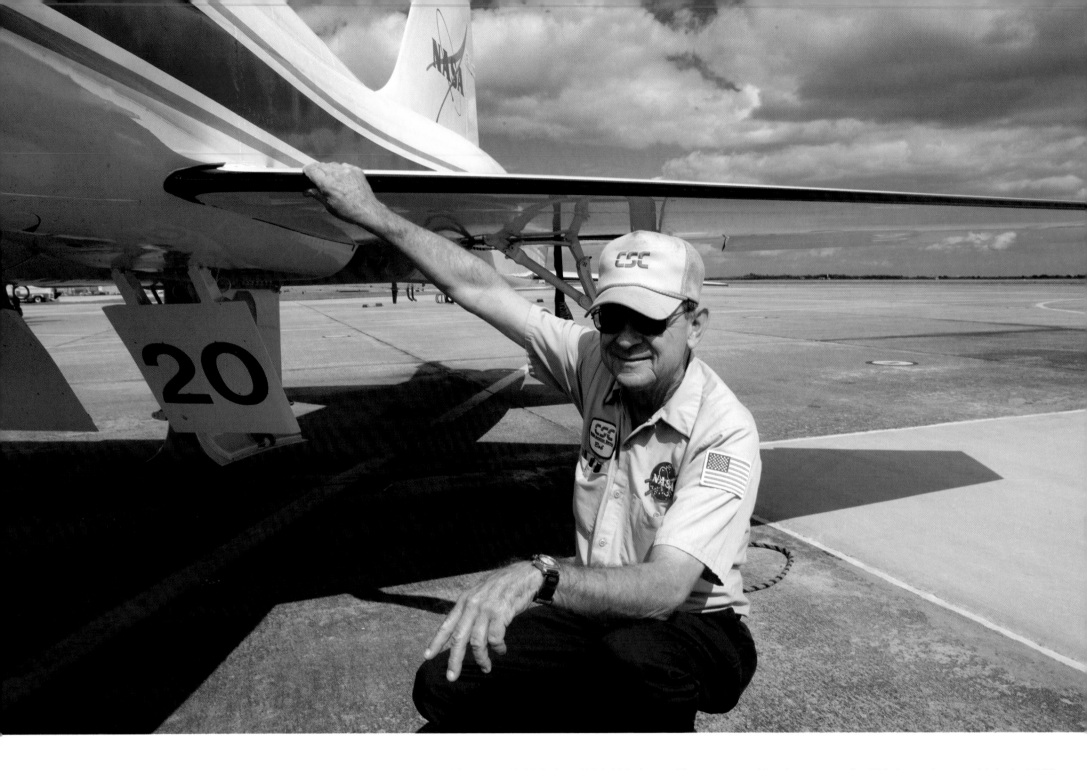

Bob Poltorak, another 40-year plus veteran of the NASA Northrop T- 38 world. He is with his baby, NASA 920, the sparkling sunny machine that gave us the 920 shoot, the most biological T-38 pictures I have ever experienced. I started flying his machine 42 years ago and took it to every realm the book allows and she always carried me safely back to earth.

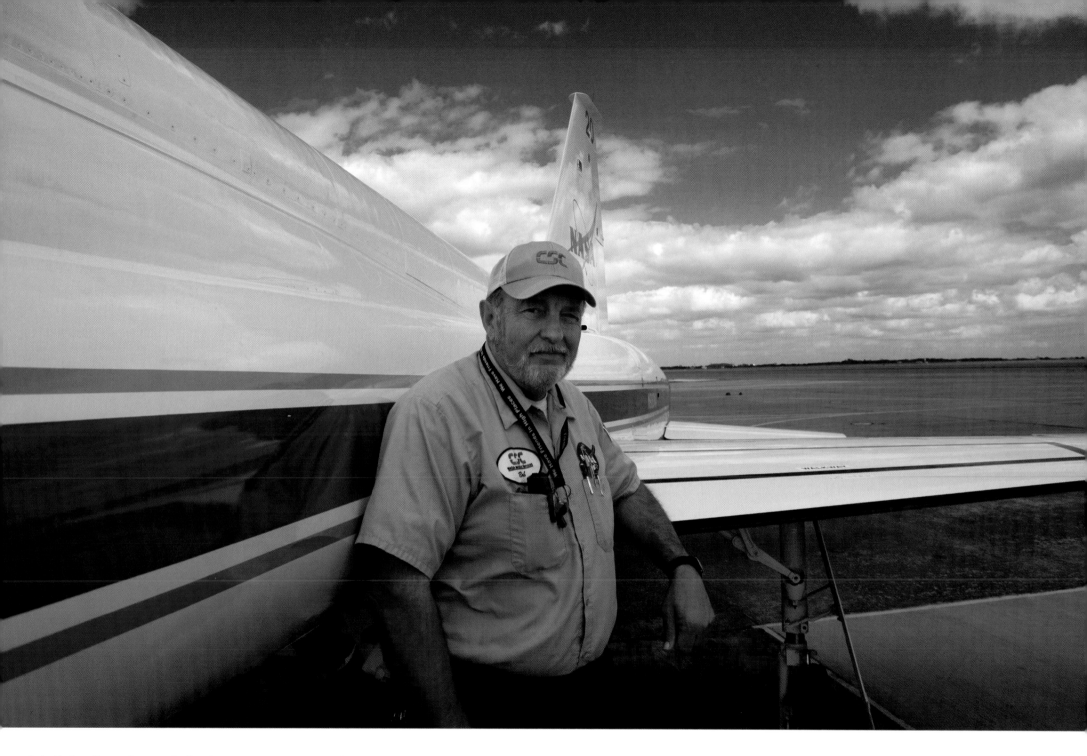

Bob Mullen. Sorry dear reader but I got to say it again - another 40-year plus mechanic, crew chief and now flight line chief. How many times have I looked into that face and acquired 40 years of knowledge and experience of our aircraft. And, my life was in that hand you are looking at innumerable times - thanks so much for always getting me home Bob!

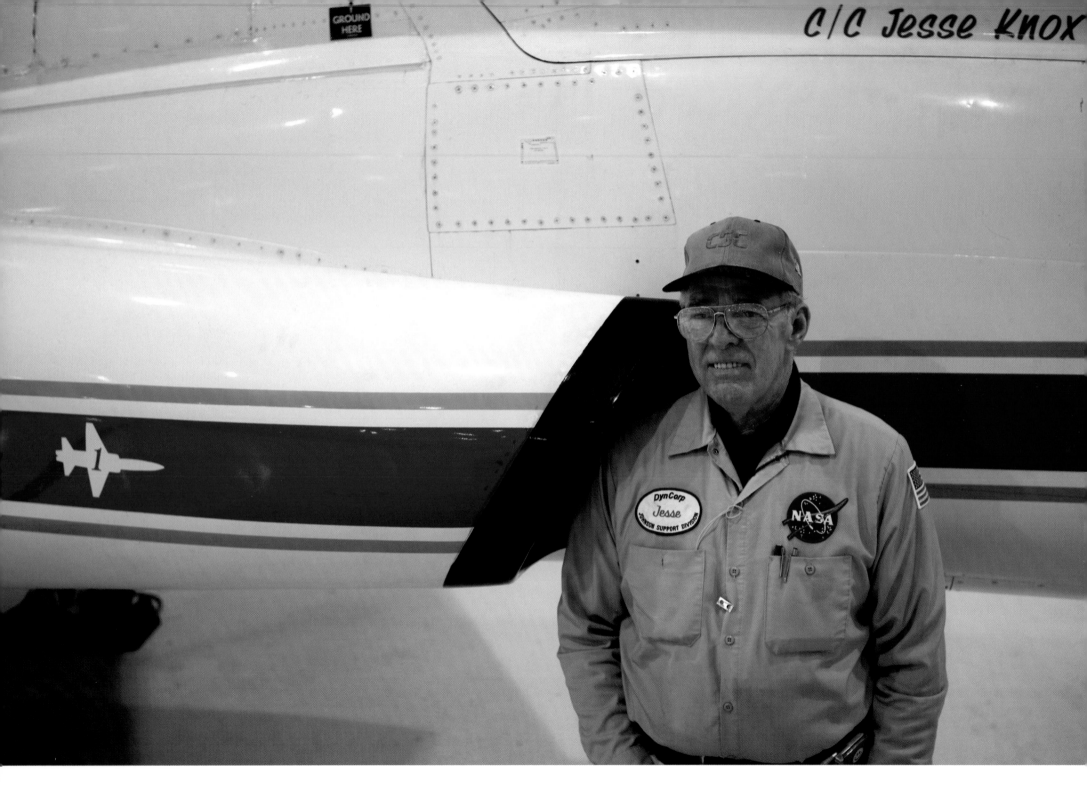

C/C Jesse Knox

GROUND HERE

Jesse Knox, dedicated crew chief to NASA 963 for decades, his aircraft.

The number 1 on the intake is there because NASA 963 was the first Northrop T-38. Yes, the first operational T-38, which has been flying close to 50 years.

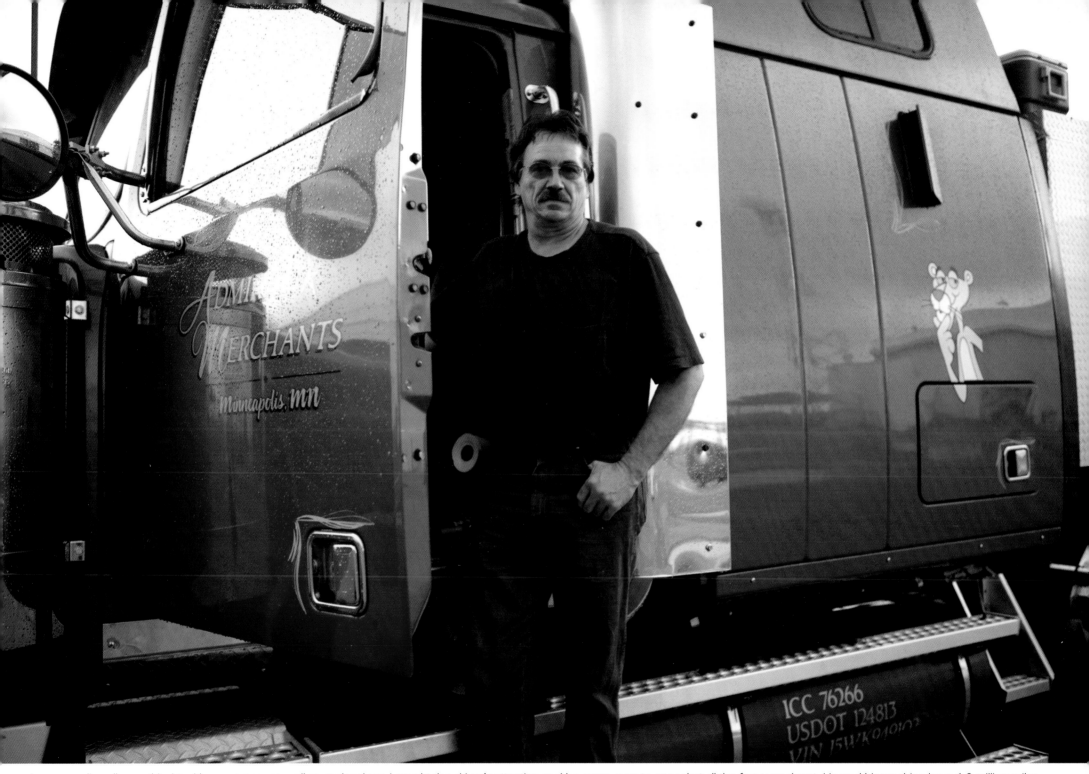

I was crawling all over this rig with my camera as well as my body so I caught the driver's attention and he came over to see what all the fuss was about. He and his machine have 1.3 million miles on the road together. It reminded me of great design, great maintenance and great operators. It also reminded me of one other component necessary to keeping the T-38 flying. This man is a professional, the best in the business; without him I go nowhere.

Sometimes a T-38 in need of heavy maintenance comes into a field that does not have the equipment. So all that is needed for any work, even an engine change, is packed onto a trailer and taken to the aircraft. They've done it before, and they will to do it again. They pretty much got it down.

NASA 966, for the moment, has her own little garage. Come to think of it, what I wouldn't give to have her in my little garage!

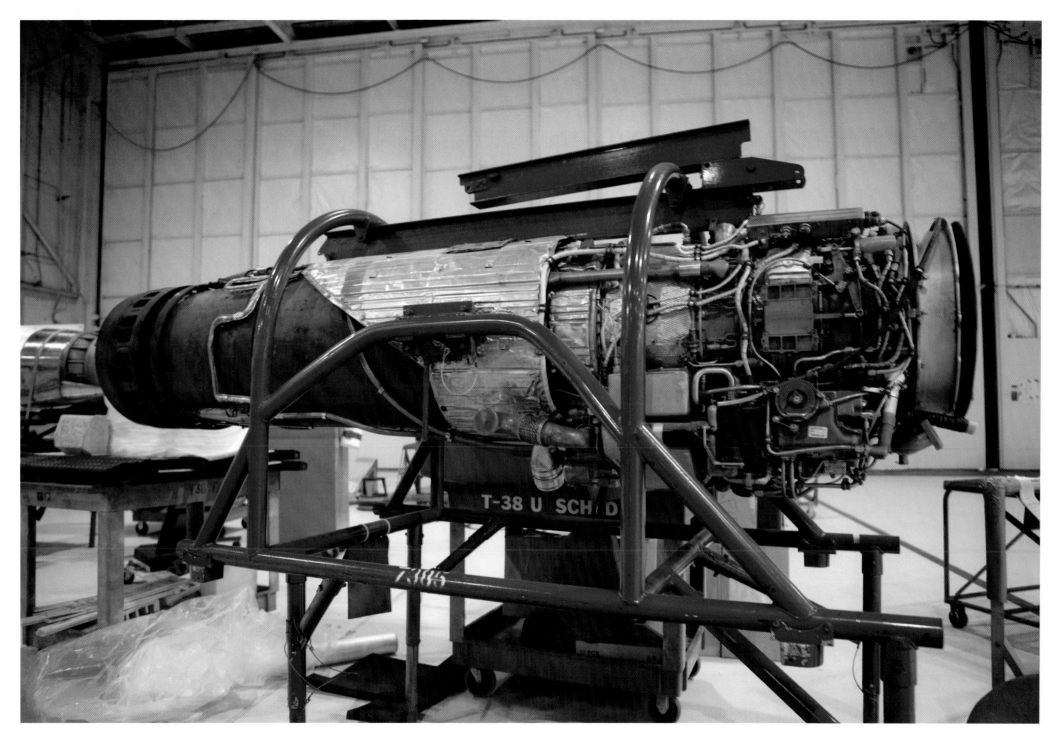

The General Electric J-85 jet engine.
The front and intake is to the right, the afterburner and exit nozzle to the left.

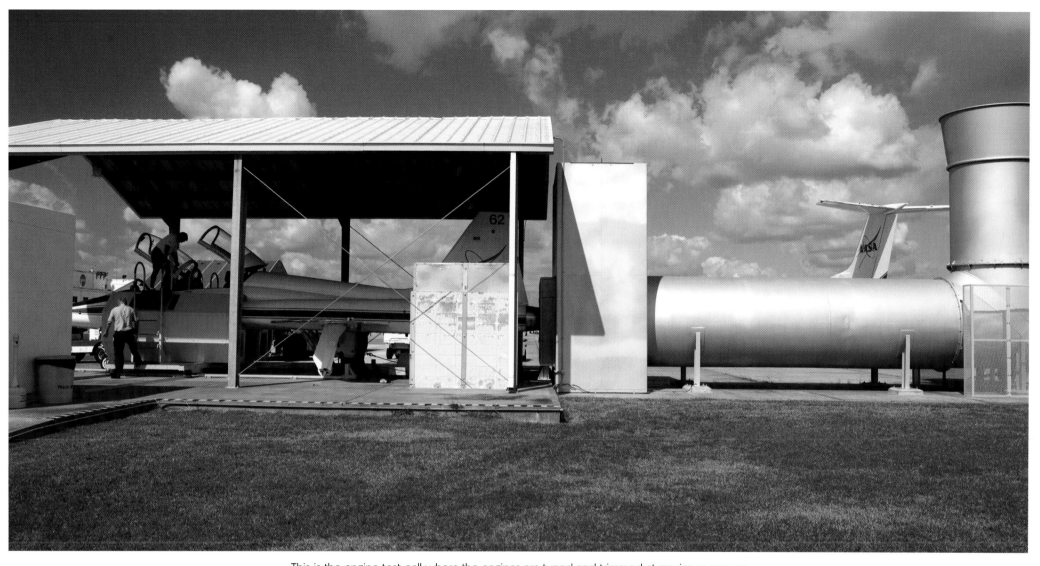

This is the engine test cell where the engines are tuned and trimmed at maximum power.

The aircraft is cradled to prevent motion and to be protected
from noise and vibration. Inside the cockpit, the mechanics are
operating and monitoring the engines at maximum power.

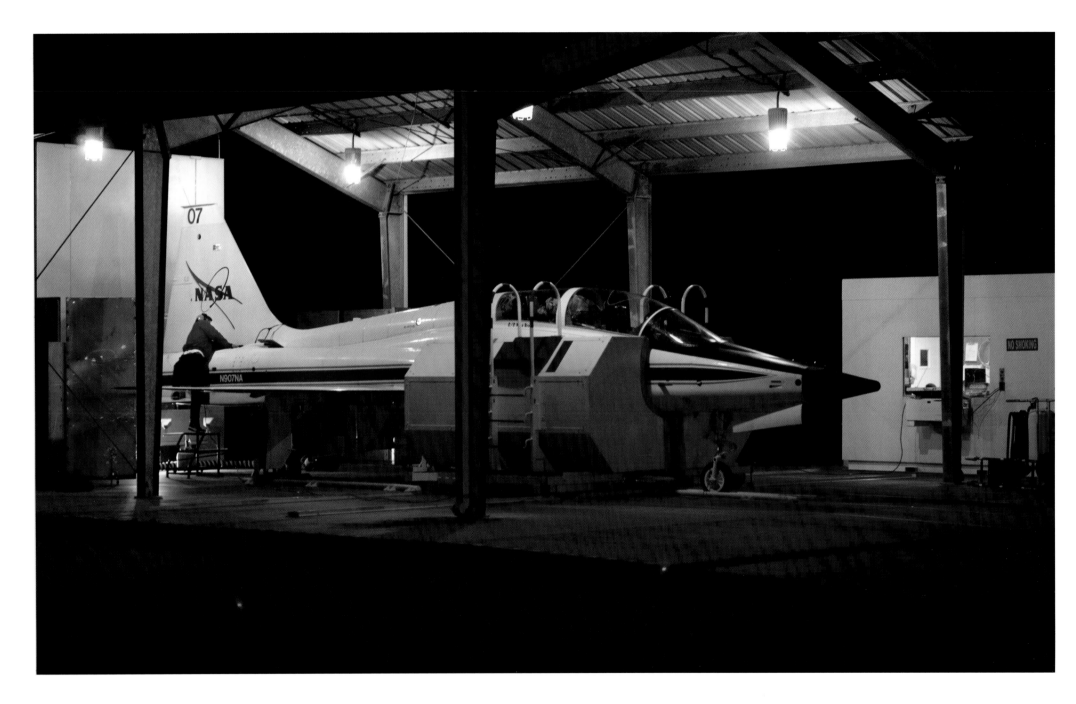

The work goes on into the night.

Randy Walker. Technical knowledge and experience, clarity of purpose, focus, concentration, enthusiasm, and spirit.
That's what it takes to do it right, and that's what they've got. That's what they have always had.

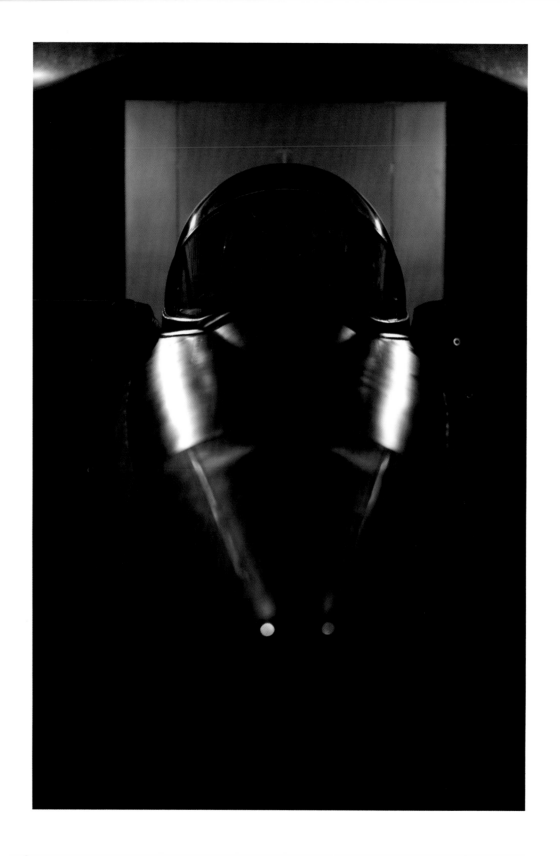

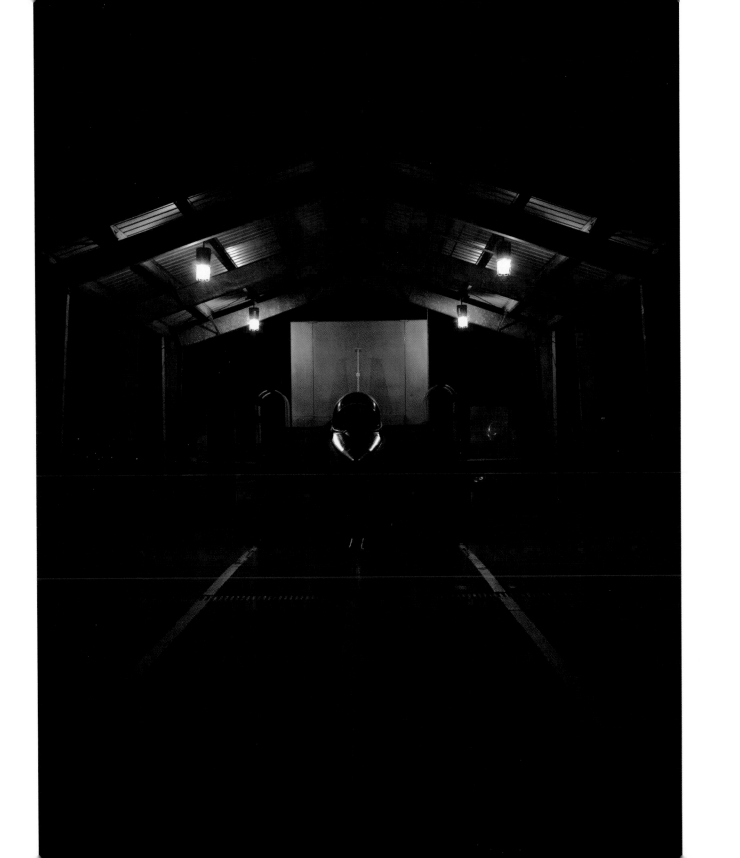

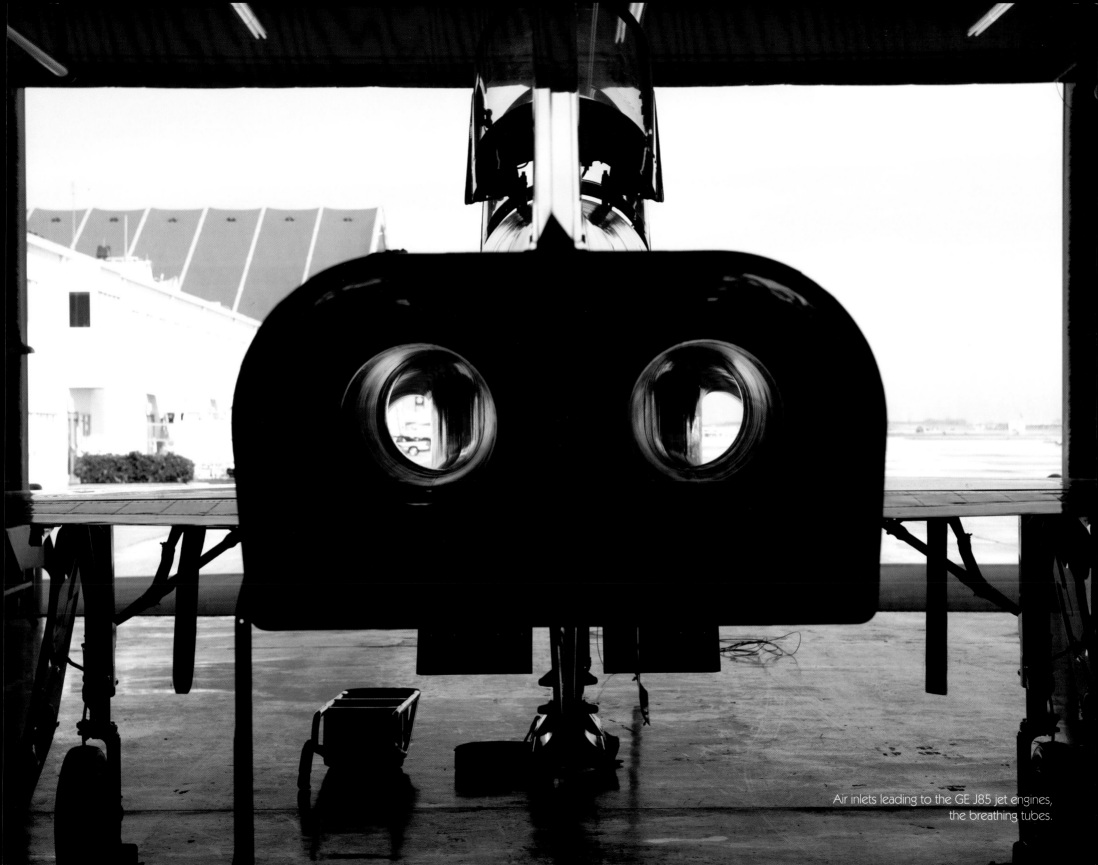

Air inlets leading to the GE J85 jet engines, the breathing tubes.

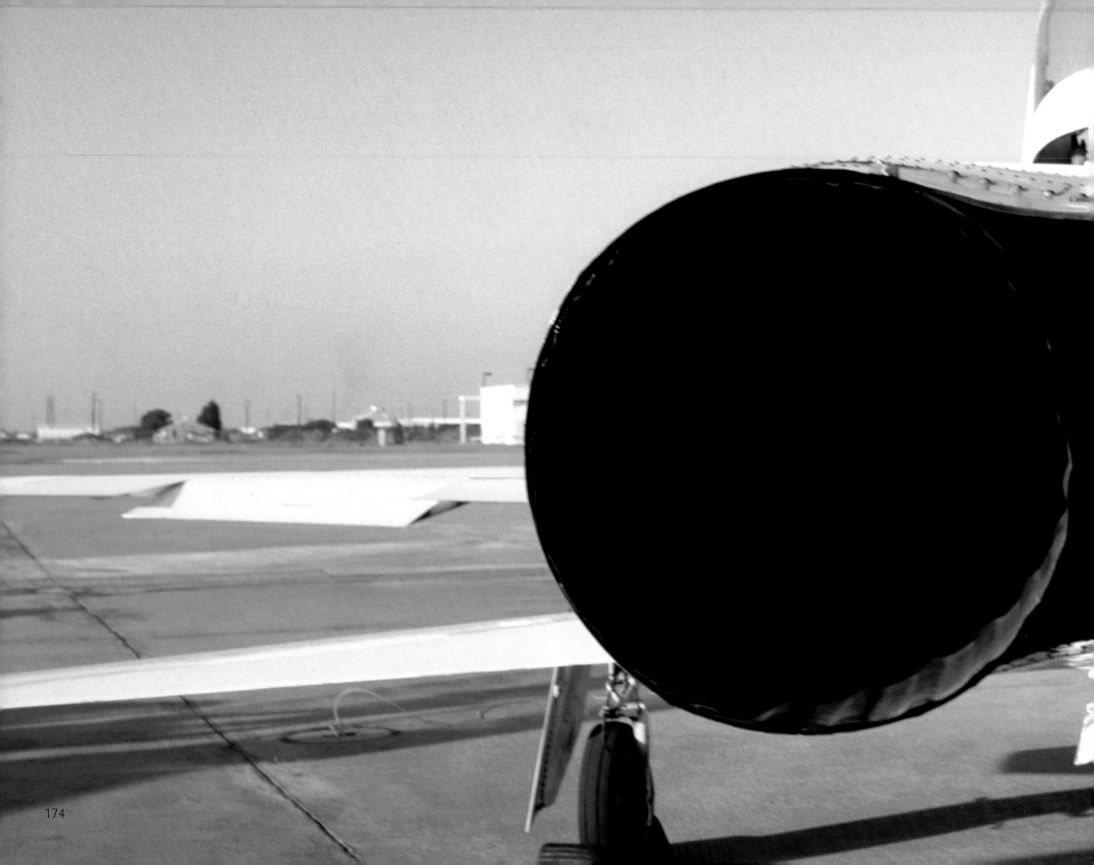

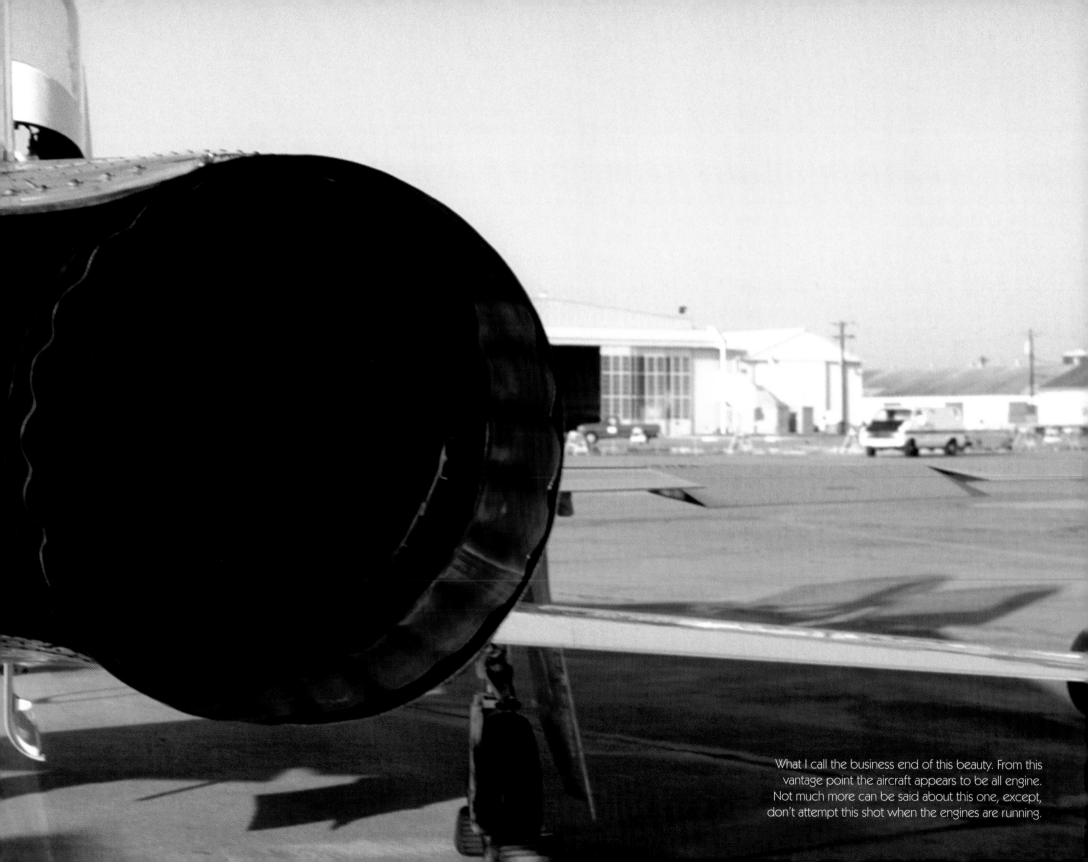

What I call the business end of this beauty. From this
vantage point the aircraft appears to be all engine.
Not much more can be said about this one, except,
don't attempt this shot when the engines are running.

The jet engine air inlet.
Even it is a work of art.
You can all but see the smooth laminar flow of air.

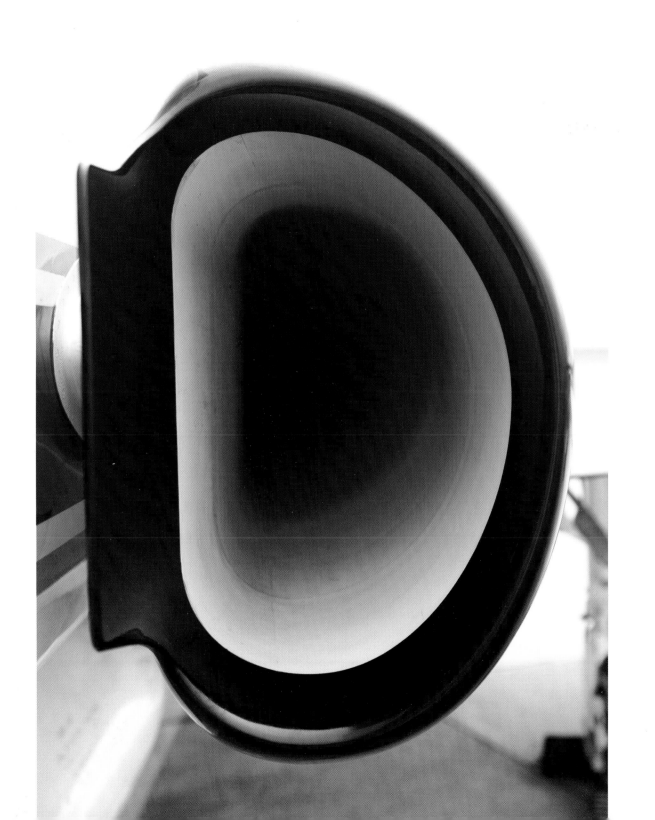

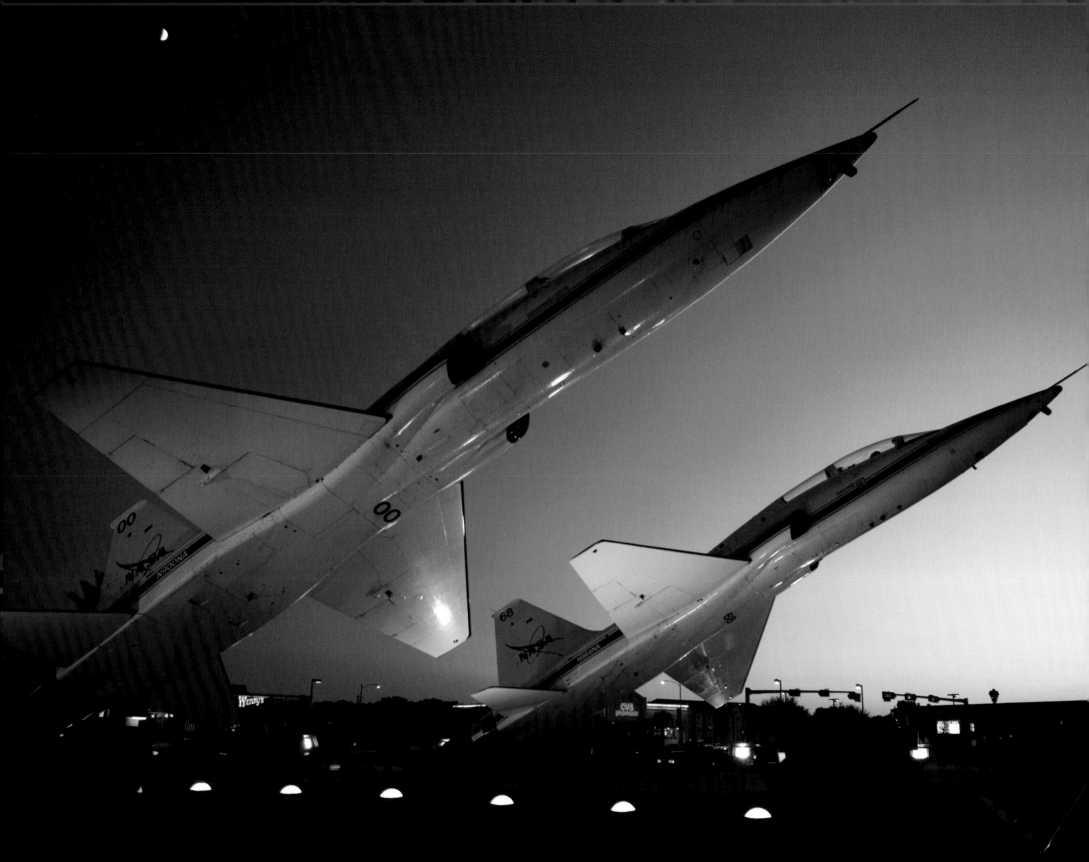

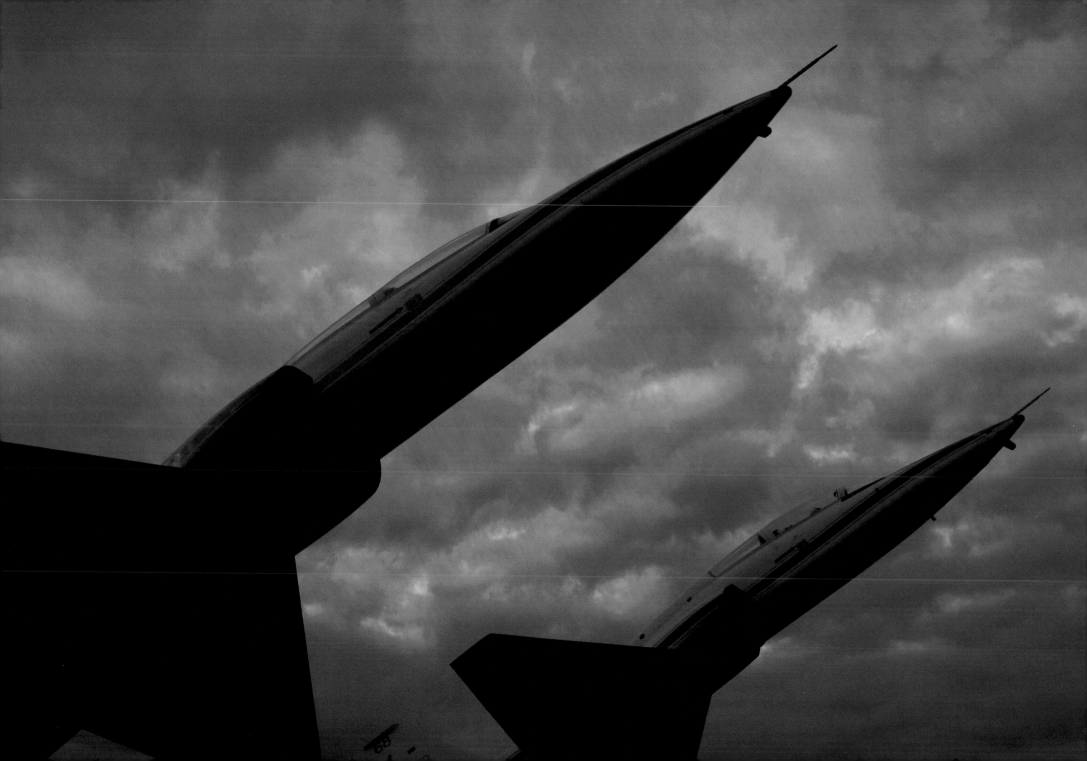

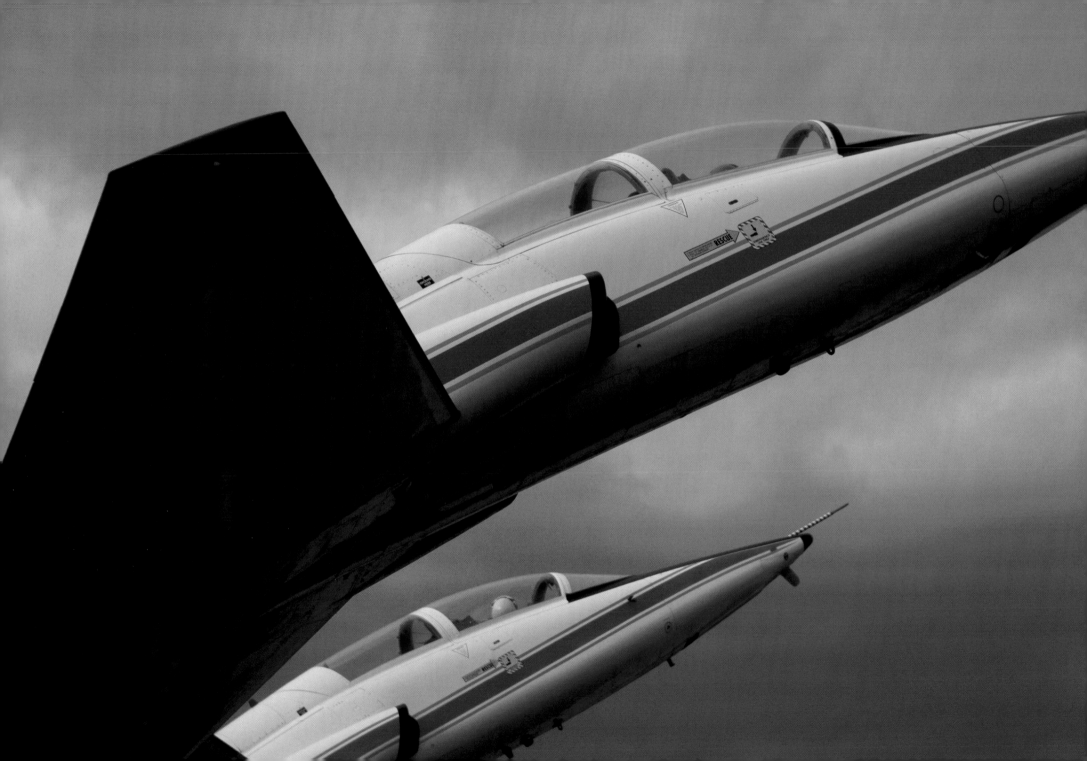

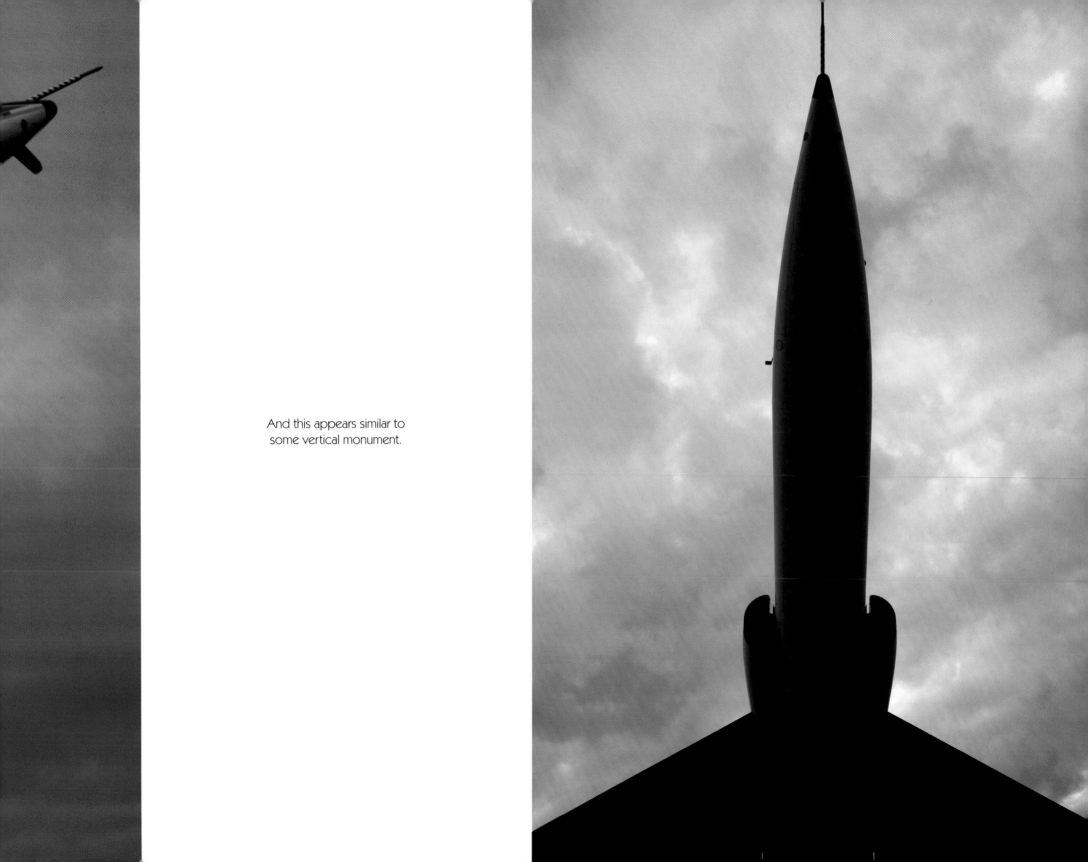

And this appears similar to
some vertical monument.

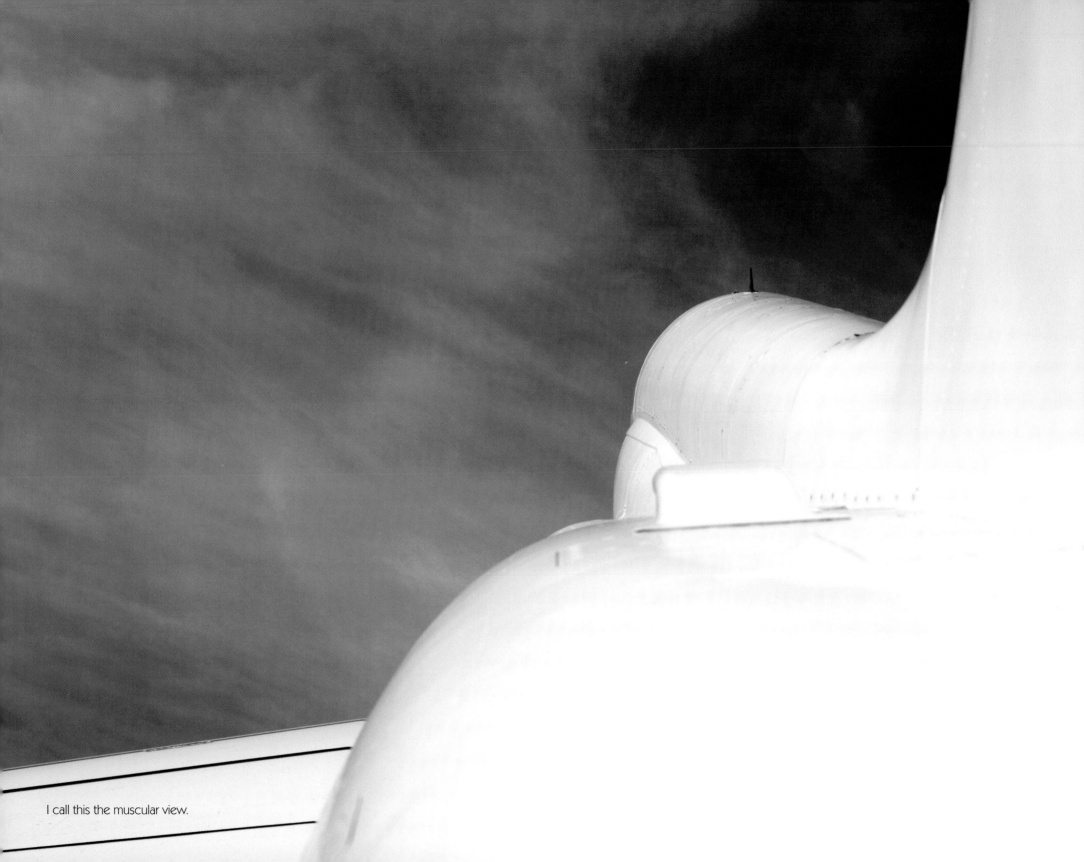

I call this the muscular view.

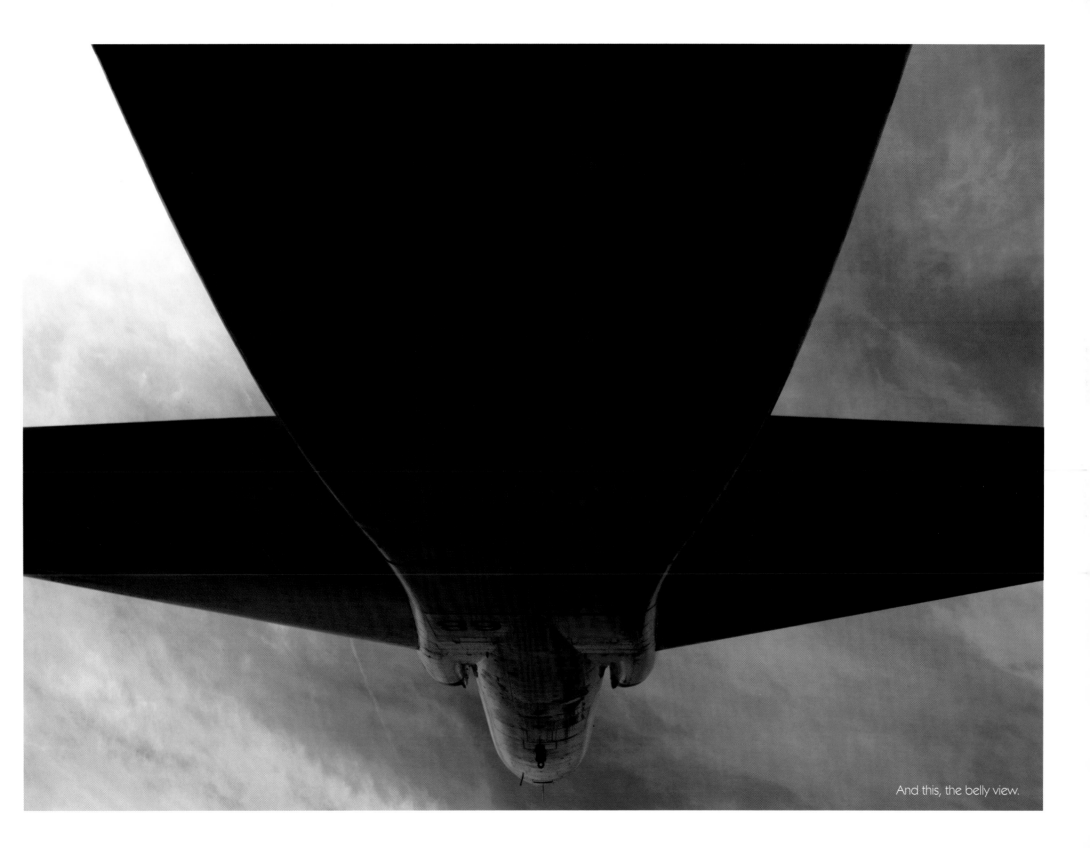

And this, the belly view.

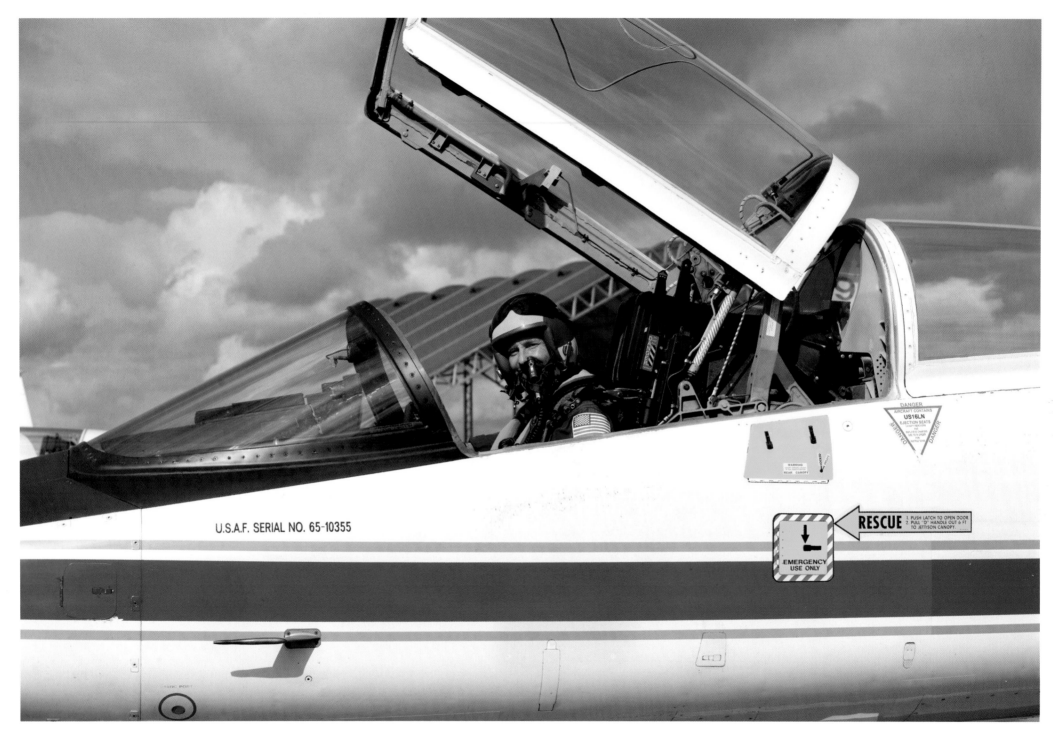

U.S.A.F. SERIAL NO. 65-10355

RESCUE
1. PUSH LATCH TO OPEN DOOR.
2. PULL "D" HANDLE OUT 6 FT
TO JETTISON CANOPY.

EMERGENCY
USE ONLY

DANGER
AIRCRAFT CONTAINS
US16LN
EJECTION SEATS

Ken Cockrell, former astronaut and now research pilot at Ellington. I flew with him on STS-80. An extraordinary technician, and extraordinary spirit, but now he is to fly NASA 913.
I love the play between the beams of the temporary hangar in the background and the canopy on 913.

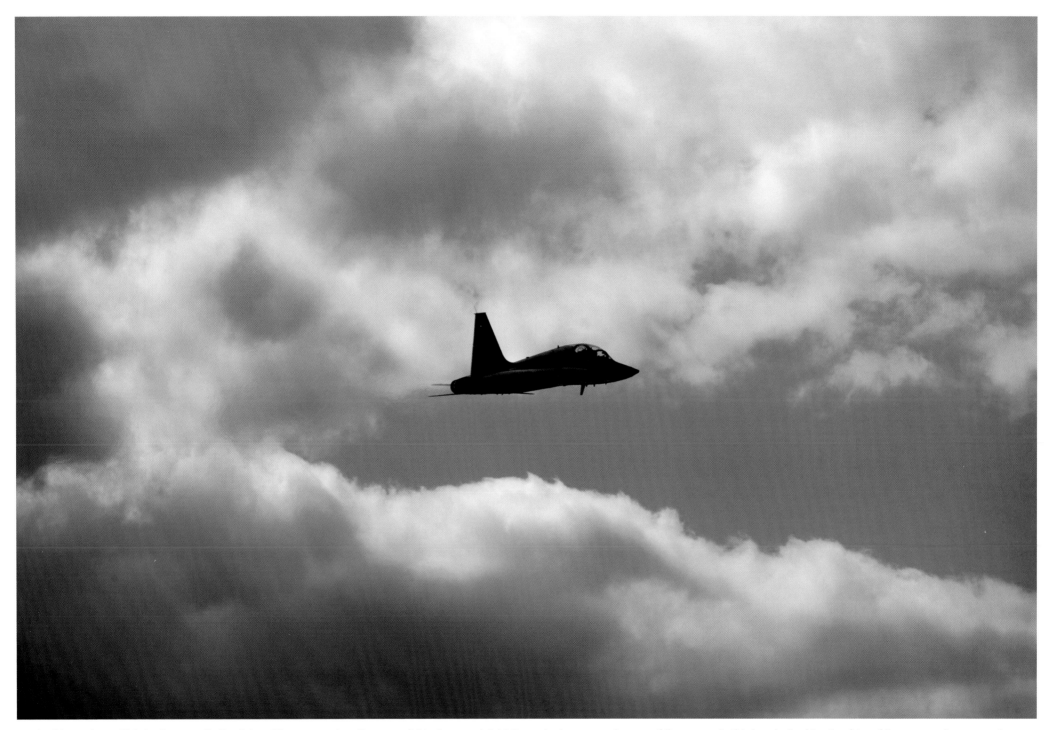

And into a beautiful sky they go. By the fate of the moment as they say, right place and right time, she has graced many of the pages in this book. And by the fate of the moment, wrong place and wrong time, she will never fly again. She is being taken to her end, decommissioned, retired or whatever the word should be, it is over. If she is not destroyed there is ever the hope of some resurrection, but in her case the chances are very slim. I wish her well on the journey ahead and I suffer for her.

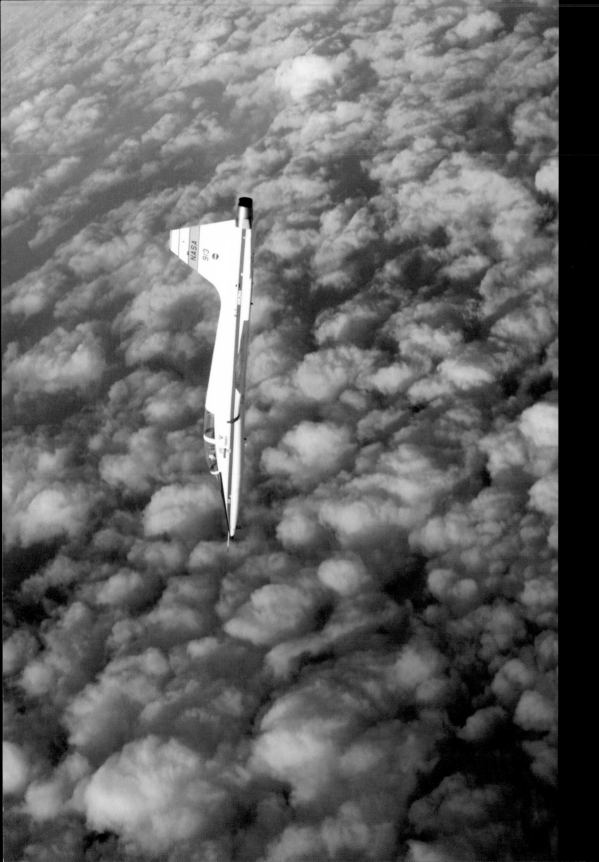

NASA 913.

Here, decades ago, she takes
me on one of those massively
exhilarating 600 mph vertical
plunges toward earth.

I celebrate the wondrous times that
we shared. Fate is the hunter, for
aircraft as well as for pilots.

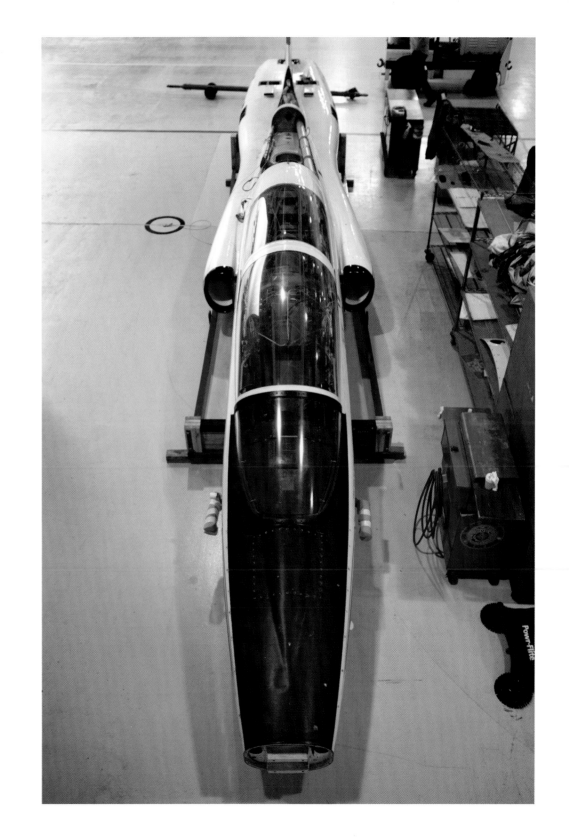

NASA 910, same story.
She is all through this book.

NASA 910

Here, decades ago, she carries me to the heavens.

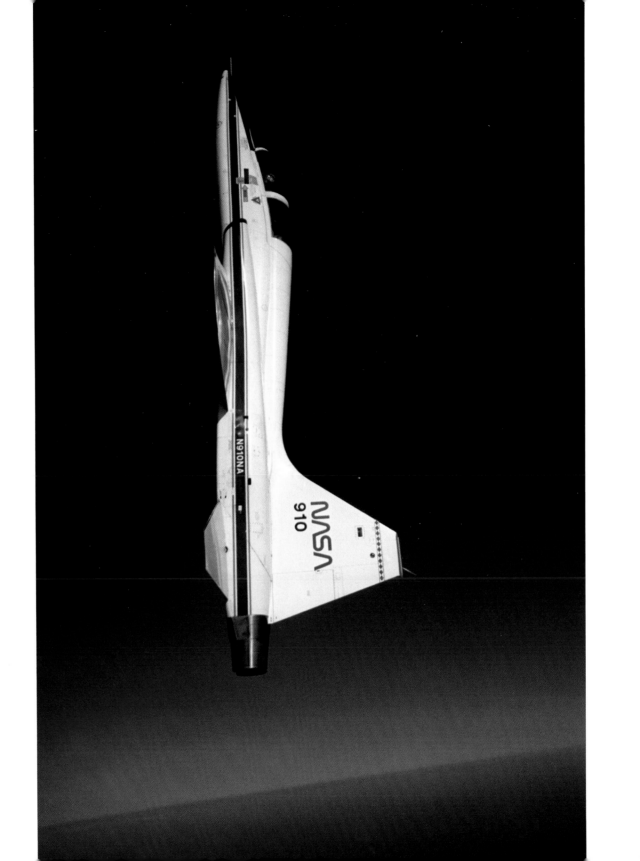

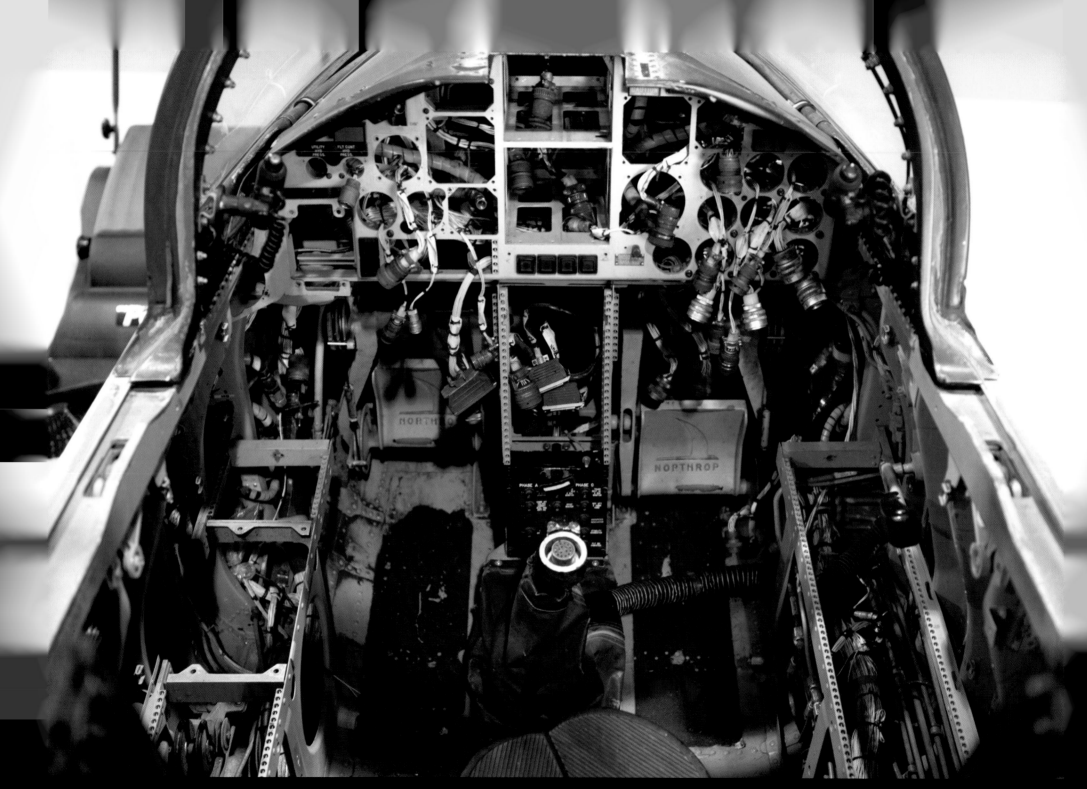

NASA 910, through no fault of her own, there is no hope of resurrection. The cannibals have already been here.
On the front of my driver's license in large red letters are the words "ORGAN DONOR". Fate is the hunter.

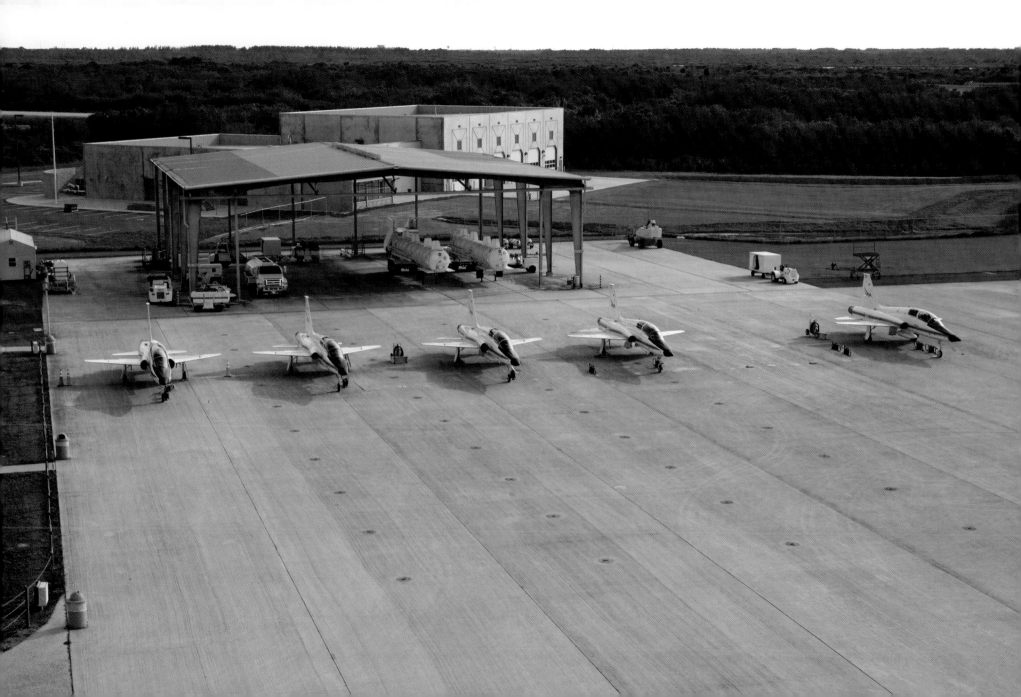

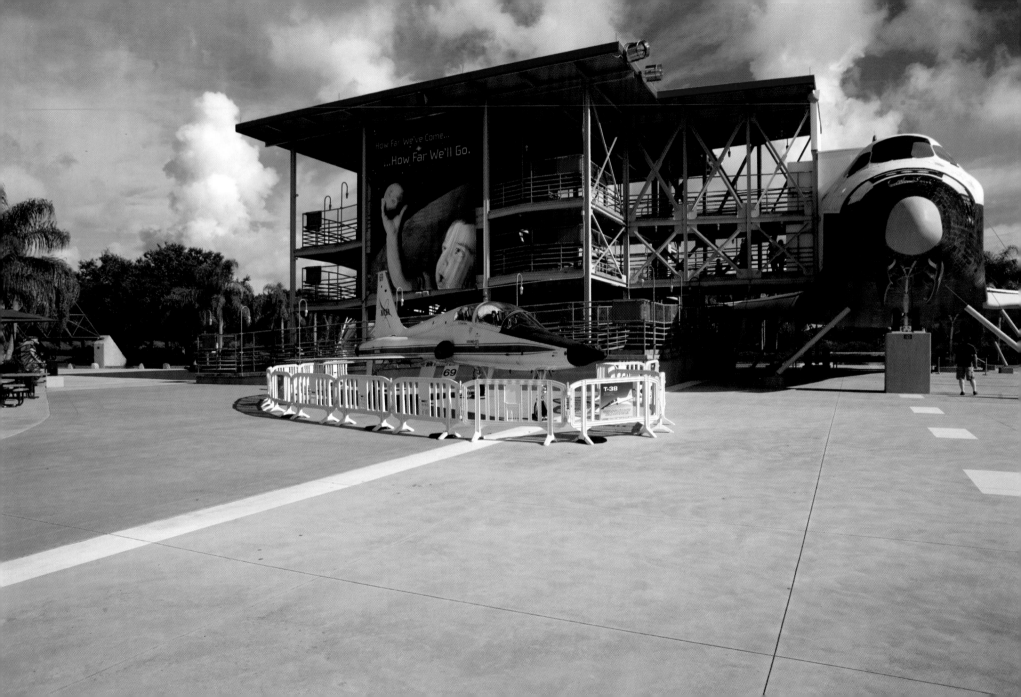

She looks like a wild mustang in a corral. My imagination is always moving those fences to let her run or to taxi down to the highway and take her for a spin when no one is there, but she has no engines, so I just go by and talk to her of the times that we had. Going by to the parking lot, I never miss a smile of acknowlegement and appreciation.

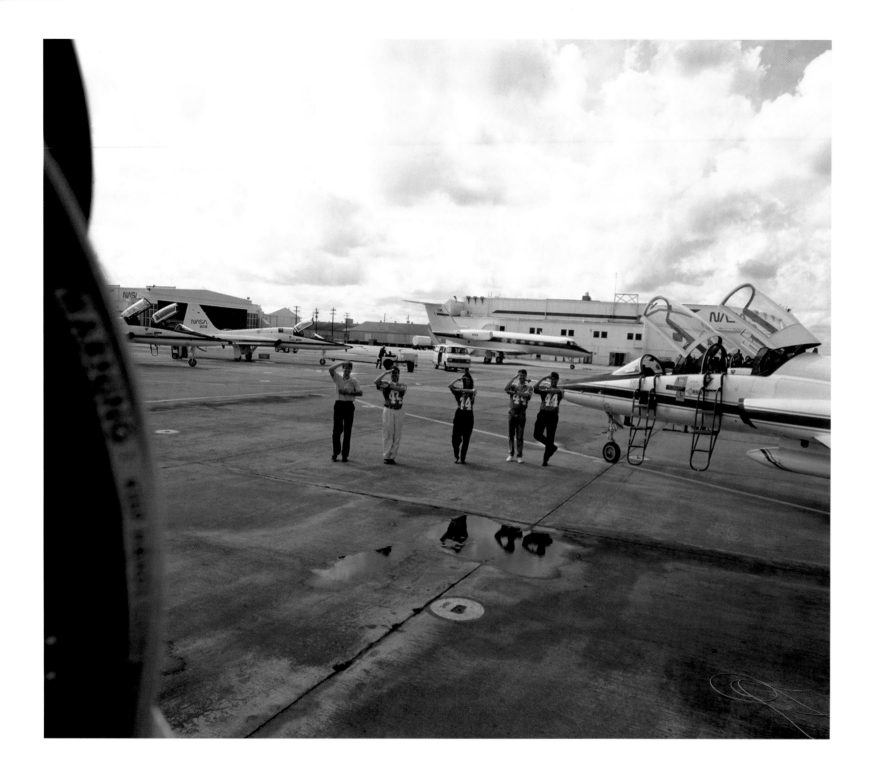

We are going to take a journey now.

Between Ellington Field, Houston, TX, and on to the Shuttle Landing Facility (SLF) at Kennedy Space Center (KSC) for launch.

We got our turbines humming and we start out of the chocks. Our STS-44 training crew sends us off with their salute to wherever the journey will take us.

They have lived with us every day of the training flow. From our assignment to the mission, to here, our departure for Kennedy.

What we know is what they gave us; what we don't know is what they did not give us. On the field, we are them and they know that.

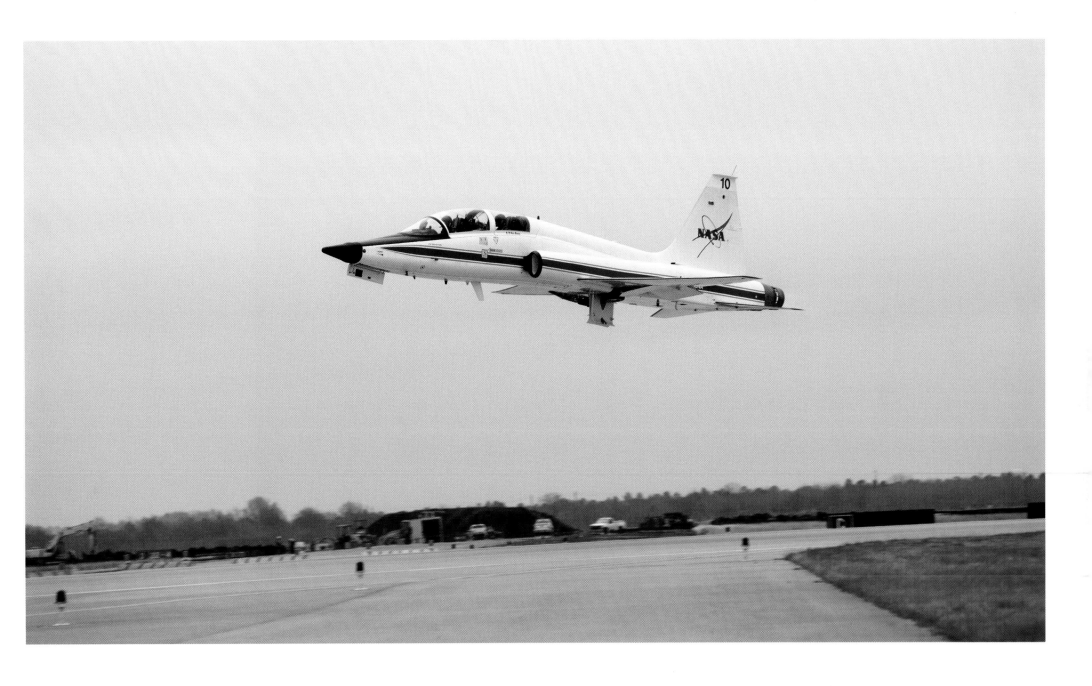

Off in our beloved NASA 910, wheels going into the wells, gear doors to close shortly, on our way to KSC and on to space.

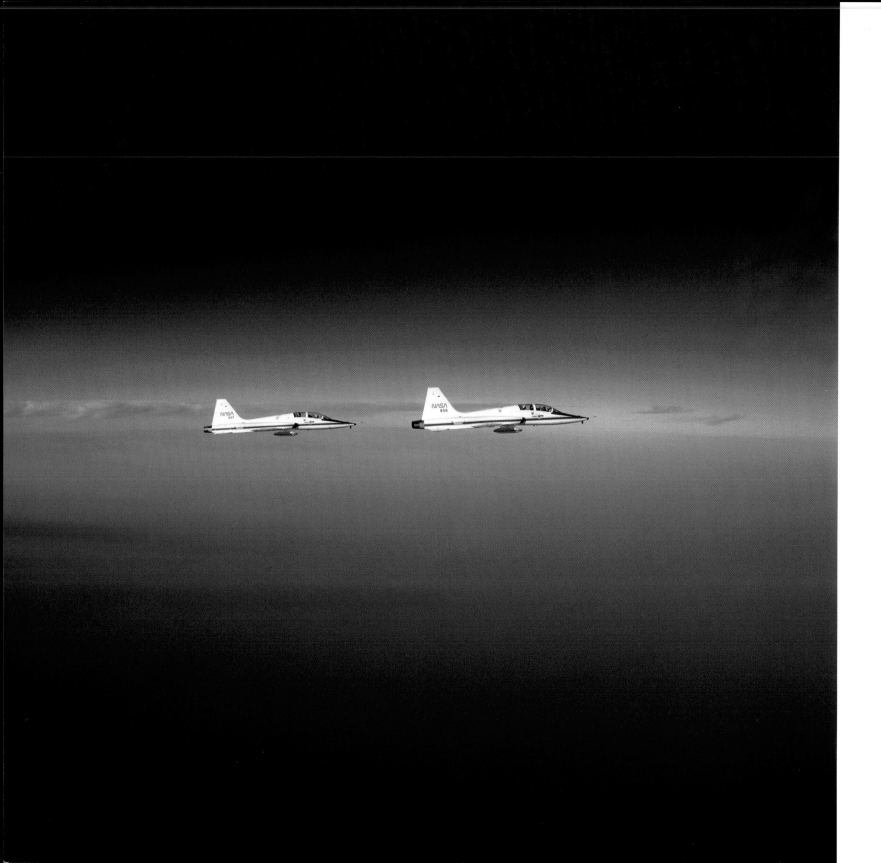

We cruise along - Mach .92, 41,000 feet.

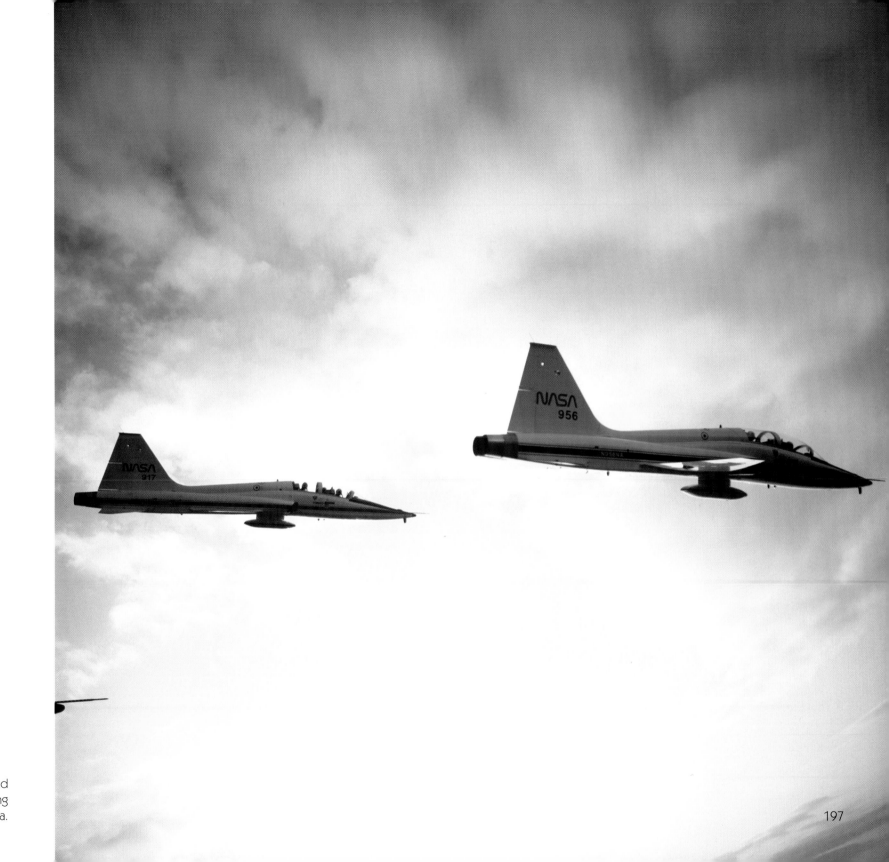

We ease back the throttles and start our descent approaching Tampa.

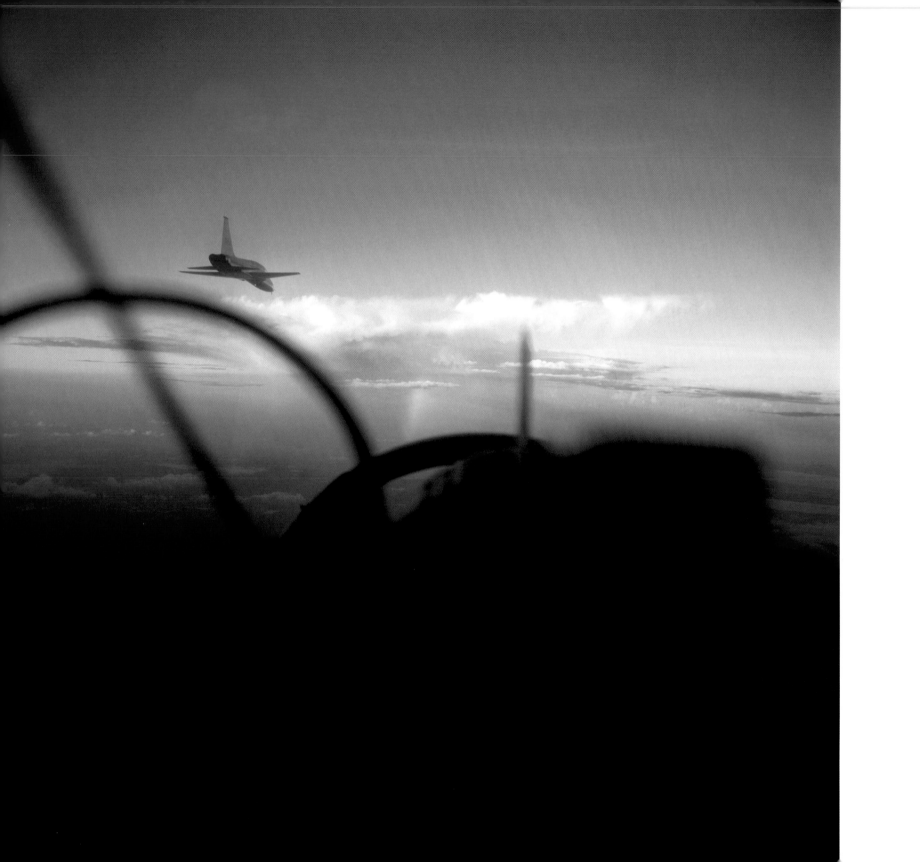

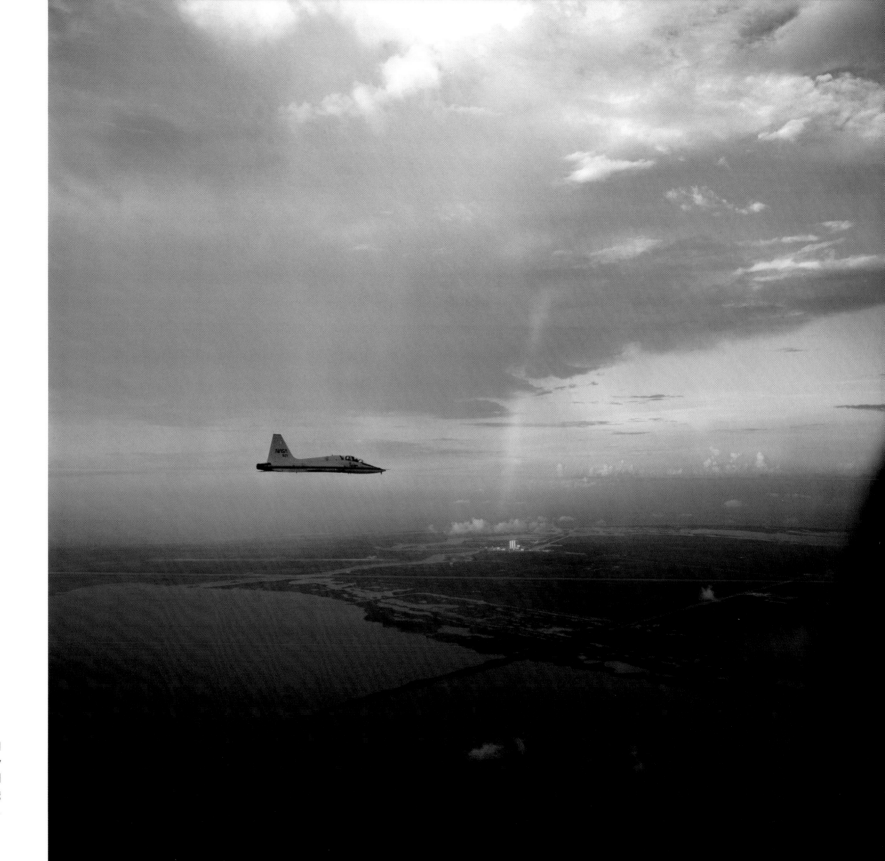

We fly over the Indian River and I time the shot and maneuver my aircraft to put the pot of gold in the vehicle assembly building (VAB) at KSC.

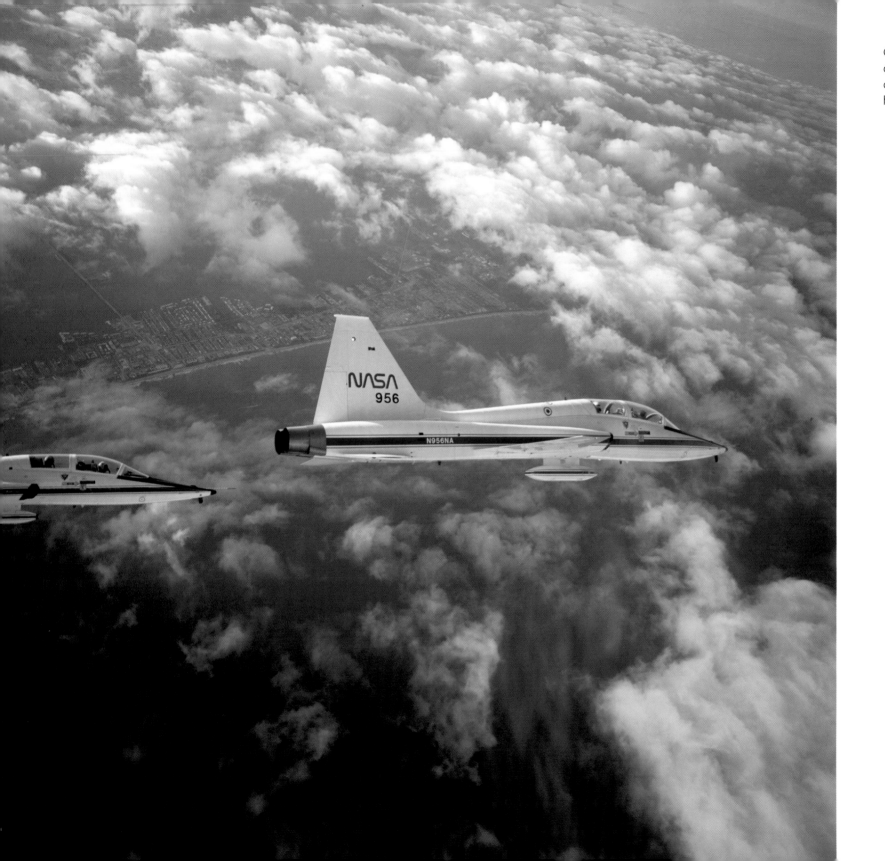

Gliding down through the clouds over Cocoa Beach, we get a visual on the VAB and a clearance to head for it.

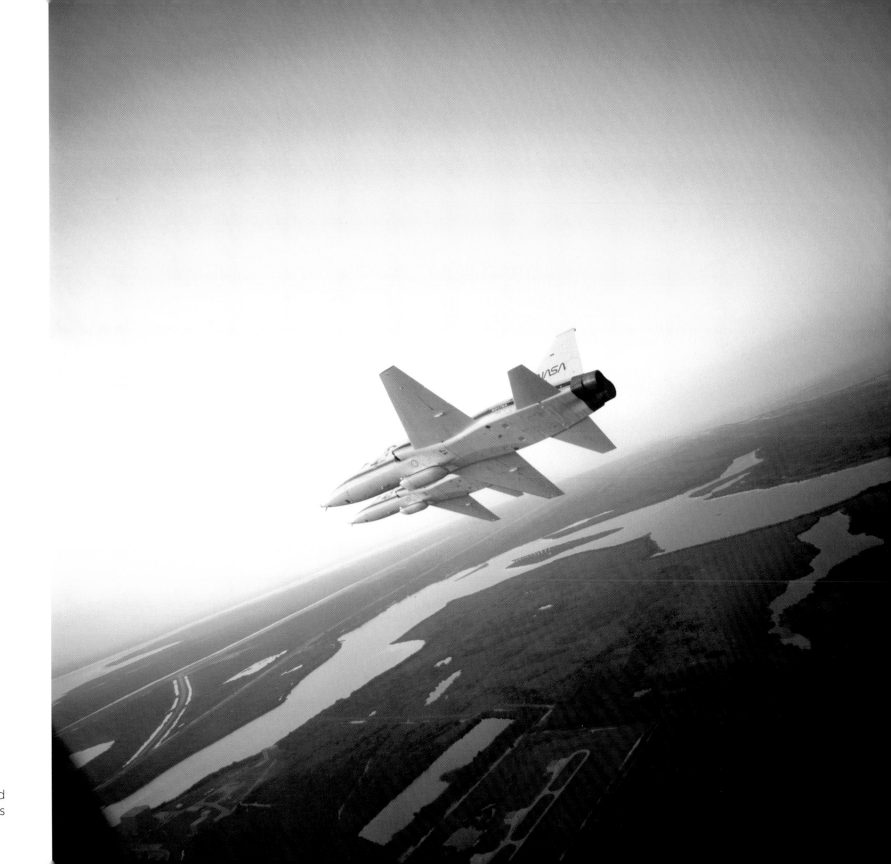

I love the perspectives provided
by "echelon" turns

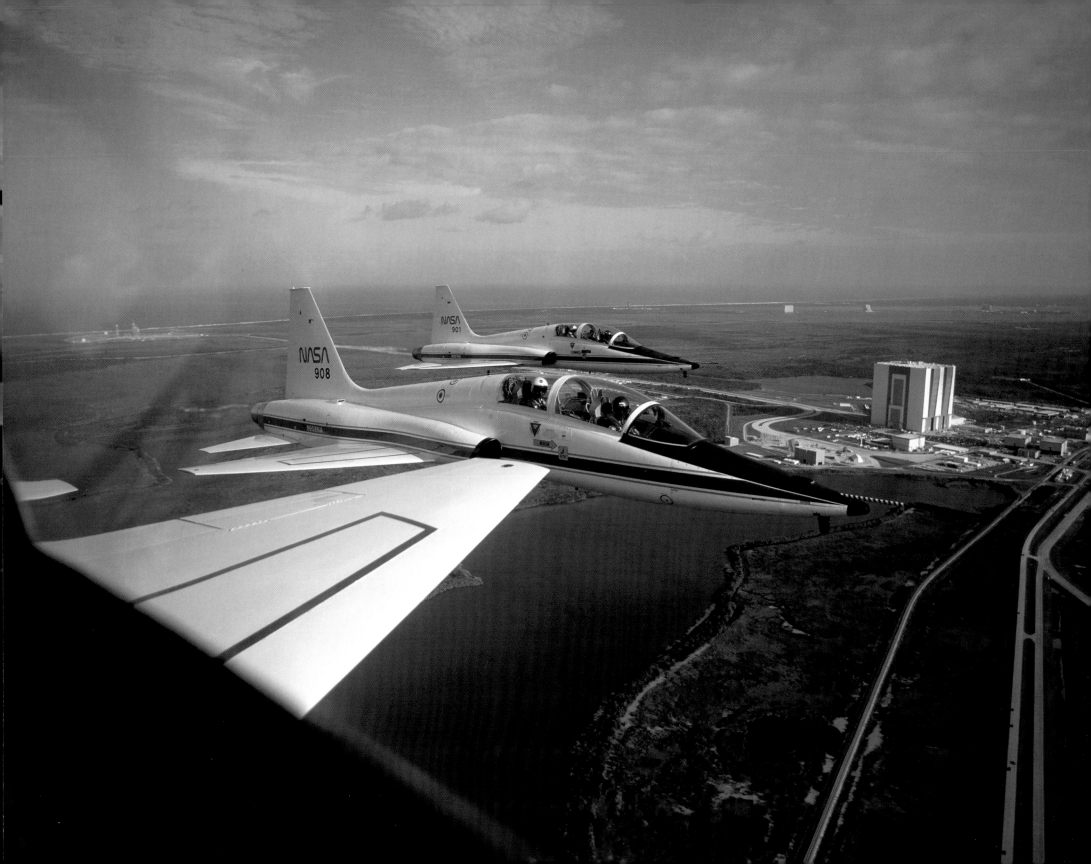

Our STS-61 crew arriving at KSC in December of 1993.

Today we work at being the best we can every second of the day, 'cause in this business a second may be forever. We play the game by the rules because an infraction may be the end of the game. We work as a team, think as a team, and we fly as a team, a singular organism.

Three days from today we launch on Endeavour to repair the Hubble Space Telescope.

As Tom said in the Foreword, all paths to anywhere in this business pass through the cockpit of the T-38. As in the aircraft, we will be the best that we can just for the sake of being the best. We are not in it for the victory or the defeat, we are in it for the journey, to be on the field with the best we got to offer.

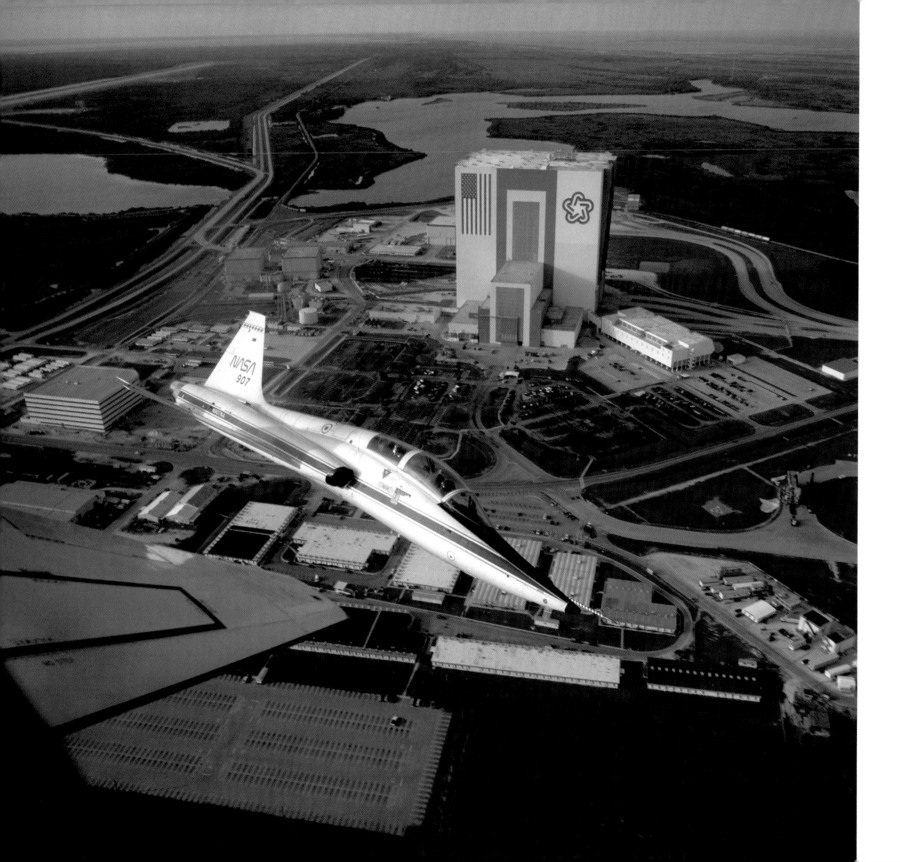

We swing around the VAB and the launch control center to the right of it - memories of 1969 when four moon rockets were being stacked simultaneously in that building and 1976, our bicentennial, when that symbol was painted on the VAB.

I am shooting over my shoulder, focusing on the other aircraft and working the canopy glass reflections to see what I can get there. The American flag is a patch on my left arm, the barber pole a rod that guides closure of the canopy.

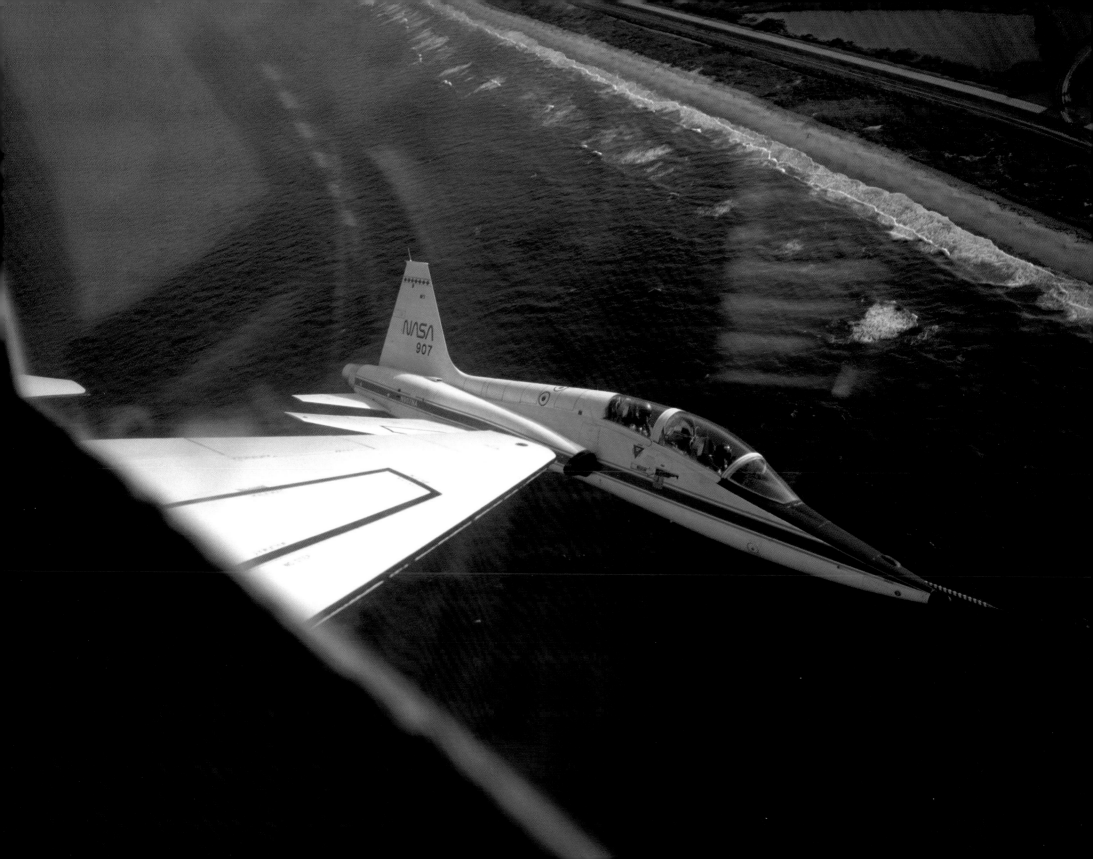

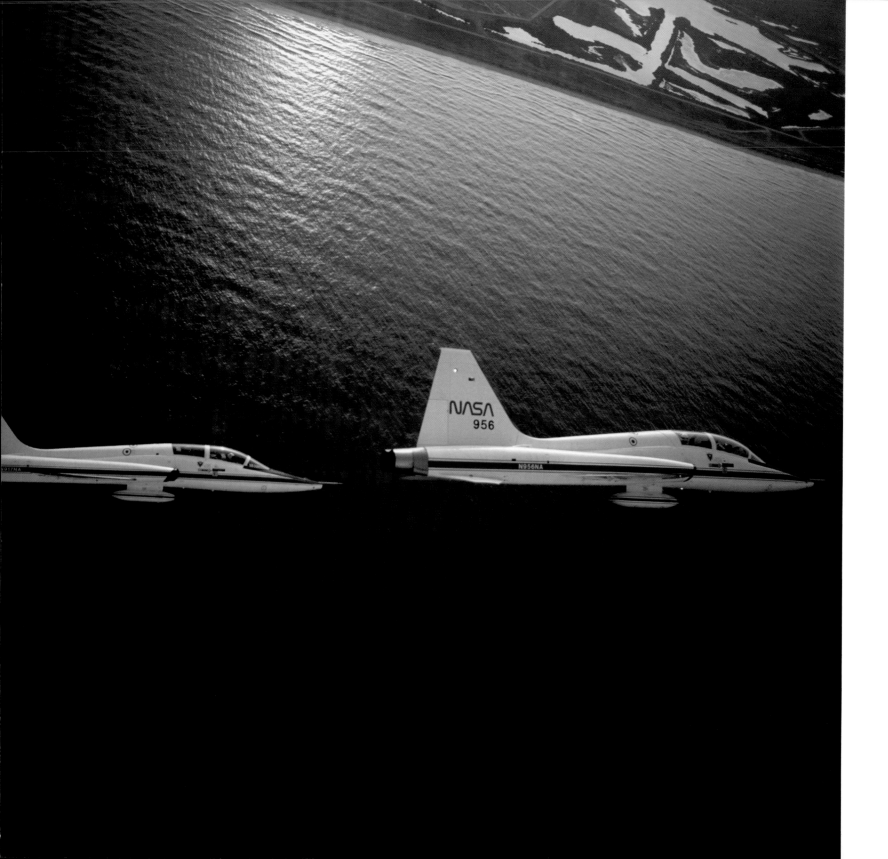

Going back again in time to another mission, we get permission to fly by our spaceship on the pad and swing out over the Atlantic to initiate an arc around her.

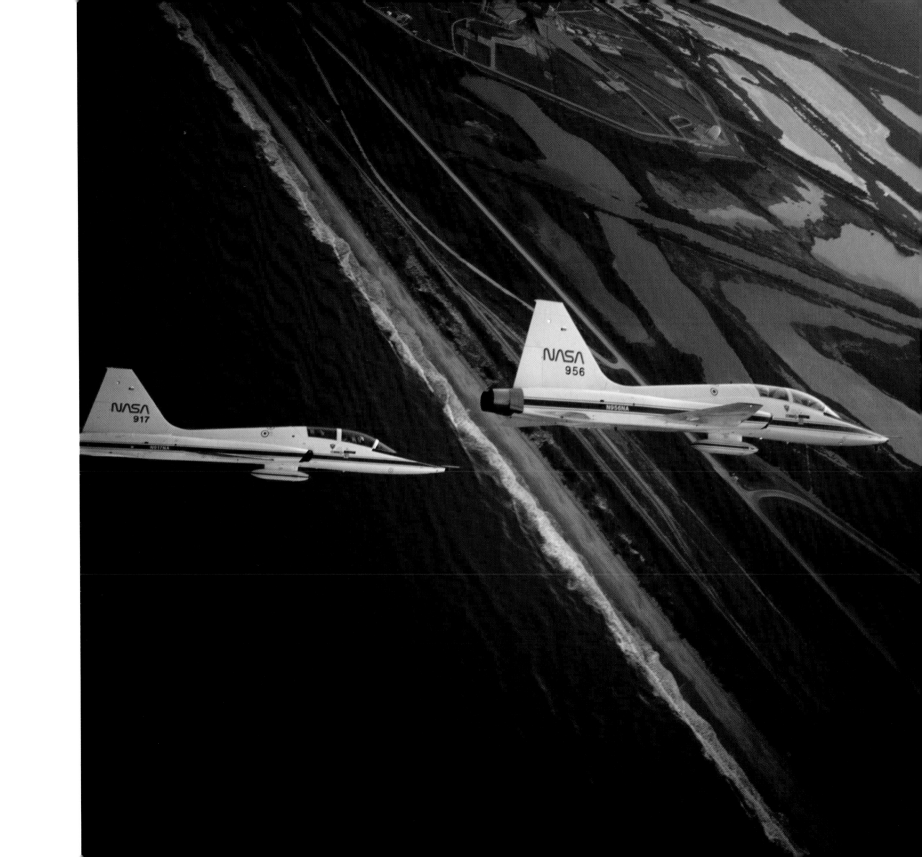

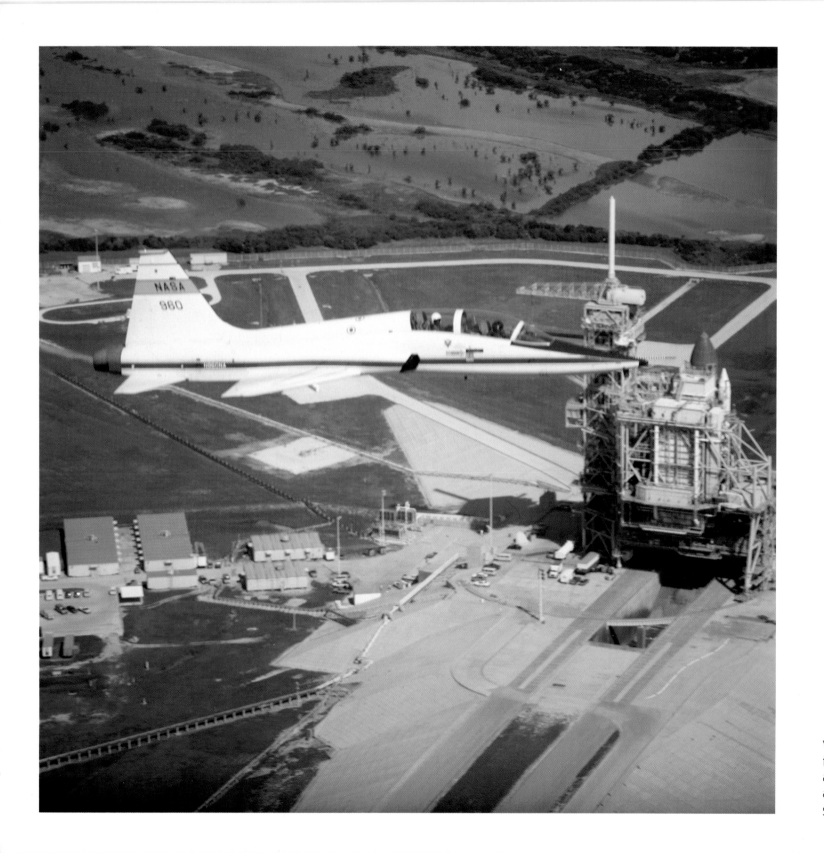

We tighten up the turn, I am working the focus for you but this camera is manual focus and I can't get my eye on the viewer. Things are changing so fast, but I am ecstatic just to get you here at all!

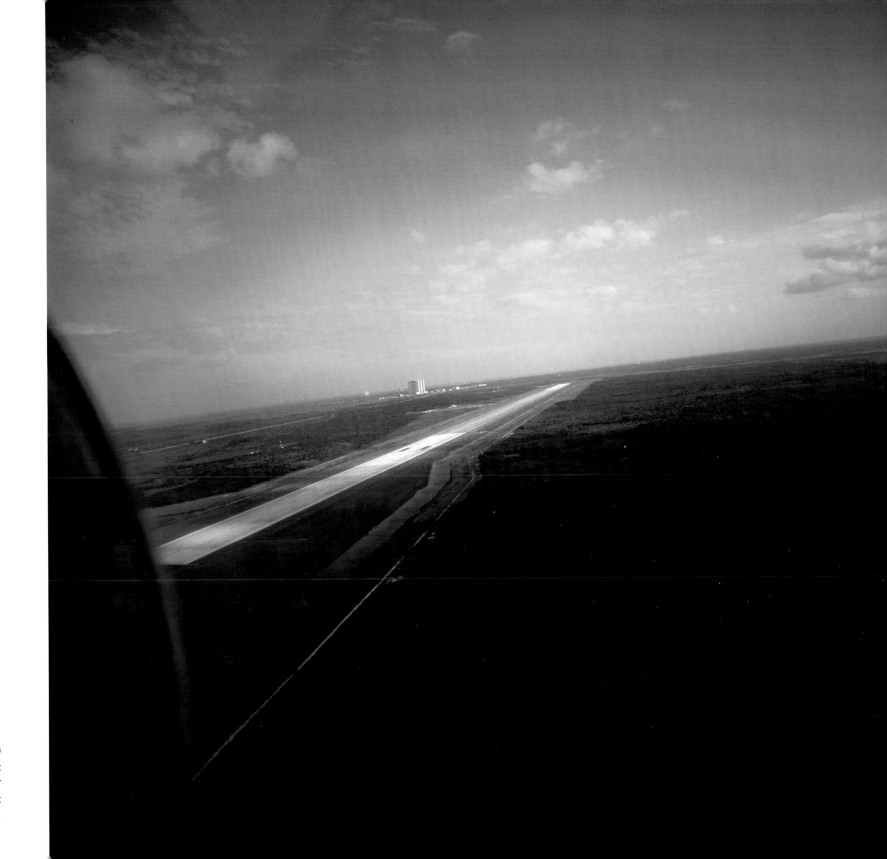

Time to land. This is the 15,000 shuttle landing runway with the VAB in the background. Our leader is on the runway, we are on a right base to land from here.

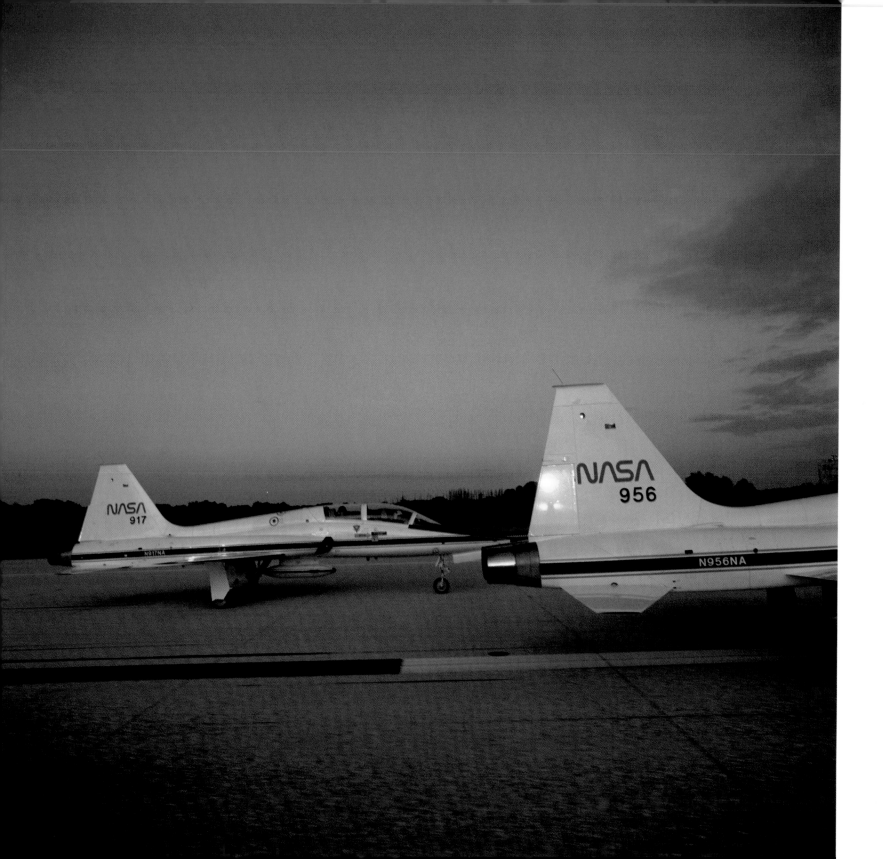

We catch up with the leader and taxi down the runway.

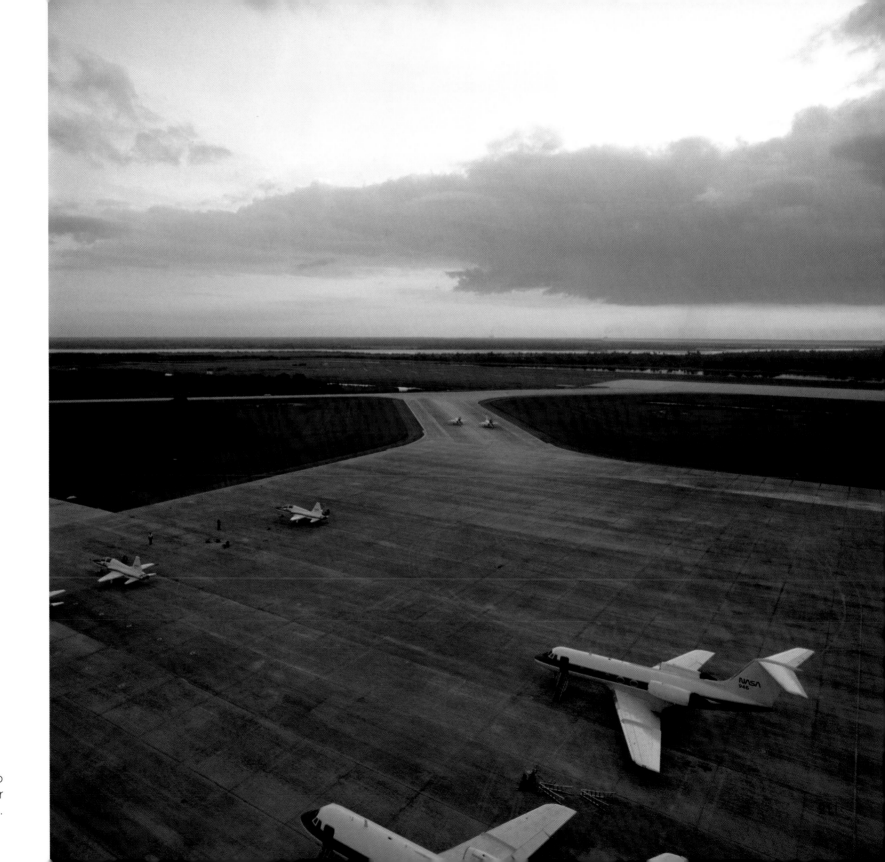

At another time, two birds pull into the ramp, the crew is ready for their arrival.

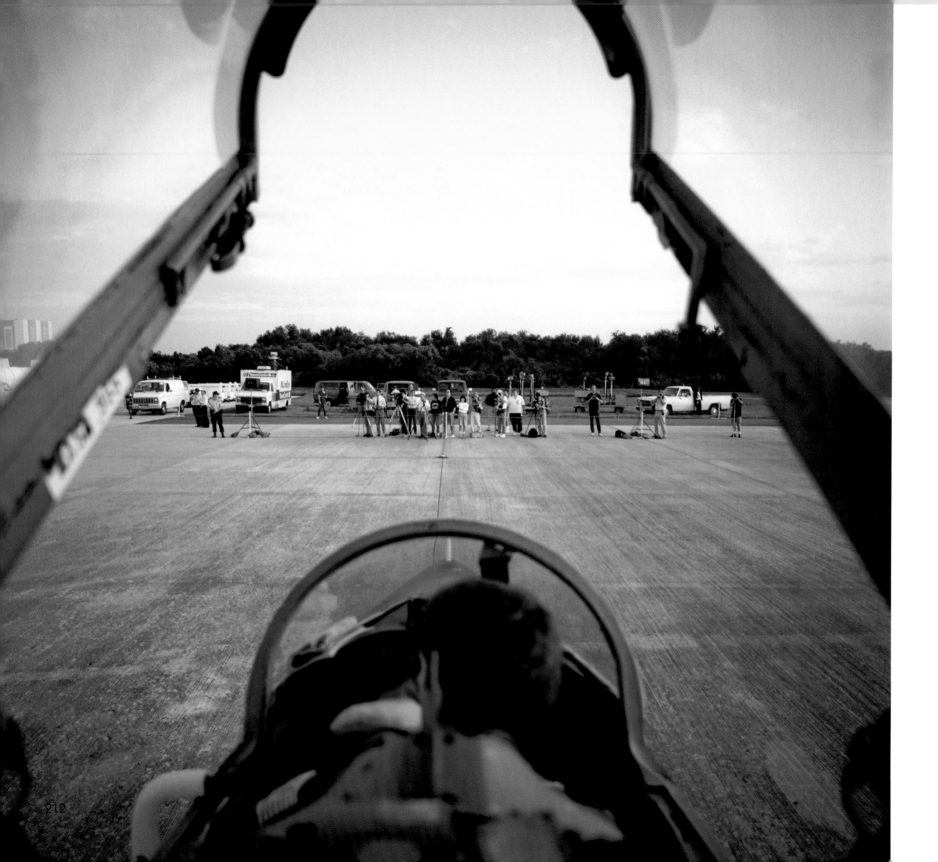

This one is our arrival at KSC for the STS-33 mission. The press became accustomed to my shooting them. John Blaha, in the front seat, is the best in the business, I would follow him to the ends of the earth, which I did.

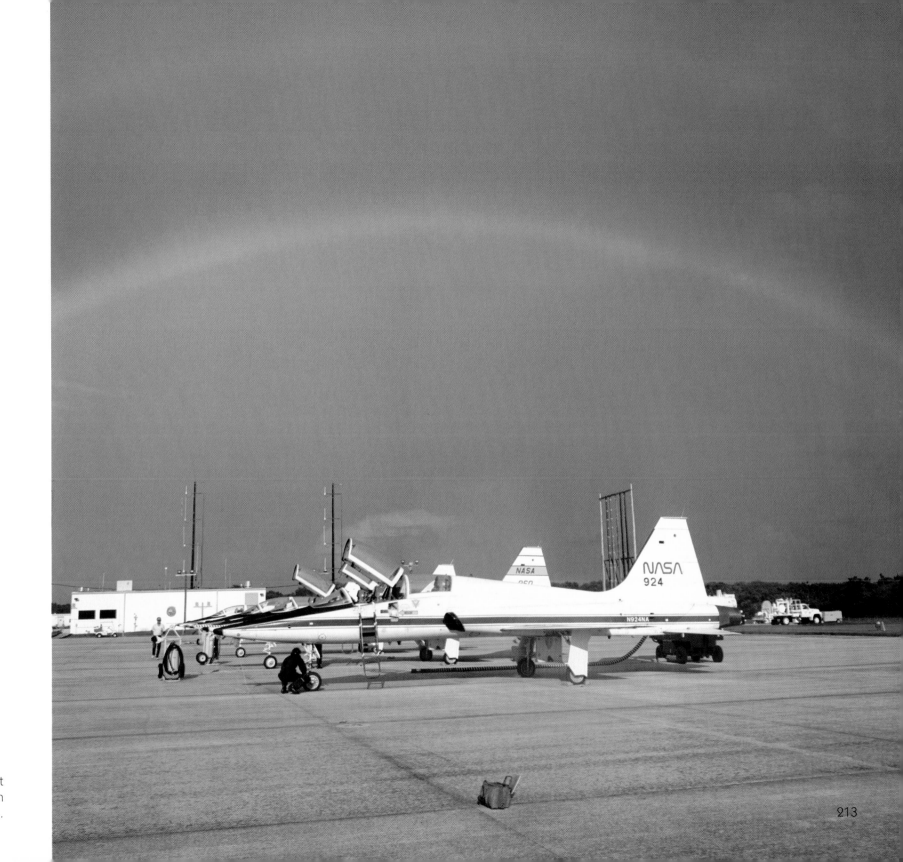

NASA 924 in preflight
inspection for departure from
KSC.

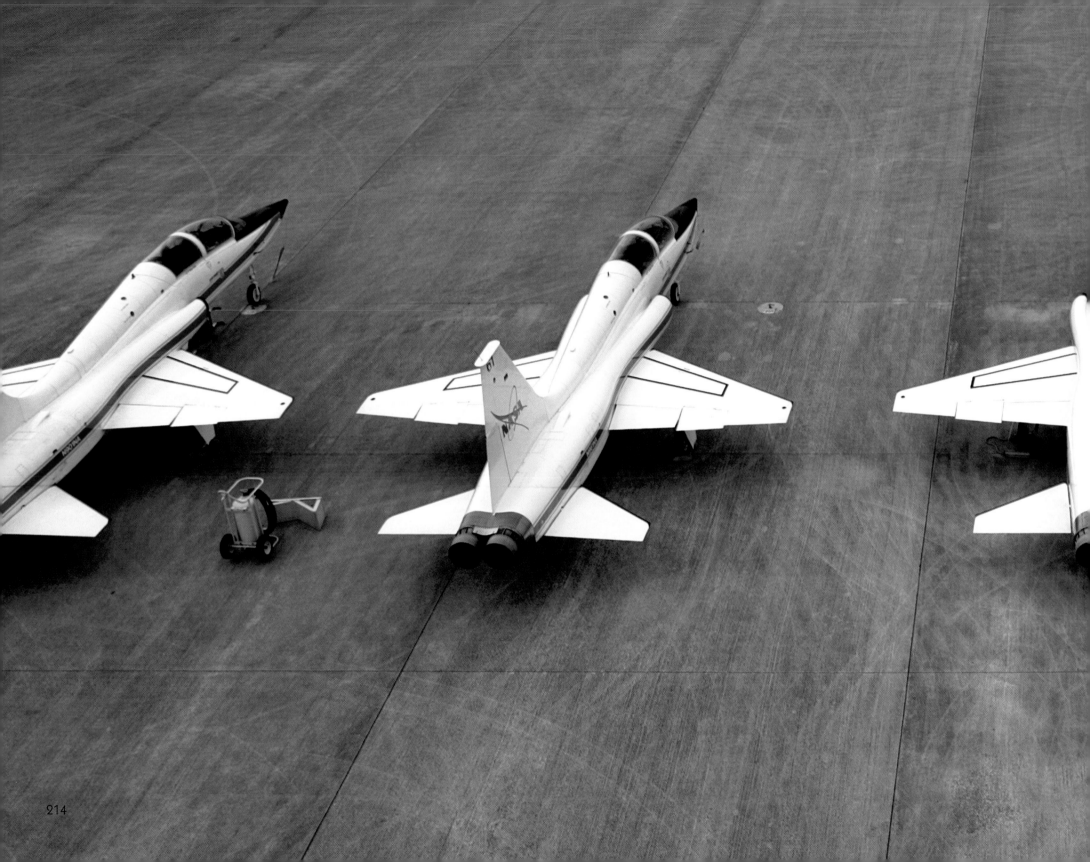

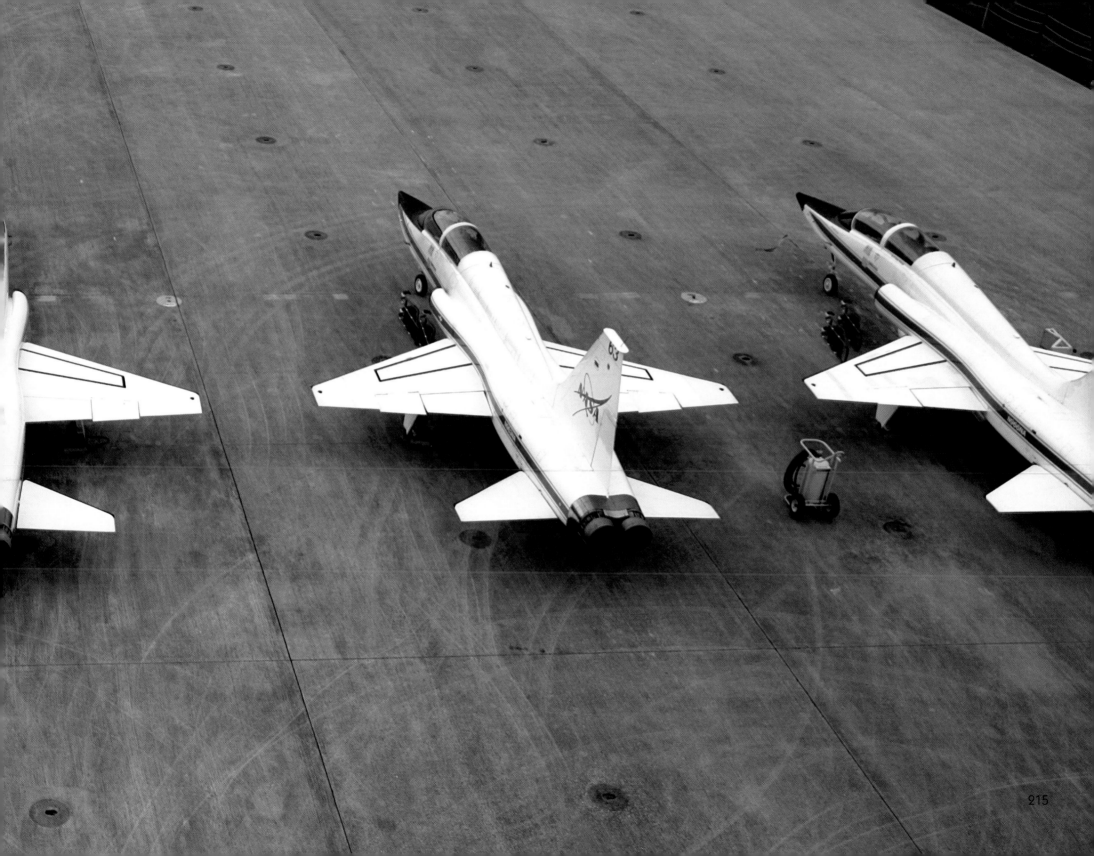

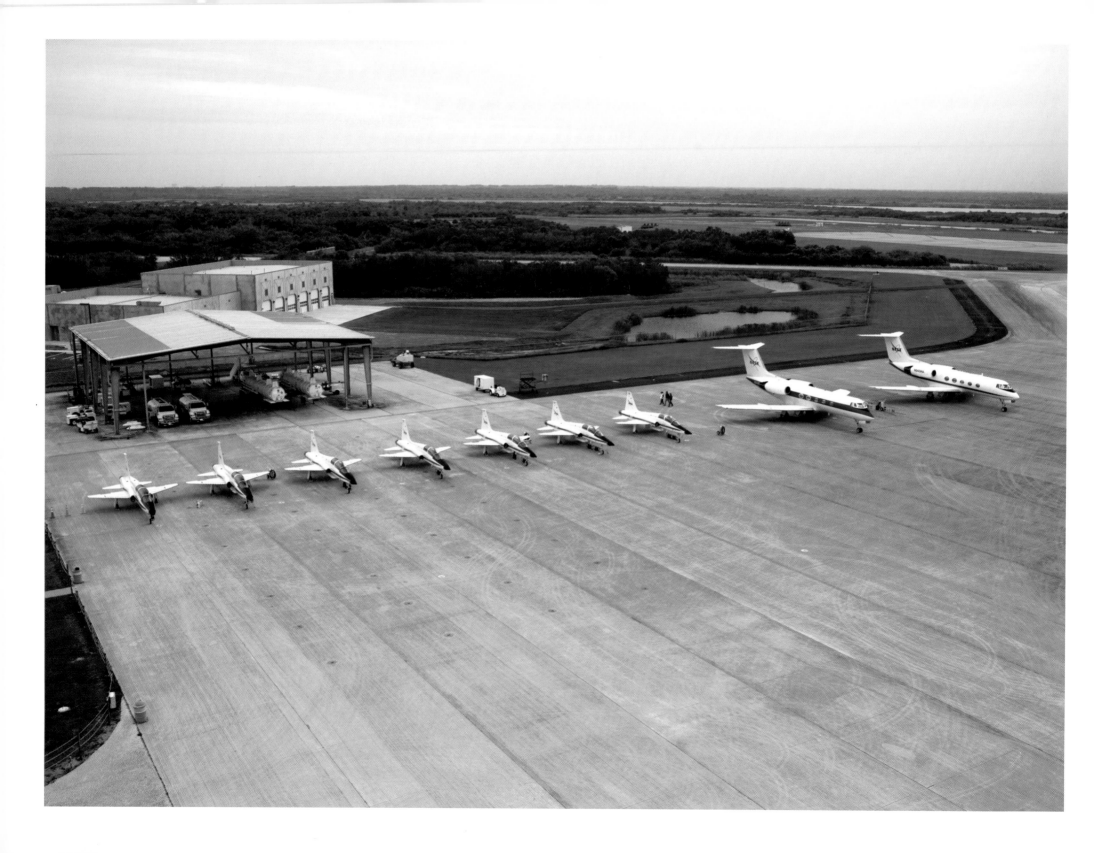

Flight line at the Shuttle Launch Facility in preparation for the night launch of Discovery to the International Space Station, Mission STS-116, Dec 9, 2006 at 8:47pm.

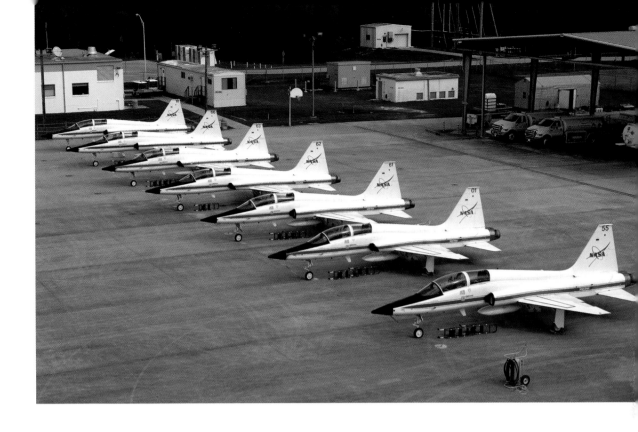

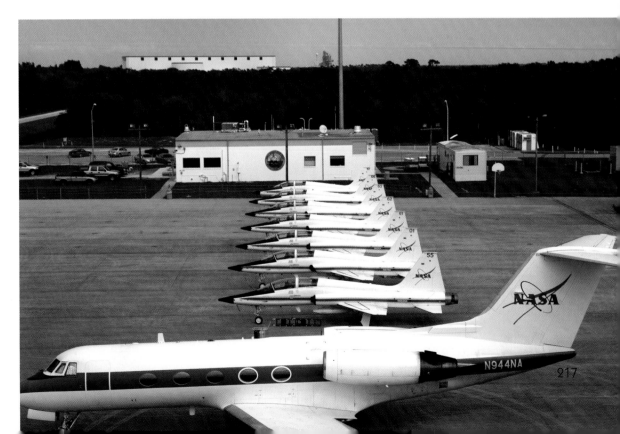

Building at the upper left is the Apollo Saturn V Center. Just to the right of it is Discovery on Launch Pad B.

217

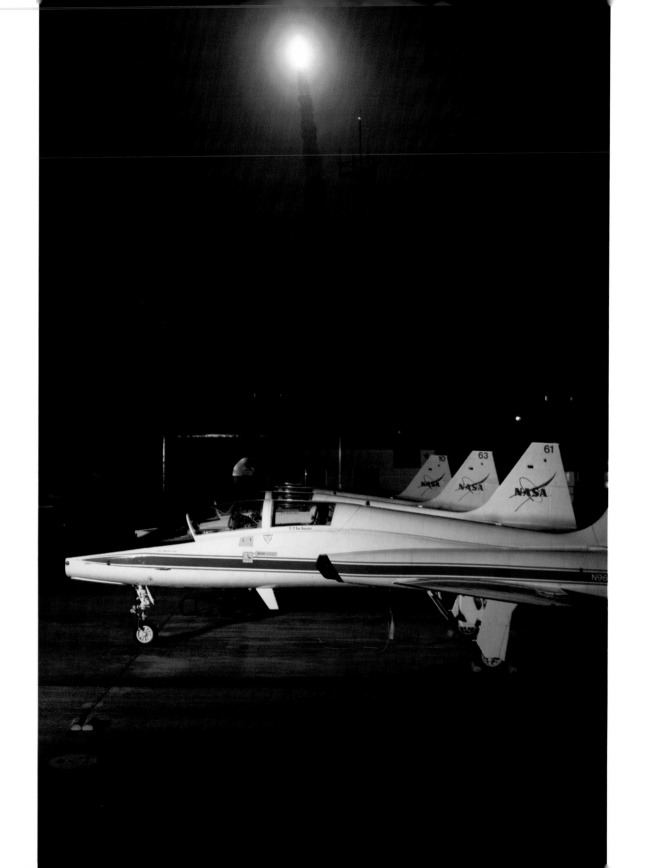

Night launch of Discovery to the
International Space Station, Mission
STS-116, Dec 9, 2006.

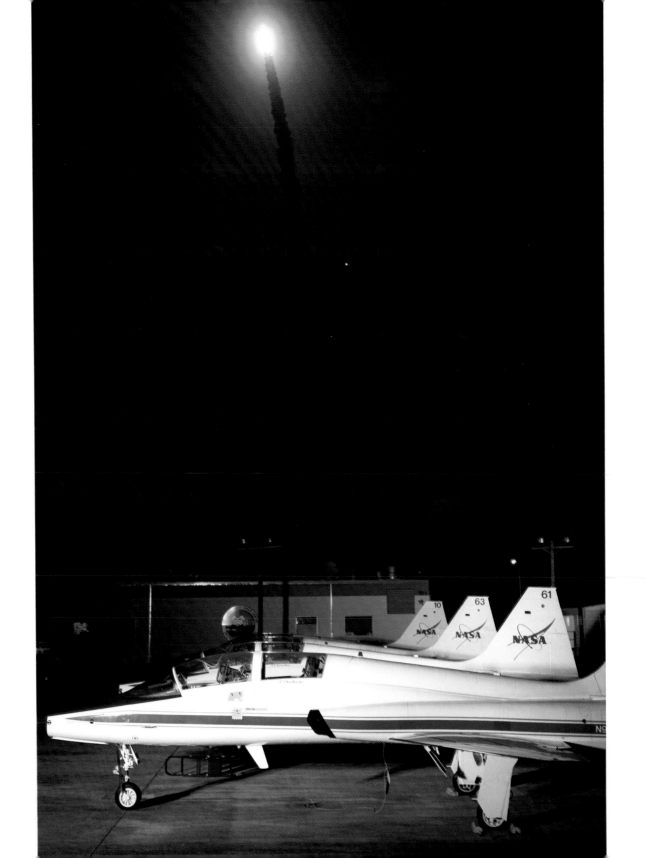

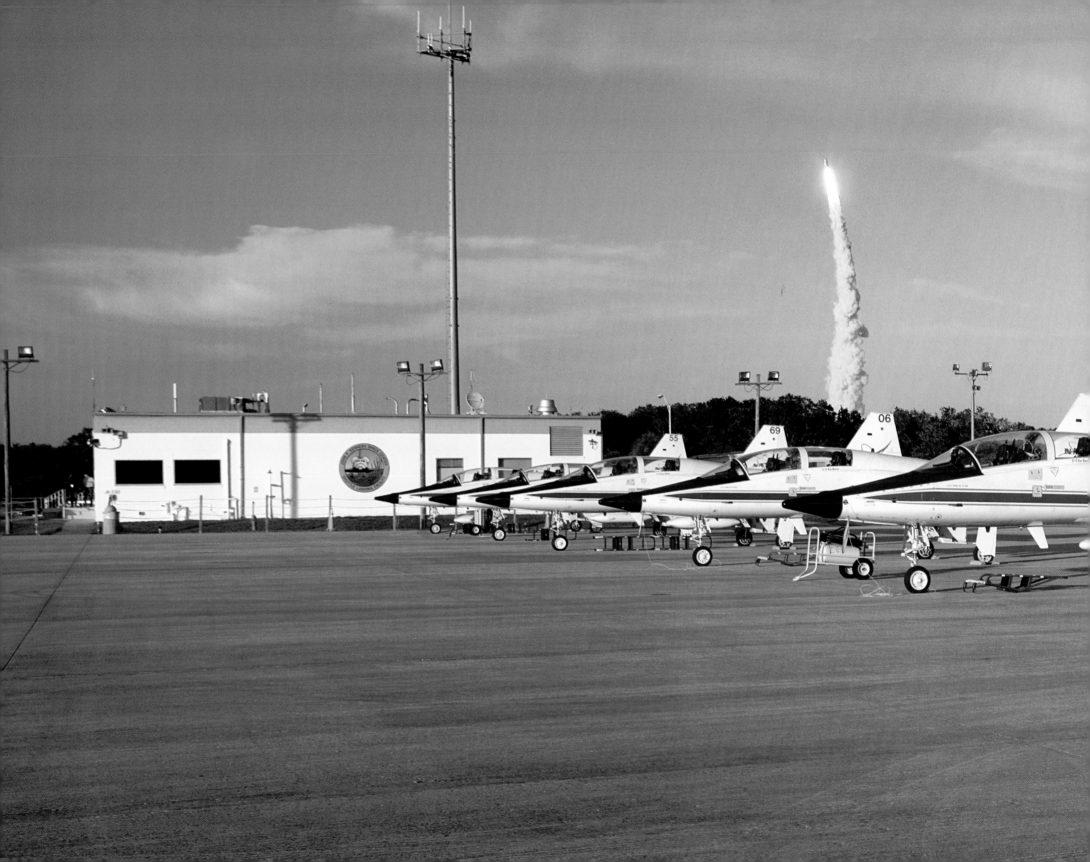

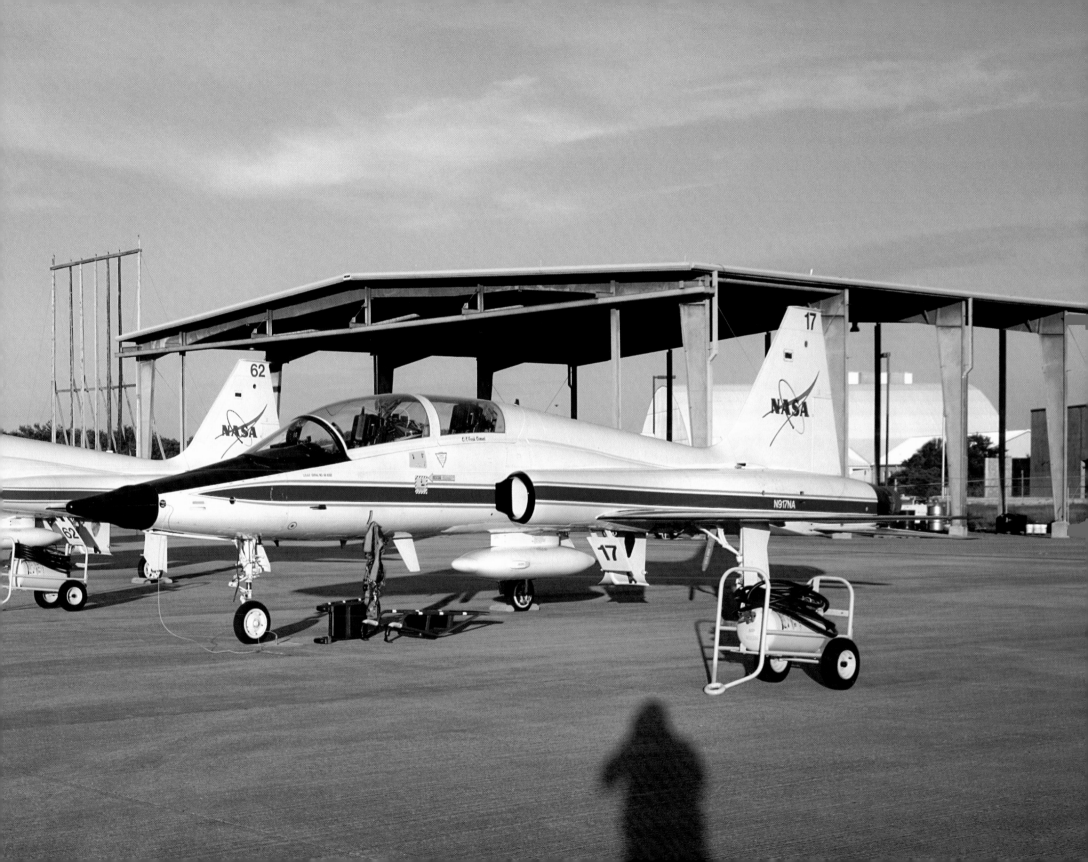

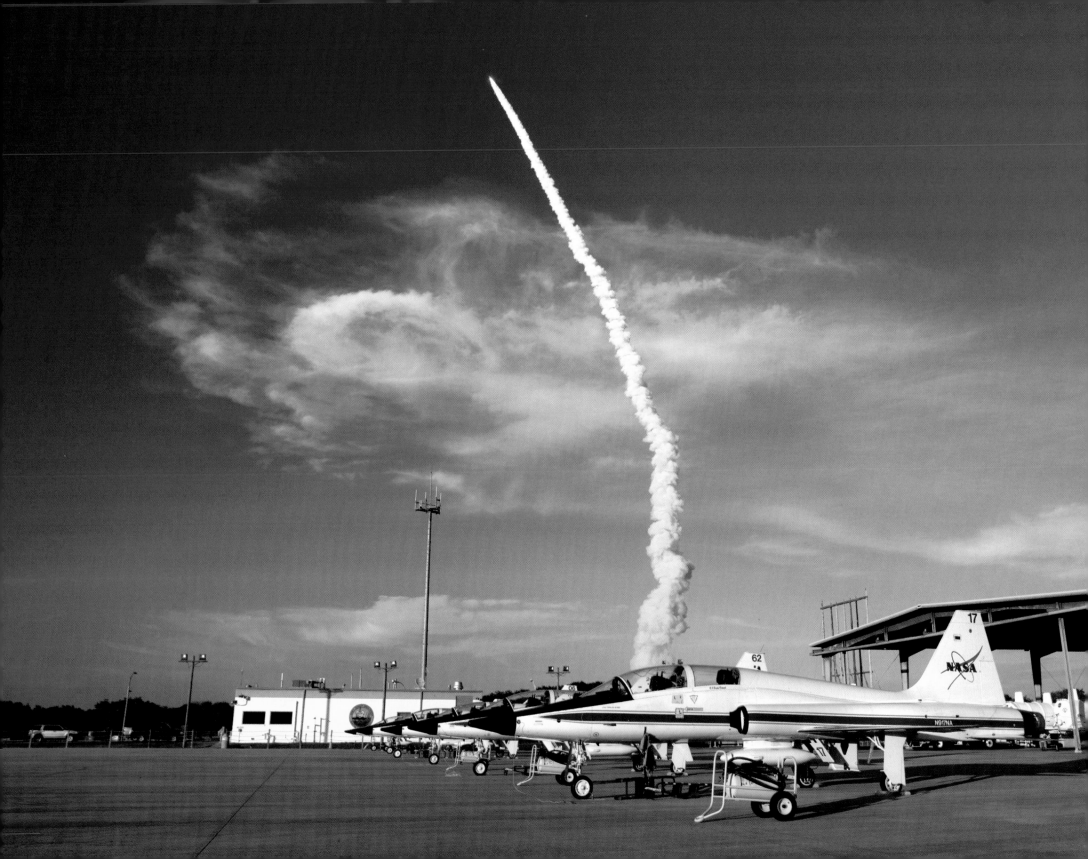

Mission STS-117 launch of Atlantis to the ISS
from Pad A on June 8, 2007 at 7:38pm.

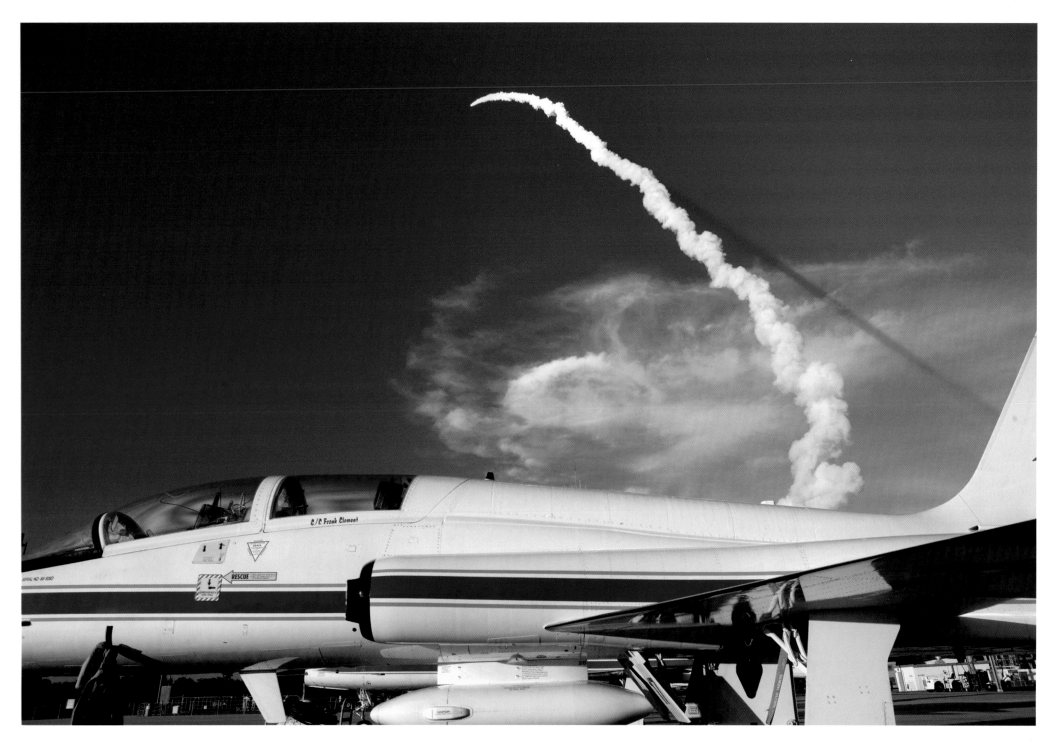

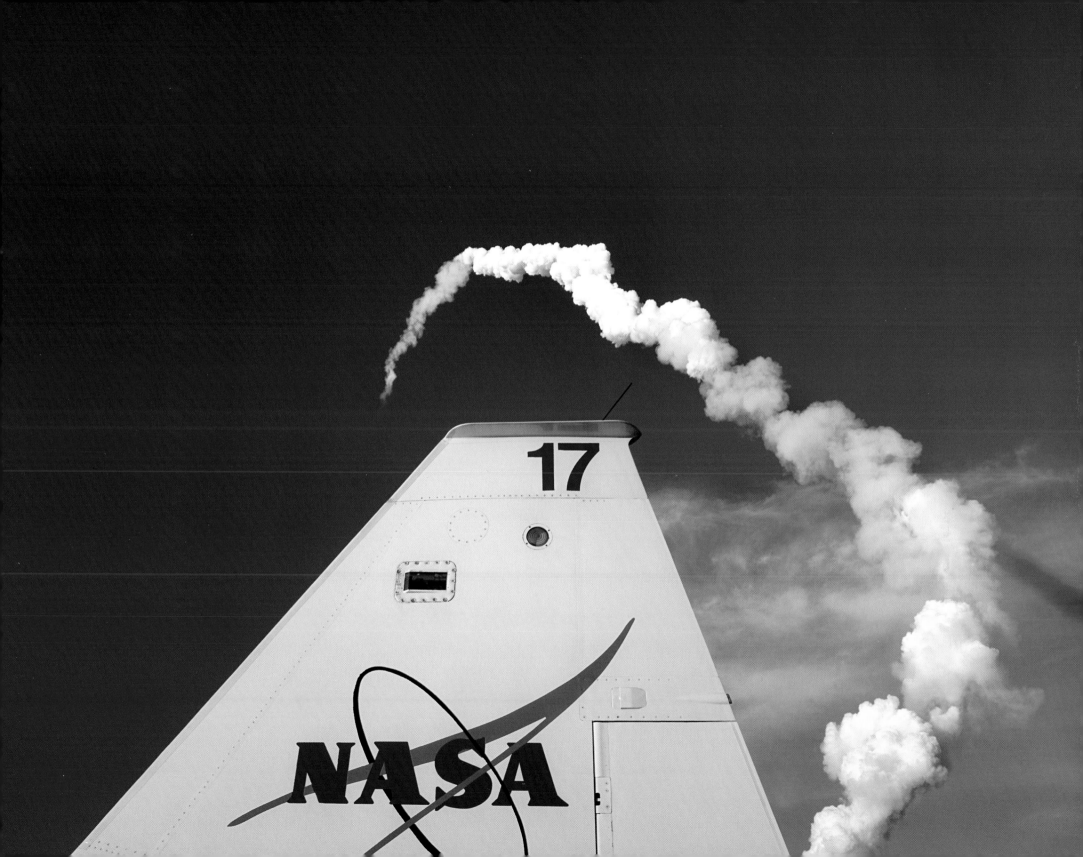

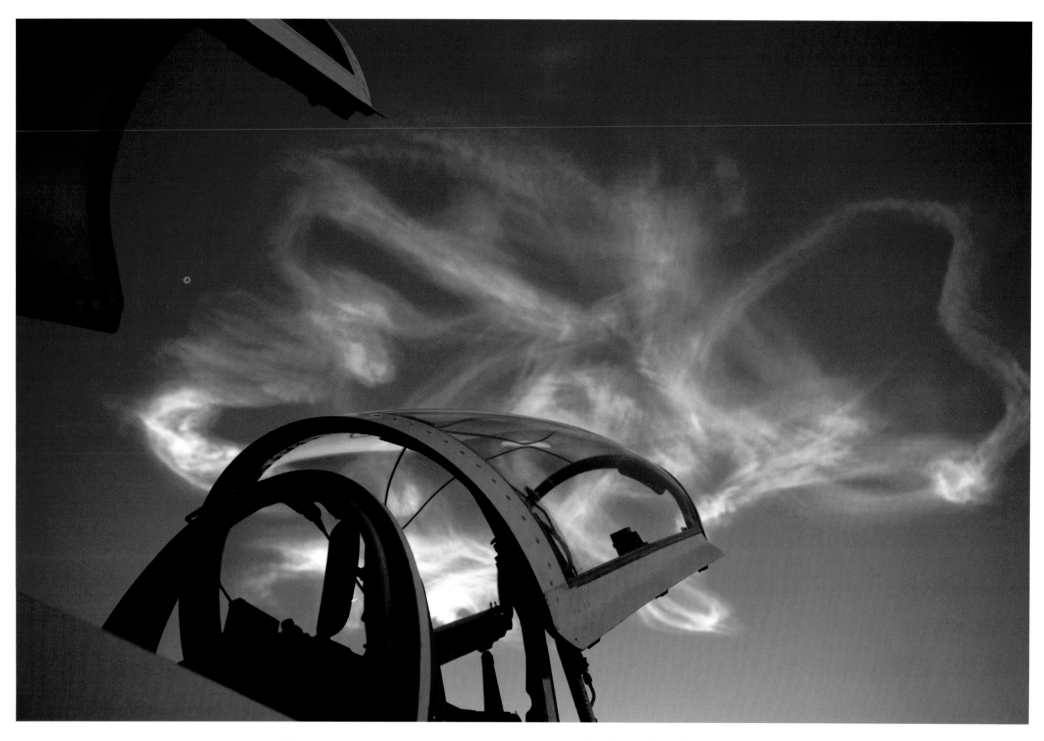

In total amazement I watched the launch plume and possibly parts of a cloud over the Atlantic transit into this extraordinary three-dimensional structure.
I would have expected the plume to disperse and to lose its definitive structure.

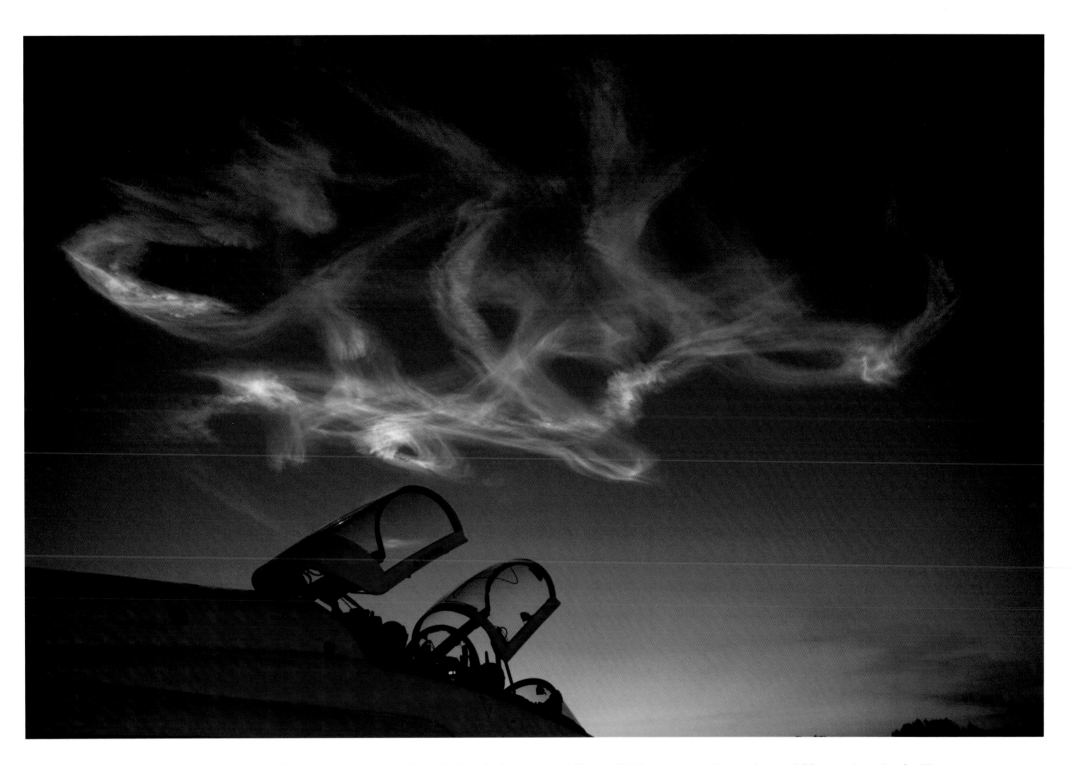

This thing became more structured and ever more precise in its detail and of course in addition to this the sun was setting and some T-38 were departing for Ellington.

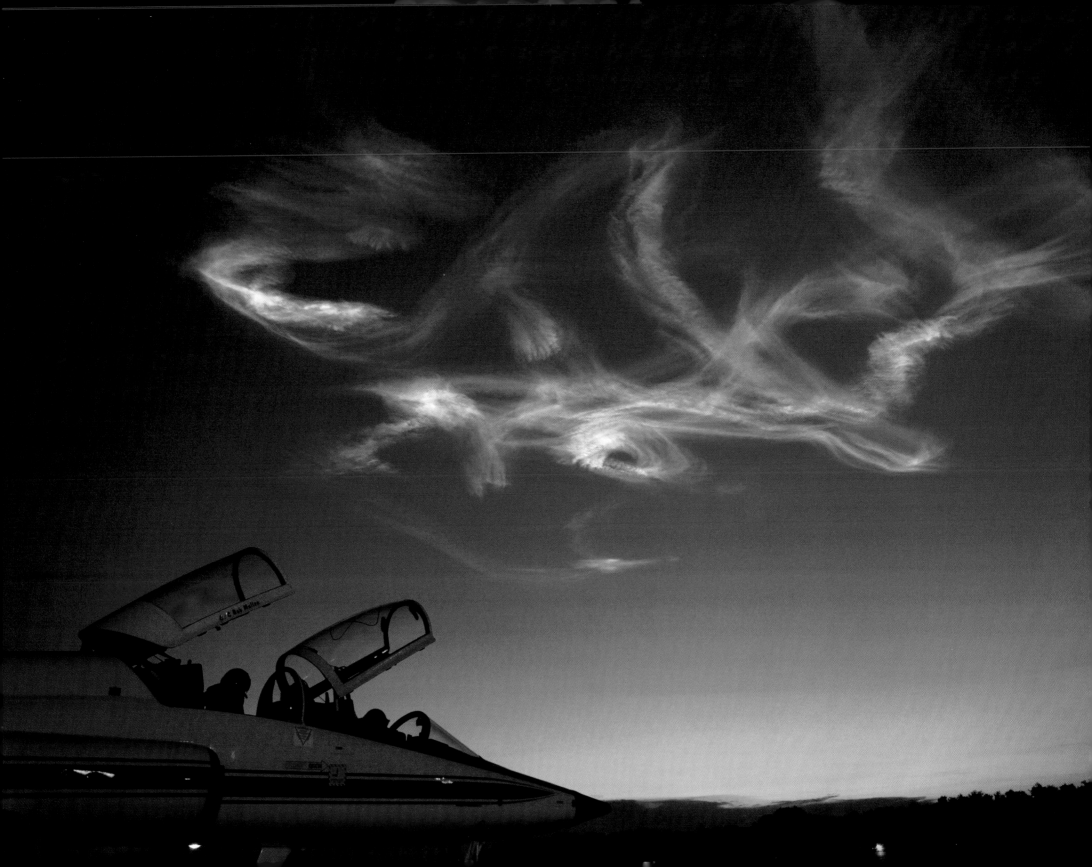

Like so many of my pictures, this one got
handed to me - all I did was shoot it.
But, I was there, and I had a camera.

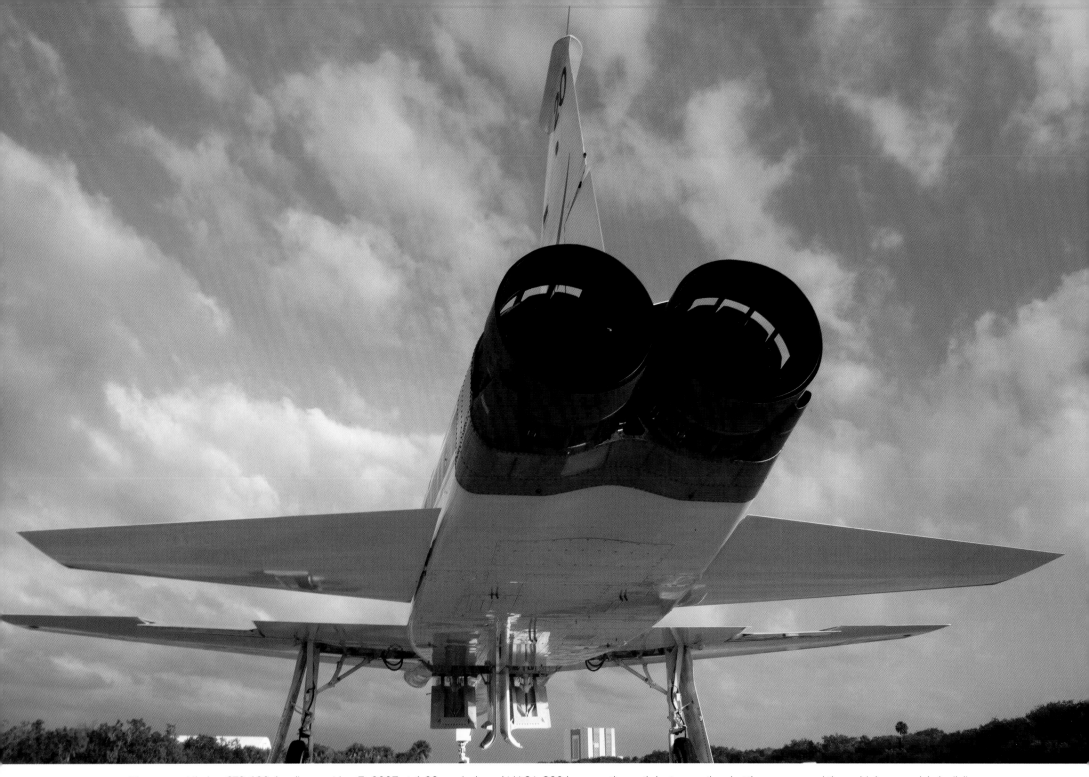

Discovery, Mission STS-120, landing on Nov 7, 2007 at 1:02pm. I placed NASA 920 here on the path between the shuttle runway and the vehicle assembly building. When Discovery is towed back to the barn I will be able to catch them together.

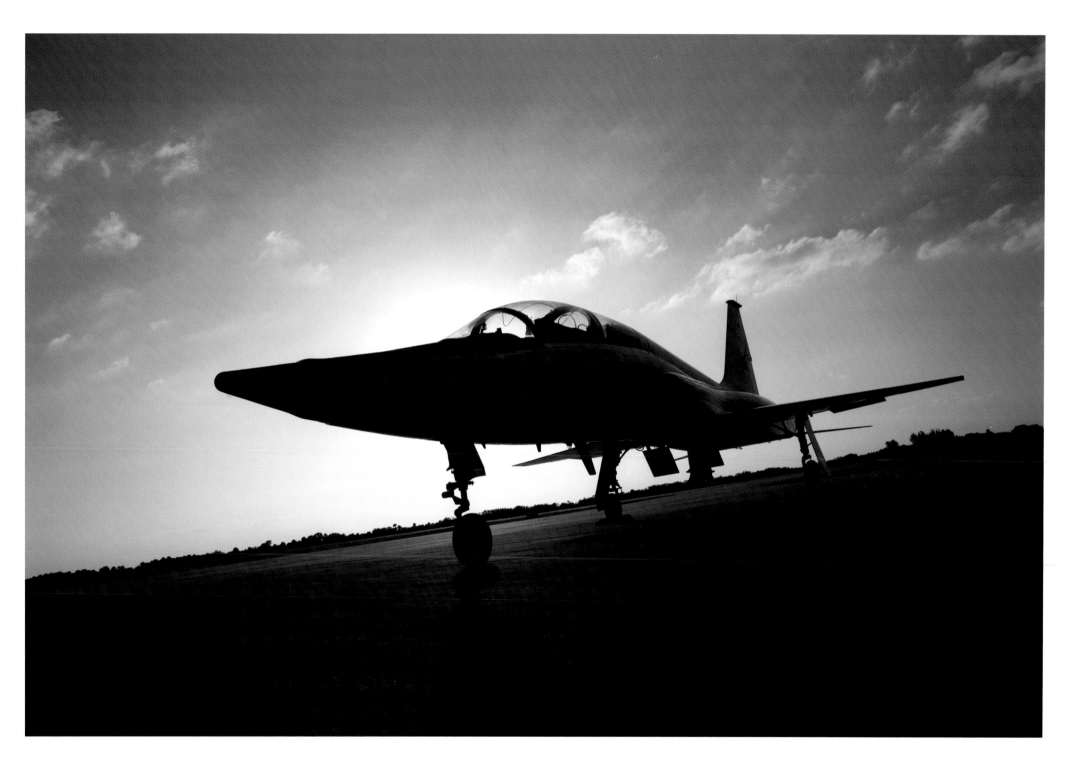

You have seen a lot of this sleek forward quarter shot but never when backlit.

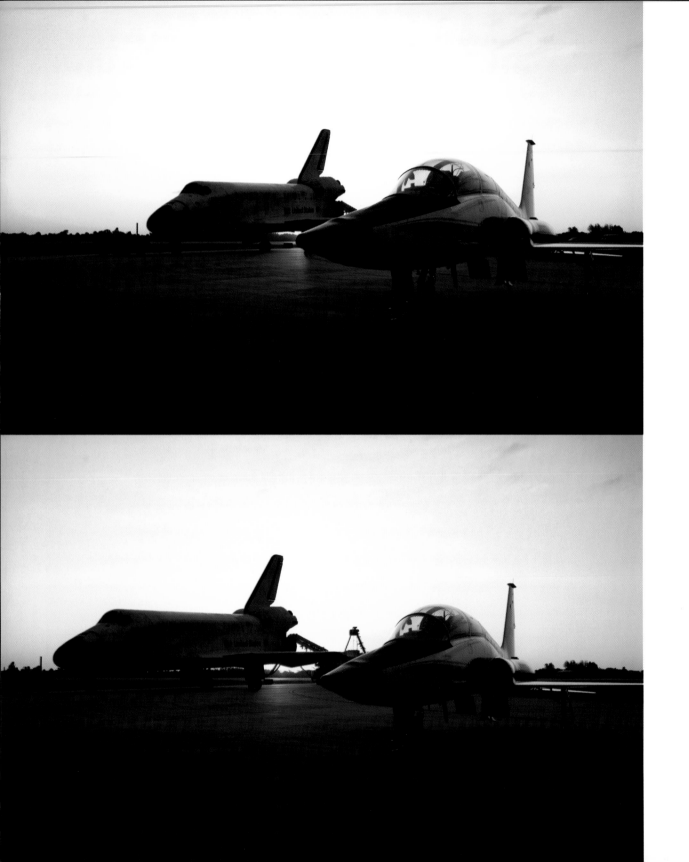

When I do these set ups there are usually 30 to 40 workers and mechanics who follow as they know something is going to come together and if nothing else it is going to be a bunch of fun.

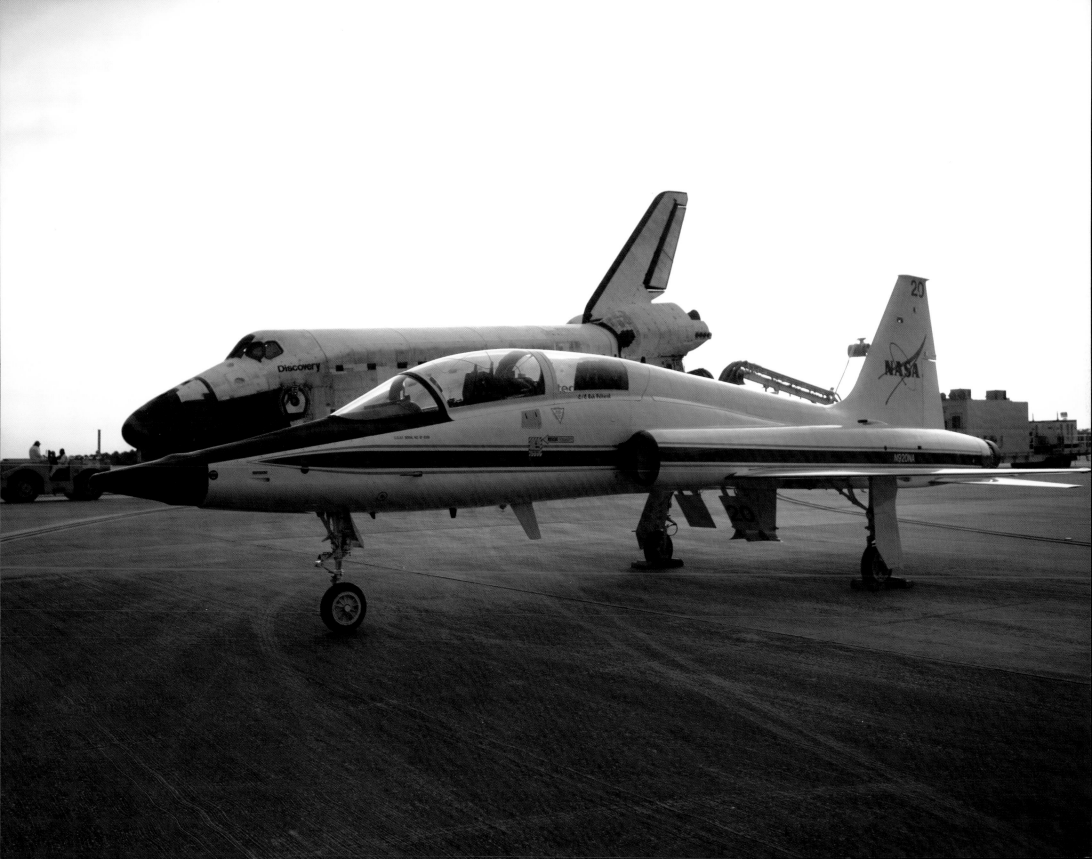

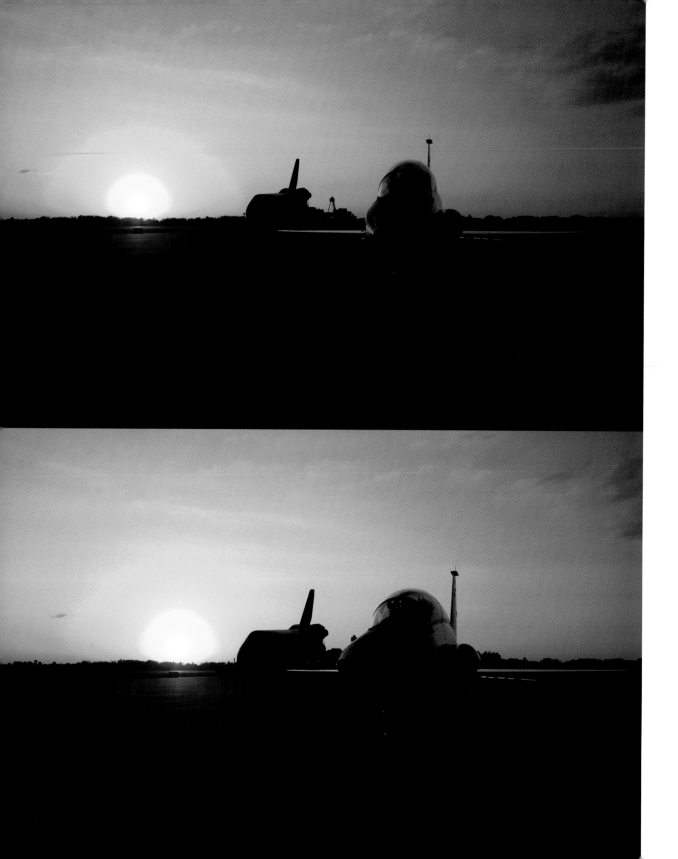

Have you noticed dear reader that the sun is always fully cooperative in all of my little endeavours?

As they pulled Discovery along Runway 15 to our rendezvous with 920 our expectations for this shoot rose as the minutes rolled by and reached an almost unbearable level as she rounded the corner and as always the sun was right on schedule.

The Discovery crew stopped the tug to give us all the time we needed to shoot or just to enjoy the occasion, a huge cheer went up from the "crowd".

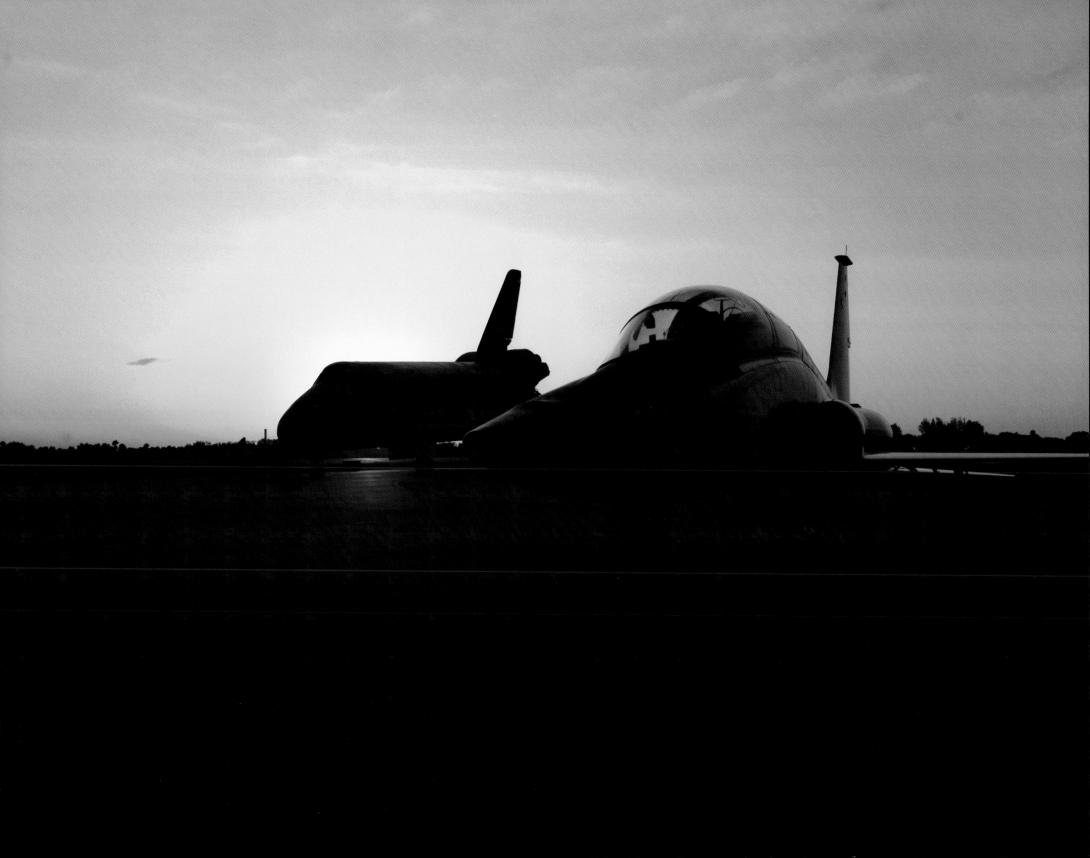

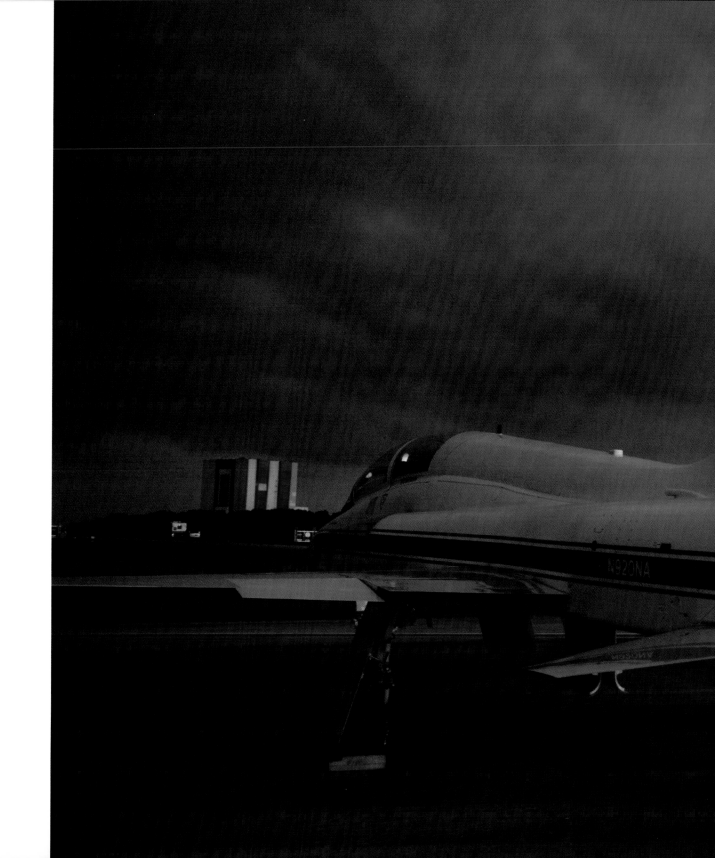

I thought that the spectacular part
of the shoot was "over" when
Discovery moved on but of course I
kept shooting.

At this point I was running back
and forth across the ramp working
the sunlit face of the VAB and the
parallelism of the vehicles with
special emphasis on the tails and
that is all I expected to get - the
powerful iconography of the VAB
and the connotative chords played
by the parallel vehicles.

Not till I got home and downloaded
this thing did I appreciate the extent
and multiplicity of the expressive
power in this scene.

236

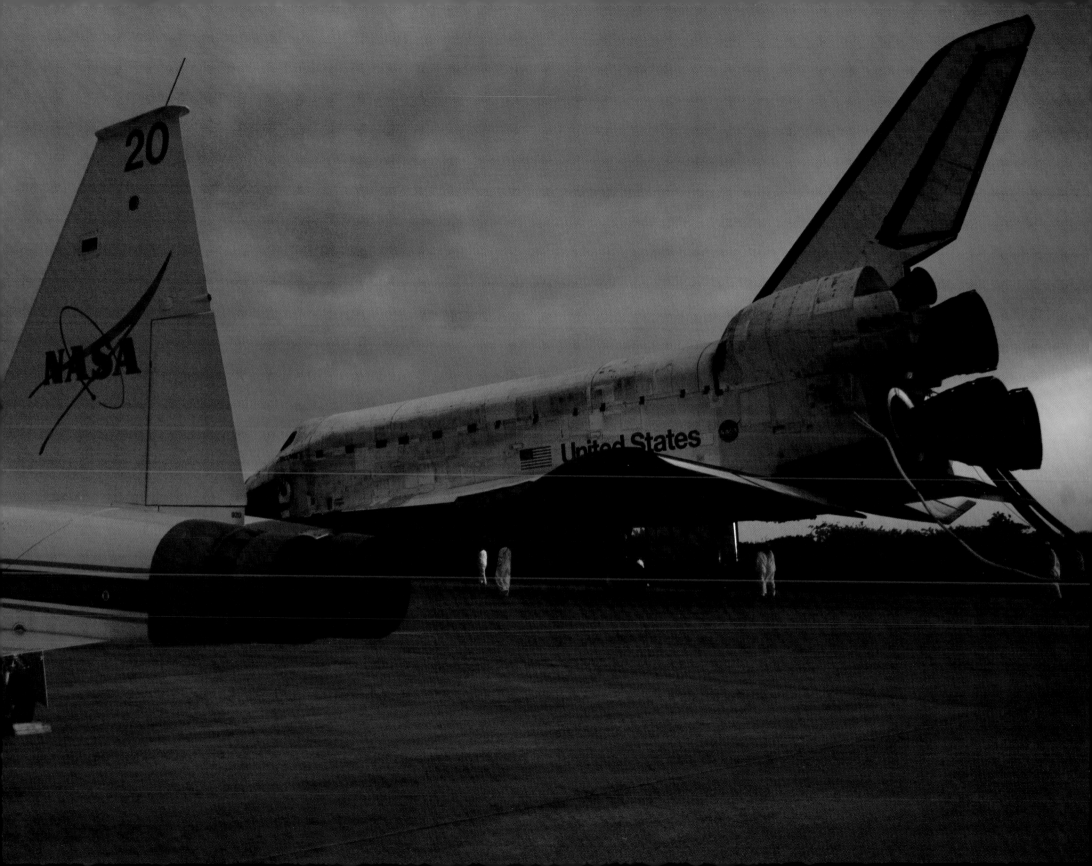

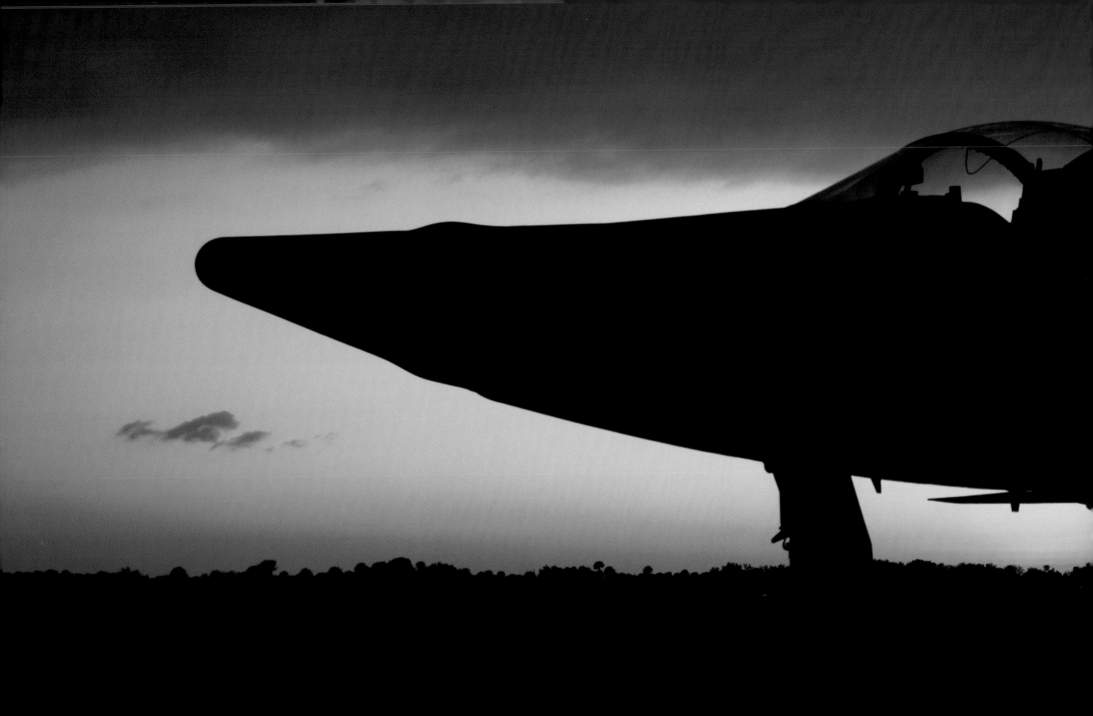

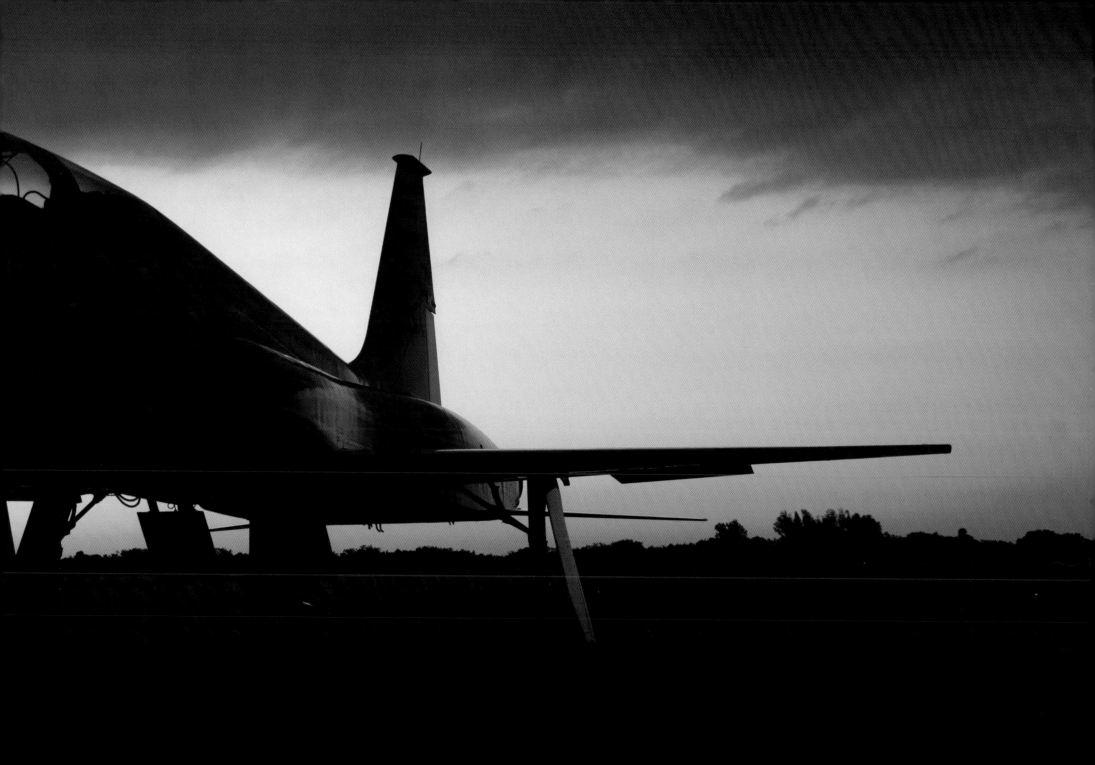

Discovery has gone to the barn for a well deserved rest but we are goin' to keep working the day.
Somebody put that dark bank of clouds there, parallel to the horizon and with just enough room to silhouette this beauty in the light.

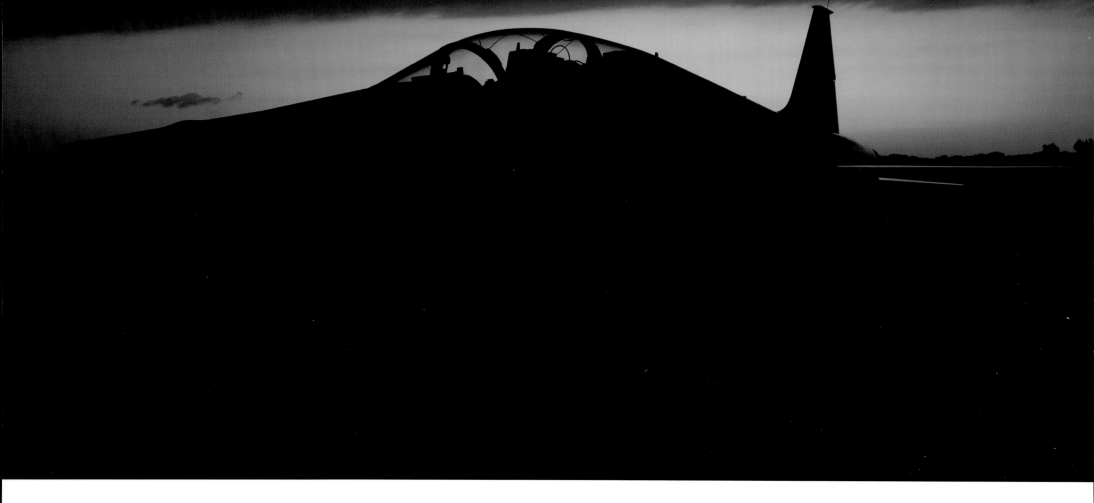

Now we' got a high speed ocean racer floating in dark water.

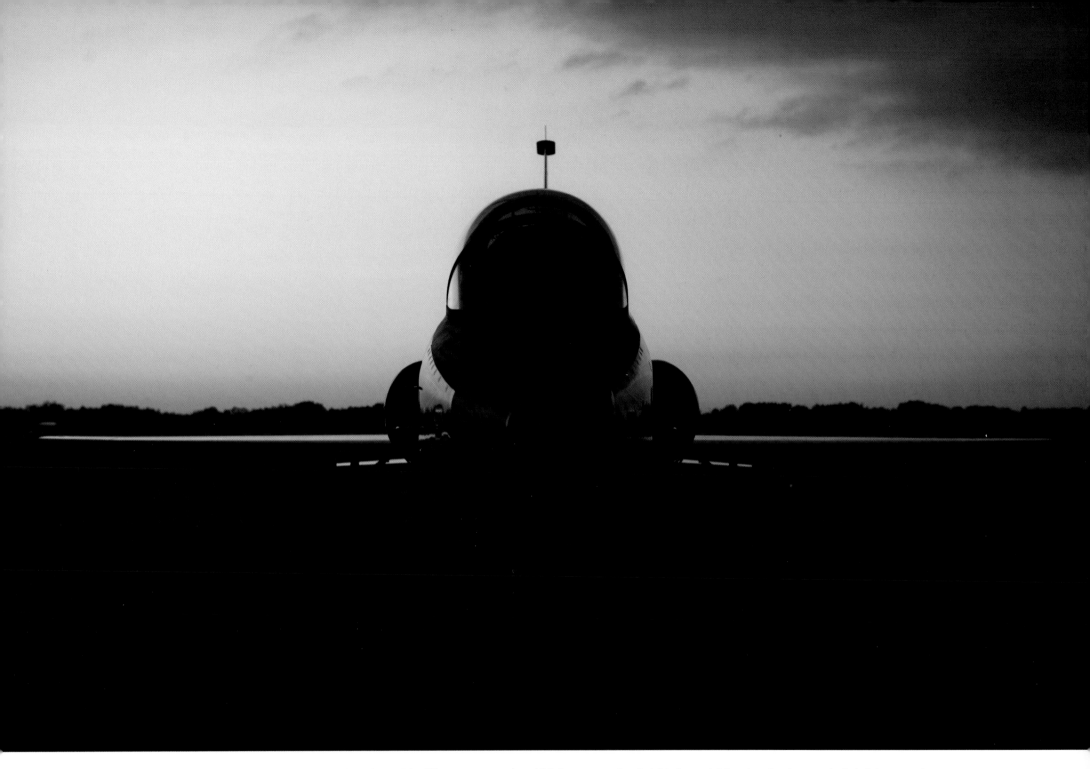

This straight into the nose dark silhouette is abundant with different perspectives. This is a great wing, bright sharp stainless in a background of dark trees and grass. The jet intakes, the nose, bubble canopy and the tail fit into each other just fine.

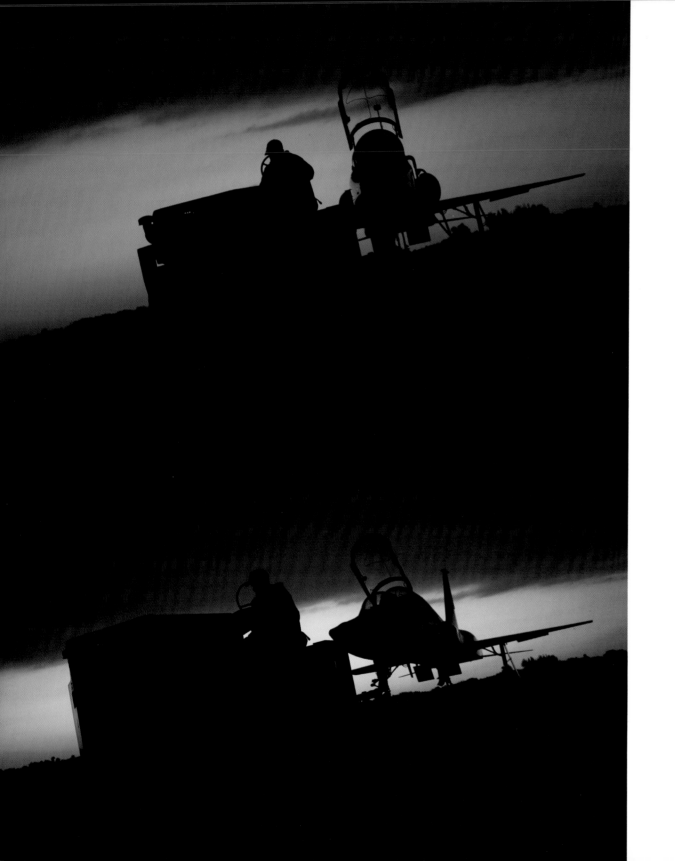

There is a mechanic in the
cockpit to monitor the tow
and to use the aircraft brakes if
needed so I use the plural, they.

Their day never ends, neither
does their night. The machine is in
their hands, their heart and their
head continuously.

I call them my babies, but they are not
only my babies when I fly them, but also
when I put them to bed for the night
and when I care for them physically or
in spirit throughout the night.

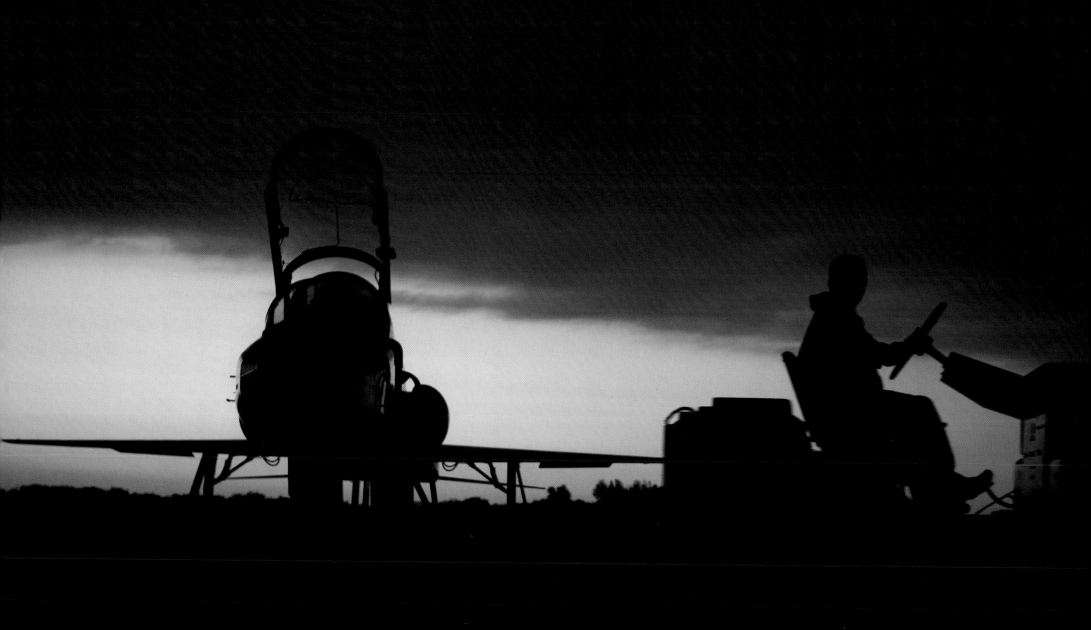

I positioned my aircraft such as to
put her in the limelight.

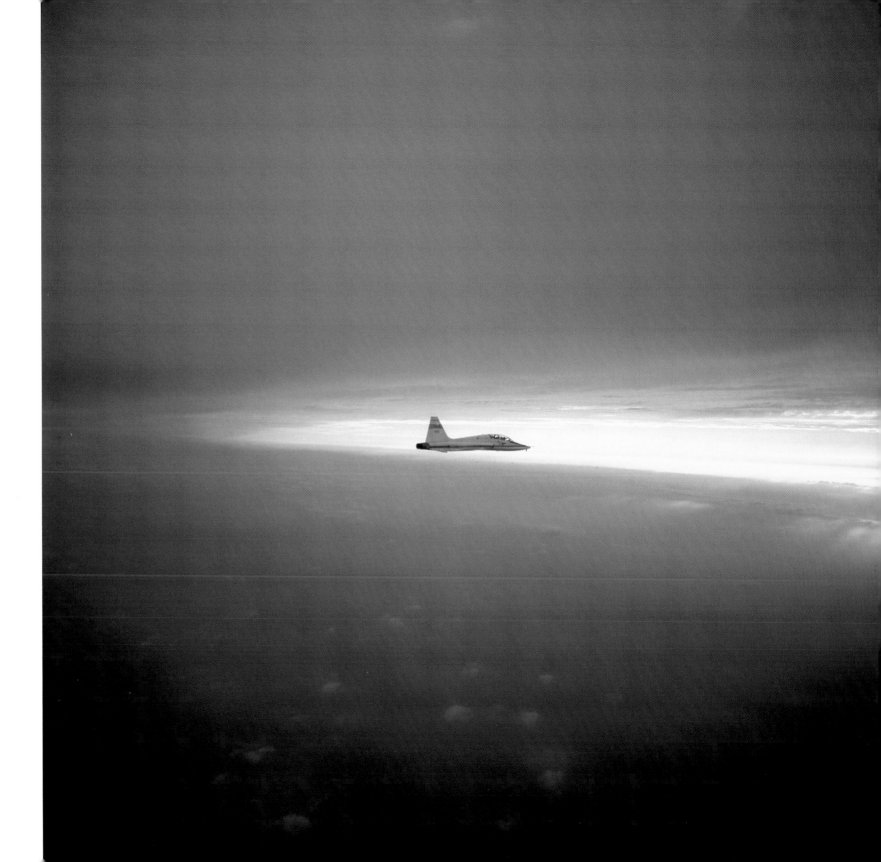

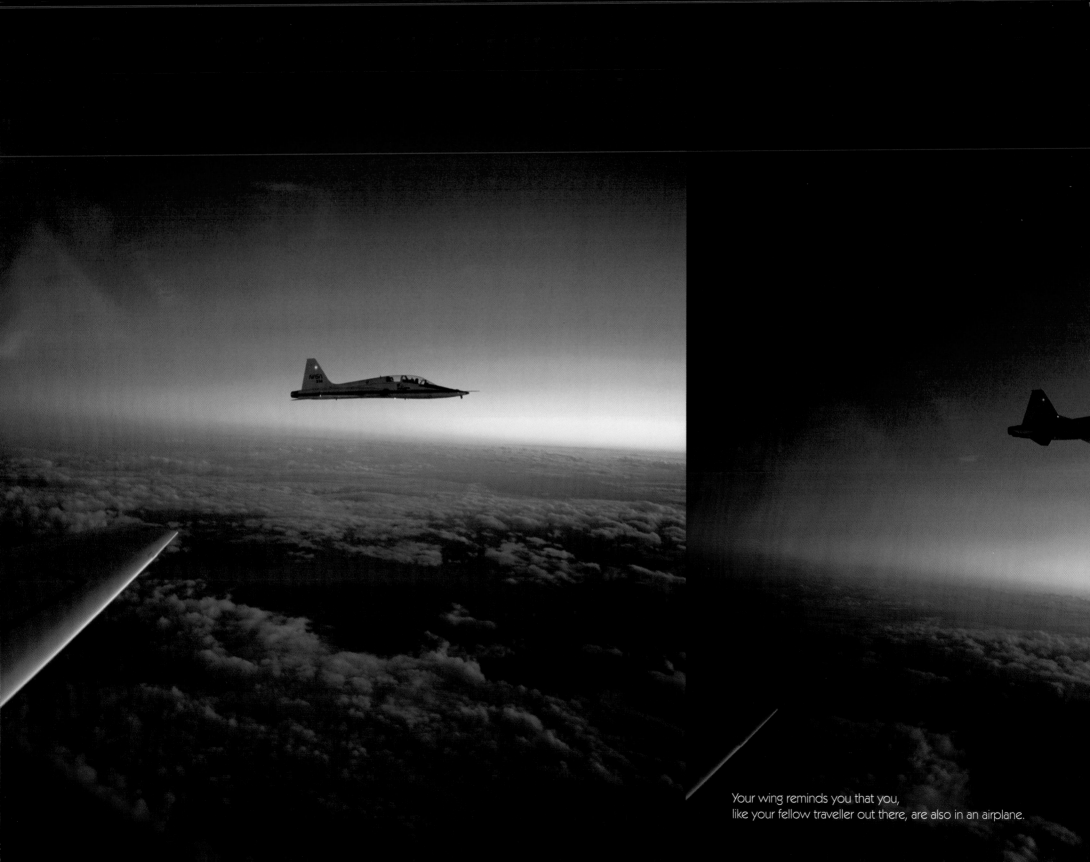

Your wing reminds you that you,
like your fellow traveller out there, are also in an airplane.

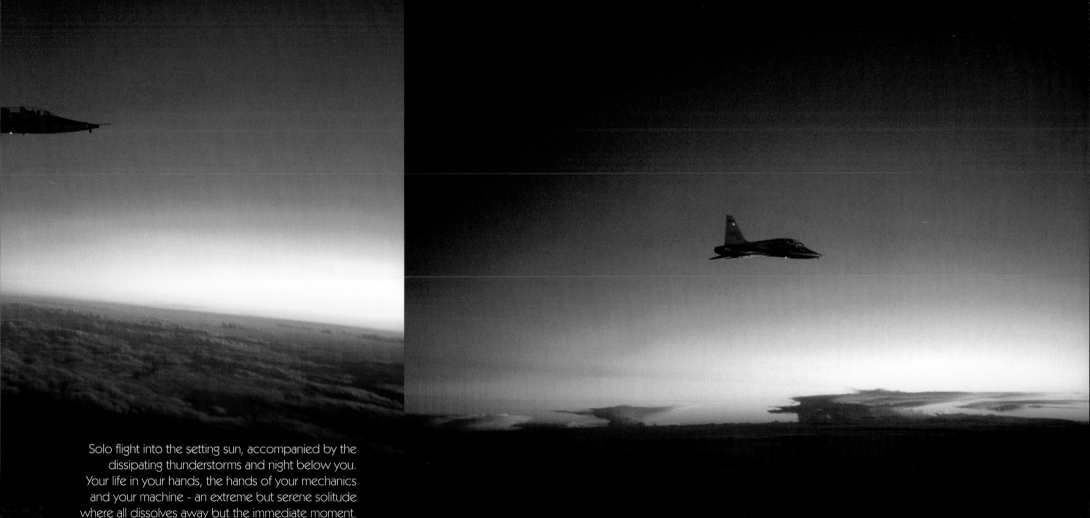

Solo flight into the setting sun, accompanied by the
dissipating thunderstorms and night below you.
Your life in your hands, the hands of your mechanics
and your machine - an extreme but serene solitude
where all dissolves away but the immediate moment.

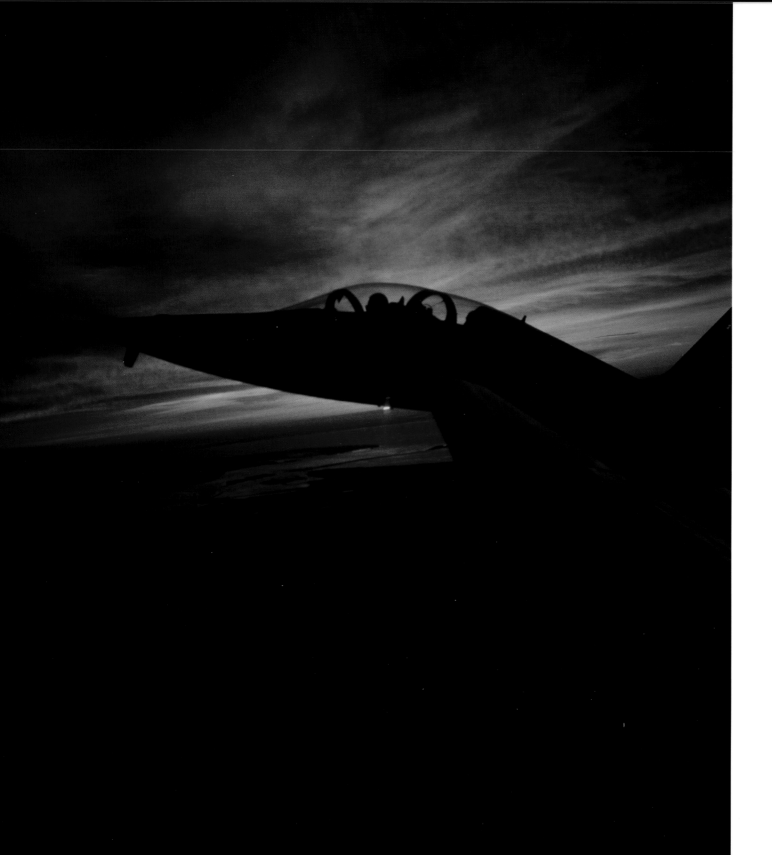

We climb out of Kennedy on a gorgeous amber evening headed for home, Ellington Field, Houston, TX. We look to the West over the Indian River the sun climbing into the sky 'cause we are climbing.

Walking all over this incredible scene with my Minolta Spotmeter I know it ain't goin' to give me a break; I got Ektachrome 64 in the Hasselblad and no light.

So I got a very long exposure and we're bouncing all over the place and I got manual focus and can't get my eye that close to the viewer cause of the mask and helmet; so, all I got is prayer.

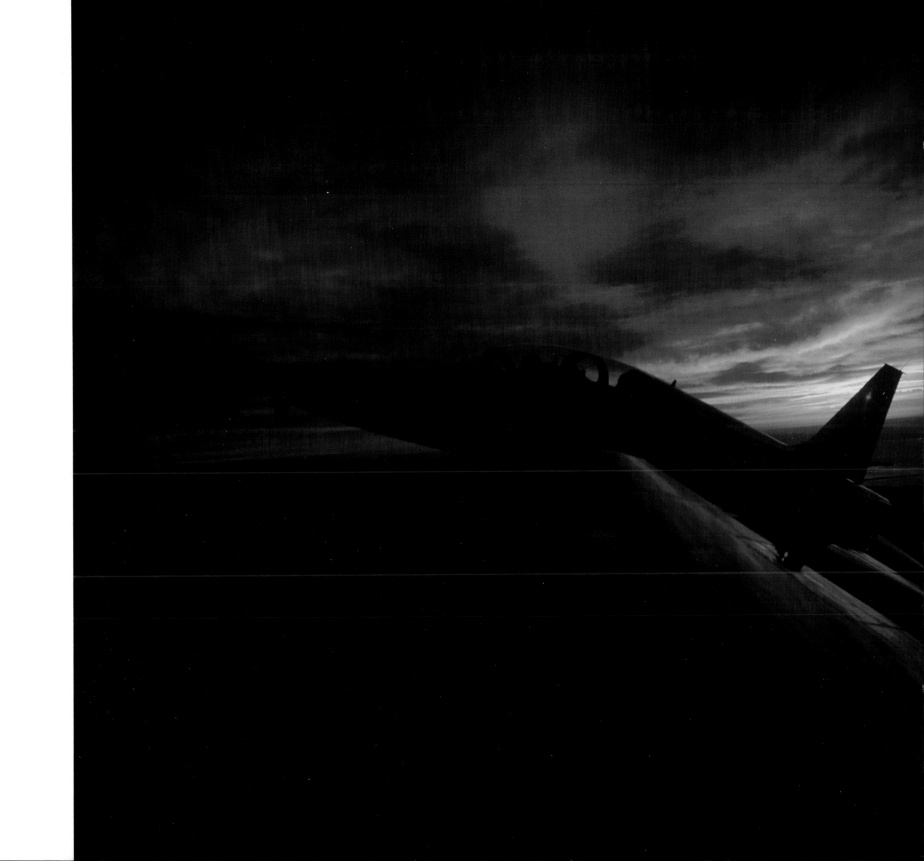

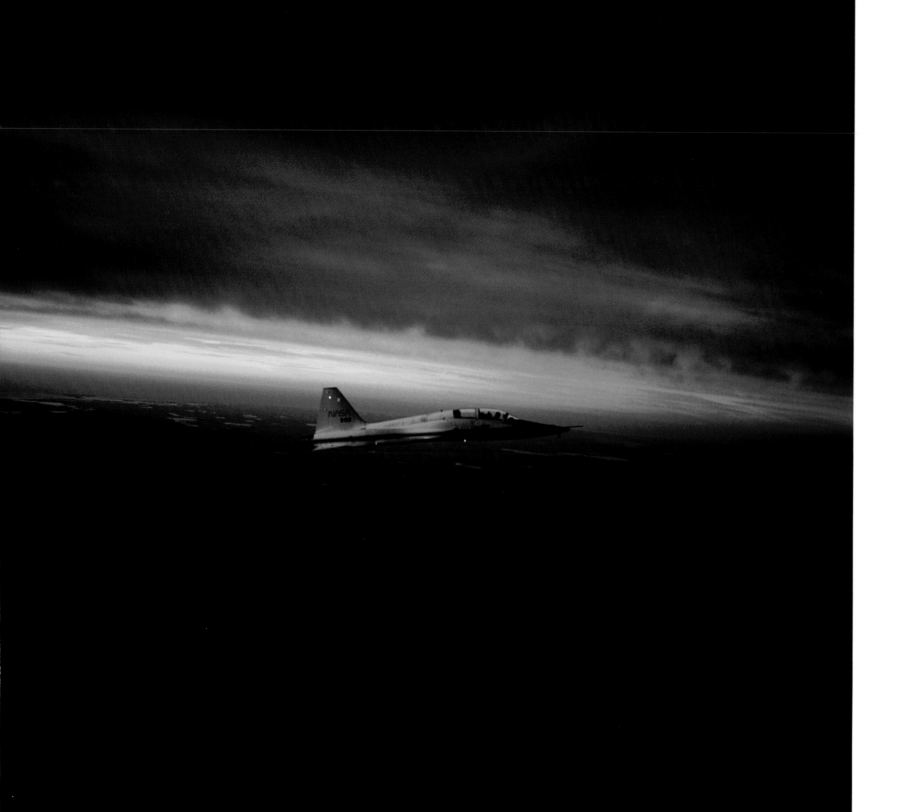

Solo flight into the setting sun, wrapped up, cradled in the extreme simplicity, beauty and grace of this creature. You look over at your brother and celebrate the moment that embraces him; you work on catching the moment, you don't wish to distract from it but you are solo too with the stick held in your knees, ASA 64 in your camera and no light, you take a timed exposure and pray. But it is okay, you look at him and that is you, he is your mirror.

There is no one on the ramp, you drive the nose wheel down the line, put it approximately on the little square, shut the engines off, turn the battery switch off, raise the canopy, unstrap your parachute, remove your mask and helmet, scoot your butt forward on the ejection seat, sink into the machine and let go of everything except the desert and a sense that the day is done.

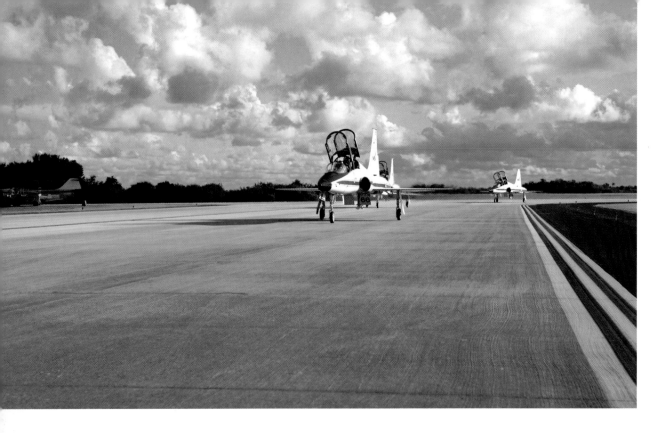

The crew of STS-125, the final Hubble Telescope servicing mission, arrive in September 2008 at the Shuttle Landing Facility at KSC for a practice launch.

I hoped to conclude this book with shots of their aircraft in the foreground of their launch in October, 2008 but a Hubble failure and other factors slipped them to May 12, 2009.

So sorry that you cannot join me. I will be there, shooting my babies and a launch; it ain't over till it's over.

STS-125 crew taxiing to the runway.

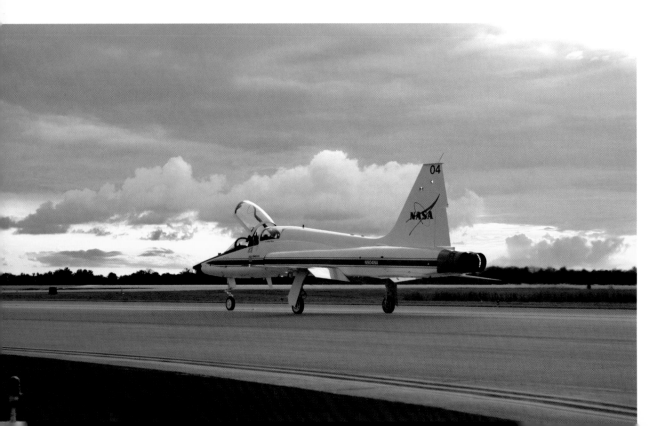

And on to the runway and off they go to Ellington in NASA 955.

Henry Watkins was the crew chief on this aircraft for decades. He strapped me into this beauty hundreds of times, she always took care of me, we did what we did, and then she brought me gently home to earth.

He has retired.

We used to call her "nine five fast".

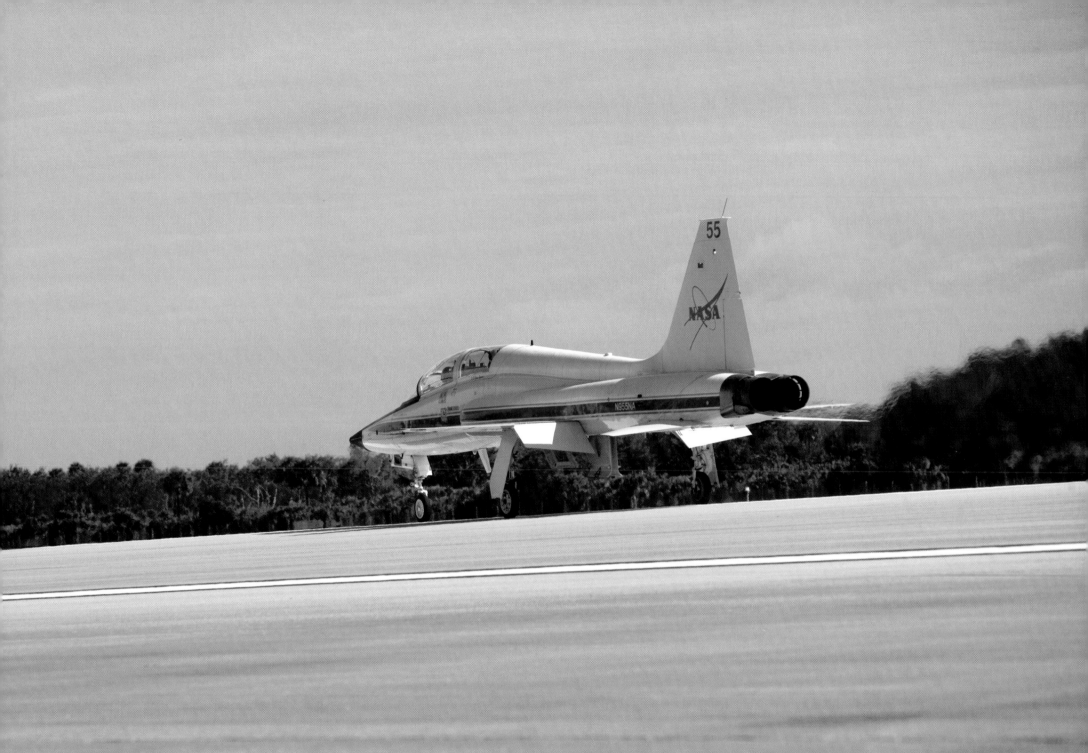

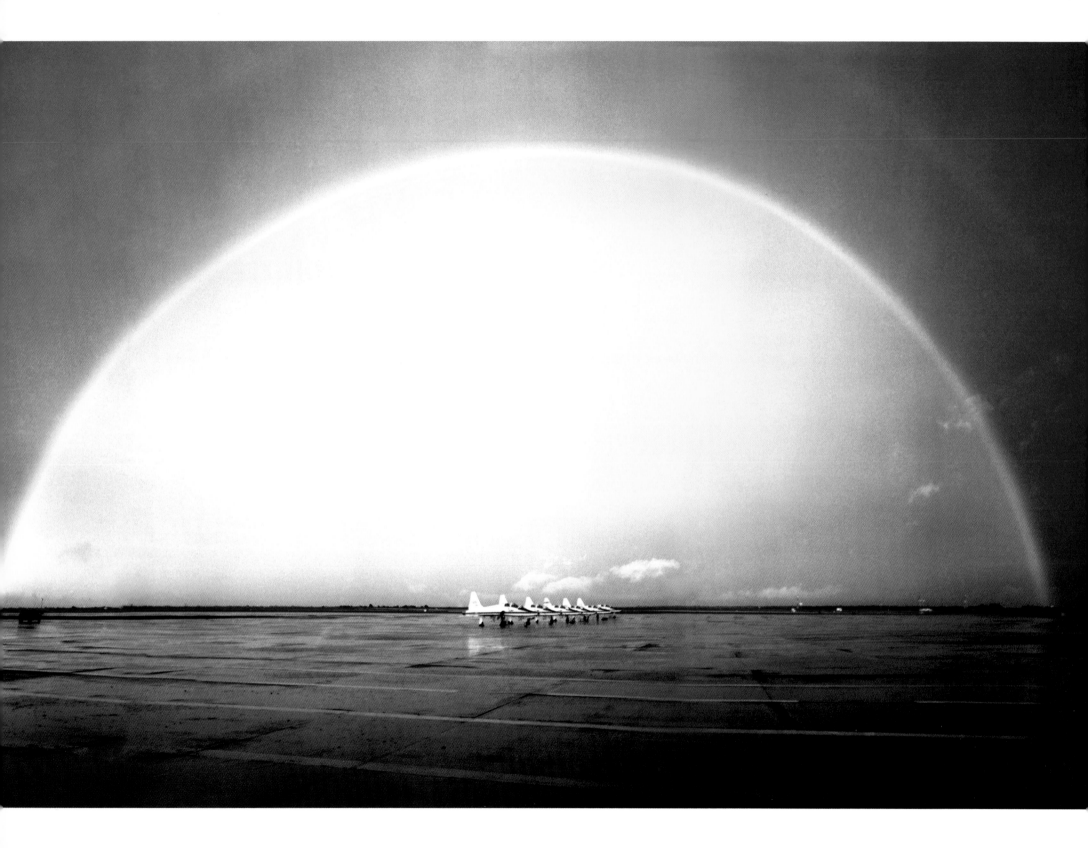

Epilogue

An unbelievable picture. If you don't want to believe it that is okay, because I don't believe it either.

We landed on a wet runway, 17R at Ellington Field, in the late afternoon. It was on Sunday so our crew was home with their families; we parked our aircraft and secured it for an overnight stay on the ramp. We walked to the hangar where our personal equipment shop was located; I put away my parachute, helmet, oxygen mask, navigation kit and gloves and headed out to the car in the parking lot. On arriving at the car I turned to say good-bye to my babies and this scene was in my face; for a moment I was stunned, beyond belief; then proceeded a perceptual ecstasy so powerful as to be simply unsurviveable, I could have died right there - a triple beam rainbow, with the most powerful enclosed light I had ever seen or could imagine, and sweeping horizon to horizon around these gorgeous machines.

In a flashing moment of sheer dread, and I mean I could have died again, I wondered if there was any film left in the Hasselblad? It had been my habit to shoot up any remaining film toward the end of a mission, so I could remove it for developing, and why, during the photographic opportunities provided by formation flying, would I leave any film in the camera for a routine flight line shot? A once ever scene like this and a Hasselblad without film would really hurt, forever. But I guess I had been lazy, or busy flying on the wing, or flying the approach, so there were eight frames of Ektachrome 64 remaining. I walked all over that thing with my Minolta Spotmeter, set up the Hasselblad, and went to work.

I could not move left or right if I was to keep my babies in the middle of the rainbow. I backed up as far as I could to get the whole image with a 55mm lens, but I backed into the hangar and could go back no further and had no wider lens. So I shot to the left and then to the right, and had NASA stitch the two transparencies for me later. I also moved far in one direction to get the rainbow coming down into the middle of the aircraft and then moved the other way to get the bow into the aircraft coming from the other direction.

So blessed am I to have been handed the extraordinary experience of this shot and so many of those over the last 42 years. I did nothing in particular to deserve it, but at least I was there flying and I did carry a camera. If you put yourself on the playing field and you are prepared, life happens.

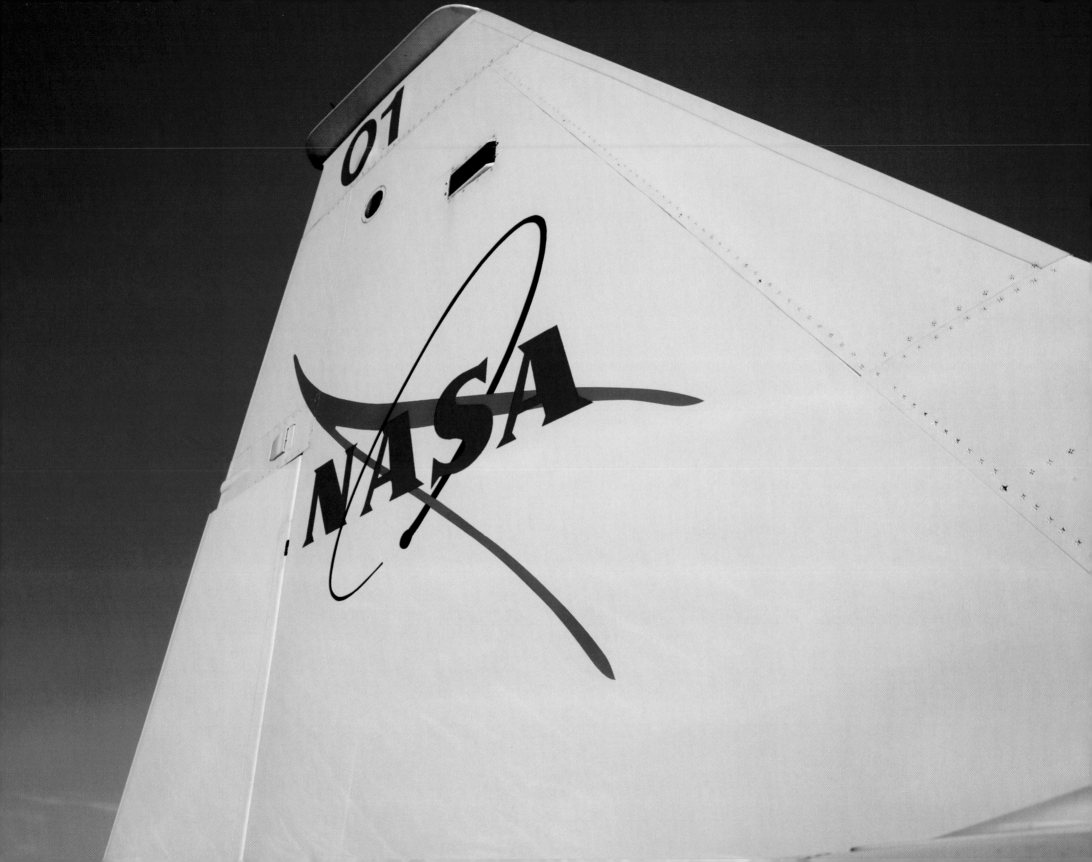

Acknowledgements

There are many people to thank.

We would like to thank the generous people at Ellington Field, Houston and the Kennedy Space Center's Shuttle Landing Facility for their enthusiastic support of this project. Over 41 years, Story photographed the NASA Northrop T-38 both in flight and on the ground. In recent times, he has continued this passion, visiting both KSC and Ellington on numerous occasions. The support of the managers, the administrators, the pilots, the mechanics and engineers has been invaluable. At times they have joined Story and his camera, sharing the excitement of the photo shoot, they have rearranged airplanes into flight lines, they have allowed him to photograph the inner workings and testing of the airplanes and, on one more memorable occasion, they parked the space shuttle beside his beloved T-38 so that the true association of the two vehicles could be highlighted.

Story's colleagues at NASA also shared the passion. Thanks are extended to all those who flew with him on the T-38 in formation while he was taking many of these photographs. And in that regard a very special thanks to Vance Brand and Bill Lenoir for the spectacular on the wing aerobatics. They were able to ensure a higher quality image through their co-operation.

Special thanks must go to Tom Jones, STS-59, STS-68, STS-80 and STS-98, for writing the Foreword. Tom shares the passion for the airplane world and, in this particular case, its association with the space program. Story and Tom shared their T-38 flying experiences in preparation for STS-80 in 1996. Tom is an author in his own right and has also written about space and flight in the books Sky Walking (2006) and Hell Hawks! (2008). His contribution to this work is greatly appreciated.

We would also like to thank our friends in the USA and Australia for viewing hundreds of potential images for this book and helping us to decide on the final selection. Without you, our task would have been much more difficult. And a special thanks to Adam Richardson for his boundless enthusiasm.

NASA photo librarians at the Kennedy Space Center and Johnson Space Center were also very helpful looking through archives for images of Story and the T-38. In particular we would like to thank Margaret Persinger and Jody Russell.

Finally, but by no means least, we extend our thanks to author and space historian Colin Burgess for the onerous task of proof reading.

This book is a testament to the enthusiam of all those we have mentioned.

Story, Lance and Anne

Lannistoria

STORY MUSGRAVE

Story started flying on grass fields in 1952. Over the next 57 years he acquired 18,000 hours of flight time in 160 different aircraft.

He joined the U.S Marine Corps in 1953 and served as an aviation electrician, instrument technician, engine mechanic and crew chief with squadrons VMA 251 at Air Base K6, Pyongtaek, Korea, and VMA 212 on the carrier U.S.S. Wasp and at Kaneohe M.C.A.S., Hawaii.

Story started parachuting in 1962 at Lakewood, N.J. and has over 800 free falls including over 100 experimental jumps involved in the study of human aerodynamics.

He took up commercial flying and had acquired commercial, multi-engine, flight instructor and instrument instructor ratings by 1965. He earned an Airline Transport Pilot rating in 1968. Assigned to the U.S. Air Force by NASA, Story received Air Force Wings in 1969. At graduation he was awarded the Commander's Trophy and had earned the highest flying and academic scores in the history of the Air Force.

Story took up soaring in 1963 and acquired sailplane, commercial and flight instructor ratings in 1976. One of his flight specialties was the teaching of aerobatics both in powered aircraft and in sailplanes.

With NASA, Story logged over 1500 hours as a flight instructor in the Northrop T-38. He was also a maintenance test pilot, flying hundreds of functional check flights on the T-38. Over a 30-year period, Story flew over 7000 hours in the Northrop T-38. Also with NASA, Story earned a Type Rating and Single Pilot Waiver in the Cessna Citation jet.

Story was a NASA Astronaut for over 30 years and a veteran of six spaceflights. He performed the first shuttle spacewalk on Challenger's maiden flight. He flew an astronomy mission, also on Challenger, and two Department of Defense missions on Discovery and Atlantis. On Endeavour he was the lead spacewalker for the first Hubble Space Telescope Repair Mission and on Columbia he deployed and operated an electronic chip manufacturing satellite.

Story has been photographing the NASA Northrop T-38 for 41 years and has several thousand images. It was his vision to combine the best of these images into a photographic work of art and to celebrate not only the beauty of the airplane and its role within the space program, but to highlight the role of those who worked hard behind the scenes to keep the airplane in service for the past 50 years.

ANNE LENEHAN

Anne Lenehan is an author, editor, graphic designer and project manager. A founding member of Lannistoria, Anne brings her unique organizational skills and editing capabilities to this project.

In 2004, Anne published her biography of Story titled STORY: THE WAY OF WATER which received critical acclaim and a nomination for the Eugene M. Emme Astronautical Literature Award.

Anne is also the lead creative artist for Story's website www.storymusgrave.com which celebrates the achievements of one of the world's most inspiring men.

The release of this book coincides with more than 40 years' service to the space industry by Story Musgrave, as well as his passion for the world of the T-38. After intense scrutiny of thousands of slides and digital photographs, Anne, together with Lance and Story, worked to produce the final selection of images for the compelling storyline.

LANCE LENEHAN

Lance Lenehan is an artist with a strong emphasis on graphic design and photography. He is also a cinematographer, composer and musician with 30 years' experience in electronic music and computing. A founding member of Lannistoria, Lance has a unique eye for design, sound and production aspects of the business.

On other Lannistoria projects, Lance has worked as film editor, cinematographer and musician. His music regularly accompanies Story's live performances to audiences throughout the world.

An exceptional technician, Lance has worked with Story to bring the images in this book to the reader in the best possible format, while juggling the logistics of text and photographic sequence. The resulting work is truly outstanding.

Humans are not the only ones who get dermabrasion!

Index

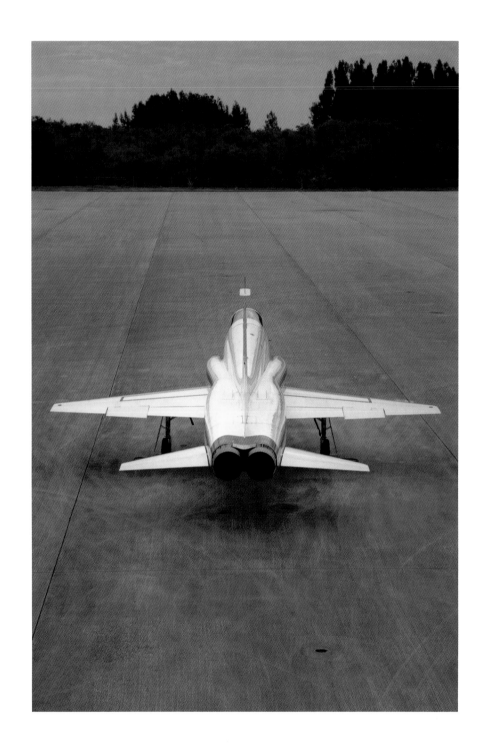

Reference

My Photographic Journal for the NASA Northrop T-38

Cameras

1967 to 1985: Nikon F, 1967 model.
Manual focus, manual exposure, used meter
in the viewfinder for exposure settings.

1983 to 1997: Hasselblad 500 EL/M.
Manual focus, manual exposure, used Minolta
Spotmeter F for exposure settings.

1997 to 2006: Hasselblad 501C.
Manual focus, manual exposure, used Minolta
Spotmeter F for exposure settings.

2004 to 2009: Canon EOS 1Ds Mark II

2008 to 2009: Canon EOS 1Ds Mark III

Scanner
All film transparencies were digitized with a
Nikon Coolscan LS-9000 ED.

35mm Film

1967 to 1974:
Kodachrome II, ASA 25.
1967 to 1978:
Kodachrome II Professional, ASA 40.
1974 to 1985:
Kodachrome 25, ASA 25.
1974 to 1985:
Kodachrome 64, ASA 64.
1983 to 1985:
Kodachrome 64 Professional, ASA 64.

6cm x 6cm
Medium Format Film

1983 to 2006:
Ektachrome 64 Professional, ASA 64.
1990 to 2006:
Fujichrome Velvia 50, ASA 50.

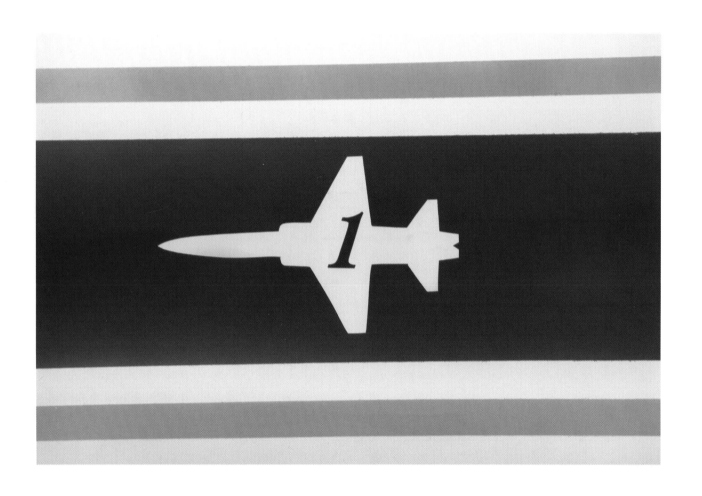